This book is dedicated to my wife, Meghan, and our four boys:
Caleb, Phoenix, Joshua, and Hawke Danger. Thank you for
putting up with this weird job that I have. Meghan,
I can't do what I do without you.
I love you more than dust loves sensors.

ACKNOWLEDGMENTS

I'd like to thank all of you crazy-ass photographers who hang out with me online and in real life. Together we've made a pretty amazing community of people who share, laugh, troll, criticize, and make fun of me, ourselves, and this industry and craft that we love. There's no other job in the world I'd rather have.

I also need to thank my editor, Ted Waitt, for believing in me a long, long, long time before anything with this project started. You have been a solid friend in this industry, Ted. Thank you. I'd also like to thank Charlene Charles-Will for her great work designing this book, and Lisa Brazieal for making sure it looked great coming off the presses.

Marc Climie—You pulled me out of a ditch, and I'll always be grateful.

Kevin Abeyta—Thanks, man. For everything.

Many, many, many people have helped me and continue to help me along the way. I cannot publish this book without giving personal shoutouts to: Mr. & Mrs. Carnes, Kim Harkins, Steve Schaefer, Sherri Finch, Michael Weeman, The 7:30 Club, Erik Dixon, Dan Depew, Hassel Weems, Joe McNally, David Hobby, Chris Hurtt, Mohamed Somji, Hala Salhi, Scott Kelby, Brad Moore, RC Concepcion, Jason Groupp, Jeremy Cowart, David duChemin, Andrew Thomas Lee, David Jay, Steve Schwartz at B&H, Mark Anderson, David Nightingale, Craig Swanson, Chase Jarvis, Mark Adams, Dan Milnor, Michael Schwarz, Phil Skinner, Matthew & Lani Martz, Rhonda Dixon, Amanda Dyson, Emily Sistrunk, The Carters Crew, David E. Jackson, Cary Norton, Syl Arena, and Joey L. To my family: Bob & Carey Lynn, Caitlin, Erin & Randy, Brett, Corey, Mom, Chris & Andrea, Mitch & Ginger, Elaine, and my late father, Martin Arias.

Dad, you gave me my first camera and set me on this path a long time ago. Thanks. I miss you.

CONTENTS

x Foreword

xii Introduction

2 Zack is a cynical bastard.

5 Feeling like a farce and a phony.

6 Exposure drills.

8 Which softbox—28" or 50"?

12 Quality of light between two lights and one box.

13 Who's got the nicest glASS?

14 **VISUAL INTERMISSION**

16 Rebels need not apply.

18 Finding portrait subjects.

20 Good days and bad days.

21 Difference between the genres.

28 Is there always a photo to be made?

29 Seamless in a small room.

30 Film camera for sports.

31 Save and buy once.

32 **VISUAL INTERMISSION**

34 Till dust do us part.

35 Best place for critique.

37 Best piece of gear under $100.

42 Photography competitions.

45 Not enough hours in the day.

48 How important is post-processing?

51 Full frame vs. crop factor.

53 Taking photos is 10%.

54 Talk to strangers, kids!

58 Previsualization and directing subjects.

61 Lightroom vs. Aperture.

62 **VISUAL INTERMISSION**

66 Lord help him. He's working at Goodwill.

67 UV filters are trash.

68 Asking about a street photo.

71 Style over substance.

72 Shootin' nekkid girls.

77 Cheap eBay lights.

78 OneLight for life.

81 All lenses are not created equal.

82 Trade shows.

84 Résumés for photographers.

85 Things I've learned while learning others.

86 VISUAL INTERMISSION

94 Gear lust.

96 My shit ain't sharp.

98 Low light blues.

104 Blowin' up some photos!

110 Asking strangers for photos.

113 Stock or purge?

116 Nudes, Bar Mitzvahs, and WTF.

118 VISUAL INTERMISSION

120 How do I sell stuff that people don't buy?

121 Don't build a following.

123 Going to school for photography.

125 Assisting and 2nd shooting.

129 Comparing yourself to others.

130 Noise reduction. Not elimination.

131 Drinking with friends.

133 Small town fashionista.

137 Follow footballers foodchain.

139 The goal of personal projects.

CONTENTS

140 Feeling confident enough to start selling.

143 How do you charge a band?

147 Gettin' paid in Cincinnati.

150 VISUAL INTERMISSION

152 Salon owner seeks slavery.

156 Setting prices. The primer.

159 Why grid a softbox?

161 Artist's statements and the innocence of trees.

163 Comparing PCB strobes.

164 Ain't no money in live music.

167 Kidnapped & Dumped. How to start.

169 Band, label, or manager directing the shoot?

170 Waves of anxiety.

171 The Catch 22. Job or jump?

174 VISUAL INTERMISSION

176 Underpriced and working.

177 Posting pricing on your web site.

180 Finding your style.

182 Packing gear.

186 Lenses and LEDs.

187 A company by any other name.

188 Mixing work on web sites or splitting them.

190 VISUAL INTERMISSION

194 Marketing and self-promotion.

199 Logos. To pay or not to pay.

201 What is a successful photographer?

202 Rare times I use Aperture Priority.

204 Cropping & Blurring.

206 Beyond the bridal booth

209 Giving the files away.

211 Giving the RAW files away.

212 Questions to ask when making a bid.

214 VISUAL INTERMISSION

216 Which of your children do you love more?
 Portfolios.

224 Genre jumping.

227 What an art buyer wants to see in your book.

228 Great photographers you should know.

230 Videos of girls putting make-up on.

231 Great excuses for my crappy web galleries.

232 Using a light meter. Know your shit.

238 Delivering images you hate.

240 Basic checklist for permanent studio space.

242 Using a studio to your benefit.

243 'merica!

244 What keeps me alive on the streets.

247 He shoots with Sony. Hahahahaha!

249 VISUAL INTERMISSION

250 Slow-paying clients.

251 When to charge for licensing usage.

254 Can't get no credit.

256 Learning to sell. Hold this book.

259 Gear porn.

269 Cards & Battery system.

270 Do as I say. Not as I do.

272 Personal Personal Projects.

280 One day you're great. The next, you're a hack.

282 Putting the camera down forever.

286 Worksheets

294 Index

Q: HI SACHA. THANKS FOR TAKING MY QUESTION, AND THANKS FOR WRITING THIS FOREWORD. AS A SENIOR PHOTO EDITOR AT *ROLLING STONE*, YOU MUST SEE A LOT OF WORK FROM PHOTOGRAPHERS. I'M A FAIRLY NEW PHOTOGRAPHER IN THE EDITORIAL WORLD, AND I'M WONDERING WHAT CATCHES YOUR ATTENTION ENOUGH TO PICK UP THE PHONE AND CALL A PHOTOGRAPHER YOU HAVEN'T WORKED WITH BEFORE. IS IT THE QUALITY OF THE WORK? IS IT A GUT INSTINCT? YOUR NECK CAN BE ON THE LINE WHEN WORKING WITH SOMEONE NEW. HOW DO YOU KNOW WHO IS OR WHO IS NOT GOING TO WORK WELL WITH YOU?

A: Zack,

Knowing what this book is—and its aim to demystify for beginning photographers certain aspects of what it means to be a working photographer—I really should have expected this very question. I hope I can do it justice.

Most publications have a list of preferred photographers who do regular work for them, and breaking into that lineup is not an easy thing to do. That being said, picture editors like myself are always looking at photography and for new (or new to them) talent. I try to stay engaged in this process as much as I can by checking out emailed and printed promos, photo books, magazines, blogs, and zines, as well as attending portfolio reviews, gallery shows, etc.

So, by the time I've picked up the phone to make that call to someone new to shoot for *Rolling Stone* (or even just for a meeting), more often than not I have probably been looking at their work for a while—basically stalking them. I might have been checking out their Tumblr, Instagram, blog, and/or web site from time to time; looking at their latest shoots; or discussing them with coworkers and photo editors at other magazines. It isn't always about seeing one amazing shot. It can help to see

someone's progression over time. That way, I get a better sense of their personal style, how they handled a particular situation, and what kind of subjects they seem to best connect with. Watching their body of work evolve also helps to get to know them better, to get a sense of the kind of person they are.

More to your question…so what is it that makes me pay attention in the first place? You asked, "Is it the quality of the work? Is it a gut instinct?" Both are true.

I'm surrounded by photography—my parents are both photographers, my twin sister is a visual artist, my wife is also a photo editor, I shoot a bit, and every day I work with photographers young and old—so I'm frequently fascinated with the processes they employ, the tools they use (cameras, lenses, film stock), how a shoot went, whatever. I totally nerd out on that. However, when I see an image that hits me hard and really connects with me, it's as if all those details fall away and they're the last thing I consider…if I consider them at all. The greatness of an image is in the intangibles.

I have my own tastes, which may differ from those of my coworkers, and since one of our tasks is to consider how someone's work could be applied within the pages of *Rolling Stone*, some discussion may occur around the office about someone being the right fit for the magazine and/or for a particular assignment.

If you are thinking about submitting work to us, I think it's a great idea to be as familiar as possible with *Rolling Stone* (this would apply to any publication you'd like to work for). Know the different sections and the style of work used in each, the photographers that are employed and how. If you consider your work to be a good fit, then hit us up.

—Sacha Lecca
Senior Photo Editor, *Rolling Stone* magazine

INTRODUCTION

I rarely, if ever, read the introductions to books. Now I'm writing one. Oh, the irony.

I have stuff to say about the stuff I have to say in this book.

This book was born from a Q&A Tumblr blog that I started during the summer of 2012. I began with a goal of answering 1,000 questions. I have since surpassed that goal. As questions come in from folks, the blog is a random brain dump of my thoughts and experiences as a photographer. My editor, Ted Waitt, and I have sifted through hundreds of pages of material to create this book. We started with the original blog posts and have edited and expanded that material for this book. The blog is the rough draft, the framework this book is built on.

I feel this book is going to be the grout in your photographic life. There are books on lighting. Books on marketing. Books on posing. I am not trying to write the definitive book on any one subject here. This book fills in the gaps. As much as I want to help explain what to do, I want to explain why you do it. I promise there is at least one sentence in this book that is going to impact your life as a photographer. At least one sentence is going to help you out and pay you back over and over and over for whatever you paid for this book.

Please do not think that I'm speaking from the mountain top of the photography industry like I'm some Grand Poobah of Light or something. If there is a mountain top, then I just recently made it to base camp. After 16 years of pursuing photography I feel I am just now getting ready to begin climbing. As I answer these questions, I'm doing so from the perspective of dealing with current issues in my own life, or I'm speaking to myself in the past. I'm saying things I wish I would have known "back then."

Here's the thing…I'm saying things to myself that, at times, I myself would not have wanted to hear back then. Some folks think I'm sort of mean and cynical.

Why am I doing this and why do people sometimes think I'm cynical?

Well, let's start with that question.

1-10

Zack is a cynical bastard.

Feeling like a farce and a phony.

Exposure drills.

Which softbox—28" or 50"?

Quality of light between two lights and one box.

Who's got the nicest glASS?

Rebels need not apply.

Finding portrait subjects.

Good days and bad days.

Difference between the genres.

Q: WHY ARE YOU DOING THIS, AND DO YOU KNOW HOW CYNICAL AND DEPRESSING YOU ARE IN THIS Q&A? I LIKE IT WHEN YOU TELL OTHERS NOT TO DO CERTAIN TYPES OF PHOTOS. IT'S FUN WHEN YOU SAY FOLKS WILL PROBABLY FAIL WHEN THEY TRY SOMETHING. CAN'T WAIT 'TIL YOU JUST SAY THAT PHOTOGRAPHY IS DEAD!

A: Look. This Q&A project is me kicking and screaming against the flood of bad advice, stupid Top 10 lists, and the overall bastardization and corruption of the industry and the craft that we all love so dearly.

In an age where we are told we need to be nice and helpful and not say mean things, we have weakened the respect for the craft. Too many young photographers completely dismiss those who have gone before them. Too many people are picking up the camera and falling into the same traps over and over and over again.

Not enough people are speaking up. Not enough people are pointing out the traps. Not enough people will be honest about how hard this can be. I've sat in keynote speeches where the world was promised to the emerging photographer. With the right branding, an 85mm 1.2 lens, and a smile, the world of photography is at your fingertips.

No it isn't.

Photography isn't going to die because I'm pissed off. It's not going to die because I tell people how to shoot or what to shoot. It's going to die because far too many leaders are leading far too many people down the wrong path. People are lowering the bar of expectations in this industry. Even manufacturers are on this bandwagon. I swear—the smarter our cameras get, the dumber the photographers become.

I'm going to tell you that if you try something like launching a portrait business and gallery fine art business, at the same time, you will most likely fail. Or I could pat you on the back, tell you to believe in yourself, follow your dreams, and wish you the very best of luck with it!

Big smiles! Positive thoughts!!!

And then watch you walk into proverbial traffic and die when I knew, all along, yeah, you're probably gonna die if you do that. If I were cynical, I'd be sitting on the side of the road laughing at your ass when you fail.

Or. How about I point out the difficulties you are about to face? I might bring a few things to the table you haven't thought about yet. Maybe what I'm doing is trying to save you several years and several thousands of dollars of frustration.

Keep it simple. Keep it focused. Work on this, this, and that. Don't get too carried away or it will be too soon and too fast and you'll fail. Honestly look at your situation. Are you prepared for this, this, and this? That lens isn't going to help you right now because you can have this other lens over here for $1,700 less and still get the job done. Spending your money in this direction will hurt you. Instead, spend less here and do this or that to grow as a photographer. You're putting too much time into photographs that aren't going to further your career for the region of the world you live in. Take a look at this kind of thing over here; translate what you like about what you are already doing over there and make it work over here instead.

If you are just getting started in photography, you're most likely, by the numbers, going to have a lot of failure to contend with. You can be 20 years into this and still have failures to contend with. So I'm the cynical son of a bitch who will make you honestly face it and, quite possibly, maybe…help you avoid breaking your leg in a few of the traps along the way.

Want to keep shooting mediocre photos that won't further a lifelong career? Go for it! Have at it! Yay! This industry is not short of folks ready to cheer you on in that endeavor. Suhhhweeeeet!

My goal with this is to kick you in your teeth. Knock the wind out of you, and take your legs out from under you. My promise is to then give you my hand, help you back up, dust you off, and show you my broken bones and bruises. I'm also going to make sure that if you think I have a strong left hook you should look up the food chain and see the great fighters. They'd kick both of our asses in a hot second.

The next time I come along to punch your lights out I'm hoping you can block it and kick my ass to the ground.

"Zack, you're so violent. I don't like that."*

Fine. My goal is to give you more padding for your saddle so you can enjoy your unicorn ride across the Gum Drop Mountains.

Photography is alive and well. It's an awesome time to be alive in photography. There's so much to do and the technology is effing amazing. However, we can get lost in all of the excitement and tech, and forget the simplicity of the craft. I want people to learn their craft, and I want the bar of expectations on us as photographers to be so high that we can't even see it. Yes, photography is fun. Yes, it's exciting. Damn it, though, it deserves to be respected, and learned, and cared for. All the bright-eyed personality-driven leaders who couldn't shoot their way out of a wet paper bag have infuriated me to the point that I'm pushing against it.

I might not be able to knock this wall down but maybe I'll be able to put a hole in it. Others are trying, as well. Many of us are finding ways to get the fast-lens-and-big-smile personality-driven photography pushed over the cliff so we can get back to knowing what the hell we are doing with a camera and our business.

Photography is all I have to do with my life outside of loving and taking care of my family. I do that with a camera. It's all a big weird mix. It's my profession but I take it very personally. I can't separate my professional life and my personal life. I care about this. I care about you. I don't want you stuck in Aperture Priority for the rest of your life. I don't want you to be afraid of life. I want you to think about the business you are running and the photographs you are making. I hope you run a great business! I do! I wish you great success! Most importantly, though, I hope you're an amazing photographer first.

Maybe you're not going to do this as a business. Awesome! That's almost better. Now you just get to concentrate on being an amazing photographer!

*Jim Gaffigan, anyone?

A: Do I ever feel like a farce or a phony? All the time. Every day.

I was recently invited to speak at a photography conference in New York City. It was a great conference with some amazing speakers. I shared the stage with two Pulitzer Prize winners, an astronaut, people developing new technologies, etc. Amazing people. People doing important work. Shooting unreal photographs. Making strides in technology.

Then there's me. A guy who shoots unknown bands, standard magazine assignments, and some commercial work. Nothing on the forefront of the industry. I'm not making images that will be iconic for decades to come. Yet I have more Twitter followers than all the speakers combined. WTF is that all about? I felt like such a farce standing on that stage. Everyone told me they were pleased to finally meet me. They had heard a lot about me. Why do you want to meet me? What the hell have I done to merit your attention? I'm a phony.

I'm constantly frustrated with my work. I'm currently struggling with a new portfolio I'm trying to create. When I close my eyes I see it. I see the cover. I see the opening image. I see the images I want in that portfolio. Know what sucks? This book I see in my mind's eye is stuff I haven't shot yet. I love my work for 24 to 48 hours after making it, then I start tearing it apart and I hate it. Just like that. That sucks. How do I deal with it?

What I've found is you can't wait until you're ready because you'll never start. You have to take what you have today and build from there. You're further along than you were two years ago. Hopefully, you'll be further along two years from now. If you are green as grass at this very moment then you have to start from the bottom. Your work sucks. It's horrible. You just started. You have to shoot bad work and get it out of your system.

Just go. Go forward. You'll feel like a farce and a phony all the time. It's okay. We all deal with it. You'll have little moments of brilliance and valleys of despair. Those who think the moon was hung on their photographic prowess are usually assholes none of us would ever want to have a cup of coffee with. Sure, we'd like their life and their clients, but you know the ones I'm talking about: You wouldn't want to be them as a person. Full of ego, and bravado, and self-importance. No one wants that.

It is this sort of struggle that drives you. Get past your insecurities. Get over your fear. Fear is a cancer in your life. Go. Keep moving. You'll finish the race. Finishing the race, IMHO, is a better goal than winning the race. Many get snagged in the nets and can't get over themselves. They'll leave photography. Many start. Few finish. Get your ass up and finish. Note the finish line is about 30 or 40 years down the road...if you're lucky.

A: Simplify. Simplify. Simplify.

Exposure is made with a combination of shutter speed, aperture, and ISO. That's it. Well, except when we introduce flash. Don't worry about that yet. Shutter. Aperture. ISO. That's it. Every scene in front of you will require X aperture @ Y shutter speed @ Z ISO.

Head out the door for an hour and shoot at ISO 200 at f4. You've now locked down two out of three exposure variables. All you have to figure out with your in-camera meter is shutter speed. Don't change ISO. Don't change aperture. Just shutter speed. Remember your camera wants to meter and make everything 18% grey. Average metering is reading everything. Spot metering reads just the middle (or it may follow your AF point. RTFM for that one). Set your camera to average metering and go shoot.

Look at the subject. Is it 18% grey? Close? Maybe darker? Maybe lighter? Solid green grass is about 18% grey. A good, deep, blue-sky color is about 18% grey. A strong red can be about 18% grey. You have to learn what is "grey" and what is not so you can anticipate what your meter is "thinking."

Head out the next day at ISO 200 at 1/60th of a second shutter speed and figure out aperture only. You'll learn the limits of your lens pretty quickly. Then go out with f5.6 at 1/250th of a second and just change ISO.

Get really comfortable changing one thing at a time. Once you find confidence doing this you'll start being able to move two things at once. Then you'll be thinking in exposure. You'll be trying to read it before you even pull the camera to your eye.

What worries me most in your question is your statement, "I get nervous."

Don't get nervous. It's just stuff. There isn't a starving tiger about to be released on you if you get it wrong. Yes, it's a lot to learn but all you need is discipline to learn exposure. As you begin to learn exposure you will take the most boring photos of your life. That's fine. Someone learning to play the piano isn't writing the lost Mozart concerto. They're just playing scales and notes. Playing the piano and writing songs are two different things. Learn to play. Once you have that down, then you'll start to write. Just don't be nervous about it. Have fun.

Wax on. Wax off.

The meter inside of your camera wants to make the world 18% grey. Pictured here is a basic exposure target that has black, 18% grey, and white on it. A good base exposure will yield each value correctly. There should be a little detail visible in the black and white areas.

If you put your spot meter on the black area and take a shot at the displayed settings, then the camera is trying to make black into grey and will overexpose the photo.

Your meter wants to make things 18% grey, so you should get an acceptable exposure value by spot metering this area of the target.

When a meter reads white and tries to make it grey, it will underexpose the image. Setting your camera meter to a multi mode or average metering mode will make the camera take readings from several areas of your frame and then average all of those readings together. If there is one thing you should read in your camera manual, it is the area on the different metering modes it has, how they work, and how to access them.

 These are different enough that some thought needs to go into this process of which one to buy.

The smaller the light source, the harder the light will be. The larger the light source, the softer the light will be. The rule of thumb when using a softbox is that the maximum working distance from the subject should be no more than twice the diagonal measurement of the face of the softbox.

Huh? Measure the diagonal dimension of the front of your softbox. The 28" Westcott has a diagonal measurement of three feet. By this rule of thumb, the furthest you want to get that softbox from your subject is six feet. The 50" has a diagonal measurement of five feet. You have 10 feet to work with from subject to softbox with this light.

Why does this matter? It depends on how you shoot. Shoot a lot of full-length shots? Like to add a good bit of negative space to a photo? If so, then you'd first go to the 50" box because you can back that thang up 10 feet from your subjects and still get a good quality of light from it. Like to shoot tighter? You do more headshot to 3/4-length shots? The 28" can work in that scenario since you are framing tighter to your subjects and the light can be closer in.

Also think about the light source you have. The further you back the light up from the subject the more power you'll need from your light. Using a hotshoe flash in a 50" softbox from 10 feet away? You'll be living at full power on that light and still only get f4 or f5.6 at best. Inverse square law is a bitch. If I'm taking my 50" to a 10-foot mark from the subject then I'm typically driving it with an Alien Bee or something more powerful than a hotshoe flash.

Now then, we're just talking about a basic rule of thumb. Yes, you can put a 28" box 10 feet from your subject. You can. But you will begin to lose the quality of light that you got that box for in the first place. As you move the box further from your subject it becomes a smaller light source in relationship to them. Think about moving a 50" box to 100 feet away from your subject. It would be a pinpoint light source on them. Move it 10 inches from your subject and it's massive on them now! A huge, soft, wrapping light source.

Another thing to think about is the spread of light from a softbox. Umbrellas and the like sort of wash an area with light. You can shoot one person or 10 people with an umbrella. A softbox is more directional than an umbrella. The smaller the softbox, the smaller the spread. I typically use the 28" when I'm shooting one to two people. Those two people need to be close together. I'll shoot one to four or five people with the 50" box.

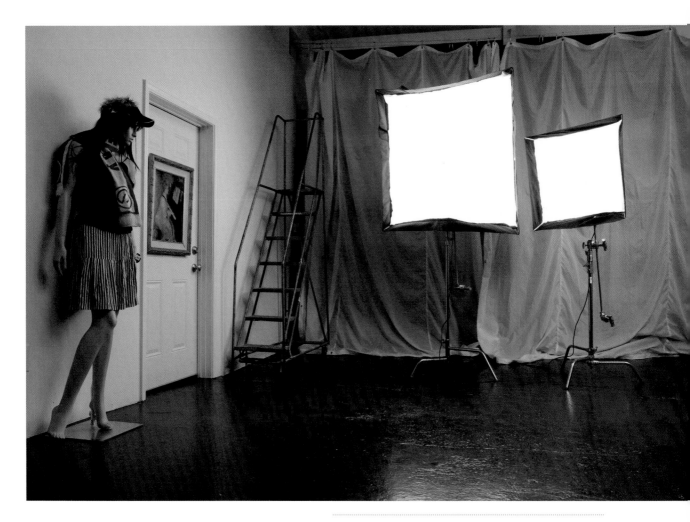

Pictured here are the two softboxes in question. They are two of my favorite modifiers. These two softboxes have been part of my regular kit of gear for nearly 10 years. They work great with both hotshoe flashes and larger strobes.

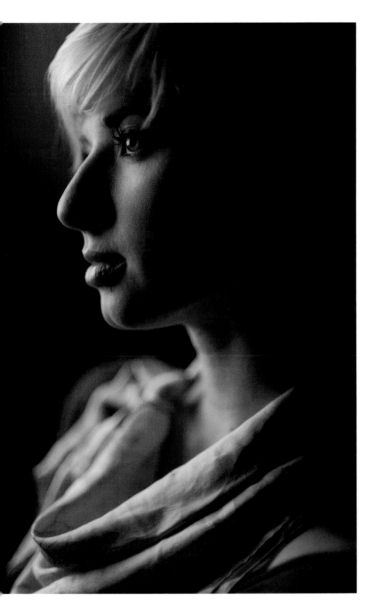

The 28" Westcott Apollo was used here. It is just outside of the frame to camera left. It creates a beautiful soft light with more dramatic shadows, as it is smaller than the 50". The 50" box would wrap more light around her face and open up the shadows. Maybe you want that in a photo. At that point, you then use the 50" instead of the 28". :: Nikon D3 / 85mm / f1.8 @ 1/250th @ ISO 200 with a hotshoe flash in the box.

You say you're mainly shooting seniors and couples. The 28" will be a good starting point. The 50" can work, as well. It would allow you to put a little more room between couples when you are posing them. You can increase the spread from the softbox by backing it away from them, but remember that rule of thumb I mentioned: You'll only want to take the 28" back to about six feet. Once you need to go beyond six feet then you'll either sacrifice quality of light or you'll jump up to the 50" box.

You could just about toss a coin and pick one. I guess I'd suggest the 28" to you first. Go with that and use it for six months. Get to know that light really, really well. Know what it will do and what it won't do. After six months of shooting you'll start to know if the 50" is the next step you need. You'll know this if you constantly find that you need a larger spread of light for couples, or if you always live at that six-foot range of the smaller box.

Another thing to think about is to get the 28" box and a 60" umbrella. The 28" is there for tight shots and single-person compositions. The umbrella gets pulled out when you are shooting more than two people or you need a wider spread of light for the situation you are in. A good umbrella can be had for $30 or so. It's good to have one in your bag at all times. It's the Swiss Army knife of modifiers.

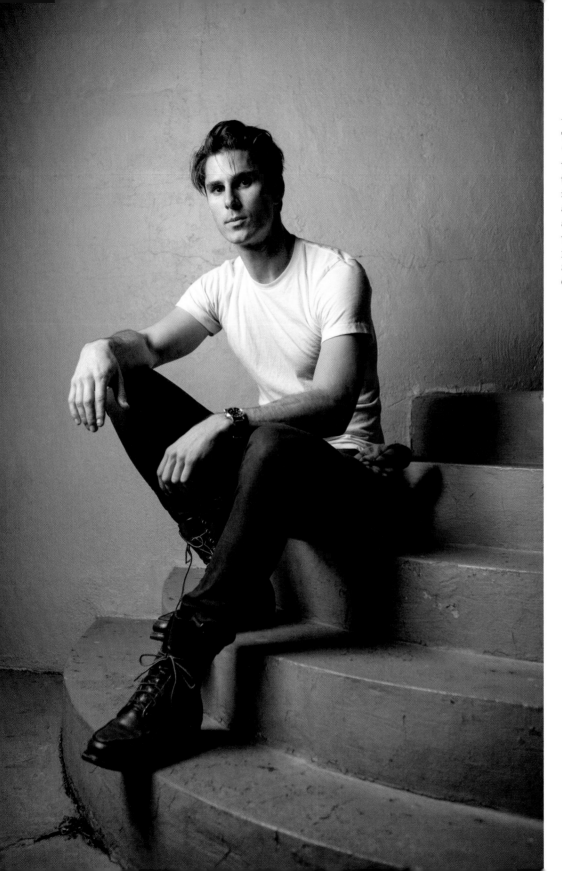

The 50" Westcott Apollo—or "Big Mama," as I call it— was used here. The face of the box was approximately four feet from the subject and was being powered with a Nikon SB-80DX flash that was somewhere around half power. :: Canon 5D Mk II / 24–70mm L @ 40mm / f3.2 @ 1/160th @ ISO 400.

Q: PROBABLY A BLONDE QUESTION BUT HERE IT GOES. MY QUESTION IS IN RELATION TO "QUALITY OF LIGHT." IF, LET'S SAY, I SHOOT A HEADSHOT AT F4 WITH A SPEEDLIGHT IN A 28" SOFTBOX AND THEN I SHOOT THE SAME RIG, ONLY THIS TIME I'M USING AN EINSTEIN AT F4, IS THE QUALITY OF LIGHT THE SAME? SORRY ABOUT THE BIMBO QUESTION.

A: The main light hitting the subject will be "softbox" light no matter what light is driving it. Some might pixel peep and find some sort of difference in the shadow under the third eyelash from the left, but yeah…. The modifier is the main "quality of light" part of this equation. Not the light inside of the modifier. Not a bimbo question at all.

A: Honestly, they're all about the same as far as quality goes in day-to-day use. It's like asking which is better: Nissan or Toyota? Feature for feature, and price to price, there isn't a massive amount of difference, especially when you're talking about their "affordable" line of lenses. There are a few stellar Nikon lenses out there and a few stellar Canon lenses. Sometimes one 85mm outperforms the other, and vice versa.

While we are on this subject, let's get this out of the way: Nikon or Canon?

Here is the definitive answer—it doesn't matter. It doesn't freaking matter one bit. Each manufacturer has a few good options over the other. Sometimes I wish they'd just get drunk at an industry event, hook up back at the Holiday Inn, and have the perfect love child of a camera. I'd take a Nikon pro body with the Canon 5D Mark whatever sensor. That would be the perfect love child between the two.

Back in the old days of film a person could have just about any camera body they wanted. The body didn't matter that much. Each camera manufacturer had a good, better, and best line. Film was then chosen based on the different qualities and characteristics that were preferred by the photographer. There were Nikon shooters and Canon shooters who both shot Fuji film; or one shot Kodak and the other shot Fuji; or the film could be mixed and matched as much as one wanted.

These days the "film" is the sensor planted in the camera body. The good, better, and best camera bodies have different sensors. A Nikon sensor has a different characteristic and quality to it than a Canon sensor. Well, you can't pick the digital body from one and the sensor from the other, at least not in the DSLR market. To some degree, you can have those options in the medium format world.

I personally prefer the Canon sensors and the Nikon bodies. Really, though, it doesn't matter. I prefer Nikon glass, as well. If I could have a Nikon D4 body with a Canon 5D Mk II sensor, I'd be a very happy man.

I could line up 10 amazing professional Nikon photographers and 10 amazing professional Canon photographers. You could then look at the work of each of them and, at the end of the day, you'd see it's not about Nikon or Canon. It's about who is using the camera. Joe McNally isn't more professional because he uses Nikon. Jeremy Cowart isn't more professional because he uses Canon. Both are great photographers with completely different camera systems, different lenses, different eyes, different brains, different styles; both of them are amazing.

Hold a Nikon in your hand. Hold a Canon in your hand. Which do you like more? Which one excites you? Buy that one. Those who participate in Nikon vs. Canon flame wars on the Internets are sad individuals. Avoid those discussions. They do nothing to further the craft of photography. People who get passionate about the gear usually have the most boring photos in the world.

Now. Mac vs. PC? Mac, of course. Duh! You're a stupid head if you use PCs.

VISUAL INTERMISSION

RED LETTER AGENT // WHY I'M A MUSIC PHOTOGRAPHER

There are going to be benchmark photographs in your life as a photographer. They may not be your best photos. They may not even be great photos. But something about a benchmark photo shows a turning point in your career or your craft. This image is one of mine.

This image was shot in November 2003. Shortly before taking this photo I was working a full time job at Kinko's. I had left the photography industry behind after a series of personal problems left me in a tailspin. It had been close to two years since I had taken a photo. My friend, Marc Climie, approached me and asked if I was willing to second shoot weddings with him. He bought me a Nikon D100 in October 2003 and set me loose at a wedding. I quit my job at Kinko's the next week.

The sum of my photography gear was that Nikon D100, an old Vivitar 285 flash, and an old Mac. I didn't own a lens. I didn't even own as much as a memory card. I took my last check and bought a light stand, an umbrella, an optical slave for the 285, and a cheap IR trigger. Marc let me borrow everything else for months on end until I could build a kit of gear of my own.

When I left Kinko's my business motto was, "I'll shoot anything but porn." A friend of mine, Travis Jones (pictured here), was playing in a band called Red Letter Agent. He offered me free entrance to a show and a few free beers. Free beer doesn't pay the rent, but sometimes it pays the soul. Red Letter Agent was playing Smith's Olde Bar, a well-known venue in Atlanta. As I walked into the venue, and saw how dark it was,

I knew I was in for some challenges. The Nikon D100 was a horrible low light performer. Anything above ISO 400 was pretty much useless. I did have that old 285 and a light stand, though.

I shot the show and was going through the edit the next day. This photo popped up, I converted it to black and white, and something in my gut said, "Stop. Pay attention to this." I studied the photo. Something about it "called to me," I guess you could say.

The next thing I did was open a web browser and type "music photographer" into Google. That was 10 years ago, and I've worked with more than 400 artists and bands since.

..

Nikon D100 / 35–70mm
lens @ 52mm / f5.6 @ 1/8th
@ ISO 200.

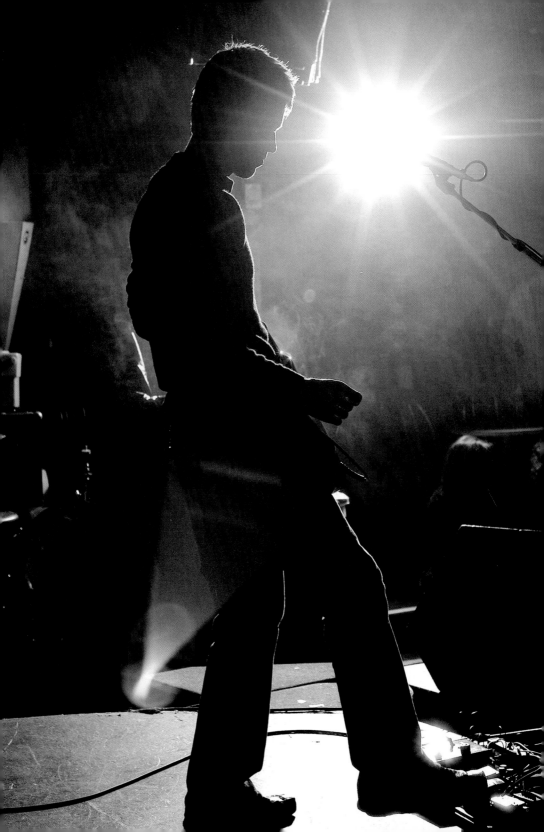

Q: LISTED IN AN AD WAS "DO NOT APPLY IF YOU HAVE A REBEL OR D90. MUST HAVE D700, 5D MK III, OR BETTER." GOT RESPONSES FROM MY LOCAL PHOTOGRAPHY GROUP RANGING FROM "SCREW THOSE GUYS" TO "PAYING CUSTOMERS ARE ENTITLED TO *ANY* REQUIREMENTS THEY MAY PROPOSE." HOW DO YOU DEAL WITH "BEAN COUNTERS" THAT ONLY SEEM INTERESTED IN THE GEAR, WHEN IT SHOULD BE YOUR WORK THAT MAKES THE DIFFERENCE?

Dear Potential Client,

I'm sorry that my gear does not meet your requirements. A decade or more ago you would have been asking for a Nikon D1. It had less than 3 megapixels. Photographers shot magazine covers with that camera. It was a staple among pro photographers. We couldn't believe that it was only $5,000.

My Canon T2i that I bought used on Craigslist for $200 runs circles around that camera. I'm capable of shooting double-truck spreads for publications without blinking an eye.

I'm now wondering if you check the kitchen of your local restaurants to see if they are using "Acme" or whatever pots and pans before eating there.

Respectfully,

Gophk y'rslf

• • •

I jest. Never send that email.

Look—you have to have the mindset of "That's not my client."

Your clients hire you for what you do. Not for what you do it with. Unless there's a very technical reason they need a photographer to shoot with a specific kind of camera. If not, then just move on.

If I had to have a pro level camera to get started I would have never been able to do so.

When I made my first run at being a professional photographer I was convinced I needed professional equipment. I went heavily into debt buying gear to shoot for clients I did not yet have. I was still cutting my teeth. I had more gear than I knew what to do with, but damn it! I was ready to do professional work with professional tools. The jobs did not come pouring in. The credit card bills did, though. I got in over my head, and it took years to dig out from under the mess that I made.

Just move on. It's okay. There are people out there who value a unique perspective that is only available through someone who can "see." If you see through a beat-up used $200 DSLR then that's what you do. That beat-up camera of yours outperforms the pro digital gear from a decade ago that cost thousands more.

Some key points:

- Don't advertise what you shoot with.
- Good clients should love your work. Not your camera.
- A medium format kit isn't going to bring clients in.

You should get into a pro level kit because it makes your life easier, gives you better AF or ISO performance, and maybe because the build quality is better and can handle the stress of a heavy workload. Not because you are losing clients because you don't have the right kind of camera.

One parting thought on this to keep in mind: A lot of people go get themselves one of those "real nice digital cameras" and begin to think they are ready for the big leagues. Perhaps this particular person with the ad listing was burned by these "Rebels without a Clue," and so now think a higher level of camera may mean a higher level of work. You never know. Just move on.

Q: AS A BEGINNING PORTRAIT PHOTOGRAPHER, I'M HAVING TROUBLE FINDING SUBJECTS. MY FAMILY AND FRIENDS HAVE BEEN FULLY EXPLOITED. I'VE TRIED MODEL MAYHEM, ETC., BUT I HAVE NO DESIRE TO DO FASHION WORK AND THAT'S WHAT THEY'RE GEARED TOWARD. ANY IDEAS ON WHERE TO FIND PEOPLE WHO WANT TO BE PHOTOGRAPHED FOR SOME PORTFOLIO BUILDING? I KNOW THAT'S NOT VERY SPECIFIC, BUT I'M LOOKING FOR GENERAL ADVICE.

A: Do you frequent a coffee shop? Any regulars in there, or employees you think you could make a great portrait of? Ask them. Have kids? Are they in school? Ask their teachers if you could shoot a portrait of them after school one day.

"Hey, my name is so and so. I'm building a portfolio of portraits and I'd love to photograph you for it if you ever had the time." Have a sample of your work to show.

Done. You'd be surprised how many will say yes. Once you get someone willing to shoot with you, do a great job and then ask if they know anyone who would be willing to do a session with you. Now you've tapped into a new circle of folks you didn't have access to before. You're not only building a new portfolio, but you are beginning to grow your first base of potential clients.

You could also meander the streets of your town looking for subjects. You'd be surprised by how many complete strangers will let you take their portrait. Atlanta isn't much of a street photography town—in the candid sense of the term—but it is a great town for shooting street portraits. I regularly approach folks who I think would make an interesting portrait subject.

"Hi. My name is Zack and I'm a photographer here in Atlanta. I'm just walking around today photographing street portraits. It's just sort of a hobby for me. I love that red hat you're wearing. That is an awesome hat. Would you mind if I took a portrait of you?"

I was walking the streets of Atlanta one day and spotted this dapper gentleman in a restaurant. I loved his style. I walked in, introduced myself, complimented him on his hat, and asked if I could shoot his portrait. He was quite willing to do so. :: Phase One IQ140 / 80mm / f2.8 @ 1/60th @ ISO 200 / Available light.

A: My wife and my kids.

My family has to eat. Doesn't matter that Dad is having a bad day or not. Doesn't matter that Dad stayed up all night comparing himself to Jeremy Cowart again and went to sleep crying. Doesn't matter if Dad lost the "artist's way" on his last shoot.

I have to feed and house my family. I have to cover and protect them.

Photography is all I have. I've got nothing outside of a camera to feed and house and clothe this family of six under my roof. If I'm not shooting photos then I'm working at Starbucks or Kinko's. I can't feed this family on an $8 an hour job. I tell you the truth—if I were single with no kids I'd probably weigh 400 pounds and live in my mom's basement. When kids entered my life I suddenly had a weight of responsibility on my shoulders. My world expanded beyond my own four walls, and I knew I had to do something with my life other than work retail jobs.

I know I'm going to have down times, bad times, frustrating times. I also know I'm going to have really good times. Inspiring times. I just keep sight of that. When things are good I brace myself for the inevitable downward spiral. When I'm in that downward spiral I'm not caught off guard; I knew it was coming. Things will get better again. You will never be stuck in one or the other. The depressing times seem never-ending when you are in the middle of them. You can wallow in the muck for only so long, but then you have to pick your ass up and get to work. You have to.

Professionally, I look to the life of Joe McNally. In this industry, no one inspires me more than he does. No one. He is the Grand Poobah on the mountain top. In my eyes, he's the greatest working photographer alive.

Q: WHAT'S THE DIFFERENCE BETWEEN A COMMERCIAL PHOTOGRAPHER, AN EDITORIAL PHOTOGRAPHER, AND AN ADVERTISING PHOTOGRAPHER? I SEE THESE TERMS GET THROWN AROUND TOGETHER A LOT—SOMETIMES TWO TOGETHER, SOMETIMES ONE, AND SOMETIMES ALL THREE. ARE THEY ALL SIMILAR OR ARE THERE VAST DIFFERENCES?

A: The easy way to differentiate advertising and commercial photography from editorial photography is this: Advertising and commercial are selling something. Editorial is telling something. Let's break it down a bit and add a few more to the mix. Knowing the difference between the genres can help you define what you do as you head out into the world and market your work.

This image isn't of a person or a particular product. It's more about the light, color, and feeling. I would consider using this image in my book/portfolio if I was meeting with an advertising client, but I'd want to pair it with another photo that shares the same color palette and "feel." I wouldn't put it in my book if I was meeting with a commercial or corporate client. :: Canon 5D Mk II / 80–200mm @ 100mm / f4 @ 1/200th @ ISO 200 / Available light.

This image is sort of commercial/corporate/editorial. It was shot for *IBM Systems Magazine*, which is an editorial publication but it's owned by a IBM, so it's kind of commercial. The subject is Ed Clary, the CIO and senior VP of distribution for Haverty Furniture Companies, so it's kind of corporate'y at the same time. See how these subgenres can run together? At the end of the day, it's an editorial/commercial portrait. :: Phase One IQ140 / 80mm / f4 @ 1/1,000th @ ISO 50 / Lit with an Einstein strobe and a 22" Alien Bee white interior beauty dish with a 30° grid on the front. The high shutter speed was used to kill all ambient light.

ADVERTISING PHOTOGRAPHER :: Typically specializes in the type of photography that you see in print advertisements, or on billboards, or as part of a large web campaign. The traditional route to gaining work is by being hired by an advertising agency, although many advertising photographers work directly for the sales/marketing/PR departments at companies needing photos in order to sell a product or service. The agency working for Levi's would call you to shoot images for an international advertising campaign. Your work would then be on the web, in magazines, and plastered on the sides of buses selling the Levi's brand.

Advertising photography is stereotypically slick and well produced. The images may not necessarily be photos of the actual product or service. You may be creating images that simply convey a feeling or mood that represents the product or service. The crew would typically consist of you (the photographer), the creative director, the art director, assistants to the photographer, production assistants, a producer, hair, make-up, assistants to hair and make-up, and the models or talent. Graphic designers and retouchers round out the crew to bring an image from concept to print.

COMMERCIAL PHOTOGRAPHER :: Similar to an advertising photographer, but the client base is a little larger and assignments typically aren't as involved as a typical advertising shoot. To put it simply, a commercial photographer serves the commercial world. That could consist of shooting portraits of the board of directors, or photographing a new manufacturing plant, or photographing products that a company produces. Crews and budgets are typically smaller but that's not always the case. Photos you take may end up in advertising for the companies you are working for. Levi's could call you to photograph their CEO, their Christmas office party, or to shoot interior and exterior shots of their new retail stores for use on their web site and internal corporate documentation.

Commercial photography tends to be fairly straightforward in style. It lacks the highly produced shine of advertising photography, but doesn't quite have as much of a candid feel as photojournalism and documentary work.

"Corporate photography" most easily fits into the commercial category, but it can be different enough that a photographer defines themselves specifically as a corporate photographer. It's more of a niche inside commercial photography.

Photojournalism is more about moments, and it's about the photographer being an observer instead of a director or collaborator with the subjects. I got caught up in a crowd of football fans in Istanbul and it was amazing! :: Fujifilm X100S / 23mm / f2 @ 1/125th @ ISO 3200 / Available light.

PHOTOJOURNALISM/DOCUMENTARY PHOTOGRAPHER ::
I'm going to throw this one in because sometimes it can get lost in the middle of all these descriptions—especially as photojournalists can wear a photojournalist hat one day and an editorial hat another. Photojournalism is straight undirected photography. You are more of a fly on the wall than a part of the process in directing the subjects in what to do. You might use a little flash here and there, but you aren't busting out softboxes in this work.

Your assignments can range from sports to portraits to features (slice-of-life photos—for example, kids playing in an open fire hydrant on a hot summer day) to long-term stories about an issue in the community or a specific person. You are there as a storyteller and an observer, trying to maintain some semblance of an unbiased viewpoint.

Documentary photography is a close sibling to photo-journalism but sometimes there is a little more room for creative expression/direction. Some may run me up a flagpole for saying that, but documentary can involve a little more lighting. It can involve directed portraits. It can be shot large format and be selenium-toned prints. The end goal is to tell something, not sell something.

EDITORIAL PHOTOGRAPHER :: Typically, with editorial work you are shooting for magazines and doing feature pieces for newspapers. Note that a newspaper photographer (photojournalist) isn't an editorial photographer, and vice versa. As an editorial photographer you are often shooting portraits; however, it can also include travel pieces, food photography, architecture, and so on. If *Condé Nast* were to produce a story about Bill Jones, who is the CEO of a new Internet company, you would be assigned to photograph Mr. Jones for the magazine. The editor may also ask for images of Bill Jones' office. *Wired* could do a story about the corporate culture of Google and hire you to photograph the people, the space, and details of that culture. You're kind of wearing a bit of a photojournalism/documentary/editorial hat here. Or *Time* magazine assigns you to go to the Levi's headquarters to photograph their CEO for an article they are writing about them.

Opposite: This is Killer Mike. He's an Atlanta hip-hop legend and has recently opened a barber shop. I photographed Mike for *Design Bureau* magazine. This is a typical editorial assignment for me. "Go to this place, on this date, and photograph this person." :: Phase One IQ140 / 80mm / f2.8 @ 1/250th @ ISO 50 / Lit with an Einstein strobe and a 22" Alien Bee white interior beauty dish with a white "sock" diffuser on the front of the dish.

The style of editorial photography runs between photojournalism and documentary work (moments and candid) with a good bit of commercial (lighting and direction) thrown in. Editorial can get slick like advertising with more lighting, more crew, and more retouching. Or it can be stripped down and be one photographer, one subject, one light source, and no retouching. Typically, editorial assignments involve the photographer, maybe an assistant, and the subject. You're dealing with "everyday" people on these assignments instead of hiring talent to be the subject.

...

The reason you see them thrown around a lot and mixed up is because the styles of advertising, commercial, editorial, and documentary can be mixed depending on the style of the end client. You can find an editorial style of portraiture in a lot of advertising. You can find really slick and highly produced portraits in magazine assignments, and you can find documentary approaches in magazines and commercial work.

A commercial photographer might be asked to photograph a new manufacturing facility in a documentary style. A "day in the life" kind of thing. Lights and assistants and all that might be around directing this "candid" moment, or the photographer might actually go shoot real candid moments. However, in the commercial world you can shoot an image that looks like photojournalism, but it was lit and directed all the way.

Things like fashion photography or music photography bridge the gap between these styles. A fashion photographer can shoot an editorial spread and an advertising campaign in the same week. A music photographer can shoot as an editorial photographer or commercial photographer. Photojournalists can light a portrait for one assignment, shoot table-top food photography for the next, and then follow the local ball team to the championships on the next.

Photographers place these labels on themselves to communicate to people what they shoot and how they shoot it. I put myself squarely in the "editorial" camp as far as the type of work I usually do, and the style of work I shoot. I can move toward documentary easier than I can move to the slick style of advertising. In order to shoot the advertising work I'd like to shoot, I need to find clients who like the editorial/documentary mix; my style matches that.

My style is typically straightforward. Simple production values. Small crew. I move from lighting and direction to finding more candid moments fairly easily. I can also handle a large crew, and I have a producer, so I can take on advertising jobs, but the "style" I shoot on those jobs still falls in the "editorial" camp. I also shoot commercial work within this style and sometimes have to go very straightforward in my approach to it. X company just produced this product and they need a simple photo of it on a white background. It isn't the most creative work, but it pays the bills and keeps me alive another day.

I'd also like to get some annual report assignments because this can take all of my skill sets and combine them into one large job. For corporate annual reports you can find yourself in the boardroom one day, on a production line the next, and in the living room of the end user of said company's product or service the next. Annual report photography falls in the corporate/commercial genre and can run from advertising to documentary in visual style.

Hope this helps!

11-20

Is there always a photo to be made?

Seamless in a small room.

Film camera for sports.

Save and buy once.

Till dust do us part.

Best place for critique.

Best piece of gear under $100.

Photography competitions.

Not enough hours in the day.

How important is post-processing?

Q: DO YOU BELIEVE THERE IS ALWAYS A PHOTO TO BE MADE, IN EVERY SITUATION OR OF EVERY PERSON? DO YOU EVER WALK AWAY FROM AN OPPORTUNITY TO TAKE PICTURES SAYING, "I KNEW THERE WAS A GREAT PHOTO THERE BUT I COULDN'T FIND IT"?

A: Yes to both of these questions.

There's always a photo to be made. Some are far more difficult to find than others. Often I will walk around a location, or will look at my subject, and say to myself, "Crap. Crap. Crap. If so-and-so-awesome-photographer were here they'd find an awesome image. They'd turn this place upside down and make something great. I can't find it. Where is it? What angle? What light? Crap!"

Sometimes I will finish the shoot still not having found it, and it will bug me. I'll go to bed that night and walk through the place again in my mind trying to find it. It pushes me to be a better photographer knowing that someone else could walk in there and kick my ass.

There's always a good photo to be made. Always. There has to be. I don't care how boring, fat, ugly, stupid, mean, or rude a place or a person may be, there's always an interesting photo to be made.

Q: I HAVE A SMALL SPACE (8' HIGH AND 6' WIDE) IN MY HOME THAT I'D LIKE TO START USING AS A SMALL PORTRAIT STUDIO. IS THIS ENOUGH ROOM TO DO SOME WHITE SEAMLESS? WHAT WOULD BE THE BEST WAY TO GO ABOUT THIS?

A: No. You are going to say a lot of cuss words if you try. You could pull off tight headshots but full length is going to be a nightmare. At six feet wide and eight feet on the ceiling you're going to have a difficult time controlling the spill of light everywhere, unless you paint the ceiling and walls dark grey or black. As it stands, you basically would be shooting *inside* of a large softbox.

20x20 feet with 12-foot ceilings is around the smallest area I'd want to do white seamless work in. It *can* be done with less. It's just far more of a pain in the arse as your square footage shrinks and your ceiling drops.

However, your best bet is to go in there and…try it out! It's in your home! You're there every day. I'm not there.

Grab a person. Set up your lights. Give it a go. You'll find out if you can pull it off (or not) far better by *doing* it rather than *thinking* about doing it.

There are some things in photography that take the right gear or the right space to pull it off. You can hack stuff together, or string obscenities for hours on end trying to do something. Sometimes you get close. Sometimes you pull it off. Many times, though, you have to figure out how to shoot something differently. You say to yourself, "I'd love to shoot full length white seamless here but I can't. I'll have to figure something else out."

Q: CAN YOU RECOMMEND A GOOD EOS CANON FILM CAMERA FOR SHOOTING SPORTS UNDER STADIUM LIGHTS? I HAVE AN INTERMEDIATE CANON DSLR AND A 70–200MM F4, BUT I THINK THAT IT WON'T PERFORM AS WELL AS USING FAST FILM.

A: Answer #1—No.

Answer #2—No. Why would you want to do that?

Answer #3—I can understand going back to film for a number of reasons but this isn't one of them.

Digital has surpassed film in this genre of shooting. I could see going back to film for artistic and aesthetic reasons but not for ISO performance. The last film I shot at a sports event was at an MLB playoff game at night. I shot Fuji 800 and pushed it to 1600. I shot the game at 2.8 @ 1/250th or so. While it was fine for what it was, most DSLRs these days look a lot better at ISO 1600 than the Fuji 800 did when pushed to that ISO.

I'd want a faster lens and a better body—but not film. I'd rather have a 7D-ish or better DSLR. They have better focusing systems than previous prosumer Canon bodies, they can be picked up for far less than a new 5D whatever, and it will be a *huge* jump in quality over your 40D. In addition, it will perform better than pushed film. Also, that crop factor will give you some extra "reach" to the 200 lens you have. Having a maximum aperture of f4 on that lens, though, is going be a pain in the ass.

Rental houses are open for this reason. Rent a better DSLR. Rent a better lens. Shoot the game. Return the gear. Keep the images. That's a *far* better alternative to buying an old film camera to get poor results compared to what you could have if you just rent the proper gear in the first place.

Good online rental places:

- Aperture Rent (www.aperturent.com)
- Borrow Lenses (www.borrowlenses.com)

Q: WHAT'S YOUR PHILOSOPHY WHEN BUYING EQUIPMENT? SAVE UP AND BUY THE BEST ONCE, OR BUY WHAT YOU CAN NOW AND THEN BUY A BETTER ONE LATER? SOMETIMES WHAT YOU KNOW YOU NEED SEEMS OUT OF REACH, WHEN A CHEAP ONE IS RIGHT THERE!

A: Spend money once. You get what you pay for. Trust me. I'd rather shoot with a single $100 50mm f1.8 lens for a year than add a crappy $200 f4–5.6 kit lens to my bag. I'd rather have a used 85mm f1.8 lens than a cheap f2.8 Tokina/Tamron/Sigma zoom lens. I've owned a number of third party lenses and, while they are a bargain, over time they just never held up to their OEM counterparts.

Don't buy cheap gear. Save your money. You don't have to have *the* best all the time; wait to get the 85mm f1.8 instead of buying some cheap lens. You don't have to have the f1.2; you'll get that when you're rollin' deep.

VISUAL INTERMISSION

BIG BOI // TRADING PHOTOS FOR DENTAL WORK

One day in 2005 I was hanging out with fellow photographer Hassel Weems, and my phone rang. A friend of mine who worked for a high-end dentist in Atlanta was calling to see if I was interested in photographing hip-hop star and one-half of Outkast, Big Boi. "Ummm. Yeah!" I replied. She explained that the image was going to be used for a full-page advertisement in *Delta Sky* magazine. She said time was of the essence, and they needed a quote ASAP.

I got off the phone, quickly put an estimate together for the job, and emailed it to her. Ten minutes later she called me back and said that the estimate was too high. I was speechless. The estimate I had put together was entirely too *low*. A full-page ad in a magazine that's in the back of every Delta airplane in the Northern hemisphere? I think it was something stupid like $1,500 all in. *Way* too low. Being a stupid photographer, I said, "Well, I'll tell you what. I really need a check-up and a cleaning. How about we trade?" I really wanted to shoot Big Boi.

She put me on hold and came back with the go-ahead on the trade. "When would you like to schedule the shoot?" I asked. "In about two hours," she replied. OMG.

Hassel and I threw some gear in a bag and hurried off to the location. I set up a few hotshoe flashes on a white wall because the request was to shoot Big Boi against a pure white background. He showed up, we did the shoot, and we hit it off by talking about our kids. I asked if I could get a few candid images while

he prepared to get his teeth cleaned, and he was cool with it. Personally, this is one of my favorite photos. Why? It's Big Boi. At the dentist. How many times can you shoot a hip-hop star while they are at the dentist's office?

Funny side note. I shot this job with a Nikon D100. Hassel was sort of my assistant on this job, and he fired off a few behind-the-scenes photos—with a Nikon D2X. My assistant had a better camera than me. I can't tell you how many times that has happened to me. Or how many times my client had a better camera than I did. It's not what you have; it's what you can do with it.

That's what she said.

- -

Nikon D100 / 17–35mm
lens @ 17mm / f2.8 @
1/60th @ ISO 320.

A: For me it's typically about one year. If it hasn't been used in a year then it needs to move on. I try really hard to not buy gear that won't be in regular use. It happens from time to time, though. I'll come across a deal on something I think I can't live without, and then it doesn't actually get much use so I sell it and learn from that buying mistake. The last such item was a ring flash. I got a good deal on it. Ring flashes are kinda cool and all but they are a one-trick pony for the most part. I rarely used it. Luckily I sold it for what I had in it.

My Hasselblad 501 and SWC cameras are most likely hitting eBay soon. I love them. I *love* the SWC but since getting the Phase One I'm just not using the Hasselblads all that much any longer. I have let friends borrow them. I've thought about using them, and then I end up just shooting with the Phase. The SWC will be a hard one to give up. This is going to sound stupid but I just love looking at that camera. It makes me happy to just see it. Do I shoot with it? Not much. I'm an idiot. Thought about taking it digital, but it's a wonky setup to do so. That would be a luxury item for me and I ain't got no business doing that.

Big lesson: Don't buy gear you *think* you need. Only buy gear you *know* you need. I've mostly learned the lesson. Mostly.

Street photo from Chandler, AZ. Hasselblad SWC. Exposure information not recorded.

A: Honestly, I have no idea. Not online, at least. My wife, Meg, and I have done several online critiques before, and we are going to start doing them again, but there's never a guarantee of getting in or not.

Posting to Flickr groups, forums, and the like is a crapshoot. You might get some good critique; you might get flamed; you might get your ego inflated; you might get drawn into an 80-page discussion about chromatic aberrations on a shitty picture of a duck. God only knows what you'll get. I once saw a Bresson photo posted to a Flickr critique group. Hilarity ensued. Many thought the photographer should have used a faster shutter speed.

Your best bet is to build a small group of trusted photographers in your area. Get together once a month or once a quarter or something, and critique each other's work. Be open. Be honest. Don't be defensive. You have to remove your emotions from your work as you get critique. You need to trust that the people giving critique do so with your best interest in mind.

It's helpful to get critique from up the food chain, as well—meaning from someone more experienced than you. Peers are good to hear from, but if you all have about the same experience level there won't be much wisdom injected into the critique. You'd be best served by someone with more experience and wisdom than you. How do you get that kind of critique? Watch for it. Nurture relationships with people you respect. Corner them and don't let them leave until you've gotten critique.

If you are doing editorial or fine art or commercial work, you can attend various portfolio reviews that happen all over the place. These portfolio reviews are like speed dating for creatives. You register for the event, pick your A list, B list, and C list of folks you want to meet, the organizers match you as best they can to the people you have selected, and then you have 15 to 20 minutes to sit down, show your work, get feedback, and make connections with folks you'd like to work with. Attending events like these can be very helpful to you as you start your career.

Here are a few of these events:

- Photo Plus Expo (www.photoplusexpo.com)
- Palm Springs Photo Festival (www.palmspringsphotofestival.com)
- NYC Photo Works (www.nycfotoworks.com)

Local chapters of the American Society of Media Photographers (ASMP), American Photographic Artists (APA), and art director clubs do this from time to time, as well. You can also hire photo editors and portfolio consultants to review your work and help guide you along your chosen path. The site A Photo Editor has a big list of portfolio consultants here: www.aphotoeditor.com/2008/02/04/list-of-photography-consultants/.

Q: BEST PIECE OF PHOTOGRAPHY EQUIPMENT UNDER $100? SOMETHING THAT EVERY PHOTOGRAPHER SHOULD HAVE?

A: The Impact 42"x72" 5-in-1 Collapsible Oval Reflector is invaluable to me. (Find it at bhphoto.com and search for "Impact CRK 4272 5 in 1 Collapsible Reflector.")

I think every working photographer should own one. Like the umbrella, it is very versatile, like a photographic Swiss Army knife. It can be a black, white, gold, or silver background. It's a great white, gold, and/or silver reflector. It can help subtract light. It can be a diffuser. You can lay the outer cover down on wet grass and lay on it for low angle shots. You can stuff gear in the cover to keep it out of the elements. You'll find so many different uses for it. Here are just a few.

My previous studio manager, Dan Depew, is holding the Impact reflector in the background. I was on assignment for *Harvard Business Review* to photograph Muhtar Kent, the Chairman and CEO of The Coca-Cola Company. I wanted one shot of Mr. Kent on a white background, and there wasn't a single clean white wall to be found. The Impact reflector was used instead.

This is the result of that setup. I used an 85mm lens to help compress perspective. What that means is a fairly small background can be utilized edge to edge for a tight head-and-shoulder portrait. :: Canon 5D Mk II / 85mm / f8 @ 1/125th @ ISO 100 / Lit with an Alien Bee B800 with the Alien Bee 22" white interior beauty dish with the sock diffuser as the main light. A Nikon SB-80DX hotshoe flash was placed on a short stand behind Mr. Kent to light the background.

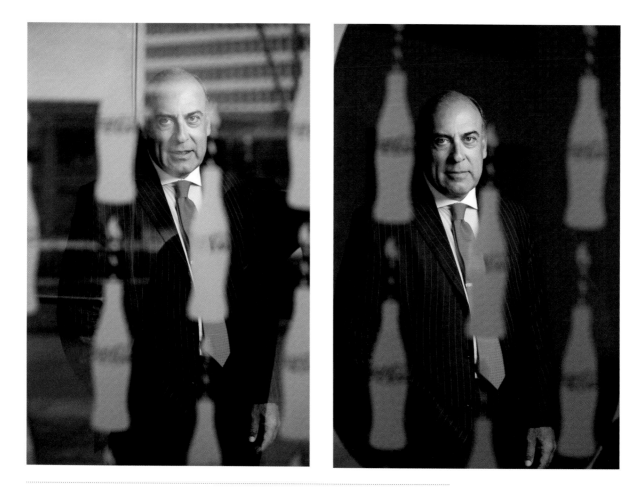

The photo editor for *HBR* asked for a portrait incorporating an element of the Coca-Cola brand. I found these glass doors covered with decals of the anniversary Coca-Cola bottle logo. I figured I could shoot through the glass doors and utilize the shapes of the bottles in a photograph. The issue I had, though, was with the reflections on the glass door. There wasn't an angle to be found where they weren't an issue. So I put the black cover on the Impact 5-in-1 and had Dan hold it behind me. As you can see in the photo on the right, the reflections from outside are now gone. :: Canon 5D Mk II / 85mm / f3.2 @ 1/125th @ ISO 100 / Westcott 28" Apollo softbox lit with a Nikon SB-80DX hotshoe flash.

Here I was on location for *Nylon* magazine, photographing Dallas Austin outside of this gas station late in the afternoon. We were running and gunning, guerilla style, and I didn't want to set up any lights. I found my frame and composition but the harsh sun falling on Dallas was blowing out his arm and the right side of his face, along with the white t-shirt he was wearing. I had my assistant hold the 5-in-1 diffuser between Dallas and the bright ray of sun. As you can see in the second photo, the exposure on his arm and face are equalized with the rest of the light falling on him. Blown highlights don't print well. You might think they look cool on a blog but they suck in print. :: Canon 5D Mk II / 50mm / f3.5 @ 1/400th @ ISO 100 / Available light.

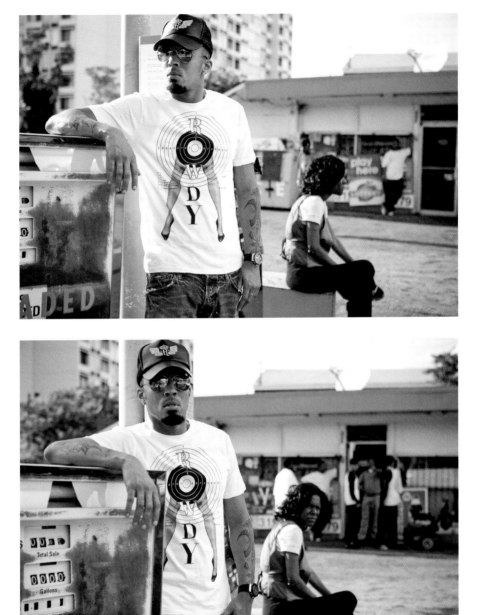

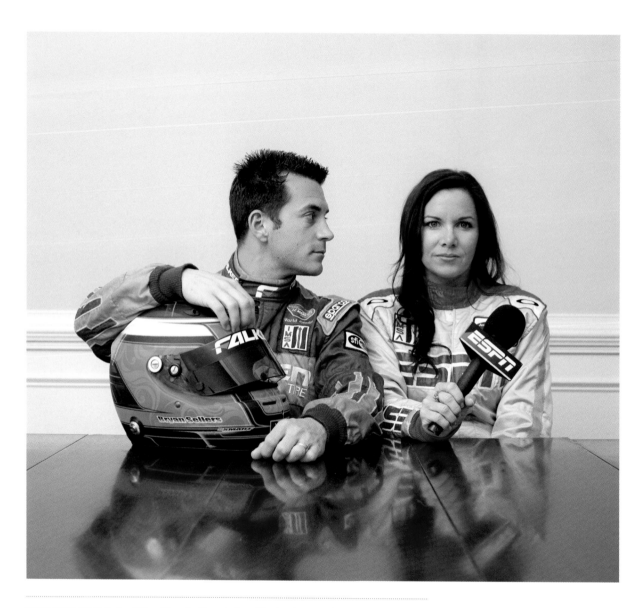

I had recently lost my 50" softbox to the wind and had not yet replaced it. But you can clamp a 5-in-1 to a stand or two and fire a light through it. Racing driver Bryan Sellers, at home with his wife and ESPN reporter, Jamie Howe. Photographed for *Atlantan* magazine. :: Phase One IQ140 / 55mm / f5.6 @ 1/250th @ ISO 50 / Lit with an Einstein firing through the 5-in-1 diffuser.

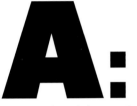

Q: HAVE YOU ENTERED A PHOTOGRAPHY COMPETITION? IF NOT, WHY NOT? DO THESE COMPETITIONS MATTER, AND SHOULD ONE TAKE THEM SERIOUSLY IN THEIR PHOTOGRAPHIC JOURNEY?

A: When I was in photography school I started volunteering at the Atlanta Photojournalism Seminar every year. I ended up working the contest portion of the event. My job was to run the slide shows of images for each category as a panel of judges reviewed the work and selected winners. The judges were the speakers and workshop leaders teaching during the seminar. These included Pulitzer Prize winners and top photo editors. Amazing people. We'd start a category, they would take a quick look at all of the entries for that category, then we'd go through it again and they would begin to cull it down. They had to place 1st, 2nd, and 3rd, and they could give two honorable mentions for each category.

As a young photographer I would sit in the back listening for the judges to say an image was in or out. An image would pop up on the screen and I'd hear "Out" from all three judges. I would sit there, wide-eyed, wondering why. in. the. hell. some of these images were so quickly cut from the category. There were pictures coming up on the screen that were *amazing! Gorgeous!* I'd kill to have those images in my portfolio! I'd pause every now and then because surely the judges were missing something. There's *no way* that image should be out.

"Out!"

I'd walk out of 14-hour judging marathons completely bewildered. Why did *that* image win first place in the category when all those other amazing images were knocked out in less than a second from being shown on the screen? Seriously, an image would hit the screen and I'd hear three outs in one second of time. WTF?

That's when I was a total newbie. Everything in photography was still new. I had not consumed images to the point that these judges had. I remember one image in the spot news category. There was a massive house fire at night. The photographer captured this great shot of two firemen in silhouette against the backdrop of the house in flames. Water pouring out of the fire hose. Smoke rising into the sky. It was a great image. Yes, a terrible situation, but a great image.

Out. Out. Out.

I ended up working the competition for 10 years and actually became the board member who was responsible for it. By the tenth year I knew if an image was going to be out or in. I later got to go back and be a judge in that contest.

Here's what happened in those 10 years. I learned a lot about photography. I learned a lot about how a photographer thinks and how one covers events from sports to news to features. I've sat and listened to folks with 20, 30, 40 years of experience talk about photography. I've gone out and shot this kind of stuff. In addition to that, I've seen a lot of photography. I've consumed tons and

tons and tons of images with my eyes and brain and heart. I've seen amazing work that was produced in horrible conditions. I've seen horrible work created in amazing conditions. I know what the expected shot is, and I've seen work that was totally unexpected in otherwise straightforward situations. If you come upon a house fire at night, the easiest shot in the world to get is a firefighter in silhouette against the flames. Water pouring out of the hose. Smoke rising into the sky. Easy shot. Everyone shoots that picture. Seen it a thousand times now.

Can you go to a town hall meeting in a boring atmosphere with crap light and make something special? Can you shoot something that isn't a firefighter silhouetted against the flames and make that image remarkable? Or better yet, rememberable*? There's a heat wave hitting your town. The kids have opened up a fire hydrant and are playing in the water in the street. Can you make a photo that hasn't been made in that situation 10,000 times already? Can you deliver something unexpected?

You're caught in a fire-fight in a major war zone. People are dying left and right. Can you get your ass up and get photos? Not just photos, but jaw-dropping photos. Nailing your exposure. Nailing your composition. Nailing your focus. Without getting your ass shot? And do it for the length of the war? And edit it down to 12 images that tell the whole story without a caption?

When you are new to photography and you see a war photo in focus it's a pretty amazing image to you. You know that it must have been difficult to get that photo. Just that difficulty is enough to impress you. But at the high end that isn't enough. You're a war photographer. It's expected of you to focus and expose properly. That's elementary stuff. Now do that plus something special. Something amazing. And stay alive. And get access. And push further than you should or would.

So, there are the kids playing in the fire hydrant. Okay. Get the safe shot. Get a wide shot. Get a tight shot. Get the silo. Now what? Drag the shutter? Climb to the rooftop across the street and shoot down on it? Throw a zip lock bag on your camera and get in the water? Ditch the shot *altogether* because you can't find anything beyond cliché?

Here's another thing I learned while working that contest and being a judge for other contests throughout my photography career: You can't please everyone. I've seen work that one set of judges would cut, while the same work, in front of another set of judges, would at least place in the top three. I've seen one photographer and/or editor *fight* for an image or a series near the end of judging a category, and the other judges could not understand why that image or series should be fought for. I've watched 30-minute debates over a single image or a series of images. I've watched

the two other judges be convinced to place the image. I've watched the one judge give up and let it get cut. I've watched negotiations. "If you'll at least give this an honorable mention, I'll vote for my second place choice to be the first place choice that you want."

I've sometimes contacted photographers after the contest was done to let them know that Editor X fought and fought for their image to place but at the end it didn't even get an honorable mention. I figured they'd want to know that their work was at least fought for by somebody.

Ultimately this taught me to *never shoot for contests*. I am *not* saying, "Do Not Enter Contests." I am saying don't "shoot" for them. I have met scores of photographers who are shooting to win contests. Photojournalism, portraits, weddings, commercial work, advertising, editorial. They are shooting to win a contest. They saw what won at the last contest and they are shooting to match that or beat it. The thing is, the next contest will have a new set of judges. What won last year might not even place this year. If you are shooting for contests you are going to be let down.

Shoot for you. Enter contests if you want. See if you can swim with the best. Personally, I'm not into them. I've seen how they work on the backside, and I know that they can be a crapshoot. Part of me wants to enter some contests. Part of me thinks I have some stuff that could place. Part of me would like the recognition. I know that winning some contests can put your work in front of some good folks. I know it can, at times, lead to work. I also know it doesn't lead to work. So it isn't crucial to me to enter. Do they matter? Yes. No. I don't know. It's personal. I'd say try it if you are so inclined.

*I know the word is "memorable." Just being silly....

A: I used to have an attitude that to be a photographer you had to *be* a photographer. Working a day job meant *not* being a photographer.

I could not have been more wrong. I was recently reminded of how wrong this type of thinking is as I've gotten to know a guy named Wes Quarles. Wes installs residential Internet service. I first found out about him via my BFF Kevin (http://ab8ta.tumblr.com). Kevin told me about Wes on Instagram and I love his IG feed (http://statigr.am/wesq).

Wes is learning and pursuing photography the old school way. He drives over an hour each way, once a week, to take a darkroom class at night. He recently traded all of his digital gear for an old Leica. He's shooting some 4x5. I let him borrow my Hasselblads

© Wes Quarles / www.tinycollective.com

whenever he wants them. The only digital camera he owns right now is his iPhone, and he shoots a lot with his phone.

He's a great effing photographer when he's not in a bucket truck hooking cable lines to houses. Which he does full time and then some. To support his family. He's doing photography for the love. Not the money. You know what? He's also a great photographer when he's in that bucket truck. Because he's a great photographer. Period. Doesn't matter if he can claim it as a job or not. You know what else? I'm jealous as shit of him. It's easy to be jealous of folks like Jeremy Cowart, Kareem Black, Dan Winters, and other successful full-time photographers. I'm a full time photographer and I get jealous of those folks. But I'm equally as jealous of Wes Quarles, if not just a bit more.

For Wes, there's no promotion campaign he has to stay on top of. No overhead of a studio and staff. No constant fretting over when and where the next check is coming from. He has benefits. He can go to work, do his work, go home, and forget his work. How awesome would that be?

Grass. Greener. Other. Side.

Cameras are always going to be around. Your kids aren't. Don't trade your kids' youth for lenses and lights. I'm a photographer and do what I do because it's the only thing I can do beyond an eight- or ten-dollar-an-hour job. I have to make this photography thing work because it's all I know how to do. I love it. I wouldn't have another job in the world most days, but it comes at a cost. I have to get on a plane and go to where the job is or where the next teaching gig takes me.

© Wes Quarles / www.tinycollective.com

Sometimes money is great. Other times money is tight. Sometimes we know where the next check is coming from. Other times we don't. It's a hustle and it affects your whole family.

I tell folks who want to leave their day job for photography to be careful what they ask for. They just might get it. You'll end up trading your day job for a day-and-night job. The first half of your career will be an uphill battle. The next part of your career won't look much different, but it'll be easier because you'll become accustomed to it.

Kill your television. Kill stuff that takes time away. *Make time for yourself to go shoot on a regular basis!* You have to make time for yourself. Meg and I struggle with this a lot. I've learned how to turn things off and go do something for me. It seems totally selfish, and Meg has a very difficult time doing it for herself, but when she does it's productive.

Grow slowly and methodically. Shoot whatever you want. You're free. You don't have to shoot stuff you don't want to. You can plan personal projects. You have a job that can finance it. You have the gear. Time is the hard part, but if you put a few hours a week into it you can get a lot accomplished. You're in a good spot. Go do your shitty job you hate and take an hour later that night to shoot pictures. Build a darkroom. Buy some film. Learn to live with less sleep. Teach your kids how to print a photo. Know how awesome that would be?

Jeez. I want a day job sometimes. In the meantime, check out a few of Wes's photos. That he shot with which camera? Oh yeah. His iPhone! A phone! Tell me he's not a great photographer. I dare you. I'm tellin' you. Wes is the type of guy that you see work hard, care for his family, shoot photos, and leave you in a place where you can't complain about much. Wes is doing it. You can do it.

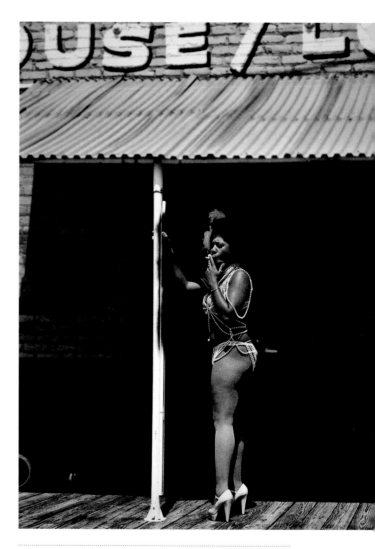

© Wes Quarles / www.tinycollective.com

Q: HOW IMPORTANT DO YOU THINK POST-PROCESSING IS TO YOUR SUCCESS AS A PHOTOGRAPHER? I'M TALKING ADVANCED PHOTOSHOP, NOT SIMPLE CONTRAST, WHITE BALANCE TWEAKS, ETC., IN LIGHTROOM. I'VE SEEN JOEY L.'S WORK AND IT IS AMAZING, BUT ALSO NOT SOMETHING PROS LIKE YOU AND MCNALLY DO—SO WHAT GIVES? DO YOU JUST CHALK IT UP TO PERSONAL STYLE? OR WOULD YOU BE EVEN MORE SUCCESSFUL IF YOU EMBRACED PHOTOSHOP PROCESSING? THANK YOU!

A: It's all about personal style. Case in point:

Last year I went to a portfolio review thing in NYC. My dear friend and fellow photographer, David E. Jackson, attended the same event. I'm fairly straightforward with my work. I do minimal, if any, post-production work. Dave puts a lot more into post-production with composites and the like. It's nothing for him to drop in a new sky, change this, add this, remove that, and whatnot.

At this review event we both met with the senior photo editor of an international magazine. I got on their radar. My book was in line with their style. Dave was told that while he had great work in his book, this magazine would *never* hire him. Why? His style didn't match their style.

It's all about style. I could go the post-processed route and get "different" clients but not necessarily "better" clients. The kind of work Dave does is done for his style. The type of work I'm hired to do is based on how I do things. They are different clients with different needs speaking to different audiences.

Most bands have four band members. Would the White Stripes have been more successful if they had four band members like other bands? Would they be more successful if they sounded more like Beyoncé? (Oh man, I don't want to even think about that.)

Style drives what you do. Your style is *your* sensibility. It's how you approach life. God knows we all don't need to approach life the same as everyone else. There's a place for all of us. We just have to find where we fit. You have to realize that, while your work may be amazing, there are a lot of people who won't hire you because your style isn't their own.

People who like Beyoncé　　　**People who like the White Stripes**

It's safe to say that there are a lot of people who like the White Stripes and there are a lot of people who like Beyoncé. It's also a fairly safe bet to say there aren't that many folks who like them both. Whoever likes the White Stripes *and* Beyoncé are the type of people who will hire anyone. Their tastes are so varied and, possibly, inconsistent that anyone can get some work from them. It is safe to say, though, that there aren't *that* many types of clients out there.

21-30

Full frame vs. crop factor.

Taking photos is 10%.

Talk to strangers, kids!

Previsualization and directing subjects.

Lightroom vs. Aperture.

Lord help him. He's working at Goodwill.

UV filters are trash.

Asking about a street photo.

Style over substance.

Shootin' nekkid girls.

I have seen a lot of questions like this one. Crop or full frame? What does "equivalent" focal length mean? Which is better? Is a 12 MP full frame better than an 18 MP crop sensor? And so on and so forth.

Get a full frame camera. Take the sensor out and put a smaller one in there. Same camera. Same lens. Now just a smaller sensor. Light comes through the lens and covers the full frame sensor area. Now that you have put a smaller sensor in this camera (and *no*, you can't actually do this), you now see less of the image being projected by the lens.

Or, look at your computer monitor. Put strips of black paper across the top, bottom, and sides. You are now seeing less of your screen. You have now made a "crop sensor" from your "full frame" screen.

Where "equivalent focal lengths" come into play is all based on the size of 35mm film. Back in the film days a negative made by a 35mm camera was 24mm x 36mm. As digital started coming of age it was very expensive to make a sensor of this size. So smaller sensors (cropped sensors) were made but put in 35mm (full frame) camera bodies. A 50mm lens no longer had the same field of view that it had when you shot film. It was 1.5x that, or 1.6x that. Or whatever the "crop factor" was for the sensor. We had to figure out how to speak about this so we talk about "equivalent" focal lengths. If you put a 20mm lens on a 1.5x crop factor body, then it was "equivalent" to putting a 30mm lens on a 35mm full frame film body. This language is sort of confusing and misleading. The lens is still 20mm. It hasn't changed optically. With a crop sensor you are just seeing less of it. It's like putting the black paper around your computer monitor. Your screen resolution is the same as it was before. You're just seeing less of it.

Now, which is better? Full frame cameras typically perform better in low light, give you your full field of view on your lenses, and are typically found in better camera bodies. That's not gospel, just a wide brush view. I live in the wider range of lenses so I prefer full frame cameras. I prefer the higher ISO performance they achieve. If I had to buy a new DSLR today I would only look at full frame bodies. So, for me, I prefer a full frame camera. Not saying that it is necessarily better than a cropped sensor.

If you love wide-angle lenses then full frame is for you. If you love longer lenses then maybe cropped sensors are for you. If you are shooting with a 200mm lens on a crop factor body and wanted that same field of view on a full frame, then you'd have to jump to a 300mm lens. Can't you just crop a full frame? Yes, you can. But you are throwing resolution away. Let's say you have an 18 MP full frame and an 18 MP crop sensor. With the cropped sensor you get that field of view at 18 MP. With the full frame you have to crop "resolution" out of your image so you may end up with a 10 MP or 12 MP image.

At the end of the day it's not megapixel numbers that count. It's the quality of the pixels. Now we start getting into the size of the pixels and blah blah blah blah blah. OMG shoot me. If I were going to go into a car analogy I'd start talking about horse-power versus torque. Or something. Not sure.

I restarted my career on the back of crop sensors. I shot those for five years. It's what was available when I started again, and it's what I could afford until I got my D3. Going forward with my career, any new DSLR that I will buy will be a full frame camera. That said—I love the little Fuji cameras that have a crop factor. My medium format camera isn't equivalent to a full frame 645 film camera. I could get a full frame 645 digital back but I'd have to sell a few of my kids to do so. I say all this to say: I personally and professionally use a mix of full frame cameras and crop sensor cameras. I care more about the quality of those sensors than the size or the quantity of pixels on them.

Q: I'M AFRAID THAT AS I BECOME MORE SUCCESSFUL AS A PHOTOGRAPHER, I WILL IN FACT BE DOING LESS PHOTOGRAPHY. WHAT PERCENTAGE OF YOUR TYPICAL WORK WEEK IS PHOTOGRAPHY VS. LOCATION SCOUTING VS. CONSULTATIONS VS. MARKETING VS. BUSINESS ADMINISTRATING VS. POST VS. PUTTING OUT FIRES, ETC.?

A: Picking up the camera and taking photos is 10% or so of my job. Ten percent of my time. Think about that in terms of your rates, too. You are getting hired to take photos, but it's a small percentage of your actual work to be able to do that. You have 100% of work to do. You have to be paid for that 90% of time when you aren't shooting. The client mainly sees the 10% of what you do.

"It's just pictures! It's digital. It doesn't cost you anything."

You love to cook. Run a restaurant all by yourself and how much actual cooking will you get to do compared to everything else? Cooking, dish washing, cleaning, serving, bartending, accounting, hosting, ordering food and supplies, marketing, menu planning, etc.

If you want to spend more time cooking and less time cleaning, then you hire someone to clean. Don't want to do accounting? Hire someone. Want someone else to serve the food? Hire. Soon you will get to spend more time doing what you love, but now you have more people involved, and that costs you more money, which means you have to raise your prices.

That's what happens for chefs. That's what happens for photographers.

I used to be really shy. I'd open up only when I really got to know someone. When I first got into photography, the camera became this magic box that I could hide behind, but I was still shy and had a hard time talking to strangers. If I was taking photos then it was the camera that brought me to that place. Not me. Myself—Zack—I was too insecure to open doors to places.

Then it came time to market myself as a photographer and I couldn't do it. I didn't know how to talk to strangers. I sure as hell didn't know how to "sell" myself. It was a mess.

My life fell apart. I left photography. I got a day job. Life went on. Then I had a chance to be a photographer again. I quit the day job, and it was then up to me and my camera.

Well, I learned that my camera didn't sell me. I put my identity—who I was as a person—in that camera. I learned the camera had no personality. It was just bits of plastic and metal. I also learned that promotional material and web sites didn't do a lot for my business on their own. I had to sell myself; I had to get out there; I had to talk to people.

My ability to pay my rent is directly tied to my ability to talk to people.

My ability to direct posing and get the best out of my subjects is directly tied to my ability to talk to them.

I realized one day that if I was going to make it as a photographer then I was going to have to get over my insecurities and my shyness, and get out there and talk to strangers.

It's like standing on the high dive. You know you aren't going to die. It isn't going to kill you. But you are still intimidated by jumping off that thing. It still scares you. You can climb down the ladder and not make the jump and live another day, or you can get over your fear and…live another day.

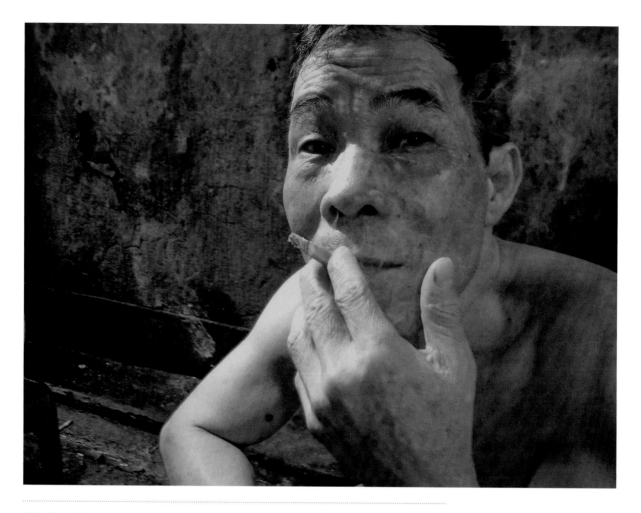

DigitalRev is the number one photography-related channel on YouTube. There is a regular running feature where a pro photographer has to shoot images with a cheap camera. It was a bucket list item for me to get to be on the show. Kai, the main presenter, handed me a piece of shit Kodak Easyshare C142 point-and-miss camera and an old Nikon flash. I had to get the two to work together, hit the streets of Hong Kong, and shoot with this rig. I had zero control of the exposure on the camera. Luckily the old Nikon flash had a built-in optical slave and manual control of flash power. I couldn't force the Kodak to use its on-camera flash so I had to find environments where its flash would fire and thus trigger the handheld Nikon flash. It was a crazy day and one of the most enjoyable photographic things I've ever done.

I started putting myself in social and networking situations that forced me to talk to people. I was broke and hungry and needed work, so I had to go out and find it. If jumping off that high dive meant I was going to pay my rent that month, then I needed to find the courage to jump.

I learned how to jump. I learned how to talk to strangers. I learned who I was as a person—who I was without a camera. I don't hide behind it anymore. I can talk to anyone now. I don't even care if we don't speak the same language—I can talk. And as Joe McNally recently said of me, now I don't know how to shut the f*ck up.

A selection of additional images from the DigitalRev shoot.

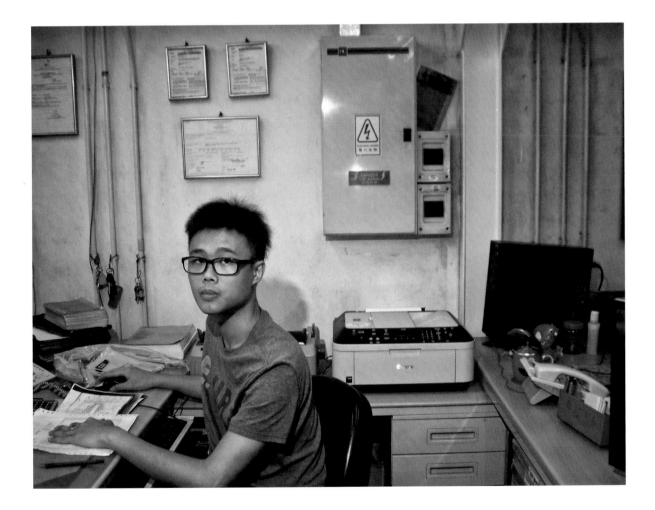

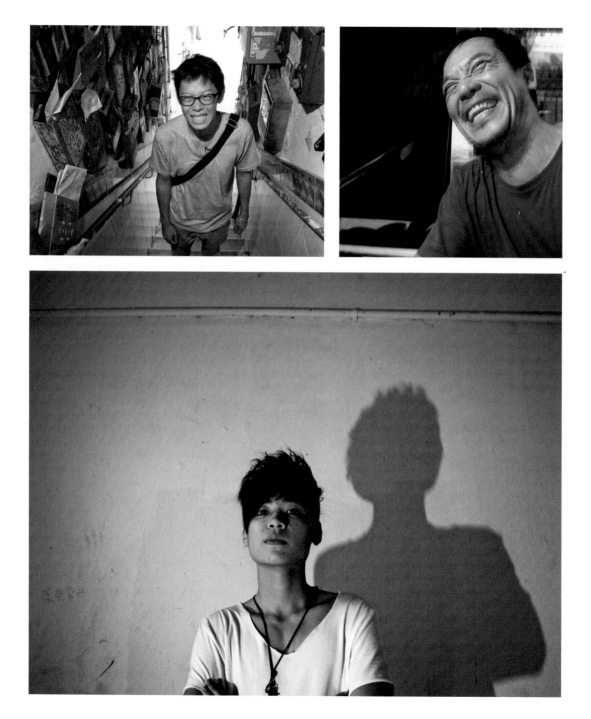

Q: I NEED A GOOD RESOURCE TO SEND TO MODELS THAT WILL TEACH THEM ABOUT POSING. SOMETHING THAT HAS A LOT OF GOOD INFORMATION IN ORDER TO HELP DIRECT THEM ON A SHOOT.

A: Resources for Directing Models. A rant by Zack Arias.

You are supposed to be that resource. You're the photographer. You're the one who has to create the final image. It's on *your* shoulders to be the resource. Not the model's. Not someone else. *You.*

A professional model brings a lot to the table. A professional photographer brings a lot to the table. Together, along with hair, make-up, and wardrobe, the image sings. The story is told. The work is great.

From where you are right now—based on this question—I can and will only recommend that she should look to *you.* Sounds like you are a new photographer working with new models.

The weight is on *your* shoulders. What photo, or series of photos, are you trying to create with this model? Why send her to learn something dramatic when you want something youthful and free? Why show her youthful and free when you need dramatic? The model isn't dictating the shoot. You are. It's your vision. It's your photograph.

What photograph do you want to make?

"I don't know."

If you ask for directions but you don't know what your destination is, how can anyone give you directions? Right?

So. You want youthful and free and happy. Now you have a destination. You want dark and dramatic and pensive. That's a destination.

What are the arms doing when someone is free? Are they spread out and flying or are they wound up tight around the body? When someone is dark and pensive are they standing on their tippy toes or are they folding into themselves and sitting?

Is it about the pose? *Or* is it about the body language? Don't think "pose." Think "body language." (Some light bulbs should be going off over your head right now.)

Not only do these questions start to form the posing, or body language, of your model but they start giving lighting clues. Location clues. Wardrobe clues. Make-up clues. Hair clues.

It's called pre-visualization. In most cases, it's your job to figure this out before the model is even booked. You book the model based on these clues. Some models are happy and free and float through the air. Some are dark and dramatic. Some can go either way as you direct them.

You think it through. You close your eyes and you picture the picture. You try to see the final image hanging on the wall or printed in a magazine next to a body of text. You try to see the thumbnails of the shoot in the Lightroom of your mind. What does your first edit look like when you close your eyes?

It sounds like I'm taking you for a ride on a rainbow while we listen to the spiritual vibrations of crystals, but I'm not. You have to begin to see the images you want before the day of the shoot. You give yourself room to change and adapt on the fly, but you need to have a loose idea (or a solid idea) of what you want. You have to have a destination.

The model walks in the door, green as grass, and cannot see the images you see in your head. You've worked out the lighting. You've worked out the location. Wardrobe is finalized. You know which lens you are going to use. Now you get that model in the light and location. You get the lens on them. They have no idea what to do from there. Now you direct them. Now you tell them a story they need to live out. You direct their body language.

"You're lost. Something is chasing you. You have no exit from the deep, dark woods you're in. You're holding your arms around you like you are part cold and part needing comfort—like the hug of a mother. You're tired. Lost. Your expression is starting to go blank as you give up and all hope is lost for you."

"You just saw the man of your dreams. He stepped off that curb over there and is lost in the crowd. You're trying to find him. Stretch your neck up and out like you're standing on your tippy toes looking for him. You're excited and happy but anxious. Not anxious like worried. It's kind of a grin/smile kind of anxious."

"You just told your asshole of a boss that you quit. You threw a drink in his face. You kicked him in the nuts. You are now walking out that door like you're ready to rule the effing universe! You've just been freed from a prison. Walk with that kind of confidence and determination."

The model stares at you like you're speaking Latin.

You step in. You stand in their place. You put your arms where you want their arms to be. You make the face you want them to make. You act out the scene and they have to mirror you. She's still a blank stare.

You pull a notebook out of your bag that has tear sheets in it that you've pulled from magazines specifically for this shoot. Point to that girl's face. "See how she looks lost?" Point to how this one girl is standing. Point to that girl's arms. "See how she's searching?" You act it all out again. You get back behind your camera and—"Action!"

Where does she look for direction? To you, and you alone.

"But I'm not good at this stuff yet."

Well, you better figure it out.

"But how?"

See the photo you want before you take it. Pull the scales off your eyes and see. We all talk about vision. This is what we're talking about to some degree. Vision. Seeing. Creating. Directing. Posing. Lighting. Lens choice. Post-production. You see it. You close your eyes and imagine it.

Why am I not fearful of people who buy a nice camera and suddenly fancy themselves photographers? Because this shit I'm talking about doesn't come in the box. The camera will never see. The camera has no vision. It's a f*cking hammer that can't build a house. It's a stove that can't cook. It's a stupid, stupid, stupid piece of plastic with some metal bits. It's useless as it sits there in a box. It knows nothing. It does nothing. It sees nothing. The camera is a piece of shit.

"But cameras are getting better and smarter and they take better pictures these days."

No they aren't. They will never take a picture. Buy all the cameras in the world. They will never see.

Study. Research. What do *you* want to create? What picture do *you* want to look at because no one else has shot it yet? You'll hear movie directors talk about making a certain movie because it was a movie they wanted to watch. You need to take a page from that.

Nikon doesn't give you vision. Canon doesn't give you vision. That new flash you want won't make you see. It won't direct your subjects. It won't do shit for you. You point it where it needs to be pointed. You control what sort of light enters it and how much light enters it. You direct your subject in that light you have decided to work in. You are in charge. You, and you alone. If you think for one second that the camera is doing something for you, then you have your brain turned off and you're being stupid. Stop it. Take control. Do it all. No matter what crazy-ass thing they make these cameras do next, they will never, ever, ever see the world.

That's your job.

Q: MORE AND MORE PHOTOGRAPHERS AROUND ME ARE MOVING TO LIGHTROOM. I'M STILL HOLDING ON TO APERTURE. AM I MISSING THE BOAT ON SOMETHING GOOD? WHAT FACTORS DID YOU CONSIDER WHEN YOU DECIDED TO USE LIGHTROOM OVER ALL THE REST?

A: I was an Adobe Bridge user when Aperture and Lightroom hit the streets. Tried Aperture 1.0, and it was a massive resource hog. I didn't like the whole import-and-catalog thing of Lightroom. I stayed with Bridge. Then I went to a "PDN On the Road" event and watched a guy give a two-hour workflow presentation using Lightroom. I think maybe it was Lightroom 2, and there was a deal to get it for $99. The presenter sold me on it, and I slowly started moving to Lightroom as my main program for editing, which I am still using to this day.

Since getting the Phase camera I'm using Capture One a little more but still hang out most of the time in Lightroom. It took me a solid six months to move from Bridge to Lightroom. I don't foresee moving fully to Capture One but I can say that I've yet to ever be romanced by Aperture. I've seen it in action. Poked around a bit with it. It's nice but there's nothing about it that makes my jaw drop and sprint to the App store to get it.

Use what you use. If you're happy with Aperture then keep going. I suppose Lightroom is out there more because it's in the Adobe family and is on two platforms, so it has a larger reach than Aperture.

VISUAL INTERMISSION

CRAIG // PHOTOGRAPH THOSE YOU LOVE

I was working my crappy day job at Kinko's one day, and a couple came to the counter with a battered 4x6 photo in hand. The photo was of a relative who had just passed away, and they wanted an enlargement of the photo so that it could be placed by the casket during the funeral service. It was a horrible photograph. Bad light. Bad exposure. Shot in the person's living room, there was a laundry basket filled with clothes in the corner. This photo would be the last thing people saw as they said goodbye. I scanned the photo and got to work on it in Photoshop. My boss berated me for the extra work I was doing at no charge. Jobs were backing up. I didn't give a shit. "Fire me if you want to," I said. I was not going to let this be this person's final photograph.

When I got back into photography I remembered that photo. This may sound weird—every time I photograph someone I think about their funeral. It is my goal to get a great photo of whoever is in front of my camera, one that is worthy of being enlarged and placed next to their casket. Everyone needs a great portrait. Everyone is going to leave it behind. The portrait that gets left behind needs to be the best it can be. I'm serious; I think about this on every shoot.

This is my late stepfather, Craig. Craig was diagnosed with ALS, and for the last year of his life I made damn sure to shoot portraits of him that would be enlarged and placed next to his casket. It was a difficult task because not only did I know why I was shooting these photos—he did too. He was such a great man. I miss him dearly. In this photo, he is in his backyard as his grandkids are running around, laughing, and blowing bubbles. The gesture of waving goodbye slays me, but it was so appreciated by family, friends, and the members of the church where he preached.

The hardest one, though, was shooting a portrait of him in the sanctuary of the church where he preached and, ultimately, where we all knew his funeral would soon be held. Photograph those you love. They aren't here long enough.

...

Nikon D3 / 50mm / f2 @
1/2500th @ ISO 800.

Nikon D200 / 35mm / f4.5 @
1/30th @ ISO 200 / Sunpak 120J
in 28" Westcott Apollo softbox.

Q: ZACK, I JUST APPLIED FOR A JOB AT GOODWILL AS AN E-COMMERCE PHOTOGRAPHER FOR $9.50/HOUR. WILL I HATE MYSELF IF IT'S OFFERED AND I TAKE IT? OR CAN I JUSTIFY IT AS HAVING A "JOB IN PHOTOGRAPHY" IS BETTER THAN NONE AT ALL? THANKS. YOU ROCK.

A: May God bless you and keep you and help you grow. Seriously.

You're about to embark on a fairly monotonous and boring job for little money. But you'll be taking pictures. I spent two years photographing apartments for apartments.com. I spent another year photographing really bad home decor knick-knacks for an import company. When you dream of photography and dream of being a photographer, being an e-comm photographer for Goodwill is not part of that dream. I get that. Chalk it up to paying your dues.

Take the job. Do your very best. I'm sure it's going to suck at times, but it's a job. Looking back at the time I spent photographing apartments and knick-knacks, I realize I learned a lot. It was sort of like Karate Kid training. Wax-on-wax-off kind of stuff. It's part of who I am today. I'm thankful I had those jobs.

It's a good thing. Do it. Stick with it for at least a year. Learn as much as you can. You'll find later that it added to your skill set. Be glad to have a job. Even if it ain't sexy. You're shooting pictures. A lot of people stuck in an office job at $9.50 an hour would rather be an e-comm photographer for the same money.

A: UV filters, and the like, are a good protection item for a lens, but they can be problematic, as well. If you have any point light sources in your composition, those light sources can flare on that filter and show up in your image, or the point light sources show up as a reflection on that extra piece of glass in front of your lens. I've tried the expensive UV filters and have still had this problem. I would always end up putting them on, then taking them off, then putting them on, then taking them off. Over and over again. At some point I just ditched them altogether and haven't looked back.

I typically always have my lens hoods on. In fact, some of them are actually gaff-taped to the barrel of the lens. Having a hood on helps protect the lens.

This one surprises folks—I don't have any front lens caps. I have bought and lost so many damn lens caps in my life that I just gave up on them long ago. The only caps I hold onto are body caps for the cameras and the rear lens caps. Front lens caps? Not one in my bag. No joke. I'll buy a new lens and just leave the front lens cap in the box. That's the only way I won't lose it. I do pack my lenses in microfiber bags when they are in my main camera bag. I take some precautions. Not many.

Q: IN A BLOG POST OF YOURS ON STREET PHOTOGRAPHY, THERE'S A SHOT THAT I'D LOVE TO HEAR THE STORY ABOUT. MAN, WOMAN, AND CHILD IN FRONT OF A BLUE "POST NO BILLS" WALL AS TWO PASSERSBY OBSERVE. SO MUCH IS GOING ON THERE. CAN YOU DISCUSS WHAT YOU WERE THINKING AS YOU CAPTURED IT? HOW DID IT COME TOGETHER? WHAT MADE YOU SHOOT IT? WHAT HAPPENED NEXT?

A: I was walking around NYC one day and I observed this couple having a discussion/argument across the street from where I was standing. "Might as well cross the street to investigate," I thought. I ran across the street and stood on the curb directly across from them; I waited there, trying to look as though I was occupied with settings on my camera. I saw the woman and girl (pictured sort of ducking in the foreground) walking up the street and was planning on having them sort of "shield" me when I took the picture.

I pulled my camera up just before they walked in front of me, thinking the guy wasn't paying any attention to me. Turns out he was paying attention to me. He clocked me as I pulled my camera up to take his picture. So did the woman and girl in the foreground; I think they were ducking, thinking I was trying to take a photo and they didn't want to be in the way. The guy was wondering what in the hell I was doing taking a photo of him. I was watching this all through the viewfinder. It was one of those split seconds where nobody knew what the hell was going on except for me.

I immediately saw the photo I had just taken in the viewfinder of my X100. I have it set to show a 1.5-second preview of the image. I knew he had seen me, and he didn't seem all that happy about it. The woman and girl had already passed by. He began talking to me from where he stood, but I couldn't hear what he was saying because there was an idling bus two feet behind me.

Act stupid. Get the shot. Move on down the street. :: Fujifilm X100 / f2 @ 1/170th @ ISO 200 / Aperture Priority with +0.7 set on the exposure compensation dial / Available light.

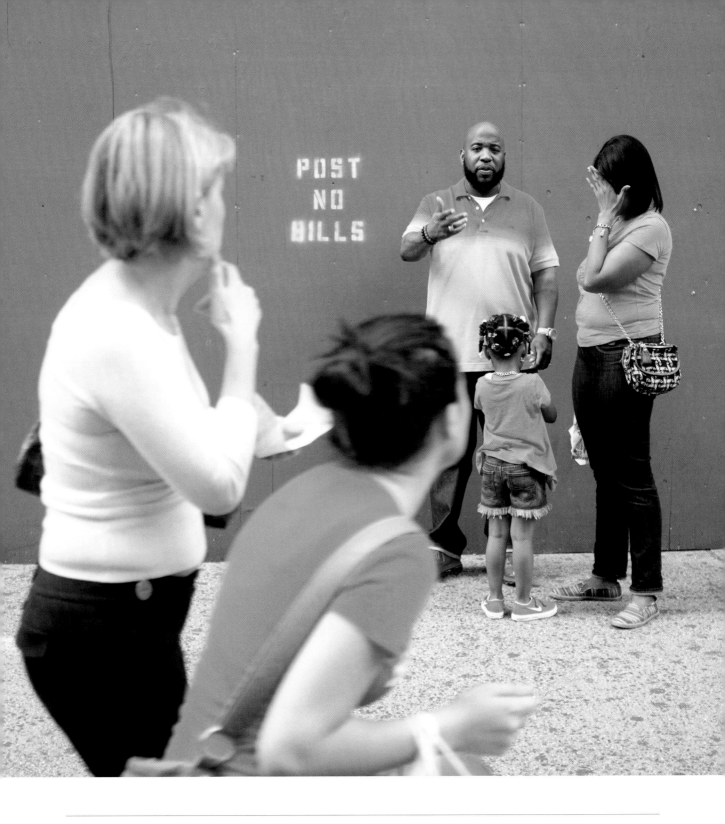

I dropped the camera to my side and immediately looked just over his head, got a puzzled look on my face, looked back at my camera, and started acting like I was changing settings. Then I pulled the camera right back up to my face and took another shot. Once again I lowered the camera and looked right over his head. I acted like I didn't even see him, as though I was just a dumb tourist trying to take a photo of something just over his head. I then looked at the back of my camera with a puzzled look on my face.

He bought into my act and figured I wasn't photographing him. He, and his family, moved on down the street in one direction, and I went in the opposite direction.

The woman and girl in the foreground were just a weird caught moment, but it feels like there was something going on there. Questions of race and all that could be read into it. Photography is such a lie! :)

Q: STYLE OVER SUBSTANCE OR SUBSTANCE OVER STYLE? WHICH IS THE MOST IMPORTANT THING IN A PHOTOGRAPH?

A: Substance over style.

Content over technique.

If you shoot for style and what's hot in the industry today, you will quickly find your work looking dated, and you'll be hopping on one popular bandwagon after another. Also note that if you are a trend whore, and you begin shooting what is "hot" right now, you're already a year behind the trend. As soon as you have that hot new style down, the world has moved on to the next thing that you will then be trying to emulate and, yet again, will already be behind on.

Content and substance always wins.

Brooks Brothers vs. parachute pants.

Q: SOMEONE HAS ASKED ME TO SHOOT HER IN THE NUDE. I HAVEN'T DONE THIS BEFORE, AND I DON'T PLAN ON DOING THIS A LOT. I THINK YOU SHOULD TRY EVERYTHING AT LEAST ONCE AND LEARN SOMETHING FROM IT. WOULD YOU DO THIS AND, IF SO, HOW WOULD YOU EXPLAIN IT TO YOUR BETTER HALF?

A: Ahhhh. The better half. I call my wife, Meg, the better 7/8ths.

I made a pact with a fellow photographer back in art school that he and I would never shoot a nude. It wasn't some sort of religious visual chastity thing. It was just a buck against the art world and all their damn nudes. That said, and years now having passed, I've often thought that I should shoot at least one nude in my life.

This is between you and your spouse, and that's it. If they aren't cool with it, don't do it. Plain and simple. Plenty of other things to spend time photographing.

Case in point. I shot some portraits recently of an older gentleman. They are some of my favorite portraits I've shot in I don't know how long. They're the most honest portraits I've captured in a long time. He was an amazing subject that just opened up to my camera. They're the simplest portraits, nothing special about the lighting or anything. But damn it all, I'm proud of a few of these frames.

I've never shot nudes. Like you, part of me thinks I need to give it a try for the sake of trying something different. If I ever do shoot a nude, then Meg has to be on board with it. For my European readers—I know. I know. In some cultures, though, this can be quite a touchy subject.

At the end of the day, give me a nude female that can possibly cause strife in my marriage, or give me an older male that will give me truly honest and beautiful portraits, and it's pretty easy to see what actually excites me more.

Rene Silvin photographed for *Men's Book* magazine. :: Phase One IQ140 / 80mm / f4 @ 1/250th @ ISO 50 / The background is an Impact 5-in-1 72" reflector being lit by an Einstein strobe that was lying on the floor behind Mr. Silvin. Mr. Silvin was lit with an Einstein strobe firing into a halfway closed-down 60" reflective umbrella. Closing a 60" umbrella halfway down looks a lot like the light made by a 28" Westcott Apollo softbox.

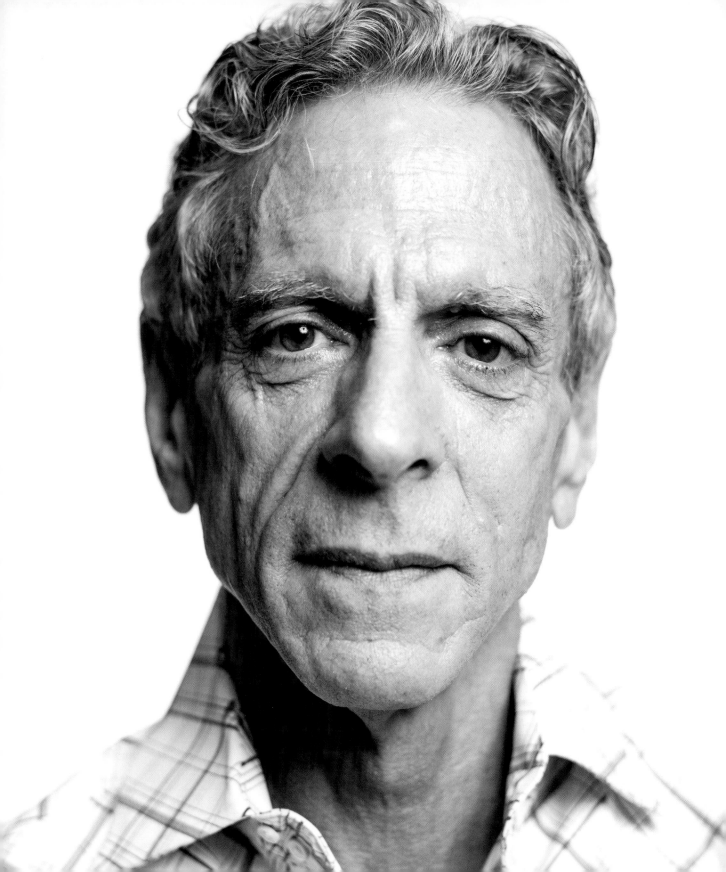

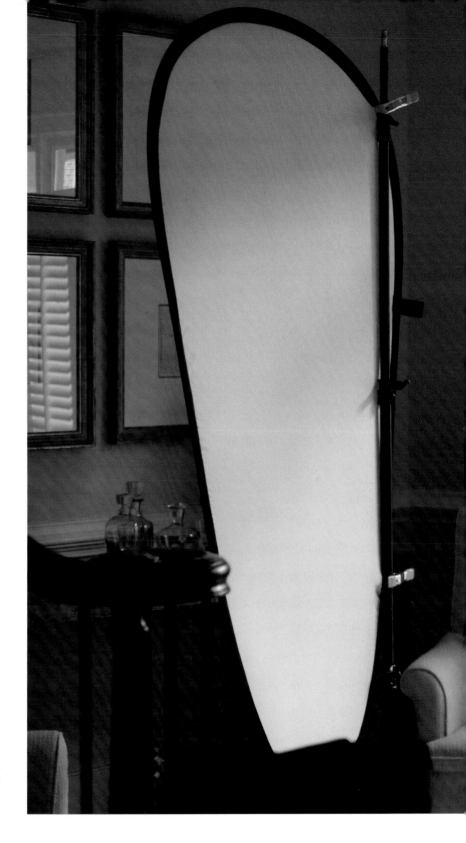

Here is the setup for the image on the
previous page. Here you see the 60"
umbrella half closed as the main light.
Note that I'm using the short reflector
on that light. That reflector is made to be
used with PCB's parabolic umbrellas. I
use it for normal umbrellas, as well. You
don't have to have it, though. A standard
reflector works just fine. The background
light is on the floor being propped up by a
few A-clamps, and it's pointing toward the
5-in-1 background that is A-clamped to a
light stand.

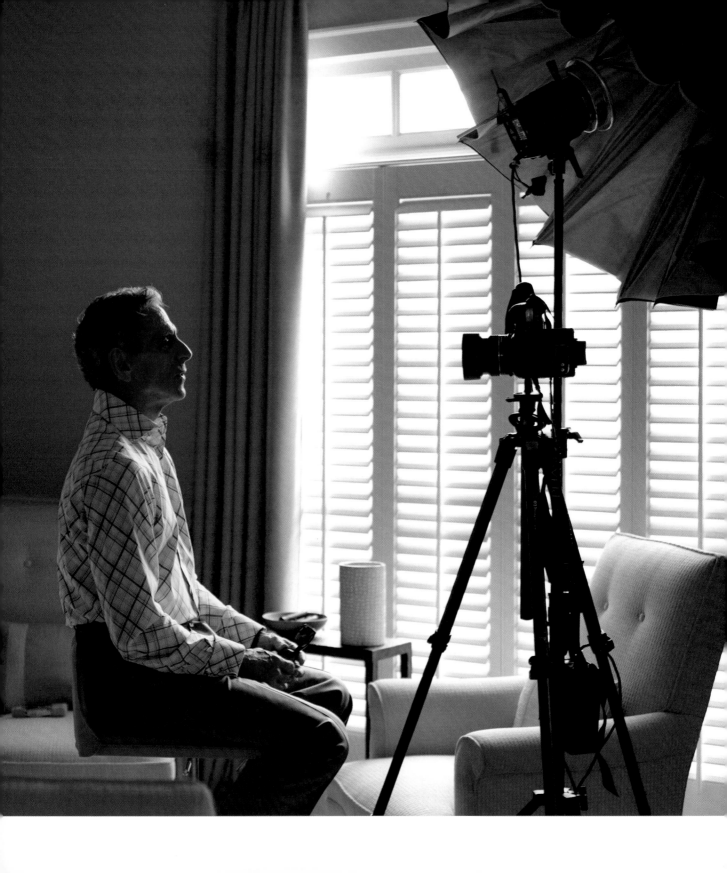

31-40

Cheap eBay lights.

OneLight for life.

All lenses are not created equal.

Trade shows.

Résumés for photographers.

Things I've learned while learning others.

Gear lust.

My shit ain't sharp.

Low light blues.

Blowin' up some photos!

Q: WHAT IS YOUR OPINION ABOUT THE REALLY CHEAP LIGHTING KITS YOU CAN FIND ON EBAY? I CAN FIND AN ENTIRE THREE-LIGHT KIT WITH LIGHTS, STANDS, AND MODIFIERS FOR ABOUT THE SAME PRICE AS ONE NAME-BRAND LIGHT ALONE.

A: Most of that cheap eBay stuff is garbage. You get what you pay for in photography. I have found that there are things that are cheap and there are things that are inexpensive. You could end up spending thousands of dollars on cheap gear before you found the things that are inexpensive. What's the difference? "Cheap" ends up not being worth the money you spent. "Inexpensive" is actually finding a good deal.

Cheap things fall apart, break, or are so quirky you can't deal with them. Inexpensive things don't cost a lot of money but they work well. Alien Bees are inexpensive. Those kits you find on eBay for the price of one Alien Bee strobe? Cheap.

Besides, you don't need all that crap that comes in the kit. Three crappy lights *are not* better than one good light. Two crappy softboxes *are not* better than one good umbrella. Yes, the whole kit seems cheap but you need to realize that *all* of it is cheap. The lights will suck. The stands will suck. The softboxes will suck.

You'll spend a bit more to get one good light, one good stand, one good modifier, and one good trigger. It will cost more but it will take you 1,000 miles further down your path than that piece-of-crap "kit" on eBay. Seriously. Take my word for it. Not only have I been sucked into thinking that cheap stuff would save me money, I've seen countless others get drawn into that stuff only to regret buying it later.

Q: HI ZACK. ARE YOU STILL APPLYING YOUR ONELIGHT PHILOSOPHY TO YOUR COMMERCIAL WORK? OR WAS THAT MAINLY TO SHOW BEGINNERS WHAT SOMEONE CAN DO WITH ONLY ONE LIGHT SOURCE, BUT WHEN YOU'RE ACTUALLY OUT ON A PAYING GIG YOU USE WHATEVER YOU NEED TO GET THE SHOT YOU WANT, EVEN IF THAT MEANS MULTIPLE STROBES? OR DO YOU STILL KEEP IT AS SIMPLE AS POSSIBLE? I'VE FOUND THAT IF I LIMIT MY CHOICES, THE MORE CREATIVE I GET. ELSE IT BECOMES, "MEH, LET'S THROW ANOTHER LIGHT IN THE MIX."

A:

OneLight for life!

If a job requires multiple lights then I go that route. I rarely find myself using more than three lights. Only once in the past year did I get into a situation where I had every stinking light I owned firing on a set. I was shooting six guys wearing black on a black background. I had one big light (7' octa) firing as the main, and then lots of grids and smaller softboxes firing as rim/hair lights. I had about eight lights firing on that set.

I typically start with a single light. If that's all I need then I'm good. That one light is my main light. It is being used to show the viewer of the photo what or who the subject is of the photograph. As I add more lights to a set, their purpose is usually to accent the main light. If I'm photographing someone with dark hair against a dark background then I may want some more separation. Their dark hair on the shadowed side of the photo may just bleed into the background. I'll add a

I was asked to do a lighting feature for *PDN* magazine and I booked my friend Mary to be the subject. I was trying to illustrate the use of small lights and how to deal with them on location. Mary was lit with a Westcott 28" Apollo softbox. Her boots were lit with a Nikon SB80-DX flash laying on the ground. :: Canon 5D Mk II / 35mm / f3.2 @ 1/160th @ ISO 100.

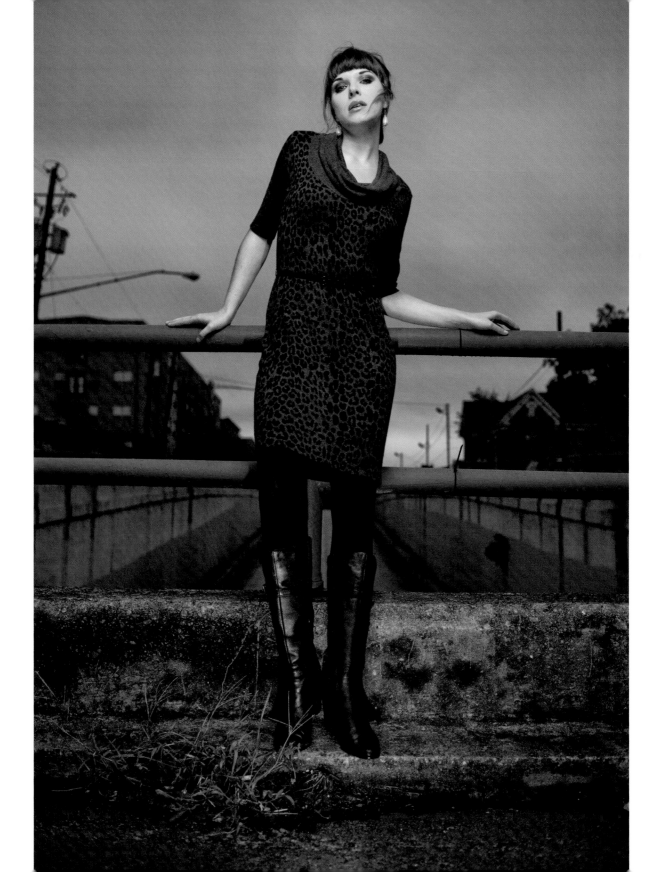

light at that point to separate their hair from the background. Sometimes that second light hits the subject. Sometimes I put it on the background. That's my typical two-light setup. Three lights come into play most of the time when I'm shooting on a white background and I want the background to be pure white. I light the subject and then light the background. Putting two lights on the background is the easiest way to pop it to white. Three lights: one main, two background.

You are correct in that limiting choices pushes creativity. When I really need a push I'll go on location with no lights. Lights are my go-to. I'm comfortable with them. When I don't have them I freak out a little bit, and it pushes me to find the light. I'll also do things like head out on location with only one prime lens. I have to make the entire shoot happen with just that focal length. It's maddening and exhilarating and liberating all at once. One camera. One lens. One light. A lot can be done with a simple rig.

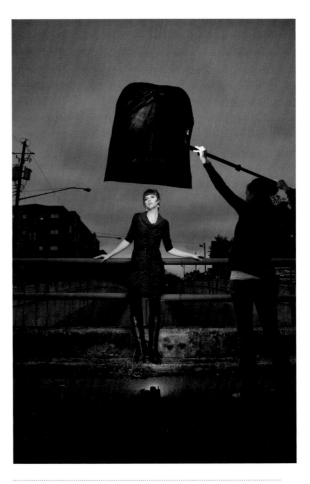

As mentioned, Mary was lit with a Westcott 28" Apollo softbox. Her boots were lit with a Nikon SB80-DX flash laying on the ground. Without the second light, her boots would have gone black since they weren't getting much light from that softbox. That's why I placed the second flash on the ground to kick a little light onto the boots. The second flash was set to 1/128th power since I didn't need that much light to just create a highlight on the boots.

Q: DO TWO LENSES—ONE PRIME AND THE OTHER A ZOOM—LET IN THE SAME VOLUME OF LIGHT GIVEN THE SAME APERTURE? WILL AN 85MM PRIME AT F4 GIVE THE SAME EXPOSURE AS A 24–105MM ZOOM AT F4? DOES THE LENS CHANGE EXPOSURE?

A: An 85mm at, say, f4 *should* let in the same amount of light that a 24–105mm lens at f4 brings in. "Should" being the key word. In the real world, though, you may find this is not the case.

Manufacturers are often allowed a +/– 1/3 stop variation in manufacturing tolerances. That means that one lens at 2.8 could be +/– 1/3 of a stop from another lens at 2.8. You could own two lenses that are possibly 2/3 of a stop off from each other.

You may come across an old, used lens one day that has "+1/2" or "–1" scratched onto the barrel of it. In film days you would test and test and test all of your gear and find out where lenses fell compared to your light meter. Then you would know that with one lens you needed to add 1/2 a stop, and with the other lens you would need to decrease one stop.

My 24–70 2.8 and my 70–200 2.8 are at least 1/2 stop different from each other.

In a perfect world, 2.8 would be 2.8 no matter what lens. In the real world, there can be a fairly wide gap between the same aperture settings on different lenses. The best thing to do is test all of your gear.

A: Photography organizations like Professional Photographers of America (PPA), American Photographic Arts (APA), American Society of Media Photographers (ASMP), Wedding and Portrait Photographers International (WPPI), and the like offer some great resources for emerging and established photographers. They typically concentrate on one or two genres of the photo industry, and you join the one most in line with the type of work that you are doing, or trying to do. PPA is very family- and senior-portrait driven, with a healthy amount of weddings. WPPI is very wedding driven with a healthy amount of family and senior portrait thrown in. ASMP is a great organization for editorial photographers, as is Editorial Photographers (EP), which merged with APA somewhat recently. APA deals with a lot of aspects of advertising and commercial photography.

Joining one or more of these organizations can be a good thing for you, but don't drink too much of their Kool-Aid. Some of these organizations can get a little cult-like at times. People get together in great numbers and begin to find their identity within the organization. They attend every event, hang on every word of their leaders, and always show up at photo parties with their association-branded t-shirts. Join one. Take some classes. Learn some stuff. Get some discounts. That's all fine and dandy. It ain't church, though.

As for the big trade shows it can be hit and miss from my experience. The thing that pisses me off the most at the big trade shows is when the platform speakers spend more time selling their products than actually teaching something of value. If people are paying to sit in a class or a lecture, then I feel the speaker needs to bring value and not an infomercial. Way too many people use those platforms to just sell you shit. I say get a booth and keep that for the trade show floor. If you are leading a session then teach and inspire instead of convincing a room of people they need to buy your crap. Some organizations are putting limits on that now in the contracts they have with their teachers and speakers. I recently gave a talk at a large convention and the contract stated I could spend no more than five minutes of my hour-and-a-half talk pitching products. For me, I don't pitch from the stage. People paid to learn. I was paid to teach. I think it's fair that I keep my end of the bargain.

My personal favorite trade shows are Photoshop World and Photo Plus in NYC. The coolest one I've ever been a part of is Gulf Photo Plus in Dubai. It's small.

Hands-on. Everyone is there to teach. It's amazing. If you ever want to have your mind blown, then you need to attend Photokina in Germany at least once in your life. It's overwhelming how huge that trade show is.

I think the value of the large annual trade shows is being questioned right now. I'm not saying they are dying. In fact, some are getting larger. There are smaller events happening these days that, as a working photographer, I find to be more valuable. PhotoShelter is one good example of an organization trying something different in our industry. They put on an event in NYC last year called Luminance. There were a few days of workshops leading up to the event, and then it was sort of like a TED talk for photography. It was a fantastic event. I think we'll be seeing more of those kinds of events.

A: I haven't had to make a résumé in years. Your portfolio is your résumé/CV. Period. Unless you're going for a staff job. Are those even around anymore? From what I understand, a CV is still valid in the fine art world when you are submitting work to galleries. If that's the case, then I'm probably not the best person to guide you in writing one. I can only imagine it is like writing a résumé for any other thing you would need to do that for.

I can tell you that I've never been asked for a résumé as a freelance photographer. Never. Ever. If someone asked I'd simply say, "Um...I haven't had a résumé in about 12 years. You sure you need one from me?" I'd then be thinking that I might not be the right guy for the job, or the person asking for one doesn't have a clue about hiring a photographer, and I may need to take some time educating them on the process.

Q: MOST TEACHERS I'VE MET CAN USUALLY RATTLE OFF SOME KEY THINGS THEY'VE LEARNED FROM THE TEACHING EXPERIENCE. WHAT ARE SOME OF THE MOST VALUABLE THINGS YOU'VE LEARNED FROM RUNNING YOUR WORKSHOPS?

A:

1. Holy crap! Look at that! The inverse square law actually works!

2. There's a good part of what I do that is second nature and seems "easy" to me because I've been doing it for so long. Then I see there is a disconnect from what I say to what students understand. I have to really think through what I do and break it down step by step. As I break it down it usually leads to a deeper understanding of what I'm doing, not only for the students but also for myself.

3. As folks put brainpower into learning a new aspect of photography, what they already knew gets thrown out the window—things like composition, subject interaction, etc. So much concentration is placed on the new information that other things are forgotten for awhile.

4. While many have a camera; while many have a web site; while many have paying gigs on the books...not everyone is a photographer just yet.

5. The best thing I get from teaching is when I open my mouth to give advice and I end up the one most in need of hearing it. #practicewhatyoupreachzack

Case in point: Been talking a lot about mailers on my blog recently, knowing damn well I'm late getting mine out the door.

I need to stop talking and start doing.

VISUAL INTERMISSION

LIVING THINGS // ONE OF MY FAVORITE SHOOTS

I often get asked what my best shoot has been. I can't say with certainty that I can peg one shoot as the best I've ever done, but this shoot with the band Living Things is one of my favorites for a number of reasons—and it isn't necessarily because of the end product.

I was hired by *Nylon* magazine to photograph the band as their tour brought them through Atlanta. The assignment was to get a solid handful of portraits and then tag along with them for their show and get a few live images. The editor said she'd love if she could get a look in studio and one on location for the portraits. Basically, I needed to do everything (studio, location, and performance) for a crap budget.

Around this time, I was very frustrated with my photography and I needed to shake things up. I felt I had hit a plateau. I couldn't break out of my rut. I had been looking at some older work of mine, and I felt that there was something raw to my old work that my new work was missing. Back then I had one camera. One lens.

"That's it!"

When I finished shooting the band in the studio I walked out the door with one camera, one lens (24mm 2.8), one battery, one reflector, and one 256 MB memory card. No backups. No extra batteries. No extra storage. No lights. Me not taking lights on location would be like me not drinking coffee in the morning. Doesn't happen. I didn't even have a camera bag with me to worry about.

I found a location on the way to the venue, shot a few portraits there, and then followed them from load in, to sound check, to show. By the time they were taking the stage I had enough room for just a handful of RAW photos on that 256 MB card. I switched to large JPG and my counter said I had 21 images. I wasn't going to delete anything off the card to make room. I felt I had some decent shots from their sound check so I decided to go for something different during their show. I remembered that my D3 had a multiple exposure mode. I'd never used it before. I set the camera to black and white, and to shoot four frames per exposure.

The PE at *Nylon* loved them. "Oh my God! Something different! Awesome!"

Something in my brain was set free that day. Some barrier that wasn't allowing me to progress was taken down. Putting some tight limits on myself made me think more. Shooting in-camera multiple exposures during a live show was frustrating and awesome all at once. I was really proud of that shoot when I was done. I shot clean. I shot dirty. I shot in studio, on location, and at a show. Tried something different. I now regularly head out on location with limited gear and it makes me happy.

Living Things on a cyc wall.
:: Nikon D3 / 35mm / f9 @
1/250th @ ISO 100 / Two
Alien Bee 800s lighting the
background. One Alien Bee 1600
in a 50" Westcott Apollo softbox
as the main light, flying on a
boom over camera position.

Nikon D3 / 50mm / f6.3 @ 1/6th @ ISO 100 /
Available light.

Nikon D3 / 24mm / f4.5 @
1/500th @ ISO 400 / Available
light with a half silver/half gold
reflector to camera left.

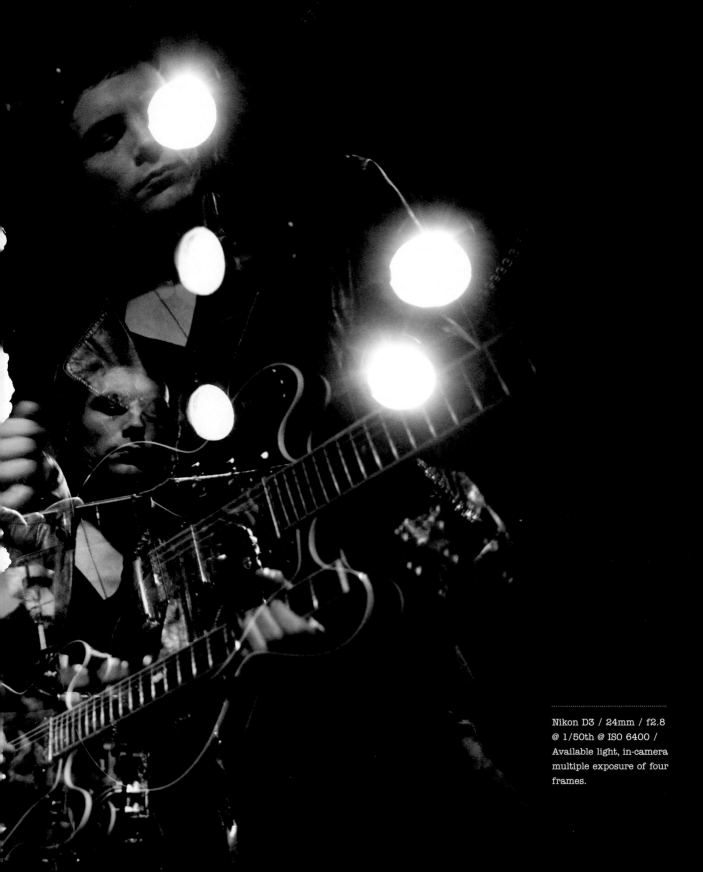

Nikon D3 / 24mm / f2.8 @ 1/50th @ ISO 6400 / Available light, in-camera multiple exposure of four frames.

Q: I REALLY APPRECIATED YOUR ANSWER TO THE ANONYMOUS PERSON WHO ASKED ABOUT GEAR LUST. I HAD GIVEN IN TO THE HYPE AND BULLSHIT AND SELF-IMPOSED INFERIORITY COMPLEX. I HAD COMPLETELY AVOIDED MY CAMERA FOR ARTISTIC PURPOSES FOR OVER A YEAR. AFTER READING YOUR ANSWER, I TOOK 10 MINUTES TO WALK OUTSIDE AND TAKE PHOTOS—SIMPLY TO TAKE PHOTOS AND HAVE FUN. IT FELT REALLY, REALLY GOOD.

A: Glad to be of service.

We need to remember how amazing our camera was when it was announced. We need to remember how excited we were to finally own it. We read everything we could about the camera. We looked at every sample image coming out of the first models. We counted our pennies until we could finally own that amazing piece of gear we wanted so much.

Then it became old. It became outdated. There was something newer. And flashier. And more advanced. The siren's call of better photographs lured us into researching the even newer camera. Looking at all of the sample images. It has us counting pennies again trying to get to the end of the rainbow to find the new pot of gold.

That great camera we already own seems worthless. It seems like an anchor weighing us down and holding us back from our dreams. If only it did what the new camera can do, then we could find success.

Then we study the masters of old. How many AF points did Avedon have? How many frames per second was Bresson shooting? What did the DXO labs find of the camera Annie was using when she shot her first *Rolling Stone* assignments?

We have so much technology and so many options at our fingertips right now. Even the simplest of cameras are good performers when used correctly. That camera you were so excited about two years ago is just as good today as it was then.

Yes, there are times to upgrade. Yes, there are times when gear matters. Yes, there are some advantages to staying up to date with certain technologies. Yes, there are times to retire a piece of gear and replace it with something new. As a professional you will see gear come and you will see gear go, but I have yet to get a camera that made my photos better. Or made me see the world differently. The closest a piece of gear has ever gotten me to something new and different was my Fuji X100 because suddenly I had a camera with me at all times. I began shooting things I would not have shot before because I wouldn't have had a decent camera with me at those times.

Enjoy what you have. Do the most with it. Remember there are folks in the world with older gear taking better photos than you are. If they had your gear they would see it as a blessing when, at times, we see the gear we have as a curse.

Take more of those walks.

My wife, Meghan, has been catching the photography bug lately. Meg is more of an analog girl and has never taken a liking to digital cameras. She prefers shooting Fuji 3000B in old Polaroid Land cameras and Impossible Project film in an old SX-70. The cost of film, though, usually keeps her from shooting all the photos she wants. I recently bought her a 10-year-old Epson R-D1 digital camera, and it is the perfect mix of analog sensibilities with a digital sensor. It's an amazing camera. Look it up. I wish more digital cameras were made like that. It's an old camera that still performs very well. :: Epson R-D1 / Voigtlander 35mm / f2.5 @ 1/200th @ ISO 400 / © Meghan Arias / Shot in Havana, Cuba.

Q: I HAVE A LOVELY 50MM 1.8 LENS AND A 70–200MM 2.8. MY IMAGES ALWAYS SEEM TO BE A LITTLE SOFT, YET WHEN MY BOYFRIEND GETS A HOLD OF MY CAMERA, HIS PHOTOS ARE *ALL* IN FOCUS. SAME SETTINGS AS I HAD BEEN USING TWO MINUTES BEFORE. WHAT THE HECK?! SHALL I JUST PASS THE BUSINESS OVER TO HIM?

A: Nailing focus is a learned skill. First, check your shutter speeds. The rule of thumb with shutter speeds and gaining sharp photos is that you do not want to handhold a camera slower than 1/focal length. So for the 50mm you want to keep your shutter at 1/50th or higher. For the 200mm you would want to be at 1/200th or higher. I highly suggest something like 1/250th or faster for that 70–200 lens when you are at 200mm. It's a heavy beast. It is possible to get focus at lower shutter speeds but you have to be rock steady, as does your subject. VR (vibration reduction) and IS (image stabilization) lenses can help.

Next. How are you focusing? I see a lot of photographers set their camera on some sort of continuous focusing mode. That means the camera is tracking focus constantly on a set AF (auto focus) point. If you are focusing on the eyes of your subject and then you slightly recompose the photo, the AF point could pick up on something else and change focus from the eyes. I also see a lot of photographers using the "auto" AF point detection thing. It sort of reads the scene and decides a focus point for you. The camera typically picks the wrong thing to focus on.

Also note: AF points were placed in your viewfinder by engineers. Not artists. They are *not* composition anchor points. They are focus points. Do not compose photographs based on those areas in your viewfinder.

I've seen a lot of people use the back button focus technique, but then as soon as they half press the shutter release, the camera focuses again because all the buttons aren't configured correctly through the menu system. I don't use the back button AF technique. It got really popular to do because some really popular photographers said that's how they do it. I saw tons of people switch to it *not* because it worked better for them, but because someone said that's what they should do. Half press AF works better for some folks. Back button works for others. It's a personal preference, and whatever you pick you have to be good at it. If you are a back button focuser then make damn sure that half pressing the shutter release doesn't also initiate focusing.

I've taught at a lot of workshops and I've watched people struggle with focus over and over and over and over again because they don't understand the focus systems

of their camera; they don't understand the different focus modes; their buttons aren't configured correctly; they're dropping their shutter speed too low for the lens they have; they hold their camera wrong; or they focus and recompose, but when they are recomposing they move the camera far too much and blow the focus.

I can't tell you how many times I've grabbed a camera from a workshop student and gone into their menus and made a number of changes to their cameras. Not only do I change AF modes, I turn off auto brightness on the LCD, turn off image rotation on the camera (but not computer), turn on RGB histograms, highlight alerts, on and on and on.

I've asked folks, "Why is your camera set up like this?" and the reply many times is, "Ummm. I don't know."

Know your gear! Know each button. Know each menu setting. Know why it is doing what it is doing. Know how to change it. Know what the focus system is doing. Know your different metering modes. Know what to

change and how to change it. That camera will never be a natural extension of your arm until you know it inside and out.

So, to your question—Keep an eye on that shutter speed. *Steady* holding on that camera. The hand you are holding the lens with needs to be cupped *under* the lens as though you are making a "U" with your hand (with your palm facing toward you). Don't hold it on the side like you're making a "C." Nothing screams "amateur" more than holding a lens on the side. Separate your feet. Have a strong stance. Pull that camera into your face. Make sure your AF point isn't constantly changing focus (unless you're shooting a moving subject). Make sure when you recompose you do so very carefully, and do not lean forward or backward after focus is locked.

My oldest son, Caleb, demonstrating both the proper way and the wrong way to hold a camera.

Q: MY QUESTION RELATES TO LOW LIGHT PHOTOGRAPHY. I CAN'T SEEM TO GET THE HANG OF IT (THINGS LIKE WEDDING FIRST DANCES, ETC.). TO AVOID THE "DEER IN HEADLIGHTS" LOOK, I DON'T LIKE USING THE FLASH SO I TRY AND USE AS LOW OF AN APERTURE AS I CAN GET (THE LOWEST I CAN GET IS ON MY 50MM) AND A HIGH ISO. THE PICTURES ARE NEVER SHARP. COULD YOU GIVE ME SOME TIPS ON WHAT I SHOULD DO OR WHAT SETTINGS I SHOULD IDEALLY BE USING FOR IT?

A: A lot of times, low light equals bad light. Just because a camera has the capability to shoot in low light doesn't mean the resulting photo is going to be beautiful. Think full sun at high noon. Easy to shoot in because there is so much light, but is it good light? Not really. Low light, typically, isn't "beautiful" light. The quality of it isn't that great. Not all the time, but as in situations you described above, most of the time it sucks.

When you are in low light and you are having issues with sharpness, there are five things at play here. Work on eliminating as many of these issues as you can.

Let's look at a basic setup at the same exposure value and how all five of these issues can cause problems with getting sharp photos. I'm going to use a hypothetical situation of shooting in low light at ISO 3200 with a 50mm 1.8 lens shooting at f1.8 @ 1/60th of a second.

Here are three images shot with a Nikon D3 and an 85mm lens at ISO 800. The first two were shot at f1.8 @ 1/100th in available light. The available light was the modeling lamp from the beauty dish I was using plus window light coming into the studio. It's fairly nice, soft light.

Image #1 shows some motion blur. An 85mm lens at 1/100th of a second can give some blur if you are not rock solid with holding the camera or if your subject moves.

Image #2 shows that it is possible to get a sharp image at these same settings as long as everything and everyone isn't moving during exposure.

Image #3 was shot at f8 @ 1/250th @ ISO 800. I had my flash power set to the lowest setting on the Alien Bee 1600 that I was using. The image is now much sharper due to two factors: closing the lens down to f8, and using flash. The light being captured now is just from the strobes being used: one strobe as the main and two on the background. At f8 @ 1/250th I'm not registering any ambient light. It's all from the flash, and the flash duration is very fast so there won't be any motion blur.

1. SLOW SHUTTER SPEEDS :: As talked about in the last answer, 1/60th is pretty much the bottom edge of shutter speed here. You've got to be rock solid in holding that camera if you want sharp images.

2. SUBJECT MOVEMENT :: At 1/60th a moving subject will blur, thus killing sharpness. You can get a sharp shot at 1/60th in this case—if you are standing dead still and your subject is standing dead still. As soon as you introduce a bit of movement on your end and a bit of movement from them, then your photos will not be sharp unless the love of God is with you at that very moment and both you and your subject are moving in the same direction at the same speed. God loves you all the time, but it's sometimes hard to see at intervals of 1/60th of a second when your images are soft. :)

3. SHOOTING WIDE OPEN :: Lenses are never that sharp at their wide-open aperture. Photo nerds and pixel peepers will point you to resolution charts that show the sharpest point of a lens is somewhere in the middle of its aperture range. But that means shooting the first dance at f8 or so. That's sort of silly. We're talking maximum sharpness in a scientific test. Not in real-life situations. The most wide-open aperture isn't going to be as sharp until you close down just a bit from there. Typically you buy a 1.8 lens because it will start getting sharp at f2 to f2.8. Need to be sharp at f1.8? You buy a 1.2 lens. At that point, though, you're selling your first-born to buy that lens.

Another thing that kills sharpness when wide open is focusing on subjects further from your lens. If you shoot f1.8 from three feet away it's going to be pretty sharp. Shoot f1.8 on something, or someone, 15 or more feet away, and it won't be *that* sharp. I had a 24–70mm f2.8 zoom that was sharp at f2.8 as long as the subject was within 10 feet of my lens. Any further away than that and I'd have to stop down to f4 to get a decently sharp image.

4. HIGH ISO AND NOISE :: While most cameras today can shoot a pretty decent image at ISO 3200 and up, and while the noise is palatable, it's still noise and it still kills the fine details in an image. Those fine details make up sharpness. Once you start to "blur" over those fine details with noise, then the sharpness starts to go.

5. QUALITY OF LIGHT :: There is sharpness and then there is "perceived" sharpness. This often comes down to the quality of light falling on your subject. Typically, low light is flat and muddy. There is a lack of good contrast from highlights to shadows. Everything in your frame is covered in this flat muddy light and the details of the image are then…well…flat and muddy. It might be technically "sharp," but it just looks flat and muddy.

Take the same scene but add a light to add some contrast, and the resulting image will have more contrast and you'll perceive it to be "sharper" than the image with the flat muddy light because there's a "snap" to the light. There's better contrast. Edges are more accurately defined. Details are lit better. The image is "sharper" because the light is "sharper."

So. Let's go through this scenario again of using a 50mm lens at f1.8 @ 1/60th of a second at ISO 3200 in low, flat, muddy light. How do we get sharper images in this hypothetical situation?

Faster shutter speed. Jumping from ISO 3200 to ISO 6400 will now give us f1.8 @ 1/125th of a second. Better for handholding but now with more noise, thus still killing fine details. And we're still in crap light.

Stop down the aperture. Let's stop down to f2.5 for decent sharpness from this lens. That's one stop less light. You've stopped down your aperture so now you slow the shutter to 1/30th of a second to get the same exposure. Oh wait. We're going slower with shutter so more motion blur. Okay. Increase ISO one stop to 6400. Oh wait. Adding more noise. Still in crap light. Still at 1/60th of a second.

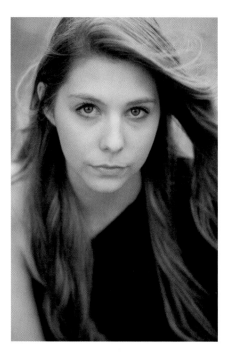

This issue with motion blur isn't something that just happens at high ISOs. It can happen any time your shutter speed is getting too slow no matter the ISO. These images were both shot on a Canon 5D Mk II / 85mm / f2.8 @ 1/50th @ ISO 100. Image #1 is just available light. Image #2 introduces just a bit of fill flash from a shoot-through umbrella. The fast flash duration combined with adding some contrast to the light in the scene helps achieve a much sharper image.

Decrease ISO. As you lower ISO (to get less detail-killing noise) you need to open your aperture or slow your shutter speed down even more. Well, if you are shooting with a 50mm 1.8 you can't open any more. Besides, the more open the aperture becomes, the less sharp that lens can be. Slowing your shutter speed down results in motion blur. Still in crap light and now you're even less sensitive to the crap light. See where I'm going with this?

Ultimately, you're kind of hosed and you're making compromises. At some point, ultimate sharpness is thrown out the window because you are at the limits of all of your gear. You can buy better lenses that will be sharper at f1.8. You can buy a better performing camera body that will give less noise at higher ISOs. Let's say you do this. Better lens. Better camera. Yay! Sharper, to a point, images. But what hasn't changed at all in this situation?

You are still in crappy, muddy, flat light!!!

So what if you could change the quality of light in this situation? What if that better quality of light happened at 1/1000th of a second? That would stop motion easily, right? What if you could get a nice contrast between highlights and shadows? What if you could shoot the same scene but at ISO 800 at f2.8 and then drag the shutter a bit to pull in some room light?

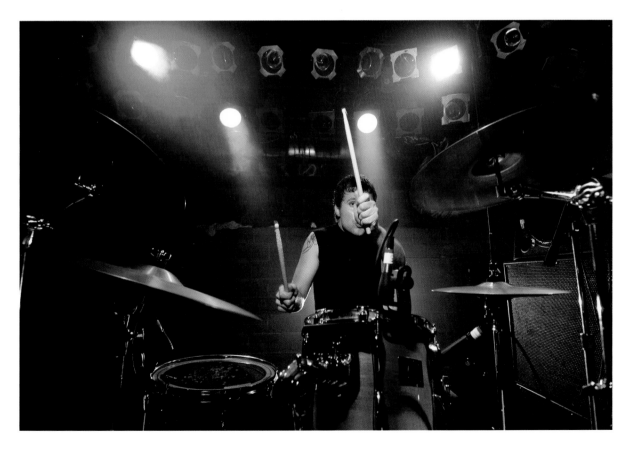

All of this is possible with...wait for it—flash. The "deer in headlights" look that you hate is because the flash is in the wrong place. You don't want the flash on your camera. You need it off your camera. Once you introduce better light into this bad low-light situation, then you can lower your ISO and stop down your aperture a bit, and your flash is operating around 1/1000th of a second so action is getting frozen onto your sensor.

Real sharpness *and* perceived sharpness have all now increased, and you have a better quality of light hitting your subjects. And let me tell you, getting into off-camera lighting can be done for a lot less money than buying 1.2 lenses and top-of-the-line, high-ISO-performing camera bodies. Once you figure out how to effectively mix flash and ambient together, you will avoid the bad light that is currently keeping you from using flash.

#learntolight

I learned a lot about shooting in low light, dealing with ISO noise, and soft images when I started shooting live shows in 2003. I had a Nikon D100 camera that I was not comfortable shooting above ISO 400 because the noise was so bad. I was working with a lot of local bands and shooting shows was my first introduction. Local music venues have horrible lighting, and having a DSLR that couldn't handle high ISO like the ones we have today made me figure something else out. That something else was using off-camera flashes at shows.

Opposite: In this shot, there was a Vivitar 285 flash on a stand behind the drummer, Noah Alexander, and I was handholding a Nikon SB24 in my left hand. The Nikon flash was connected to my camera via a Nikon TTL cord, and it was zoomed to 85mm so that it wouldn't wash the entire scene with light. I just needed some light to hit Noah. This image was shot at f4.5 @ 1/50th @ ISO 200. Dragging the shutter at 1/50th of a second allowed enough ambient light to mix in with the flash so I could avoid that "deer in the headlights" sort of lighting. One interesting additional note here is that I shot this soon after leaving my full time job at Kinko's. The lens I shot this with, the Nikon flash, and the memory card in the camera were all borrowed from my friend Marc Climie. I didn't have crap for gear back then.

Q: I KEEP GETTING FRUSTRATED WHEN I BLOW MY IMAGES UP TO 1:1 AND SEE THAT THEY ARE NOT SHARP FROM ISO 400 UP ON A FULL FRAME BODY. IT'S NOT A FOCUS ISSUE; IT'S MORE OF A NOISE ISSUE WHERE THE IMAGES DON'T LOOK AS CLEAR AS I THINK THEY SHOULD. AM I BEING TOO MUCH OF A PIXEL PEEPER AND SHOULD GET OVER MYSELF, OR AM I DOING SOMETHING WRONG?

A: First—"…when I *enlarge* my images to 1:1…."

You don't blow up a picture. You *enlarge* it.

Second—water is clear. Photographs are *sharp*.

#PhotographySpeak101

You are being too much of a pixel peeper and, well, you're not going to get the sharpest, cleanest files on DSLRs at ISO 400 and up. I'm never happy with my 35mm format images at 1:1 so I always judge them at 50% view. For a long time I thought I was the only one. I thought that I couldn't get that super crisp, sharp image that I wanted. Was it my lenses? My camera? My monitor? Then I asked some friends for a few of their RAW files and saw the same lack of tack sharp details, and their images seemed to fall apart at 100% viewing. I mean—the images were sharp but not *that* sharp.

I accepted this to be just how it is. In the days of film, 35mm film wasn't the sharpest thing out there. Medium format and large format film rendered *much* sharper images when you put a loupe on them or made prints. Four years ago, I went to a gallery showing that had the work of five or six photographers. One photographer's prints shined above all the others. There was clarity to his prints. A sharpness. A quality about them that no one else's prints had. I got close to them. I studied them. They were about 30x40 inches in size. The details were amazing.

I can't tell you how many times I've heard photographers complain about the quality of a camera or a lens and then back up their complaint with a stupid photograph of a squirrel or a table full of kitschy shit. So if we are going to pixel peep, we are doing so in the time-honored tradition of looking at a squirrel and some kitschy shit.

The photographer who shot these images, Drew Gardner, walked up as I was studying them, and I turned to him and said something like, "There's something about...."

He stopped me mid-sentence and said, "Phase One. Medium format."

"Ahhhhhh," I said aloud. "Shit," I said in my mind.

When you see a large print from a large sensor, your DSLR goes limp and crawls into a corner with its tail between its legs. You can't ever go back to your DSLR images again knowing what's out there. Note that I'm not talking megapixels. I had as many megapixels in my DSLR as Drew had in the Phase One. It was the physical size of the sensor. A medium format sensor, like medium format film, renders an image with astonishing detail. It will ruin you.

Please know that I don't say this to wag my medium format camera in your face. I left that gallery show and started planning my way to a medium format system. It took four or five years to get it. Now that I own a Phase One, there's no going back. I wish every image in my portfolio was medium format. Is it the best camera for all situations? No. It's horrible above ISO 200. It's slow. It's tedious. When I nail focus it's amazing. Get it off by the slightest bit and it's unusable. Yet, for the portrait work I do it can't be touched by any DSLR I've ever used because of the dynamic range, the shallow depth of field that comes from using a larger sensor, the sharpness, and the fact that it can sync with flash at shutter speeds up to 1/1600th of a second thanks to its leaf shutter lenses. That's not some sort of hyper-syncing or tricking the system. That's just straight-up 1/1600th of a second sync speed.

The problem? I could have bought a car. A nice car—or the camera.

Actor Chris Kayser, dressed for his role as Scrooge in *A Christmas Carol*. Photographed for *Atlantan* magazine. ::
Phase One IQ140 / 80mm / f4 @ 1/500th @ ISO 50 / Lit with an Elinchrom Quadra in a Westcott 28" Apollo softbox.

41-50

Asking strangers for photos.

Stock or purge?

Nudes, Bar Mitzvahs, and WTF.

How do I sell stuff that people don't buy?

Don't build a following.

Going to school for photography.

Assisting and 2nd shooting.

Comparing yourself to others.

Noise reduction. Not elimination.

Drinking with friends.

A: If I'm shooting candid street stuff, then no. I work to make sure they don't know I'm taking their photo. I'm stealing their moment; I'm pick-pocketing an image.

With street portraits, there is interaction. I stop them, talk to them, and hope to get a portrait that I then direct. Look this way. Look at the camera. Look over there at that building. Step over into this light for me. So forth and so on.

This question comes up a lot as well—I don't get releases. In the States I can shoot whatever and whomever I want as long as we're all on public property. Restaurants, and the like, are grey areas since they are technically private property but it's a public space. I can use the images in my portfolios, and I can even sell them for profit via editorial outlets, but I can never sell them for commercial purposes like advertisements. If *Time* magazine is doing a story about a particular city where I shot portraits, I can sell them an image that I don't have a release on. But if ACME Corporation wants to use one of my street shots in an advertisement, I can't sell them an image without a release.

I've never had anyone ask me to remove an image from my site, blog, or other visual outlet. If I were asked, I would consider it. If I felt very strongly about the image then I'd most likely keep it up. Then the subject would need to get a lawyer involved. I'd *most likely* get a cease-and-desist letter first. Then I'd consider the importance of this image some more. If I felt I really wanted to continue to show the image then I'd get a lawyer and go over my legal options and figure out how much this would cost everyone involved. I'd probably try to negotiate with the subject and see if they would finally consent to me using the image for my portfolios.

I'd really have to believe in the image, though. If I were on the fence about it, I'd remove it. I don't want there to be bad feelings about photographers from the general public, or from someone I photographed.

A recent street portrait shot in Atlanta. :: Phase One IQ140 / 80mm / f2.8 @ 1/800th @ ISO 200 / Available light.

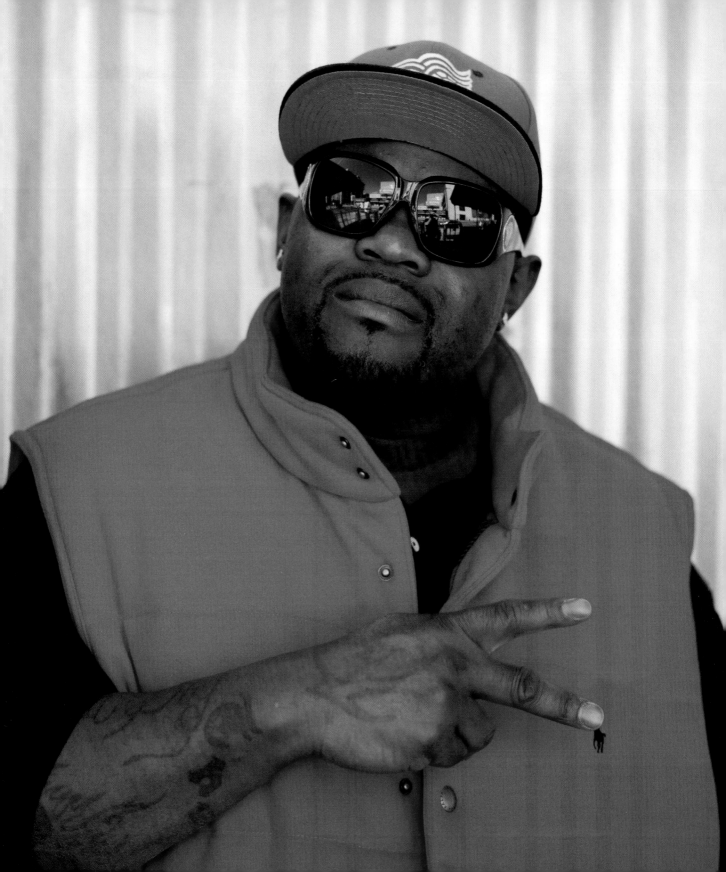

On a few occasions, I have approached a few people after taking their photos to let them know I just got a nice photo of them. I give them a card and tell them that if they'll email me I'll send them a copy. None of those folks has ever emailed me.

Goodbye kitty! Poor Hello Kitty didn't have the proper permit to be soliciting tourist snapshots at Times Square. The police officers were telling her she had to leave the area but she did not speak English very well. :: Fujifilm X100 / f2 @ 1/100th @ ISO 640 / Aperture Priority mode with exposure compensation dialed to +0.3 / Available light.

Q: WHAT'S YOUR TAKE ON IMAGE ARCHIVES? I'VE GOT TONS OF PHOTOS FROM VACATIONS, PERSONAL PROJECTS, PHOTO WALKS, AND WORKSHOPS THAT ARE JUST HANGING OUT ON HARD DRIVES. SHOULD I POST THESE FOR SALE AS STOCK, HANG ON TO THEM "JUST IN CASE," OR JUST PURGE?

A: I don't know. I have these kinds of images, too. I have no clue what to do with them. Getting into stock is quite a job. You might think it's a fine stock photo but it's amazing how finicky stock companies can be on images that are submitted. There will be things in your photos that you thought weren't an issue, and suddenly you're doing a lot of retouching to remove this or that. Then you have to learn the art of keywording. I've looked into it. Talked to folks doing it full time. My conclusion was that it wasn't worth my time to work on something I wasn't really into and most likely wasn't going to bring in substantial income. If you're going to make money in stock, you need to really get into it.

I'm just hanging onto my miscellaneous shots. Every now and then I'll pull something out for a project. I've grabbed bits of sky, clouds, or whatnot out of some of those shots to include in another photo. Those are rare cases, but it has been helpful to have them around. Maybe I'll put them into stock one day. I'm not completely against it.

I also think about these things when I'm taking photos. I was recently in Amsterdam, and as I aimlessly walked around the city I would see a "photo moment." You know. Green-bike-leaning-against-red-door kind of a thing. Picturesque boat floating in picturesque canal. Looks like the typical stock shot. What am I ever going to do with that photograph? Who would I ever show that to? I could buy that photo for $1 somewhere.

So I pass on the photo. I don't even take it. I'll never do anything with it. It isn't important enough for me to have as a personal photo that's just going to sit on the hard drive somewhere.

You never know, though, what you'll need or what you'll be doing 10 or 20 years from now. Always shoot what interests you. I love shooting sidewalk textures and street art details as the street art decays. I love that stuff. I have hundreds of photos of weathered paper decaying on walls. Not sure why I love it, but I do. It might become apparent to me later in life and I'll use it for a project.

Don't purge it. These photos are your little babies. Keep them around. Storage is cheap. They might grow into something later.

Here is a photo I took of a bird and the ocean. I was on vacation. I like the picture. I like the colors. I like the bird. WTF am I ever going to do with this picture other than illustrate a point about WTF am I going to do with this picture? There. The photo now has a use.

Q: I'M A NEWBIE TO THE PHOTO INDUSTRY AND I'VE JUST REDESIGNED MY WEB SITE TO INCLUDE SOME OF MY NUDE WORK. I WANT TO GO INTO COMMERCIAL AND EDITORIAL WORK BUT, AT THIS POINT, I FEEL THAT I SHOULD TAKE ANY JOB THAT COMES MY WAY. I'M PROUD OF MY NUDE WORK AND THINK IT'S IN GOOD TASTE, BUT I AM CONCERNED THAT IT MIGHT TURN AWAY CLIENTS LOOKING FOR FAMILY PORTRAITS, WEDDINGS, OR BAR MITZVAH PHOTOS. SHOULD I KEEP THE PHOTOS ON THE SITE OR DITCH THEM?

A: If you're going after editorial and commercial work then I think you can have a gallery of personal nudes—as long as they're done really well. If it's just more naked folks lying on rocks then you may want to reconsider. You know, because the world doesn't have enough of those photos already.

Anyway....

If you are going for family portraits, weddings, and Bar Mitzvahs, then you need to ditch the nude galleries. No question about it—especially with regard to religious events.

Think about it. How many families are going to appreciate your nude work enough to hire you to shoot a sacred religious event? It's as bad as photographers who show nudes/glamour and advertise senior portraits. No way in hell I'd send my teenage daughter to that photographer. Sorry. Eff off. No way in hell I'm sending teenagers to you. I've seen some photographers mix nudes and slutty Model Mayhem shoots in the same gallery as family and children portraiture. Seriously? Who thinks that's a good idea? Yeah. No one. No one thinks that's a good idea.

Now then, if your site is editorial and commercial with a gallery of personal work that includes nudes and there ain't a dang thing on there about weddings, families, or Bar Mitzvahs, then it's up to you. If someone is looking for a Bar Mitzvah photographer and they happen upon your site, they will know that you aren't their photographer. So you lose those jobs. Well, what do you want? Editorial or events? Commercial and nudes? Or kids reading from the Torah? Some things mix. Others do not. Make a line in the sand, and stand on one side of it. If you think for a moment that your nude work might impact the work you do to pay your rent, then ditch it. Make a 500px account with your nude work and just let it sit out there.

If we were sitting at a bar right now I'd get past this "what to do with nudes" topic and go straight to your concern about other work. What do you want to shoot? If you want editorial and commercial then go after that with everything you have. Don't worry about weddings, portraits, and events. There are plenty of people going after that work. Plenty of people going after the work you want, as well. Why split yourself into pieces and get nothing accomplished with any of them? Focus. Focus. Focus.

VISUAL INTERMISSION

JACK WHITE CHANGED MY PHOTOGRAPHY

Getting a photo pass to a concert is a fairly easy thing to do if you know a few people and pull a few strings. I once got access to the photo pit at a show by flashing a library card to the security guy standing by the stage. (No, really—a library card and a camera. Anyway.) The problem with shooting big shows is the three-song rule. You get to shoot the first three songs, then you are escorted out of the pit and, at times, out of the venue altogether. I hate that rule.

The White Stripes came to town to play the Atlanta Midtown Music Festival, and I scored a press pass for the entire three-day event. I was excited to see the White Stripes because I liked their music but I wasn't a *huge* fan of theirs. No reason why. I just knew a few of their songs and liked what I had heard. I had also heard they put on a great show. My friend, Marc, was a big Stripes fan, and I wanted to make sure to get a photo for Marc. I had one music blog picking up my images, but other than that I didn't have to invest too much in the show.

Jack White hit the stage and blew my mind in the first 10 seconds of the first song. I shot like mad for the first two songs, and then I fell to the back of the photo pit and just watched him play guitar for the third song. I was mesmerized. It was like he wasn't there. He played the guitar like he was trying to fight off demons. It was like he was trying to save someone's life—maybe his own. I can't fully describe it. It was beyond just playing passionately or putting on a show. He fully "checked out" and was somewhere else. He was fighting something—or fighting *for* something.

I was in awe. I stood there, mouth open, and thought, "I want *that* for my photography." Jack was loud. Messy. Frantic. Fighting. Insane. It's been eight years since I stood there and watched him. It's been eight years of me trying to unpack that thought: "I want that for my photography." I can look back and see little glimpses of me letting go and fighting for my photography. It is still eating away at me, though. I'm still searching for it. Needless to say, Jack White is currently the number one person in the world I want to make a portrait of.

..

Nikon D100 / 85mm / f1.8
@ 1/250th @ ISO 250.

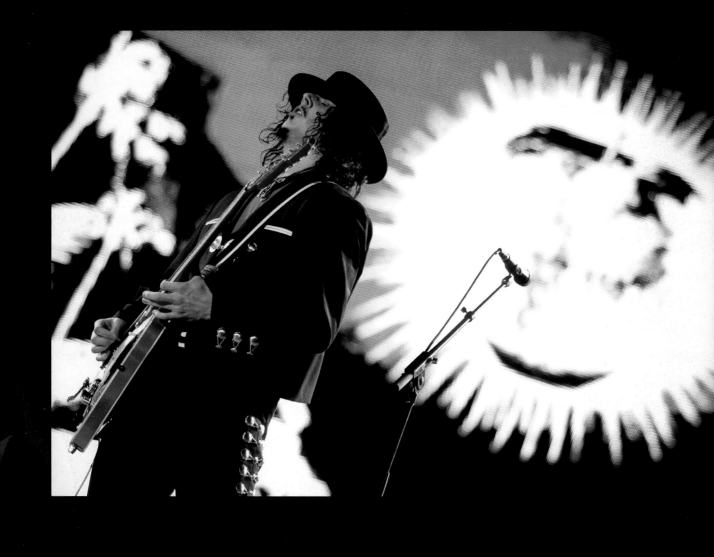

Q: I'M ABOUT TO START MY PHOTOGRAPHY BUSINESS AS A WEDDING PHOTOGRAPHER. IT'S SOMETHING I LIKE BUT I'M *REALLY* INTO CITYSCAPES. CAN YOU IMAGINE A SITUATION WHERE CITYSCAPES WOULD TURN INTO A BUSINESS EVEN ON MY ENTRY LEVEL, OR WILL IT ALWAYS BE FINE ART FOR MYSELF? FROM ANOTHER POINT OF VIEW: HOW CAN SOMEONE SELL CITYSCAPE FINE ART PICTURES ANONYMOUSLY?

A: Your question could be, "How do I sell stuff that people don't buy?"

I have no idea how cityscapes (or landscapes, or nudescapes, or puppyscapes, etc.) can become a viable business unless you get in with the right people at the right time. Let's say a hotel chain, like Marriott, found your work and wanted 5,000 prints to put in hotel rooms. That could bring some decent income but that's more about knowing the right person at the right time. There is the stock industry. There are postcards. There is traveling around to art fairs and setting up a tent and selling prints to the general public. Calendars maybe. Mouse pads. Anyone remember mouse pads? Is that stuff going to pay your rent? Most likely not.

You could build up a big audience on a site like 500px or on Instagram and have people clamoring for your prints. But you're going to have to a) take *really* amazing photos, and b) build a community who loves them enough to pay you for them. You asked about doing it anonymously. Not sure why you want to do that. So it doesn't mix with wedding clients? You can keep different work on different sites but still put your name on each.

You know…if you love it—shoot it. Your market for selling them, though, is going to be a hella narrow niche, and I have no idea where to point you to get that going. I'm not saying it can't be done. I'm just saying your market for selling them is far smaller than, say, brides getting married.

You say you are just starting in all of this and that you want to start a wedding business. Do you realize how busy that's going to keep you for some time to come? Starting a wedding business is going to take all of your time. It's a full time job if you do it right.

Weddings, you may find, feed your belly while your cityscapes feed your heart. That's what street photography does for me. I love shooting stuff on the streets of cities. It excites me. It resonates inside of me. I love it so much. I'm not making any money with it. It's my hobby. I share it as personal work. Maybe someone likes my street stuff and hires me to shoot portraits. Cool. Am I selling prints of that stuff right now, though? No. Do I care? Not right now. I'm plenty busy doing the other stuff that pays my bills.

Q: SOME DAY I WISH TO BE HIGH ON THE FOOD CHAIN OF PHOTOGRAPHERS LIKE YOU. I WANT TO ROLL WITH THE BIG DOGS AND DO SOMETHING AWESOME THAT THE PHOTOGRAPHIC COMMUNITY CAN GET BEHIND. THE BIGGEST ISSUE I AM HAVING RIGHT NOW IS GETTING CONNECTED IN THE RIGHT WAYS. I SPEND A LOT TIME THINKING (MORE THAN I SHOULD) ON HOW TO FIND THE HELP WITH THE SUPPORT I NEED TO KEEP GOING. ANY ADVICE ON BUILDING A FOLLOWING?

A: Yes!!! *Do not try to build a following!!!*

Don't actively try to be a "big dog." Don't actively try to create buzz about yourself in the industry of your peers. We can all see that from 14 miles away and would rather just steer clear of you.

Don't think a following is the end goal. Being a great photographer is the end goal. If anyone actually gives a crap about what you are saying, then great! If not, you're still off being a great photographer. Photography is first and foremost. End of story.

"Follow me! Follow me!" just reeks of ego and narcissism.

I'll tell you how the "big names" in the industry got a big following, though. It's pretty simple and straight-forward. Look at Chase Jarvis, David Hobby, and Joe McNally:

A. They worked really hard at their craft and became great photographers.

B. They are very open about what they do and how they do it, and they share freely with the people around them.

C. They kept doing A and B for years. Years. Hear that? *Years.*

Working hard at your craft and being open to share is the secret. One person started to read their blogs. Then 10. Then 100. Then 1,000. They added signal to the noise and helped a lot of people while they themselves were working diligently on their craft. They are actively struggling up the mountain but often lend a hand down to help someone up.

They aren't sitting around trying to figure out how to build a following. They aren't giving shit away in order to bring their numbers up. They're actively getting stuff done and lending a hand every chance they have. We all respect the hell out of them for that, and thus, we "follow" them. See how that works?

Don't let "rolling with the big dogs" be a life goal. Be a great effing photographer and lend a hand to folks along the way. In five or ten years, maybe we'll have a drink at a bar together in some crazy-ass place in the world and wonder how in the hell this all happened. We'll enjoy the view for a moment and then get back to work doing what we do. Climbing and helping.

Also note that I'm not high on the food chain. You just know about me, and I have a decent online following. Dan Winters is high on the photographic food chain. Way up that chain. He doesn't blog nor is he on Twitter. More people know about me than know about him and he's 100x the photographer I am.

A "following" doesn't mean you are at the top of your game. A "following" doesn't mean you are talented. A "following" doesn't mean that you're now an important person. Do not let a "following" get to your head. I've seen it happen to others. They start to think they're the shit and they lose sight of what made them great in the first place. Don't be that asshole. Just remember that you suck, and if anyone listens to anything you have to say you should just be grateful.

Lastly, don't look at people on your social media outlets as "followers" or "fans" of yours. They are peers. They are colleagues. They are equal to you, if not better. It's an honor to have folks care what you have to say. Don't take it lightly, and don't start to think that you're the shit. Because you're not. Dan Winters is the shit. He has zero followers on Twitter. I hope to meet him one day and shake his hand. He is such an amazing photographer.

 It depends on you and the school.

If you are the type who learns best by being shown and made to replicate what you've been taught, then school is for you. If you tend to be a self-starter and like to figure it out on your own, then school is not for you.

If the school is a "fine art" school run away as fast as you can. 9.5 out of 10 fine art schools will never prepare you to do this as a profession. There are exceptions but not many. My first adventure in studying photography was in the art department at the University of Georgia. It was a fine art program. It sucked. I've had students from that program apply to intern at my studio. These are students in their senior year. They should know something about photography, right? Something. I wouldn't have them answer my phone.

There are some kick-ass schools like Savannah College of Art and Design (SCAD), Portfolio Center, Art Center, Brooks, RIT, and a few of the Art Institute campuses. The problem with these is they can run tens of thousands of dollars a year. You head into one of those on student loans and you are *f*cked* when you graduate. Proper f*cked. I just read an article about SCAD having one of the lowest ROIs (return on investment) in the

nation. Tuition there will set you back $180,000. You know how many photo shoots that is?

I went to a little two-year community college here in Atlanta called Gwinnett Technical College that had a commercial photo program. This was after I failed out of the art school at UGA. I went to class right down the hall from welding and two halls over from auto body repair. It cost $314 a quarter to be a full time student. That was less than what parking would cost me at some other schools. I learned everything from portrait photography to product photography. I did all my own developing and printing in color and B&W. My teachers taught part-time and were working photographers the rest of the time. That school hammered the technical into my head. It is an amazing school.

Where it fell behind an art education is that I learned the technical but not the conceptual. I think SCAD and the like run a good mix between those but at 100 times the cost. Eff that.

Guess how many times a potential client has cared about what school I went to?

Zero.

I've never been up for a job and then been asked about my schooling.

It's. All. About. The. Book.

Period. Done. End of story. In the real world it doesn't matter what school you went to or if you went to school at all. School can give you a great foundation to build on. You'll build your first book there. But what you *must* do is put that first book in a box along with your cap and gown. As soon as you graduate, bury your student book because guess what? It looks like a student book.

School is my foundation. I'm the guy who needs to be shown and tested. Weekly critiques were massively important to my learning of the craft. Absolutely invaluable. I'm so glad I went to school. I'm also really glad I didn't graduate with student loan debt.

I also went to school when I was young, unmarried, and had no kids. It's 10 times harder to do if you're 30 or 40 and have a few kids. It can be done. Just harder. Forty-year-olds ask me if they should go to college. Now that we have digital cameras and the internet and the Strobist and the Kelby and the like, I just tell them to go to school online, shoot their ass off for two years, and assist or second shoot as much as possible.

Q: I'D LIKE TO START ASSISTING OR SECOND SHOOTING FOR A WORKING PHOTOGRAPHER. I'VE APPROACHED A FEW PEOPLE BUT HAVEN'T HAD ANY LUCK YET. I HEAR IT'S AN IMPORTANT PART OF THE PROCESS TO BECOME A FULL TIME PHOTOGRAPHER. HOW DO I GET THAT STARTED?

A: I hear this from a lot of people. "I contacted photographers asking to help and no one got back to me or they just said no." Let me break this down for you from the perspective of someone who gets emails and phone calls asking if they can assist me. Also note that I spent four years of my career as an assistant and seven years as a second shooter.

First, let's look at this from the other person's perspective. The one who isn't getting back to you or saying no.

A new assistant on a job is typically more of a liability than an asset. If you don't know how I work, how I pack my gear, or how I deal with subjects, then you'll be standing far in the background. When I'm on a job, I can't take a lot of time training you. Take something like a wedding gig—I sure can't take a risk of bringing someone along who I don't know. I've had assistants say the wrong thing, at the wrong time, to the wrong person on a job. And who is that a reflection of? Them or me? Me.

You will have a very difficult time getting anyone to let you tag along on a job if they have zero history with you. I only bring new assistants along on personal shoots or on jobs that are under controlled conditions, or the assistant is a personal recommendation from another photographer. If I don't know you except from a single email or phone call, and you don't know anyone I know, then chances are I'm not going to get back to you, or I'll politely tell you no.

Also note that if you're offering a "one-time assist for a day" deal, that isn't much help for you or for me. When I'm on a job I have to focus completely on that job. Period. You'll get very little from standing around for one day. If you don't know how I work, and what I need when I need it, and where it is when I need it, then you aren't much help either. Neither one of us is getting a lot. Both of us have a good chance ending up frustrated. Trust me. I know. From both sides of the coin.

Your best bet is to do your homework. Find someone whose work you respect. Find every bit of information on them that you can. Their blog, Twitter, Facebook, LinkedIn, Google+, Instagram, etc. You can mine a lot of information about a person from these outlets. Do they like the same music you do? Do they hang out at the same places? Do they have kids the same age as yours? One of the most important questions Meg and I

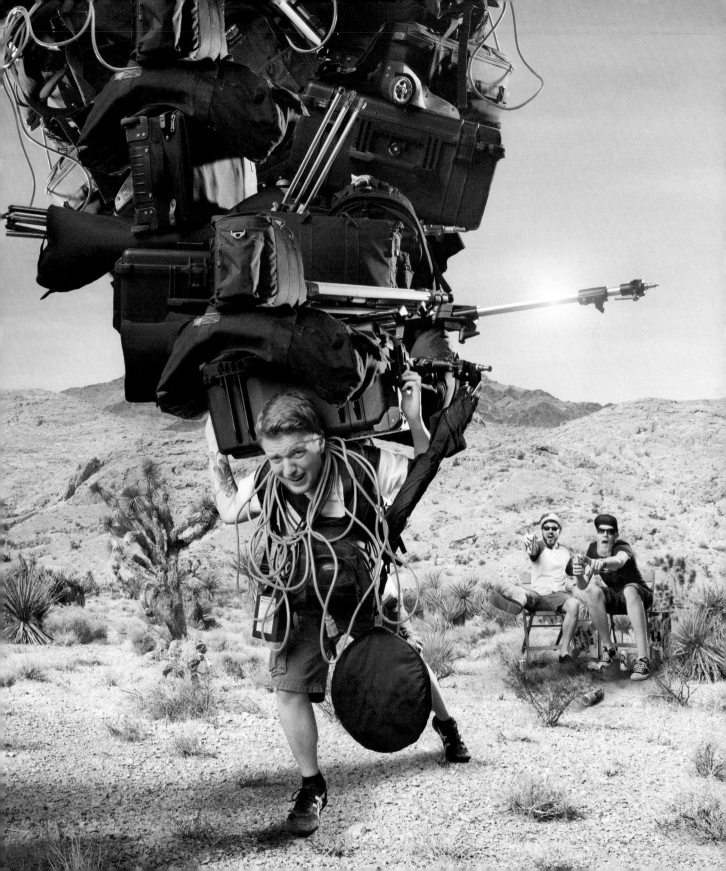

ask of someone new is, "Can they hang?" Will we actually like hanging out with this new person? As much homework that you are doing on the photographer you would like to assist, they are probably doing as much homework on you, as well.

When you find someone you really feel you would mesh with, send an email:

Dear Photographer,

I've been a fan of your work for a long time and I'm just getting started in the industry. I know you've had your ups and downs and I'm really hoping that I could buy you a cup of coffee at [coffee house where photographer always Twitters from] or a cold pint of [beer photographer always tweets about].

While I'd love to assist you, I know you're busy and just getting a cup of coffee might be too much to ask. My schedule is open if yours is. I know I'm as green as grass but here is a link to my web site. I really want to pursue [portraits/weddings/editorial] work. I know I have a long way to go. That's why I'm looking for some assisting work. I appreciate your time very much.

Thanks,

New Kid on the Block

PS—Love *that shot you did recently of [so and so]. Congrats on getting that job.*

•••

Maybe you'll get on their radar. Maybe. Note that if you want to take them to coffee, or assist them, then someone else wants to, as well. Maybe 10 other people have emailed them this month. Maybe 20. Imagine 20 people wanting to go have coffee with you. If you sit with everyone for an hour that's 20 hours of time you've spent. I personally don't have 20 hours a month to sit and drink coffee with folks. You need to understand that a lot of photographers already have someone assisting them, or they have their regular roster they call on when needed. They aren't being an asshole if they say no. They aren't trying to keep you from competing with them. It means you have to find another photographer to ask. Then another. And another.

Be persistent without being a pest. Reach out to busy assistants in your town and make some connections there. Try to be a second assistant for free or cheap. If a few assistants can trust you, they can help with referrals. Like all things, it seems impossible to break in, but you just need to crack the surface a few times and things will start to happen.

The same thing goes for second shooting. Put yourself in their shoes. You're covered in weddings. You have emails and phone calls to get back to. You're six albums behind. You're married. You have kids. You have 32 more weddings to shoot for the year. You're trying to get your blog updated. You'd love to just have a week off.

Someone emails you out of the blue about second shooting for you. You have no idea who this person is and they don't have a lot of work to show. Is this person going to be a hard worker and become an asset to you, or are they just going to leech information from you and disappear into the night after they get what they want? You also have five other people asking the same thing.

You're covered up with work. Your spouse is calling. You need to head out the door to make it home in time for dinner. You will have to eat and run because you have a meeting with a bride and her mother that evening. How likely will you get in contact with these people you don't know? Then add the fact that you already have a second shooter who you love, and you know they aren't going anywhere soon.

So…this person getting in contact with you. How high on your priority list are they? Not very.

How likely is it that you'll even get around to replying to them? Not likely.

What is the chance they will feel slighted and call you an asshole? Likely.

So *you* are that person reaching out to someone who isn't looking for you. How do you cut through the noise of their life to stand up and be noticed without looking like a pest or a fool? You've got to get on their radar. Just a cup of coffee would be a great place to start, but how do you get there?

I'll tell you what typically grabs my attention. I get a lot of emails asking for this kind of stuff. Most get thrown into a folder to be looked at later, and I usually don't see them again. That folder is sort of an abyss. Anyway, a lot of people email and say they like my work, they think I'm great, blah, blah, blah. Sometimes they'll talk about the gear they own. Blah, blah, blah. Sometimes they talk about the lighting style they like. Blah, blah, blah. Sometimes they talk about how well they know Lightroom. Blah, blah, blah.

Then someone will say, "I can shoot and edit the hell out of some video." "I can program Wordpress." "I'm a good writer and can help create and edit blog posts for you." "I'm a certified CPA and know QuickBooks like the back of my hand." "I'm a lawyer and I know contracts."

Do you think I need help with my gear? No. With my lighting? No. With Lightroom? No. I got that. That's what I do. However, what piques my interest is when folks write to me and have something different to offer that is outside of my typical skill set but deals with my day-to-day job.

Assisting and second shooting can be difficult to break into. You need to show that you're a hard worker, you're efficient, and you have some unique skill sets that you can bring to the table. Don't worry if your photography isn't that great. I'm not expecting it to be. In fact, the better your photography is, the more likely I'll tell you that you shouldn't be assisting. You should be shooting.

Remember that the process of working with someone is a two-way street. You want to learn from behind the scenes and gain experience and knowledge. The person you are working for needs to have some things taken off their plate so they can concentrate on other important aspects of their life and their business. I can't stress to you enough, though, that persistence pays off. You have to dance along that thin line of being persistent and being a pest. I can't tell you exactly how that works. No one can.

A: No. You can't. You just can't do that. It's so easy to do. It's a bad trap. It's okay to think you suck and let that push you to get better, but there's one Dave in the world and that is all we need. Trust me. I know the guy. :)

While you can sort of categorize Dave into a genre, he does have has his way of doing things. I have my way of doing things. Cowart goes about things his way. As do you. Or, you should.

Comparing yourself to others usually puts you in a rut that is self-defeating. Let other photographers that you respect *inspire* you. Understand that if they found a path for their work then there is hope for you to find a path for yours.

I don't have to look at anyone else's photos to think I'm a hack or get depressed. I can just look at my own photos and feel that way! Grow. Learn. Step by step by step. If someone else is finding success then that is a good thing. It means it's possible. Dave doesn't have any special DNA in his blood that is different from what you and I have. He works really hard, he started from absolute zero, and he will be the first to tell you that he's not fully happy with what he is doing. He's constantly pushing himself further and further and further.

Knowing your faults is a good thing. Know where your weaknesses are and work on that stuff. But sitting around comparing yourself, your work, or your clients to others never seems to help. Turn your attitude around and rejoice when you see great work and great clients from other photographers. It really does give you hope that you too can find some success.

Do you suck? Well, of course you do silly!

Your work ain't shit....

Yet.

See how powerful "yet" is? Yet is one of the most powerful words in the dictionary. Yet is a goal. Yet is a destination, a point on the horizon. Yet is awesome. I love yet. It means you're on your way.

I make it black and white and call it fine art. (I make joke....)

When I'm in a situation where ISO has to go up to a point where noise is going to be an issue, then I start lighting the scene so I can shoot at lower ISOs and have less noise.

However, that's a perfect-world situation, and with things like street shooting you don't have those options. In those cases I lightly use Lightroom's noise reduction. Back in the Lightroom 2 days, the noise reduction seemed useless. It's as though the slider was there but a programmer forgot to turn it on. It has since been turned on and is getting better with each new version. I say "lightly" because it can still kill details, so instead of trying to eliminate it completely, I just reduce it like the term we use for it—noise reduction. I think some people want noise reduction to be noise *elimination*. Technology just isn't there yet.

Q: MR. ARIAS, I'M CURRENTLY LIVING A LOT OF THE STUFF YOU TALK ABOUT WHEN YOU WERE STARTING OUT IN YOUR CAREER: EATING A BUNCH OF CEREAL, NO CABLE, NO EATING OUT, ETC. AND EVERY TIME YOU TALK ABOUT THIS STUFF, IT MAKES ME WANT TO GO DEEPER IN THE RABBIT HOLE. IT SUCKS. IT REALLY DOES. BEING HUNGRY SUCKS, BUT I WILL HUSTLE AS MUCH AS I CAN BECAUSE THIS IS ALL I GOT. NOW TO THE QUESTION: WHAT DO YOU CHERISH THE MOST ABOUT YOUR EARLY DAYS?

 A: Good question. It's one I think about quite often.

While I have grown as a photographer—grown in skill and confidence and all that—I can look back at my work when I was scraping the bottom and see a fire in my gut. I was fighting for every pixel and every dime back then, and there's something to that in my older work. I can't place my finger on it exactly but I see it. Maybe it's an emotional thing, really. Maybe that fire isn't in the photography per se, but I see it. Maybe looking at those photos just reminds of me of those days.

I also miss the extra time I had back then. Believe it or not, I had more personal time back at the start. I mean, since I left my day job nine years ago I've never had a time where I didn't have something I needed to be working on for my career. But I had more time to hang out. I wasn't going going going all the time.

A year or so ago I was driving home and saw fellow photographer Andrew Thomas Lee having drinks outside of one of our local watering holes. He had just quit his day job and started photography full time. No-going-back sort of place. He was laughing while having drinks with friends. I realized it had been two months since I just hung out with friends. I had too much stuff going on, and by the time the house got quiet in the evening I was done. I knew then that I had to scale back a bit or do something different. I needed some more personal time.

So…you're broke. You're hungry. You're fighting for every job. But remember to take $20 and go have a drink with friends. These are good days. I look back and cherish them. This is *not* to say that I'm completely out of the woods right now. Don't read that into this. We have our tough months and periods, as well. But it's not as hard as it was. It has gotten better. There is a point where you can take a breather for a bit. Be sure to hang out with friends and family when you hit that point. I'm trying to remember that.

51–60

Small town fashionista.

Follow footballers foodchain.

The goal of personal projects.

Feeling confident enough to start selling.

How do you charge a band?

Gettin' paid in Cincinnati.

Salon owner seeks slavery.

Setting prices. The primer.

Why grid a softbox?

Artist's statements and the innocence of trees.

Q: I LIVE IN A SMALL TOWN AND WANT TO GET INTO FASHION. I TRY TO BOOK MODELS FROM MODEL MAYHEM AND THOSE OTHER SITES BUT I'M HAVING A HARD TIME FINDING PEOPLE TO COMMIT TO SHOOTS. I ALSO FEEL LIKE THERE'S SOME CREEPY STUFF ON THESE MODELING SITES. I'M ABOUT TO SIGN UP FOR A FASHION PHOTOGRAPHY WORKSHOP IN MY TOWN AND I'M THINKING I MAY BE WASTING MY TIME.

A: First, let me address this *creepy* vibe you speak of.

Name me an environment where a middle-aged man can hang out with a hot young thang and still be able to talk about it in mixed company? "Fashion photography"—that's where.

You tell me which one sounds better:

"How was your weekend?"

"Oh, it was awesome. I hung out with a bunch of other dudes taking pictures of girls we found on the internet. I mean—not the kind of girls that strip completely naked or anything, just partly naked."

Or...

"Oh, it was awesome. Some friends of mine and I got together and we shot some fashion portfolios for some local models."

Right.

"That's it, Zack. You're an asshole. I'm never reading your stuff again. You just don't understand."

Did I just convict some of you? Do some of you reading this have your tail between your legs? I know what it feels like.

I'm a hot-blooded male. I get it. Don't think that I don't. Throw some pretty light on a pretty girl and you can talk about it at church on Sunday like it's nothing? I get it.

Is this the whole of the amateur fashion industry?

Of course not. However, I've worked with models that have story upon story of GWCs (guys with cameras) who are obviously behind that camera for a cheap thrill. I've been to meet-ups where I want to walk around and say, "Pick your chin up off the ground, Grandpa." Or, "There's a light stand in your pocket. Might want to put that away." Why do so many models on these modeling sites talk about bringing an escort to a shoot? Why? Because of the creep factor.

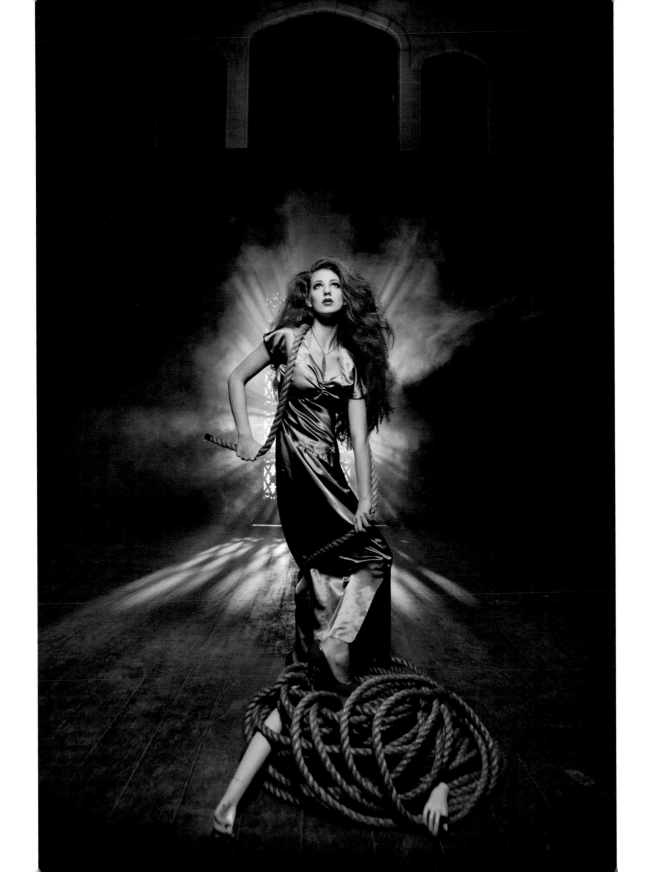

Opposite: This is from a series of personal "fashion"-based work. The full story was based around the board game Clue. This was the final image of the story. Miss Scarlet. In the ballroom. With the rope. Other images had—get this—clues. Awesome, huh? This work was never well received by folks I was trying to get work from. It hasn't seen the light of day since, until publishing this book. :: Canon 5D Mk II / 24–70mm lens @ 24mm / f4 @ 1/160th @ ISO 100 / Main light: Alien Bee 1600 with white interior 22" beauty dish. There is an Alien Bee 800 in the back lighting the smoke from a smoke machine. And one more Alien Bee 800 was on a 13' stand with a 20° grid to light the top three arches on the wall in the background.

Now then, when it comes to this type of workshop you mentioned, and about "fashion photography" as a whole, what I see a lot of is something like this:

"Welcome everyone! Thanks for coming out to my war photography workshop here in Toledo, Ohio, today. It's going to be a great day of shooting. Once the lecture is done we're going to go out in the back alley where we have some models dressed up in urban assault gear.

"The models are going to run around the alley yelling, 'Bang! Bang!' while I man the smoke machine. My first assistant will be throwing dust in the air and playing 'The Sounds of War' on his iPod. My second assistant will sneak up behind each of you at different times to yell, *'Boo!'* This is so you get a real sense of fear while we are shooting.

"While our models today haven't actually been in a war, many of them are on the night security force at the mall and they've seen some action! Phil has called the cops on two break-in attempts and Bob's friends on Xbox Live have told him he'd make an awesome soldier.

"If any of you need a bathroom break, it's down the hall to the left. There's also a cooler in the back that has some cold sodas and water for you.

"Now let's go shoot some war photos!"

Ahem. I make this analogy to illustrate a caricature of garden-variety modeling and fashion photography. Mall cops throwing rocks at each other while yelling,

"Bang!" isn't war photography. Some softboxes, a pretty girl, and short skirts isn't fashion photography. A pretty girl does not a model make. Pretty girls aren't models. Pretty girls aren't models. Ya hear me? A pretty girl—*is not a model!* Same thing goes for hot dudes.

Honestly ask yourself: You live in a city that is *not* known for fashion. You spend a lot of time taking photos of girls who *aren't* models. What do you do with these photos? What's the point?

The models might make a little money being hired by other photographers who are also *not* shooting fashion. Perhaps a few of them are picked up by a local agency for small local jobs in local magazines or for commercial shoots. But other than that—what? I know a few photographers who have built a business shooting modeling portfolios like I shoot local bands for press kits and CD artwork. I know a few photographers doing some interesting fine art projects who use local models.

There is no shortage of people in the world who have been told how pretty they are and that they should get into modeling. There is no shortage of people who play music who have been told how great they sing. There is no shortage of people who take pictures who have been told they're really good and that they should be a photographer.

If you're going to really make it in fashion—you move. You go to where fashion is: New York, Milan, Paris. If you're going to make it as a war photographer you have to go where there is war. If you have some dudes in a

back alley running around yelling, "Bang," do not for a second try to tell me you are shooting war photography. I call bullshit.

Are the dudes running around in a back alley a stunt team that performs at corporate events? And you're shooting their promotional photos? That's kind of cool. Get a smoke machine. Light them dramatically. That looks different than trying to hack together a "war" photo doesn't it? Advertising and press and promotional photos look a lot different than war photos.

Pretty girl being OMG fashiony for no reason at all? I call bullshit. Pretty girl laughing in the sunshine in an advertisement for your local power company? That's commercial. Not fashion. The power company shoot has purpose. It isn't creepy and it isn't useless.

A 42-year-old insurance salesman in a Toledo/Tulsa/Atlanta suburb has a portfolio full of 18- to 25-year-old girls in bikinis because why? Because Toledo is the bikini capital of the world? Oh wait. No, it's not. Is it because Tulsa is the mecca for new voices of the fashion world? Zac Posen can't get his private jet there fast enough? Nope. Maybe it's because a tool company is based there and they always want new calendars and posters to send to auto repair shops? That's possible.

Portraiture. Everyone needs a great portrait of themselves. Pretty people. Ugly people. Interesting people. Boring people. Fun people. Business people. Moms. Dads. Kids. Grandmas. Grandpas. Everyone needs portraits. Families want them. Magazines want them. Businesses want them. Stock companies want them.

You can take some clues from the fashion industry and shoot a portrait of a local business owner with a similar lighting setup you recently saw in *Vogue Italia*. Fashion inspires your portraiture but you aren't making bad fashion. You're making portraiture that has a little fashion flair to it. Your subjects aren't trying to be something they aren't. You're just giving them something that is very different from what they could get at the mall. Do you see the difference here?

A few years ago I started shooting some "fashion inspired" personal projects. I hired models, make-up artists, hair stylists, and wardrobe stylists—the whole shebang. I spent a lot of time, money, and resources shooting some new work that definitely had a fashion flair to it. I wasn't trying to become a fashion photographer. I just wanted to shoot some different stuff that my normal assignments didn't bring me.

I put some of this new work in my book, went to New York City for portfolio reviews and meetings, and I got my ass kicked by photo editors and art directors. I got off track with my work. I lost sight of a goal. I was beat about the head. My work *looked* like I was trying to be a fashion photographer. I was showing it to people who know fashion and my work clearly was not fashion. I cleaned out my book. Shot new work and that new work has gotten me on radars and gotten me work. I'm thankful I did that. I got it out of my system. I learned some technical things. I learned that as soon as an image of mine starts to lean towards looking like fashion, it then needs to die. I'm still inspired by fashion; I'm inspired by the lighting, or the composition, or the pose, but I take that inspiration and shoot images that don't scream "fashion."

Fashion has a role in my life. That industry lives on the edge of creativity and someone is always throwing themselves over that edge and it's interesting to watch. Sometimes it's beautiful; sometimes it's carnage; however, it's always interesting. You don't look at Model Mayhem or a local fashion meet-up group or fashion photography workshop to see what is happening in the real fashion world. You look at the publications and major blogs. They live fashion. They breathe it; they eat it; they have a damn near unhealthy relationship with it. They are the gatekeepers and purveyors of it. They are the editors.

Take the workshop. Maybe you'll learn some lighting or something. Just don't think you're about to embark on a new career in fashion photography in your small town.

Q: I'M A FOOTBALL FAN. FOOTBALL AS IN "FOOT" AND "BALL"— WHAT THE AMERICANS CALL SOCCER. I WANT TO TAKE PICTURES OF THE BEST PLAYERS, EITHER ON THE FIELD OR IN THE STUDIO, LIKE GARY LAND DOES. MESSI IN BARCELONA, IBRA IN PARIS, DOS SANTOS IN LONDON, HUMMELS IN DORTMUND. YOU GET THE POINT? HOW LONG WILL IT TAKE? WHAT PATH TO FOLLOW? WHO TO CALL?

A: Take a look at the photographers shooting the work you want to shoot right now. I would bet that there are more Starbucks employees within a ten-mile radius of you than there are photographers—in the entire world—shooting the type of work you want to shoot. Right?

Find those top shooters and study them. How'd they get to where they are? Research their paths. I'm sure you'll find several different paths but you'll find some similarities. Where did they start and what does that look like in your life at this moment?

You have to find the food chain. You're at the bottom of the food chain for this kind of work. There's a top end of that food chain you can follow backwards to where you are. Find the decision makers who hire these photographers. From photo editors at magazines to agencies working with the sponsors to the marketing departments for the teams.

You mentioned Lionel Messi in your question. What can you quickly find out about him?

1. He plays for Barcelona. (Google who does marketing and PR for them.)

2. He's the captain of the Argentina national team. (Again, Google marketing and PR for them.)

3. He's been sponsored for Adidas and Turkish Airlines. (Google who does advertising for these companies. With Adidas you may find several agencies that work with this brand. One or two may specialize in football advertising.)

4. Look at his charity involvement. He has established his own foundation dealing with education and healthcare for children. Who does the marketing and PR for his foundation? He's also a goodwill ambassador for UNICEF. Who is handling that? (Google, Google, Google.)

5. He's been involved with video games, as well. What companies are working with him? And their advertising agency is…? (More Google-ing.)

6. What are the major magazines and publications that cover football? Who are the photo editors at these magazines? (You should know what to do here by now.)

That's just Messi, and that's just what I found on his wiki page. I don't know shit about football but I now know a number of things about Lionel Messi. There are at least another dozen players you can research. As you do this research, start making a list of agencies, marketing and PR companies, as well as charities, corporate sponsors, and publications that are involved with these players. There's a food chain to be built here. You build it from the top down and work it from the bottom up.

You currently do not have access to Messi but you need a portfolio of work that could get you to Messi. You now have to find football clubs you can access. Junior leagues. Local dudes kicking a football around on the weekends. Maybe some school teams. Find good-looking, character-filled players who love the sport and start building your portfolio with them. Treat those shoots as though you are shooting Messi himself.

Lastly, what can you bring that's different than the other shooters doing this work? Don't ever look at someone's shot and say, "I know how to shoot like that." So what? 1,000 people know how to shoot like that. 1,000 people aren't shooting that shot, though. You need a unique point of view. You need a unique perspective. Bring something just a little different to the table of these decision makers. Not only with your book, but also with who you are as a person. How are you different enough to get the job? To be noticed?

It's tough stuff. It's a lot of hard damn work. Ask Gary. His email is on his site. Maybe he would respond. Maybe he wouldn't. I don't know Gary but he sure does have some great work. He also likes to kick around his studio and build shit for fun. Go through his blog. Get to know him. Reach out to him. Who knows, maybe he'll get back to you. Maybe he can put a few links in that food chain for you. It's worth the try. He's probably going to hate me now. Please do not say, "Zack Arias told me to email you."

Q: WHEN YOU DO A PERSONAL PROJECT, DO YOU JUST DO A BLOG POST AND IF SOMEONE, SUCH AS A GALLERY, MAGAZINE, WEB SITE, ETC., SEES IT AND WANTS TO SHOW IT THEN GREAT, AND IF NOT, NO SWEAT, AS IT WAS JUST YOU SHOOTING WHAT YOU WANTED? ESSENTIALLY, IS THERE A GOAL WITH PERSONAL PROJECTS OTHER THAN JUST PHOTOGRAPHS?

A: There are typically several goals I have when doing personal projects. Some of the goals are personal. Some are related to business. The overarching goals of a personal project are:

- To hone my skills.
- To photograph a subject or topic that I'm not being hired to photograph.
- To promote myself as a photographer to be hired for other projects.

When sending a promotional mailer or setting up a second meeting with someone, I want new work to show. No reason to keep promoting the exact same set of images. Sometimes a mailer can go out showing a bunch of new assignment work. Or a mailer can go out announcing a new personal project. A lot of editors and art directors will, at times, specifically ask to see your personal work. That shows more of who you are as a photographer than the assignments you shoot. Your hope is that people will get excited about your personal work and hire you to shoot something similar.

At the end of the day, though, you're doing personal work because it's personal, even though there are business aspects to it. You'd shoot it whether anyone ever sees it or not. Look at the gorgeous work of Vivian Maier. She shot for the love of shooting.

 Q: HOW LONG DID IT TAKE FOR YOU TO FEEL CONFIDENT ENOUGH IN YOUR WORK TO SELL IT TO OTHERS? I'VE BEEN INVITED TO LIMITED ART SHOWINGS, AND NOW EVEN HAVE A REGULAR FLOW OF LOCAL CELEBRITIES WANTING TO SHOOT WITH ME. THIS IS SOMETHING I LOVE, BUT I'M NEVER CONFIDENT THAT MY WORK IS WORTH SELLING. HOW DID YOU MAKE THE LEAP?

A: How did I make the leap? Like this…

Nine years ago I basically did this. That capsule was a day job. The earth was photography. My day job was taking me further and further away from what I really wanted.

When Felix Baumgartner opened that capsule door there wasn't any going back. No one was going to pick his ass up. There was no ladder to climb down. His only safety net was strapped to his back. He either jumped, and maybe died, or stayed in his capsule and definitely died. Jump for glory or hang on to temporary security. There was nothing in between.

When I quit my job I was in a bad marriage and had one child at that time. When I quit, the only thing I had to fall back on was going back to my hourly day job. Note that I didn't quit a "career" job. I was making an hourly wage doing a job anyone could walk in off the street to do. My work experience is cashier, barista, temp worker, rental car agent, and copy machine runner.

I had to make photography happen. Confidence or not—I had to jump! And jump I did. I had a safety net of my last paycheck and the idea that if the photography thing didn't work out I could go find some other $8 an hour job. I was living in a crap apartment. I was driving a crap car. My son was in a crap day care. If one little thing went wrong I was screwed or I was asking my mom for a set of tires. You know how much it sucks being 30 years old and asking your mom for a set of tires? Know how much that sucks? I couldn't get a credit card because I had horrible credit.

So, I jumped. I had to make it work. That's how I did it. Not saying that's what you should do. I don't know your position in life. I don't know the responsibilities on your shoulders. I *had* to sell it no matter what level of confidence I had. I knew I could shoot. I knew I could come through. I had a solid foundation of technical ability under my belt when I jumped. When Felix jumped, it wasn't his first rodeo but that was *the* jump of his life. After all his training and preparations he was hoping it would all go well. And—it did. One little thing going wrong could have killed him, though. Luckily, my life isn't in that delicate of a balance!

You have a day job. Your spouse has a day job. Bills are basically covered. You hate your job; you dream of being a photographer, but you like the security of the check. You dream of jumping but you don't think you can actually do it and so you beat yourself up. You think your work is crap; you compare yourself to others; you think you need just one more year at the day job and *then* you'll be ready. You said that five years ago.

Look, if you want to jump you just have to jump. You may go *splat* very quickly. Felix couldn't tip toe his way back to earth. He couldn't pull over for a rest if it got too intense. There was no one in that capsule to put a boot to his ass when it was time to jump. He had a coach on the phone and a bunch of people on Earth cheering him on, but that jump? That was all his. Yes, he had training. Yes, he had practice jumps. Blah. Blah. Blah. We all have some sort of training before we make the big jump. You don't buy a camera at Best Buy and call your boss to let them know you quit before you're even out of the parking lot.

Your jump? That's all on you.

Here's what I've learned: If you wait until you're ready you'll never get anything done because you won't ever be ready. "I just need to get my book ready then I'll start a promo campaign." Newsflash: You aren't ever going to be completely happy with your book. You'll want to keep working on it and never get anything out into the world. "As soon as my web site is where I want it, then I'll promote it." It ain't ever going to be ready. "As soon as I have this or that or the other thing then I'll do this or that or the other thing."

Sometimes you just have to take what you have, stick a price tag on it, and jump your ass out into the world and figure it out from there.

That advice will *never* get you a loan from a bank. You know that, right? There are a lot of business teachers cringing at this answer to your question. I get that. I do. I know.

A: It's impossible for me to tell you, in black and white terms, how to charge a band. What I can do is share my story of working with bands and how I came up with pricing. You can read this and then sort of figure out how much of it would work for you and what would not work for you.

The very first call I got for press kit photos came from this girl named Meghan Coffee. She was a local Atlanta singer/songwriter and needed some portraits shot for her press kit. She asked how much it would cost; I told her I'd call her back. I tallied up my utility bills and it came out to something like $347. I called her back and told her $350 for the day of shooting. She hired me. I paid my bills. True story.

I also married that girl some years later. :) True story. Now I pay *her* bills. Nudge nudge. Wink wink.

Anyway….

When I was starting I knew that I needed to have a better pricing model than adding up utility bills every time my phone rang. I did a lot of research and found a lot of photographers working in the music industry had pricing for signed bands and pricing for unsigned bands. I personally wanted to have one price. If a label were to call I could quote my rate. If an unsigned band called I could still quote the rate but have a lower option for them.

Here's how I figured it when I got started. I figured out I needed to make $100 an hour and work X number of billable hours a month to break even. I figured a full day of shooting would be at least 10 hours of work so I made a day rate of $1,000. Label calls. What's my rate? $1,000 a day. Done. How about the local bands with smaller budgets?

I cut my day rate up. I had a half-day at $500 and a quarter day at $250. I would still charge $1,000 a day on the invoice but under the "quantity" column I put 0.25. I knew that I couldn't stay at $250 a band forever. I'd eventually like to get out of the shit hole apartment I was living in. I'd want to upgrade my son's day care. My old beater car would eventually need to be replaced. I'd need to increase my rates over time so I started dealing with that at the start.

Band calls and asks about my rate. I quote $1,000. They choke. I then let them know about quarter-day and half-day options. They resuscitate themselves.

My first press kit shoot. Meghan Coffee (now Meghan ARIAS!). :: Nikon D100 / 35mm /
f2.8 @ 1/160th @ ISO 320 / Available light.

I book them for $250. That's a three hour-ish shoot at one or two locations with 50 or so final images. Half day is a five-hour-ish shoot with an extra location and more photos. Full day is as much as we can make in a day. Band calls me later in life for a shoot. I quote $1,000. Even. Remember back then? $1,000 a day. Maybe my quarter-day would now be removed. I didn't know; I just wanted to come up with some sort of a future plan for dealing with higher rates later in my career from returning customers.

Needless to say I was hired for $250 shoots far more than anything else. I worked that plan for two years and built a business from it. I was also second shooting weddings with my friend Marc Climie. He was paying

me $800+ a wedding. (Note that $800+ for second shooting weddings is not industry standard. Marc took very good care of me when I was shooting weddings with him.) I picked up other gigs, as well, here and there. Shot some shampoo bottles once for $1,500. Got that rate simply by asking.

"What's your budget?"

"$1,500."

"Okay. I can do that."

So bands, weddings, family portraits, shampoo bottles, corporate events, headshots—all piled in to pay my

bills. I started concentrating on music more and more and more. I enjoyed that the most. I wanted more of that and less of everything else. I got really busy with $250 shoots. So much so that I was sort of becoming an Olan Mills for local bands. I was so busy with bands I was getting burned out. I needed to keep the same amount of money coming in but I needed to do so with fewer shoots. I had no idea where to go from there.

Enter my knight in shining armor. A guy named Michael Weeman took me to lunch one day and offered to start managing me. He was the head of the regional BMI (Broadcast Music, Inc.) office and was leaving there to manage four music producers; he wanted to add me to his roster. He saw me busting my ass and knew I wasn't charging enough. My problem was I could not ask for more than $250. I felt that was my ceiling. I didn't have the confidence to ask for more even though I was just barely squeaking by financially. If a main piece of gear went down, I was screwed. I had nothing in reserves. I was flying by the seat of my pants on every job. My main gear sucked to some extent. My backup gear was even worse. It's what I had to work with; you do what you can with what you have.

Weeman took over booking. Anyone who wanted to hire me went through him. He got 20% of whatever he booked. If I had low rates and wasn't making money then he wasn't making money. He immediately changed my pricing to $350 for a quarter-day, $650 for a half-day, and $1,100 for a full day. I was a bit skeptical but I stayed as busy as I ever had been. I had fewer things to deal with, as he was taking care of phone calls, emails, and booking. That was all sorts of awesome.

Within 90 days he bumped me to $450 for a quarter-day, $850 for a half-day, and $1,200 for a full day. I was scared to death now. I never booked half-days at $500. Ever. I booked a full day every now and then but that was rare. I thought this was going to be the end of me. To my surprise I didn't slow down a bit. I was just

as busy at $450 as I was at $250 but I didn't have to deal with booking clients, and I was now making more money. I was able to upgrade a few things here and there and got a better space to work out of. I was still shooting weddings and anything else that came in, which helped with the burnout problem I was dealing with. My stress levels were falling a little.

Then—one day—Weeman calls.

He asked me to pull up Google Cal and look over the schedule. He had just booked a half-day for me for the following Tuesday. While I was on the phone with him I started looking over the last 30 days and realized that for the past month I had only shot half-day rates of $850 or more. It had been over a month since I shot a quarter-day. I couldn't believe it. I made a comment to this effect to Weeman. He replied, "You know why you are only shooting half-days? Because I stopped offering your quarter-day rate over a month ago. If someone wants to work with you, it's half-day or up from here on out."

I nearly had a heart attack. *What???* Quarter-day rates were my bread and butter. It's how I lived. I thought he was messing with me.

He wasn't. I was $850 and up from that point on. I never went back to quarter-day rates except for special circumstances, or for clients who brought me a lot of work on a regular basis.

The point here is I couldn't get my rates beyond $250. I didn't have the confidence. I didn't think it was possible. I didn't think that was an achievable goal. Before the music industry completely collapsed I was regularly getting $1,200 and up for shoots with unsigned bands. Then the bottom fell out. I didn't backslide all the way back but I have brought rates down for unsigned artists. Nothing like my quarter-day packages of old but back to half-days and up. Plus digital capture fees, an assistant where needed, HMU, etc. Total invoices creep back over $1,200.

[rabbit trail]

Weeman didn't know an f-stop from a bus stop. He didn't know a thing about lighting. Or cameras. Or Photoshop. He didn't have to. He wasn't shooting for me. He wasn't assisting me. He wasn't dealing with a single photographic thing. He was dealing with business; I dealt with the photography. I've had others come in and help me. Sherri Innis was a huge help to me. She started with me as an assistant but loved the numbers and took over the business side of things for a while. The point is: You may have someone close to you that doesn't know shit about photography but they love business. They also like making a commission. This can be a friend. A co-worker you currently have. A family member.

"Hey, you're organized and good with numbers. I'm not. If you book work for me and I pay you a commission would you be interested in doing that?"

[/rabbit trail]

When I was priced at $250 I had two kids and a cheap place to live and a beater car and beater gear. My life has changed a lot since then. I'm in a happy marriage with four kids to feed now. I live in a better neighborhood so we can be in better schools. Nicer car. Nothing fancy. 2005 Scion xB—but it's paid for. There aren't any car payments in my household, no furniture payments, and it is cash and carry on all my gear. Gear has gotten a lot better since then. I'm more experienced now and have more to offer; I can get more done and my rates reflect that. Can't book everyone but I can't handle booking everyone.

So. That's a simple history of the last 10 years of my life as it concerns pricing. Pricing is part science. Part art. Lots of negotiations. Some success. Lots of failure. You learn a lot as you go on. You'll quote a job and then get in the middle of it and realize you are losing money based on all the work you are doing for that particular job. You'll say to yourself, "If I get a job like this

again I'm going to quote it a lot differently." Some jobs you do, and deliver, and get the check, and you say, "Yeah. That was a great job. Great client. I didn't lose my shirt on that either. That was the right price for the gig. I'll stick with that. Didn't break their bank. Didn't break my back. Win–Win."

Every job these days is different for me. It's not as cut and dry as it once was when I was just shooting local bands. I get everything from editorial to corporate to advertising. Different needs. Different crews. Different logistics. Different usages. Different budgets.

I'm on the Wonderful Machine roster and I use them to help me navigate waters of pricing that I haven't been down before. I pay them a consulting fee and they deal with the bids and negotiations. I pay that fee whether I get the job or not. It's worth it to me because they have more experience than I do on some things I run into. I also get to watch their process and it's an educational experience for me doing so. Well worth the price for the service they offer.

So, I hope that answered your question well. If you want you can also take a look at "Salon Owner Seeks Slavery" ahead in this section.

P.S. This whole quarter-, half-, and full day thing is *not* industry standard. In fact, it is kind of the wrong way to do things. It worked for me and has failed a lot for others. PPA and others will never advise you to go this route. I'm not really advising you to go this route. I pulled this out of my ass and made it work. I sort of do that a lot. It frustrates peers in the industry and people around me at times. Heck, it frustrates me at times.

Flying by the seat of your pants is fun but stressful, as well. I'm just telling my story. Proceed with caution. Don't try this at home. Get sound legal advice. Not applicable in Puerto Rico, Hawaii, and Alaska. Void where prohibited. Effing go for it!!! :)

Q: WHAT CAN I DO TO GET TRUE PAID WORK AS A PORTRAIT PHOTOGRAPHER? I'M IN CINCINNATI AND I KNOW YOU HAVE NO CLUE WHAT THE MARKET IS LIKE HERE AS OPPOSED TO ATLANTA, BUT I JUST MEAN FROM THE PERSPECTIVE OF A PHOTOGRAPHER TRULY TRYING TO MAKE A CAREER OUT OF THIS ART FORM WE LOVE.

A: Scratching head.

I can't answer this other than to say that you have to get up off your couch and go out into your world and meet people. And meet more people. And get "connected."

You have to be able to communicate *what* you do and *how* you do it and *who* you do it for and *where* you do it and *how much* it costs for you to do it. You know—like a prostitute. That theme has popped up before, but it got me quoted on APhotoEditor.com so I'm going to keep running with it.

You have to turn your love of photography into a business that isn't any different from running a dry cleaning place, or being a landscaper, or a CPA, or dentist, or whatever. You have to set up shop, open for business, and do what you do. This isn't saying you need a physical location like a studio. You get what I'm saying.

I'm sure dentists are glad that they never have to say, "Boy, *everyone* is a dentist these days," but I'm positive they have their industry issues.

"Anyone with a calculator these days thinks they're an accountant!"

"Someone gets a washer and dryer and now they think they're a laundromat!"

"Anyone with a hammer these days just thinks they are a house builder. Business sucks for me right now."

"Ever since IKEA started selling pots and pans, there are dozens of new restaurants popping up everywhere and taking all of my customers!"

Yeah. Those folks don't say that. Photographers do. And it's sort of true and it's sort of false. A camera does not a photographer make, but there are enough folks out there who think that it does, and it's whacking away at our business. So you have to be smarter than them. You have to be more agile. You have to be more skillful. You have to be more talented. You have to market better. You have to find different clients. You have to move up the food chain and get off the bottom.

True paid work? Put a price tag on it. Find people who want to hire you. I know that answer is like:

How to climb the mountain? Go up. Left foot. Right foot. Climb. Have fun! Don't die!

In reality that is the reality. In learning to climb a mountain you have to learn technique. You have to have X amount of gear. You need to attain a certain amount of fitness and strength. A high level of it, I guess you'd say. You start with hills and then tackle small mountains. You have to learn to breathe in thinner air. You have to be able to climb when your body is screaming to shut down. There's a ton of training involved here, but at the end of the day, when you have trained, when you have gathered your gear, you go up. Left foot. Right foot. Climb. Don't die!

Let me rant for a minute.

A person just entering this industry hasn't a clue as to how deep this rabbit hole goes. They take some photos. They get the background out of focus for the first time. Their friends and family think they are *OMG Awesomez!* Family and friends post on their Facebook wall, "You take such good photos! You should be a photographer!" This new photographer hates their day job. They are unfulfilled in some part of their life. They've always wanted to be "creative" but couldn't draw or paint or play music but they can get some *OMG Bokeh* with their new camera!

This person makes $100 a day at their shitty day job and thinks that shooting one wedding for $1,500 is fifteen times more money in a day of work than what they make now. How is that *not* awesome? "I could be a photographer!" they exclaim. People do this for money. Real money! And then they could hang out in coffee shops and Twitter with the cool kids all day. They see folks like me bitching and moaning that I have to get on yet another airplane. Oh poor me. Poor Zack having to travel around the world. "Let me cry for you, Zack." They sit in a cubicle all day.

You don't need a license to be a photographer. You don't need a degree. You don't need anything really, other than a half-ass decent camera and a lens.

So-and-so did it. That person did it. This person over here did it and has 50,000 followers on Twitter. They're famous; they must be rich; they travel the world. I bet they fart rainbows in the morning.

What a fantastic f*cking life it must be to be a professional photographer! Off they go with Aperture Priority and stars in their eyes and blur in the background and zero freaking business knowledge! Wheeeeeeeeeeeeee!!!!

I can't tell you how many scores and scores and scores of people I've met in this spot. Hell—I was there. We all were. But there they go, skipping and smiling and singing songs of love through the field of sunflowers, and trust me—mark my words—they'll hit their foot at the edge of this rabbit hole and down, down, down they go. Everyone hits the rabbit hole.

Some go down in flames. Some come scrambling out of that hole as fast as they fell in it. Off they go to do something else. Some, very few may I say, stay down there and want to see how far it goes. Those people figure out how to navigate the waters of doing this. Those folks who go deep into photography figure it out. These folks are hungry, and they have a fire in their gut that only photography can keep fed. For most, though, the rabbit hole isn't as pretty as they thought it would be.

It's so much work. It's hard. It takes a toll on you. I swear to you that "day jobs" are far, far, far easier than being a full time photographer in this market right now. Photography calls many and chooses few. A photo product company recently sent me an email saying they were looking for a marketing person. They asked if I could spread the word to help them find someone to fill the position. I looked at the job description. I fit that job description perfectly. I'm the person who could do that job. I showed it to Meg and I told her that I was considering applying for it. She thought I was crazy. Do you know how awesome it would be to have a day job again? To have some stability in my schedule? To have a job description made up for me so that I could just

connect pre-determined dots all day? I sat on that for three days. I know a guy who did a similar sort of thing. He found a perfect balance of having a secure gig and it has allowed him time to just shoot his own personal projects. He looks far more relaxed than I do.

So you love this art form. You can still love it without attaching dolla dolla billz y'all. To turn it from a love of the art to a business that sustains you sometimes requires you to throw that love out the window and just do what you have to do to survive. Some days you are more of a technician than you are an artist. Some days it's for the money and not for the love. Then you have to do taxes! And come up with new marketing ideas. And sit for hours on end doing post-production. And deal with countless emails and phone calls. Ten percent or less of what you are asking to do here will be taking photographs.

You have to love what you do—the good and the bad. You have to go make your own paycheck. No one gives you the desk, the phone, the computer, and the regular schedule to get stuff done. You have to do all that yourself. I sometimes tell folks who want to quit their day job that they'll be trading it for a day *and* night job.

There's great satisfaction in all of it, though, and you have to find that satisfaction in the struggle. When your body is screaming to shut down and you're only halfway up the mountain, you have to keep going. You have to find satisfaction and joy in the pain and the suffering it takes to get you to the top. And by "the top" I mean just being able to regularly pay your bills with a camera. Not be Terry Richardson or something. Just being a regular full time photographer is sometimes the best thing we can achieve. Just doing that is "the top."

Those who make it in this industry have tenacity.

te•nac•ity (noun):

- the quality or fact of being able to grip something firmly; grip
- the quality or fact of being very determined; determination
- the quality or fact of continuing to exist; persistence

Do you have tenacity? Can you go ahead and fling yourself down the rabbit hole and see how far this thing will go? Is your family ready to go down that hole with you? Are you ready to kiss the security of a regular paycheck and benefits goodbye to go after it?

True paid work? Put a price on it. Go after it with everything you have. Chances are it's going to fail, but who cares? Go out trying. If it does fail, then take a step back, refocus, and try again.

If you have this tenacity then go up. Left foot. Right foot. Don't die.

VISUAL INTERMISSION

JANET

Some days I don't know if I have chosen to be a photographer because of the photographs I want to make or because the camera simply introduces me to people and places I would otherwise never meet, see, and experience. The photographs are what I'll leave when I die. The experiences are what I'll keep. When I breathe my last, I'm not entirely sure which will have more value to me.

Self-assignments are great things to do on a regular basis. Maybe you can spend an entire afternoon photographing reflections, or you only photograph the color blue for a week. Fellow photographer and educator Chris Hurtt talks about this kind of stuff a lot, and he inspired me to do more self-assignment work.

During a trip to NYC I gave myself an assignment to photograph 10 strangers in 10 hours. I stopped in a Starbucks for a break and noticed a woman sitting by

Starbucks. As I shot, she started telling me stories. I must have spent close to half an hour with her. She gave me her address, and I mailed her about a dozen copies of the photos I had taken. I wanted to make sure she had copies, as did her family. You know why, right? Yeah.

Being a photographer is such a rewarding hobby/craft/job *if* you get out into the world and let it loose. Let it open some doors for you. You never know what might happen. You may just make something happen for someone that hasn't happened for them in decades. It's rewarding for you and for those you meet.

Canon 5D Mk II / 35mm /
f2 @ 1/800th @ ISO 800 /
Available light.

Q: THE OWNER OF A SALON WANTS ME TO TAKE PHOTOS AND THEN GIVE HIM MY FILES SO HE CAN BLOW THEM UP AND HANG THEM IN THE SALON. HE HASN'T MENTIONED PAYING ME. HOW SHOULD I INVOICE HIM? ALSO, SHOULD I HANDLE THE PRINTING ON MY END, OR SHOULD I GIVE HIM THE FILES?

A: Here's where photography is like prostitution, at least the kind I've seen in movies:

"Like what you see?" If so, then you talk money.

If you want to get paid you bring that up as soon as there is *interest*.

"I'd love to do this job for you! What's your budget?"

That gets the topic right to the front of the conversation. There's no getting around that question. They may ask how much it would cost. That puts the ball back in your court. The best way to approach that is to start asking more questions. How many people will need to be photographed? Will they be booking the models for this or will you? Can the shoot happen in the salon or do you need to find another place to shoot? How soon do they need it? Do they have a lab to make the prints or will you need to handle that for them? Are they going to want to use these on their web site and social media pages? What kind of look are they going for? Are you going to need to rent gear or get an assistant for this? Do they want this to be an ongoing project or just a one-day shoot? Who will be doing the make-up? What about wardrobe?

When you start the barrage of questions you show that you are knowledgeable about what you do, and you will most likely bring up a lot of things they don't even know they need to think about. Sometimes folks just think, "Come take photos and put prints on the walls."

Those are only two steps out of a process. Take pictures. Put them on wall. You and I both know there's a lot more to the process than that.

1. Negotiate rate and deposit.

2. Invoice for deposit.

3. Schedule time.

4. Find models.

5. Schedule models.

6. Re-schedule shoot based on availability of models.

7. Find hair and make-up.

8. Book hair and make-up. (Well, make-up at least for this job.)

9. Find photo assistant.

10. Book photo assistant.

11. Coordinate space to shoot. (Furniture may need to be moved and rearranged if shooting there. Off-site place might need to be booked.)

12. Clean gear. Charge batteries.

13. Pick up rentals if needed.

14. Arrive for shoot.

15. Do shoot.

16. Re-set furniture in salon.

17. Pack up and go home.

18. Return rentals.

19. Post-production.

20. Work with client on edits.

21. Order test prints.

22. Get prints approved.

23. Order final prints.

24. Invoice for final payment.

25. Arrange for framing.

26. Hang prints on wall.

27. Deliver final images to client, models, make-up artist.

I'm sure I'm leaving stuff out. In these 27 basic steps notice how "Do shoot" is number 15.

So, the salon owner wants you to do a shoot (#15) to put prints on the wall (#26). And this is all for free? I mean, I am all for doing free work as you get started, but I'm also for educating yourself and your client about how much work this is actually going to be. As you start talking to them about the process they see that this is going to be more work. Not just for you, but for them, too.

You need to have that discussion at the start. Don't roll over in bed and then wonder how to get paid after you just got screwed. I know. I'm crass. But it sort of drives the point home, so to speak. :)

If they want this for free, and it's the sort of thing you'd like to take on, then you hand much of that list over to them. They find the models. They schedule the make-up. They rearrange the furniture to accommodate your needs. They pay for rentals. They pay for the assistant. They pay for printing. They pay for framing. They hang them on the wall. They deliver the final images to the models and make-up artist because they booked them.

You are responsible for picking up the rental gear, finding the assistant, doing the shoot and post-production. You can order the prints for them or let them take care of all of that. If you do it add some to the print price. If you can get a 20x30 for $50 then charge them $100 for the print. Make something for your time. Or get 10 free haircuts. Get something. They get something of value for having the prints hanging on the wall. You should get something, too, aside from experience.

If they say they have the budget of, let's say $500 for the whole thing, find out what size prints they want and how many they want. Find out how much that will cost for printing. Subtract that from $500. Let's say you have $250 left over. You need $75 in rental gear. That's $175 left over. Count up how many steps above you will need to take care of for them. Let's say you have to do 12 of them. Any 12 of those can take an hour of your time each (not counting the shoot time). Let's say you shoot for six hours. 18 hours into this project for $175. Oh! Post-production! Let's say four hours for that. Dealing with the printing will be a minimum of two hours. 24 hours of work for $175.

(maths, maths, maths)

That's about $7 an hour you'll be working for.

Yes. I know. How about gas, and insurance, and gear depreciation, and food, and on and on. Start to figure *all* of your costs into this and you're probably around $3 or $4 an hour.

Oh wait!!! $50 for a roll of seamless? Damn. Now you're down to $2 or $3 an hour after you put in all of your expenses that aren't at the surface.

You can do better than that at McDonald's. You can deliver pizza two nights a week and make more money.

Armed with the knowledge of how much goes into a shoot like this; how much time you're going to spend; how much money everything will cost you—having this knowledge lets you look your client dead in the eye and say, "It's going to cost $2,000."

What??? $2,000???

Yep. You have to do this, this, this, this, this, this, and this (x20). You'll be spending about X hours on the job. To do it—and really do it right—you'll want XYZ gear. You'll need an assistant to help you, because, you know, you don't want to put some crap photos on their wall. You want to be professional. They wouldn't use bad products on their client's hair, right? Pick up a bottle of their shampoo. It's probably expensive. You could go to the drug store and get a bottle of shampoo for $3 compared to their $20 shampoo. Why should anyone pay more? They'll tell you why. You'll tell them why they need to pay you $2,000.

Until you work with experienced photo editors and art directors and the like, you'll be working with folks who don't understand everything we do. They don't see all the work behind the scenes. They just see "shoot photos" and "put photos on the wall." It's your job to educate them. Do it nicely. Be respectful. Don't mock them for offering you a low-ball estimate. Don't think they are stupid. They are ignorant. They just don't know.

So take their $500 budget. That's *your* fee. Type up an estimate:

Photography fee	$500
Assistant	$175
Make-up artist	$250
Post-production & retouching	$150
Seamless	$75
Rental	$100
Printing	$350
Total	**$1,600**

Now then. I padded these numbers a bit. Not over the top. Not "real world" in some cases. But notice where I took care of some of your other expenses so you aren't completely losing your shirt here:

- $500 for your fee. Flat. Done.
- $175 for an assistant. You take your time to find and train someone. You'll have paperwork to deal with at the end of the year in some cases. You pay them $125. (+$50)
- $250 for make-up. Hire at $200. (+$50)
- Post-production. This is on top of shooting. (+$150)
- Seamless. Added $25 here and $25 extra on top of rentals.
- Added $100 to the prints.

(maths, maths, maths)

That's $900 to you now. Your basic hourly rate is now $37.50. You want to work for $37 an hour or $3 an hour? Which rate will you actually be able to live on? And raise a family? And pay your rent? And feed yourself? And get that new camera body you need? And fix that lens that broke last week? And update your computer in eight months? And put a new set of tires on

the car? And maybe let you put some money away for retirement? And maybe take a bit of a vacation? And pay your taxes? Can you do all that shit for $3 an hour? No. You can't do any of it for $3 an hour. Suddenly your rate should be north of $50 an hour. You're still not making enough on this. However, now you know. You see the numbers. You break it down.

I typically pay my assistants and other crew the face value of what I charge to the client. I typically charge what I need. If I can get $250 for an assistant then I pay the assistant $250. If I'm close to losing my shirt on the quote then I may pad a tiny bit into expenses. It takes time for me to find my crew. It takes time for me to train them. I take them to lunch after the job. I cover their parking. I deal with their invoices. I write out their checks. I deal with the IRS paperwork. That stuff takes time. So, I can sleep at night when I charge one rate for their work and not pay that full rate back to them. If I make the rate I need to make, and I can pass that full rate on to the crew, then I do so. It's a personal choice. Some have gotten into heated discussions around this topic.

When you see the numbers you can go forth with confidence to ask for the rate that you need to make. You can educate your customers. Suddenly Bob Jack down the street with a DSLR and zero effing knowledge looks like a complete hack. Why do they want a hack doing this job for them? They want this done—and done right. They better find the money to pay you. It happens. Trust me. It happens.

I've lost a great number of jobs to "friends with a camera" only to have those folks come back to me and pay what I ask because their friend who had a nice camera had no clue what to do with it.

When you show the value of what you do, folks find the money.

Right? You find the value in that new camera body. You can't get a D4 for $500. It ain't gonna happen. You have to find the money to get that camera. Nikon isn't going to hand them out. $1,500 for new lights. $2,000 for a new computer. $800 for a new RAID. $1,100 for a new lens. $500 in Pocket Wizards. $1,200 a month for rent. $400 for new tires. Shit adds up. Charge accordingly.

P.S. You don't "blow up" pictures unless they suck and need to be blown up. The client wants "enlargements made" of the photographs to hang up in the salon. #PhotographySpeak :)

Q: HOW DO I SET PRICES THAT CAN BOTH COVER THE COSTS OF RUNNING MY PORTRAIT BUSINESS *AND* MAKE PEOPLE WANT TO INVEST, ALL THE WHILE MAINTAINING SOME KIND OF INTEGRITY? ON ONE HAND, I'VE GOT THE EDUCATION AND TRAINING, AND I'M PAYING TAXES/INSURANCE/BUYING LEGIT SOFTWARE. YAY ME! BUT I'VE GOT TO CLEAR AT *LEAST* $800 PER SESSION JUST TO COVER ALL COSTS *AND* FEED THE KIDS. IT SEEMS THAT EVERYONE IS DOING THIS FOR CHEAP AND HANDING OVER A DISK OF WAY TOO MANY IMAGES. HOW DO I SET MYSELF APART?

A: It's good that you know your base price. Let's talk about getting to that point first. Then I'll get directly to your question.

The basic pricing guideline goes like this: How much money do you need to make every month just to survive? Divide that by how many shoots you honestly think you can shoot. That equals bare-bones minimum no-profit pricing.

Let's say you need to make $5,000 each month to just stay alive. This is rent, food, gas, car payments, car insurance, cell phone, cable, Starbucks, child support, utilities, lens caps, web hosting, clothing, dinner out, medical costs, credit card payments, school loans, so forth and so on. Five grand. Each and every month just to live.

If you can do 10 jobs a month then minimum, minimum, minimum you need $500 per job. Period. End of story. If you shoot 10 jobs for $400 a job then you will be $1,000 short at the end of the month. No more lens caps for you! Nor food. Or gas. Note that you haven't paid taxes yet. You haven't put any money away in savings or any money aside for gear. You will break even with 10 shoots at $500 each. You have to do this every single month. You'll have some good months and make $7,000. Then you'll have months that you make $3,000. That's a cash flow issue! And that sucks as a self-employed person!

So you have to make $5,000 a month. The first and easiest thing to do is cut your expenses. Sell your car. Move to a cheaper place. Cut out Starbucks and eating out. Maybe you can get that down to $4,000 a month. That's a big chunk of stress out of your life.

Let's say you're at $4,000 a month now and you're shooting weddings. Let's say you charge $1,500 a wedding. You have to shoot three weddings a month to hit your $4,000 mark. Every month. You most likely can't shoot three each and every month. Maybe some months you have four or five. Some months you have zero.

Cash flow! Fun! Your prices suck, don't they? You're gonna have a hard damn time staying alive.

Do this. Go to the National Press Photographers Association (NPPA) Cost of Doing Business Calculator (https://nppa.org/calculator). Plug in your numbers. See what happens. You're going to choke at the money you have to charge to live.

It's simple math when you get down to it. You need to make X amount of money. You can only shoot for X number of days per month. You need to make X amount on each job.

X x X = X. See? Easy! :)

To the original question. "How do I set myself apart?"

Ahhh. Here's where math isn't as helpful. You've run your numbers. You know you need $800 per session. I'd ask if you have cut your expenses as much as possible. I'm going to assume so since you come to the table already knowing your numbers.

We covered the science part of the pricing. Now here comes the art of it. Marketing. Networking. Value. *Perceived* value. Client base. This is where the waters get murky; this is where answers are more difficult. I want to say it should be your talent as a photographer that gets you to a good place in this situation but we all know mediocre photographers running a good business. At the end of the day, that's what this all is— a business. How does the Mercedes dealership stay in business surrounded by a bunch of Toyota dealerships?

You're going to have to push harder; you're going to have to find clients who don't want the cheaper alternative. Your work needs to be stellar and your customer service needs to be awesome. The entire experience of working with you needs to be fantastic.

It's tough. It's stressful. This is what new photographers don't see. They don't run real numbers. They don't pay real bills sometimes. Maybe their spouse works and pays the rent. They just have to make up the difference. Those aren't real situations. Run your business as though you had to pay for everything on your own and you'll start to see how effing hard this is.

It ain't a walk in the park. It's not a dance through a sun-drenched field of flowers and lollipops. It's hard. Effing. Work.

You have to put some blinders on. Don't look at all the cheap photographers cutting you off at the knees. You've run your numbers so you're already a step ahead of them. Keep your head down. Keep an eye on what you need from this career and go find it. You have to market more and you have to shoot better. You have to be able to deliver something that no one else in your area can.

Get this: Your prices have to be at a point that you can't afford to hire yourself and you have to have the confidence to ask for those prices.

I once saw a lady shooting portraits of a little girl at a roadside pumpkin patch. She had that "blogger photographer" look. You know the look. Designer jeans. Designer camera bag. She even had some awful looking bedazzled "designer" camera strap. Had the cute little fedora hat. Scarf. All put together. I can close my eyes and see her blog template already. Cool, hip, trendy blogographer.

5D Mk'something. 85mm 1.2 and a 580EX on the hotshoe. I was sitting at a red light watching her. She was in gorgeous light. I'll give her that. The light was awesome—until the 580 fired. *OMG*. Straight from the hotshoe. I saw the little girl's shadow all over the pumpkins behind her. Vertical shooting. Holding the lens wrong. Not using the vertical grip release. Pinky in the air. *OMG!!!*

The little girl's mom was standing nearby with her hand to her mouth. So obviously proud of her little girl in her fall dress sitting on a pumpkin like a little angel. I had my hand to my mouth, too. Trying not to yell something at the photographer.

"Turn off your flash! Your light is perfect as is! *WTF* are you doing designer camera bag lady? *WTF? You idiot!*"

I'm such an asshole. I didn't yell that but I wanted to. I wanted to stage an intervention. I wanted to go Gordon Ramsay on her ass right then and there.

There's that lady. Designer everything. 1.2 glass. Canon body. Taking photos for the mom. God only knows what she is charging. How she is charging. If she is charging. How many shoots she f*cks up with on-camera flash. Who knows? There she is. Doing it. Living the dream.

So is that your competition? Is she responsible for taking you down? I know there might be a million of her and her guy counterparts. One won't take you down, but a million of them? You can't stop them all. As soon as she closes up shop another takes her place. Hell, I was one of those bright-eyed ignorant fools. We all were. You were, too. We don't wake up knowing what the hell to do.

I don't want to compete with her. I want to be about 10 miles down the road past her. While she's caught up in the "coolness" of being a photographer I'll be busy *being* an effing photographer. Complete with the crappy strap that came with my camera.

Well. That went in a different direction. It's all connected. Who you are. What you are. How you do what you do. What your numbers are. How you crunch them. How you relate them to other people. How to convince people you are worth more. How well you shoot. How well you light. How well you handle cash flow. How good the people you surround yourself with are. It's all one big volatile cocktail called "full time photography." It's a poison I can't get enough of. I love this stuff. Well, except the maths. I hate the maths.

Q: HI! SOFTBOXES AND GRIDS. WHY? WHAT DEGREE? FOR WHAT PURPOSE? I FIND IT DIFFICULT TO UNDERSTAND WHY YOU WOULD USE A HARD LIGHT MODIFIER ON A SOFT LIGHT SOURCE. GRIDS ON SOFTBOXES JUST DON'T MAKE ANY SENSE TO ME.

A: Think of it like this: Grids aren't a light source. They modify whatever light source you put them on. A grid on a hard light source is a hard light source. You're just controlling it more with a grid. A grid on a soft light source is still a soft light source. You're just controlling it more with a grid.

Let's say you're in a situation where a subject is three feet from the background. You want that background to go darker but you can't do it because the light from the softbox is *spilling* on the background and, let's just say, you can't get the subject any further away from the background. Pop a grid on the face of the softbox and you still get that nice soft light but now it isn't spilling on the background.

Grids are there to direct light and control spill. The tighter the grid, or smaller the degree, the more directional it becomes. Right in the dead center of the grid the light maintains pretty much the same quality as if you weren't using it. Start to get off the center of the grid and the light begins to fall off.

Put a big grid on a big light source like an octa and you can get this amazing beautiful soft light that falls off very quickly. It can be gorgeous! As with all things, though, it isn't the best for all situations. Sometimes you need the light to spill onto the background, so you keep your grid in the bag.

These are the 24" pop-up softboxes made by Cheetah Stand (cheetahstand.com). They are new additions to my bags of gear and so far I'm quite pleased with them. They come with grids.

Notice how adding the grid to the softbox (right) controls the spill of light on the background. You use grids to be specific regarding where you want light to fall in the entirety of your photo. Not just where it falls on the subject.

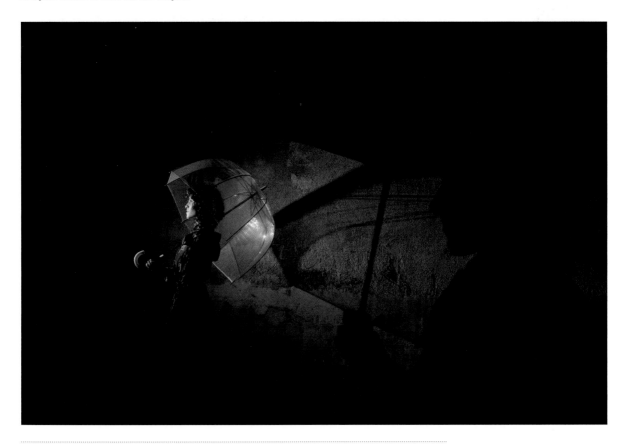

This is an example of using a grid on a hotshoe flash. Just a straight Honl Photo ¼" grid. No softbox. It's a very hard, directional light. :: Canon 5D Mk II / 35mm / f4.5 @ 1/160th @ ISO 100 / Nikon SB80-DX flash with Honl Photo ¼" grid spot.

A: Artist statements are *usually* the biggest load of crap one can ever read. I find they range anywhere from pompous loads of crap to humorous loads of crap. There are some in MoMA in New York City that are particularly ridiculous. I remember one hanging next to a blank white canvas that talked about the innocence of trees.

Just keep it on point, and short and sweet. You aren't reinventing the genre. You aren't curing cancer. You aren't offering deep and powerful statements about social injustice. Because if you happen to be doing any of those things with your photography, the photos will be proof of that and you won't have to say a word.

If I made an artist statement it would be something like this:

"My goal is to make photos that people stop and look at for a second and say, 'Damn. That's cool.' Then they buy one or go about their day."

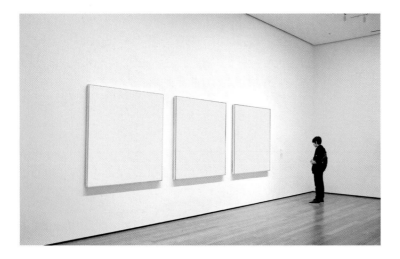

My son Caleb reads an artist statement about three white canvases hanging on a wall in a museum. :: Fuji X100S / f2.8 @ 1/60th @ ISO 1250.

61-70

Comparing PCB strobes.

Ain't no money in live music.

Kidnapped & Dumped. How to start.

Band, label, or manager directing the shoot?

Waves of anxiety.

The Catch 22. Job or jump?

How photography can kill your relationships.

Underpriced and working.

Posting pricing on your web site.

Finding your style.

Q: COULD YOU COMPARE THE ALIEN BEE B1600 STROBE AND THE EINSTEIN? I'VE SEEN THE 1600 ON A COUPLE OF YOUR STARTUP GEAR LISTS OVER THE EINSTEIN. I ASSUME THIS IS A VALUE DECISION IN ORDER TO PUT THE ADDITIONAL $140 TOWARD A VAGABOND MINI, 85MM F1.8 LENS OR SOMETHING ELSE, BUT IN YOUR EXPERIENCE WHAT DOES THAT EXTRA $140 GET YOU, AND IS THE EINSTEIN WORTH CONSIDERING OVER THE LONG HAUL?

A: The Einstein is a great upgrade from the 1600 for a few reasons. One is for the faster flash duration. The 1600 is slow so I usually lose 2/3 of a stop in sync speed to catch it. The Einstein allows me to go to full sync speed of whatever camera I'm using. It also has a color mode that gives a more consistent color from shot to shot and at different power settings.

The other *big* upgrade is the ability to dial it down to 1/256th power. That covers the range from a B400 at its lowest setting to a B1600 at full power. All in one head.

It's worth the money to get that over the B1600. If it comes down to a 1600 + Mini or just an Einstein alone, then get the 1600 and battery. Work with that for a few years, then upgrade.

I have a kit right now that is an Einstein plus two B1600s. The Einstein is my main light and the 1600s are background/rim/backup/etc. It's a good kit of lights that are powerful and affordable. I've traveled around the world with them in my checked luggage and have yet to have a problem with them. So, if you can only afford a 1600 right now, go with that. It will eventually fall back to being a second light for you once you upgrade.

Q: I WANT TO GO INTO LIVE MUSIC AND PORTRAIT PHOTOGRAPHY, BUT I'M NOT SURE WHERE THE BEST PLACE TO BE FOR THAT IS. LOOKING TO POTENTIALLY ASSIST MUSIC PHOTOGRAPHERS AND SHOOT FOR MAGAZINES/WEB SITES/NEWSPAPERS. ANY ADVICE ON WHAT CITIES I SHOULD BE FOCUSING ON?

A: I'll first let you know a pretty universal truth: There ain't no money in live music photography. That's just the truth. There is some but it's hard to get into. You need to shoot for wire services like AP (Associated Press), WireImage, etc. to find some money in live photography. To sustain a life from it, you need to be at *every* show and be pushing those images to as many outlets as you can.

I'm not saying there's zero money in it, but there is very little, and it's very hard to make a living on. Shooting shows are good opportunities for networking with bands, PR folks, and labels, hoping and praying it will get you in the door to shoot portraits for press, promo, or CD artwork. That's where there is still a budget for photography in music these days.

As for assisting, a live music photographer is doing pretty well to have *one* pass to get in to shoot the first three songs of a set. They rarely get a second pass to take an assistant or intern with them into the pit. You would want to assist a photographer who shoots stuff outside of live music as you'd have a difficult time getting in to assist during a show unless you're assisting someone like Danny Clinch. He's *way* up the food chain and if he's shooting a show then he's the type to have a *real* all-access pass to go anywhere he wants because, well, he's Danny effing Clinch.

There's some money in magazines. Not much. Average magazine jobs I shoot are $300–$500 an assignment. Sometimes I get a budget for an assistant. Sometimes. Half of the time, maybe. I've never made more than $500 on a music-related magazine assignment. My $1,000 and $2,000 assignments are all business/industry related. Guys-in-ties sort of stuff. A far cry from "music photography." I get called regularly for $0–$50 assignments to shoot a band/artist for a magazine.

As much as I love shooting live shows, I've found that portraits for press and promotion are more valuable to bands and artists, as well as more profitable for photographers. Pacific Theater shot in NYC for press and promotion. :: Canon 5D Mk II / 24mm / f3.5 @ 1/15th @ ISO 1600 / Available light.

I know of some newspapers who pay $15 if they publish one of your images. These are fairly large papers. $15. That's an insult.

I've never had a web site pay me for a music gig. Ever. Ever. I shot images for a client who paid me, and those images were going to be sent to a music site, but the site didn't pay a dime.

If you want to make a living in music photography you'll want to work for artists, managers, labels, etc. People who hire photographers for press, promo, CD, artwork, and the like. If you want to be an assistant, look for magazine/commercial photographers who do *some* work in music. They have to be shooting in other genres to afford an assistant since music doesn't pay much. Or they have to be busy shooting press/CD work, and by busy I mean busy. Doing it weekly.

Cities to focus on? L.A. and NYC are huge markets but you're going to be a minnow in the ocean the minute you arrive. Chicago, Nashville, Seattle, and D.C. are good markets. A lot of music-related work gets done in Florida. I've often thought that market isn't tapped

enough. Nashville is a tough market because there are tons of great photographers already established there. Atlanta is coming back. It was dead for a few years but it's picking back up these days. I think Chicago and D.C. are pretty good hotbeds. I'd be happy to work out of either of those cities.

I don't want to kill your dreams or tell you it can't be done. It can. It totally can be done. I just want to let you know it's really, really, really freaking hard to get established and build a life out of the music industry right now. I don't want to sugarcoat it or send you on a trail to the end of the rainbow, just for you to find out later that it's hard as shit to make it. I'll just tell you that up front. However, it can be done.

Someday New :: Nikon D70 / 35mm / f2.2 @ 1/30th @ ISO 320.

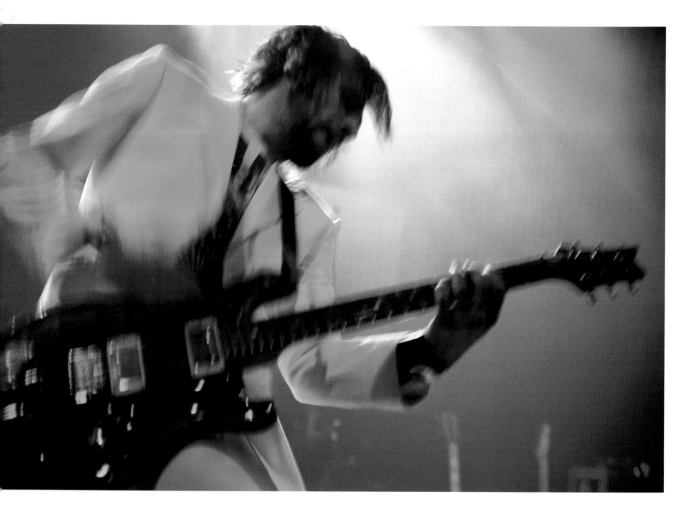

Q: SO YOU ARE KIDNAPPED, DUMPED IN A CITY WHEREBY YOU KNOW ABSOLUTELY NOBODY. YOU ARE GIVEN A CAMERA AND LENS SETUP AND A FEW MISCELLANEOUS BITS AND BOBS. ABSOLUTELY NO WAY OF USING EXISTING CONTACTS OR FRIENDS. WHAT'S YOUR FIRST MOVE? AND THEN WHAT NEXT?

A: First move is to find some sort of industry I want to work in. Music. Family portraits. Corporate. Etc. I'll then offer 10 bands/families/companies my services for free in the next 30 days to build a new portfolio and make my first round of new connections in this town. Note that I'd be very targeted in my offer for free work. Not just any band or family or company. I'd want 10 "connected" people/companies that will connect me to their network of people.

Think about it. You can find good-looking people to photograph, or you can find "connected" people to photograph. Let's take music photography. Say you meet a really good-looking singer/songwriter and they'd look great in your portfolio. The problem is they only perform at the coffee shop in the local bookstore on Wednesday afternoons, they've never really recorded their music, and their live set is mainly made up of covers of other people's songs. However, imagine you meet a singer/songwriter who may not be as easy on the eyes but they perform at some of the best live music venues in your town. They perform in these venues on the weekends, they have two EPs recorded of their original music, and they also perform in two other bands in town. Now then, who would you rather shoot in this scenario? The correct answer is the second one. They are connected. They are out in the industry "doing it."

You can find this exact same scenario in any photographic endeavor you wish to pursue. There are good-looking families who don't socialize in the community very much. Then there are "not as good-looking" families who pack the streets with cars anytime they are having a party at their house. They are involved at their church, schools, civic organizations, etc. You hang a 30x40 print on their wall and a lot of people are going to see it. They're going to Facebook it. *That* is the type of family you want.

Company that has a crap warehouse that sells hydraulic fittings with a web site that looks like it was made on AOL, or new tech startup that has 1,000 followers on Twitter? Hmmmm. Who would I connect with first? Research the hell out of the genre you want to work in and find the movers, shakers, and moneymakers in that genre. Go after *them* for your first shoots.

I'd put everything I had into those 10 shoots over 30 days and then ask for referrals. These 10 people could possibly give me five referrals. That's 50 connections to go work. I'd ask them for referrals whether they hired me or not. Two connections from them and my network is now a total of 160 in 30 days.

Bam!

Cheap-ass apartment. Beater car. Crap low-end gear. Coffee not lattes. Beer only on Friday. Done.

It sounds easy, doesn't it? It is. I mean—it's totally not easy; it's hard work. You have to really hustle but, if you break it down, it's kind of easy.

Notice I didn't say a word about advertising. I'd make a simple Wordpress site with a gallery on it. I'd print simple, simple, simple business cards. Then I'd go find people because you can't wait for people to find you. Let me say that once more: I'd go find people because I could not wait for people to find me. I would be proactive in marketing.

Q: WHEN SHOOTING A BAND, DO YOU WORK CLOSELY WITH THEIR MANAGEMENT OR THE BAND ITSELF AS FAR AS THE "LOOK" THEY DESIRE, OR DO THE MAJORITY LET YOU DO YOUR THING? HOW DO YOU HANDLE A BAND THAT TELLS YOU HOW TO SHOOT RIGHT DOWN TO WHERE THE SHADOWS FALL?

A: Typically the band and the management are on the same track as to what they want. Sometimes there's a rub between band and label. Sometimes no one has an idea of what they really want, or one of them has the idea. So, it's hard to say but I guess for the most part everyone involved has some sort of loose idea of what they want. We then collaborate to make that happen.

A lot of times, though, I get clients who just ask me to do whatever I want. No one has a set idea. They may have some loose ideas like, "We want an urban setting. We like black and white. We don't like field shots."

I usually ask music clients to send me 10 band/artist photos they love and 10 they hate. I don't copy the ones they love, but seeing what they love and what they hate gives me a good idea of what they are going to respond to and I build the shoot to their taste within the style of how I shoot.

I've never been micromanaged on a shoot but I have had a few occasions where the client wanted something I didn't want to shoot. But that kind of thing is very rare. One band asked to be shot on the altar of a church with blood all over the altar. Yeah. That's not happening. Another would be the "I want to walk down a lonely road carrying my guitar" shot.

Umm. No again.

I will take time to let my clients know that if we shoot those photos people will make fun of them. They are "douchebag" shots in the music industry. These requests only come from really new musicians who haven't learned all the clichés that need to be avoided.

Q: THIS COULD BE A QUESTION FOR YOU OR FOR A COUNSELOR. I LOVE MY JOB BUT I HATE GETTING READY FOR A SHOOT. I GET WAVES OF ANXIETY SEVERAL HOURS BEFORE ANY SHOOT. ONCE I AM SHOOTING I FEEL FINE. I HAVE FELT THIS WAY FOR YEARS. AM I SILLY IN THE HEAD? HAVE YOU EVER HAD THIS HAPPEN TO YOU? I DON'T KNOW IF I SHOULD EMBRACE IT OR GET SOME HELP FOR IT. I WILL BE HONEST AND SAY THAT SOME DAYS I SECRETLY WISH THE CLIENT WOULD RESCHEDULE ON ME TO SAVE ME FROM THESE FEELINGS.

A: If you find a counselor who can help you with this please forward their number to me because I need to schedule a few sessions with them. :)

I deal with pre-shoot anxiety on every shoot. No matter how cut and dry the assignment may be, I get nervous. I pace the floor. I re-arrange the furniture 14 times. I scratch all the ideas I had in mind and start to rethink everything 30 seconds before the client walks in the door. Maybe if I had just one more day to think through the shoot I'd be ready; maybe a week.

Client walks in. Camera starts clicking. All my worries float away after a few minutes and I find my groove. It happens at every shoot, without fail. It's just part of the process for most of us. I've asked this same thing of legends with 30 years of experience and they deal with the same feelings.

Fun, ain't it?

Q: I AM THE SOLE PROVIDER FOR MY WIFE AND SON, AND I AM BALANCING THE 8–5 GRIND, FAMILY TIME, AND FREELANCING FOR A LOCAL NEWSPAPER ALONG WITH MY OWN PHOTO AND VIDEO WORK. I AM ABOUT TO GO INSANE. I AM CAUGHT IN A CATCH-22 LOOP OF WORKING TOO MUCH TO HAVE TIME TO PROMOTE MY PHOTOGRAPHY BIZ. I STAY UP UNTIL 2 A.M. GETTING WHATEVER EDITING/MARKETING/ETC. I CAN GET DONE, AND THEN THE ALARM IS GOING OFF AT 7 A.M. I WANT TO GO FULL TIME PHOTO BUT I DON'T SEE A JUMPING OFF POINT ANYWHERE IN SIGHT.

A: Sort of like one foot in the boat and one on the dock, huh? Commit to one or end up swimming. Right? I know that feeling well.

Typically there's a point when you are working a day job and freelancing on the side, where you have to make a choice because you can't keep up with both. I typically advise folks to make a decision one way or another when the day job is being compromised because you're working so hard on your photography business, and your photography business is being compromised by your day job. You're showing up late to the day job because you've been up all night editing and your boss is pissed. You can't get back to your photo clients in a timely manner because your day job is taking too much time. Throw marriage and children into this mix and welcome to Stressville. Population—you.

It sounds like you're at that point. You and your wife need to sit down and look at your finances. You need to see what you can cut out of your lifestyle for awhile. Coffees. Cable. Eating out. Is there a car you can sell to get out of a car payment? Or can you double-down for a year and get some debt off your plate or a few months of income saved up?

The day job is security; the photo job is your heart. You have responsibilities to your family and that keeps you holding on tight to that secure job at the cost of killing your heart. If you get off the dock and into the boat, you are hoping you and your family can weather the open seas.

Can you move to part time in your job? Can you go out and get a part time job to help with the bills? Or can you find someone you can hire to go out and market

and promote your business for you? Is there anything you can outsource right now? It might cost you some at the beginning but you'll be able to grow your photography business as you get ready to leap full time. It's like sending someone else out in the boat to see if it will float before you put your family in it.

This doesn't have to be a full time, hard core, photo rep. You may have a friend or family member who can jump in and learn as they go. My best producers and business managers didn't come from a photography background. They brought their experience to my studio and figured it out as they went with direction from me.

I know you're in a tough spot. It sucks. I can't tell you to just quit your job and reach for the stars. I won't tell you to jump in over your head and swim for the top! I'm not going to go Tony Robbins on you. Best I can do is hang out with you, have a beer, and say I know how much it sucks. Give a few pointers. At the end of the day it's not me jumping; it's not me dealing with that stress. That's on you.

I can say—from a guy bailing a lot of water out of a leaky-ass boat in the open seas—there's nothing else I'd rather be doing.

Q: HOW DID PHOTOGRAPHY COST YOU YOUR FIRST MARRIAGE? MY MARRIAGE IS FALLING APART, WHICH IS NOT ENTIRELY PHOTOGRAPHY'S FAULT, BUT HAVING A FAILING MARRIAGE MAKES IT HARD TO CREATE GREAT IMAGES.

 A: I put more time into working on my photography than working on my personal relationships. Photography will take your time, money, credit ratings, relationships, and sanity if you let it. It will take everything.

It takes two to tango, as they say. There's always work to be done for both people involved, but if you spend more time on the internet reading about photography, and you max out your credit cards on glass and lights, and you put your relationship in stress because of it, then your relationship is stressed out for some glass and plastic. What's more important?

Running your own business of any kind is stressful as it is. Adding to that the fact that you have to be creative in those times of stress just compounds the issues. It's building stress on top of stress. Your spouse/partner needs you to be present; your business needs you to be present; your clients need you to be present. You're a cook with six dishes to cook on a three-burner stove.

People ask my wife, Meg, and I how we find the balance. The answer is we don't. We are always looking for balance, but I'm starting to think of it like this: We aren't looking for our balance, we're trying to find our rhythm. If we can pace this out, then we'll be okay.

The worst is when you are lonely in a relationship. It drives you deeper into your career and craft at times, so you can escape the issues at home. Take some time off from the camera and hang out with your spouse. Cameras will be here forever. Your spouse may not be.

I know a lot of very creative people.

I know a lot of very lonely creative people.

VISUAL INTERMISSION

TWO-SHOT T.I.

I was hired by BMI to cover a charity event they were sponsoring. The headlining performer was T.I. He was just stepping into the national hip-hop spotlight, and I was really excited to have the chance to photograph him. I was supposed to deliver some images from his show, as well as a few portraits.

The event was scheduled to open at 8 p.m. T.I. would arrive at the venue at 9 p.m., and the performance would start at 10 p.m. I was given his manager's name and number, and we set up a plan to meet them at the back door of the venue at 9 p.m. I'd have 10 minutes—tops—to shoot portraits before he went upstairs to the VIP area. I confirmed this plan the day of the shoot. Everything was set.

I arrived at the venue at 5 p.m. to scout the location, find my shots, get my lights set, and be ready to roll as soon as his crew walked through the door. I found three vignettes to shoot that were along the route from the back door to the VIP area. I'd get five or six frames here, then another five or so there, and then a few shots over there, and be done. I would easily be done in less than the 10 minutes I'd have.

9 p.m. came. And went. 10 p.m. came. And went. I sat at that damn back door for hours. Around 10:30 p.m. this frantic little girl came running down the stairs and said that if I wanted to shoot T.I.'s portrait then I had to go with her *right then* to the VIP area where he was and shoot it there. OMG. He came in the front door right after 10 p.m.

I grabbed my Vivitar 285 off of the light stand, snatched a little LumiQuest pocket bouncer thingy I had in my bag, and ran up the stairs to VIP. I fought my way through the crowd of people to find T.I. slouched on a couch. His manager half-ass apologized and said I could shoot his portrait where he sat. I asked if he could stand up. His manager talked to him and relayed back to me that he'd rather sit. I was pissed. I said, "He looks like an asshole sitting there. I just need him to stand up. You want your man lookin' like an asshole in this picture?"

His manager leaned down to T.I., talked to him, and T.I. stood up. I shot one frame, tweaked my exposure, shot another frame, and then T.I. said, "That's it. No more." He sat back down, and I was grabbed by the arm and escorted out of the VIP area. Just like that. Two frames. Click. Click. Done.

I was donating my services to the charity that night. There was no check on the line. I'll bend over backwards but at some point I break. I went downstairs, packed up my gear, and left. Never shot a single pixel of his performance.

I delivered one image the next morning. BMI asked if there were more. I told them the story, and we all had a laugh. All was well in the world again. I got my damn shot of T.I. and managed to stay in the good graces of BMI.

Nikon D70 / 20mm / f3.2 @ 1/60th @ ISO 200 / Lit with a handheld Vivitar 285 flash with a small LumiQuest pocket bouncer thingy on it.

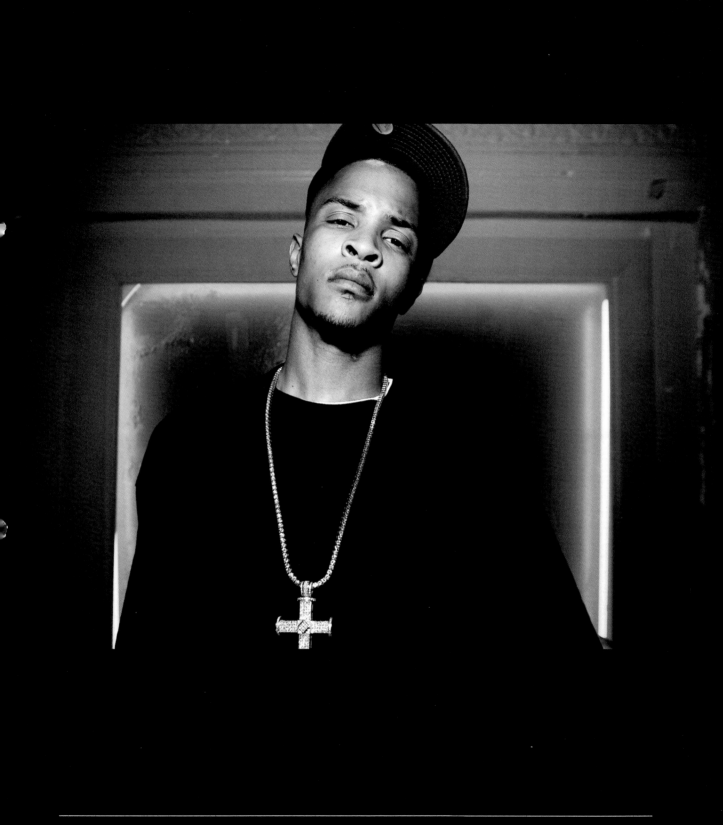

Q: IS IT BETTER TO TAKE THE UNDERPRICED JOBS AT A SILLY RATE AND HAVE WORK COMING IN, OR POLITELY SAY THANKS BUT NO, AND HAVE NOTHING?

A: When you are just getting started I kind of have the blue-collar philosophy of git what you can git when you can git it! You're just starting. You're inexperienced. You need to learn on the job. You'll be doing crap work for crap pay for a while. Hopefully you are keeping your expenses as low as possible. Hopefully you are handling $50 jobs as though they are $5,000 jobs. You have kids to feed? They won't live long on a plate of "integrity." Sometimes you do a job just because you need grocery money today.

You do that for a while. Some will struggle here for a year or two; some will go through this crap for five years or more. If you can survive this sort of boot camp then you'll start to get the jobs you want. The ones you've been fighting for. You'll have experience and skill and talent. Your expenses will begin to grow a bit to handle it. Your rates will get to a point where you have to start picking and choosing jobs based on rates.

Once you are at that point then you can politely say no. You have a track record to look back on and know what you can expect to come in. You will know that if you have to come down on a rate, you will also have your client come down on their expectation. You want two days of work done for half my rate? I'll do one day of work for that. You've made a compromise. They will have made a compromise. You navigate those things based on experience and you get that experience by doing anything you can get your hands on.

Some photographers tell new photographers that they need to get to X rate and stick to it. The problem with that advice is new photographers don't have the experience to get that kind of rate. Someone has to do the $500 weddings, right? Someone with one year of experience can do that. Someone with 20 years can't. Someone with 20 years shouldn't be losing sleep over the folks with one year of experience.

If you have to eat then take the job. As the late great Paula Lerner used to say, "If you are getting screwed on a job then at least *know* that you're getting screwed." Know why you are working for a bad rate and know why it is a bad rate for you. Know your numbers. Know why you are getting paid dirt to deliver gold. You're at the bottom and that's okay. You have to start there; just don't stay there.

A: To publish your prices or not to publish your prices. This is the question.

I'm a big advocate for publishing your prices on your site when you are just starting out and you're dealing with what I call "general public" types of photography. Family portraits. Weddings. Headshots. Promos for local bands.

Here's why I'm an advocate for this: You need to pre-qualify your leads. All of your marketing should be pointing people to your web site: your business cards, your promos, your discussions, your Facebook page, your Twitter account. Everything is pointing in one direction and that is to www.YourNameWhatevers.com. Don't have marketing pointing people to your web site on one thing and your Facebook page on something else. Point *everything* to your *main* site. It will be the one thing left standing when we're all sick of Facebook, or we've moved on from Twitter. We'll be on to some next new thing. Make sure that next new thing is pointing to your site. The one constant for you in this online world is your own web site.

On your site people can see your work and see what you charge. Weddings Package A—$1,500 includes yadda yadda yadda. Package B—$2,000 includes blah, blah, blah. Whatever. Family portrait sessions are $150 and you get 20 photos on a thumb drive. Or $150 sitting fee and 8x10 prints are $20. 16x20 prints are $75. Whatever. I'm making numbers up. Maybe your sitting fee is $1,500.

As you are starting you need to get people calling and emailing you but you want those calls and emails to be pre-qualified. If they are contacting you then they've been to your site (because that is where your contact info is). Your pricing is there, as well. They, hopefully, have checked that out so once they contact you they aren't in for a surprise. It's tough to constantly get calls and emails asking for a price. You send a price; you never hear back from them. Or they balk; they're surprised. Let the tire kickers move on to the next photographer. Put your prices out there and stick to them! Don't apologize for your rates.

What about "call for price"? You know what I do when I see a "call for price" on a site? I look at another site. I don't call for the price. If you'll tell me on the phone but not on the site then why do I need to call you? Is this a sales pitch thing? Besides, it's 3 a.m. I doubt

you'll answer. Oh look, this other place has the same or similar thing/service. And has a price. Now I have the information I was looking for—from someone else.

When you're getting started you don't have a "client base" yet. You don't have a "brand" to defend or support. You are green as grass and you just need people to start hiring you. Your client base needs to start; your brand needs to develop.

Someone looks you up and they know what you do and how much you charge. Make it easy for people.

Please do not be one of those bait and switch assholes who puts, "Portrait prices starting at $25!" only to find out that's for a 10-minute session with one look and one image posted to Instagram. When someone calls or emails, and then you try to sell them on the $500 sitting fee package and $100 wallet prints, they feel like they are getting swindled. If you want to shoot for $500 then clearly state that you shoot for $500. Period. Let people know what they are getting into.

Also, don't be a person who has a "Pricing/Investment/Rates" link on your site that directs people to a page that says, "Please contact us for pricing." *OMG!* Really? That's annoying. I just clicked a link to get pricing information only to find zero pricing information. Next. If you don't want to publish pricing then don't put a "pricing" page on your site. Seems like a simple idea but you'd be surprised how many do that.

Once you are established and your pricing is set where you need it to be, and a lot of your work is coming in from referrals, *then* you can decide if published pricing works for you or not. You'll now have experience under your belt and will be able to make that decision. I've seen established photographers state something like, "Pricing starts at $500. Clients typically spend $800 on prints." It's semi-vague yet still lets the client know if they can afford this person or not. Or the web site may state, "Wedding pricing begins at $5,000 for eight hours of coverage. Contact us for a quote." That gives me an idea of what to expect when I call you. Usually this information is on an FAQ page. Something that isn't labeled "pricing."

I do not suggest that you put pricing on your page if you are working in editorial, commercial, or advertising. That's a whole new world of pricing and negotiations. One job could be $300 and the next is $3,000 and the next is $30,000. It's *impossible* to nail that down on a pricing page. The thing here, though, is the type of clients looking for you know this. Advertising clients know their needs are different from editorial clients. They know everything has to be bid on. Every bid is different. You can have somewhat of a base creative fee you work from but you deal with that after you have been contacted. Your portfolio is the pre-qualifier at this point, not your pricing.

When you start with general public photography, you are typically dealing with folks who want to know a price. Let them know what that is. Once you get the level of

clients that aren't as price–conscious, then published pricing isn't as important. They love your work and they'll pay whatever they have to for it.

I've heard some photographers say they don't state their prices because they don't want their competition in the area to know what they are charging. *Really?* That makes no sense to me. "Well, they can undercut me by $50 and take my business!" If your published pricing is the reason work is being taken away from you, then you might have other issues in your business and photography. Besides, all they have to do is have their cousin call you and get a quote. Duh! Make it easy on your competition to find it out so you aren't getting a bunch of dummy calls. :)

Now, to address freezing up when asked how much you charge:

You *need* to know your numbers. You *need* to know what you charge and why you charge it. Part time. Full time. Whatever. Set prices. Stick to them! Your landlord has no problem letting you know how much your rent is, right? The bank has no problem telling you how much money you owe on your credit card, right? The Mercedes salesman doesn't flinch, nor apologize, for the price of a new S class. You're a photographer. You're an artist. You're a business. You charge a price. That is your price and you state that with a smile. It's not your fault if they can't pay what you need to make.

Q: I'VE BEEN TOLD THAT MY PHOTOGRAPHY DOESN'T HAVE A "STYLE." THERE ARE CERTAIN TYPES OF PICTURES THAT I LIKE TO TAKE, AND CERTAIN STYLES THAT I PREFER TO ATTEMPT, BUT I TEND TO ATTEMPT TOO MANY STYLES. I'M HAVING DIFFICULTY BRANDING MYSELF WITH A MORE SPECIFIC STYLE THAT OTHERS CAN RECOGNIZE AS BEING MY STRENGTH AND TALENT IN THE PHOTOGRAPHY WORLD. AS WITH OTHER SITUATIONS IN LIFE, I FEEL "GOOD" AT A LOT OF THINGS, BUT I'M STILL TRYING TO FIND THAT ONE THING I'M "GREAT" AT.

 Style takes time. Style rises to the top after you've searched through a lot of different ways of shooting. Style is uniquely personal; style can't be forced. As difficult as it is to find your style, it's that difficult to one day change your style, as well. Joel Grimes speaks of style as being a *sensibility* one brings to a shoot. It's just how you do things.

You have to be patient. Keep whacking blindly through the weeds. Keep at it; keep searching; keep getting lost in it. I'd say style usually starts to show after eight to ten years of *consistent* shooting, unless you are a phenom. Single-digit percentages of photographers can find their identifying style in less than five years.

Keep being good at stuff. Maybe your visual style isn't showing right now but maybe you have a style of interaction with your subjects. Maybe you have a style of marketing. Style can pop up in other areas of your photographic life.

The good thing is you're looking for it. Just don't force it. Style has to arrive. It doesn't arrive announced either; it just sort of sneaks up on you one day. It's like a ghost that's just in the corner of your eye. You know it's there but you can't look at it directly.

71-80

Packing gear.

Lenses and LEDs.

A company by any other name.

Mixing work on web sites or splitting them.

Marketing and self-promotion.

Logos. To pay or not to pay.

What is a successful photographer?

Rare times I use Aperture Priority.

Cropping & Blurring.

Beyond the bridal booth.

Q: I KNOW YOU LOVE YOUR THINK TANK BAGS. HOWEVER, HOW DO YOU CARRY YOUR EINSTEINS, MODIFIERS, STANDS, AND OTHER ASSORTED BIG STUFF? I HAVE (AT LEAST) TWO ISSUES: FIRST, I USE THE BUFF BAGS, BUT WOULD LIKE TO HAVE SOMETHING WITH MORE PROTECTION AND WHICH IS EASIER TO CARRY. SECOND, WHEN I DO A SHOOT, IT TAKES ME A LONG TIME TO DRAG ALL MY CRAP TO THE SHOOT AND THEN START SETTING UP. I AM MAKING TRIP AFTER TRIP TO GET STANDS, LIGHTS, BAGS, AND MODIFIERS. I WOULD LIKE TO REDUCE THE TIME ON THAT PROCESS.

A: I recently had a corporate job in Florida that pretty much required I pack my entire studio into my car and drive it to a hotel in St. Petersburg. I had to photograph 80 employee headshots on a pure white background. As there isn't a good rental house in St. Pete, I brought enough gear to have backups to my backups. I had one day to get the entire job done. If gear went down, I was screwed. I'll break down each thing on this cart in the image shown here and then talk about how I reconfigure it for different kinds of jobs.

1. **Photoflex Pro-Duty Backdrop Support Kit from B&H.** This is a great kit to have if you are needing to set up a roll of seamless paper or other type of backdrop when going on location. It's strong, stable, and can be configured in widths from four to 10 feet.

2. **20-pound sandbags.** I have three on this particular cart. One for each side of the background, and one for the main light.

3. **Lightware RC1048 48" Rolling Stand bag.** This is the best lightstand/modifier bag I've owned to date. It holds three stands, a tripod, a C-stand arm, the 50" Westcott Apollo softbox, and a good selection of umbrellas and smaller softboxes. It travels well as a checked bag on flights, too. I've had this bag for three years and it has nearly circumnavigated the globe. It has wheels, which is a big plus.

Not pictured in this photo is my Kata softside 50" bag. It's a good bag to just throw a stand or two into, along with a few modifiers.

4. **Westcott 9'x10' wrinkle-resistant white cotton backdrop.** I've started using this backdrop instead of a 9' roll of white seamless when I don't need a sweep on the floor. For headshots and ¾ shots it's perfect. It's much easier to set up, take down, and transport than a 9' roll of seamless. It's sort of stretchy so you can use A-clamps to pull it tight on the background stands for a solid, wrinkle-free background.

5. **Eagle Creek luggage.** Clothes and stuff. I love Eagle Creek bags because they carry a lifetime guarantee no matter what happens to them. I use their tech cubes a lot to transport battery chargers and the like. If you ever find yourself starting to travel on a regular basis don't forget your luggage. I used to buy the cheapest bags at the store. After a few flights they would begin to fall apart and I'd end up having to buy another cheap bag. Just spend the money once.

6. **Think Tank Photo Airport Navigator.** For this job, this was my grip bag. It held clamps, gaff tape, extension cords, power strips, etc. It's also a great bag to configure to hold my Elinchrom Ranger Quadra lights and packs.

7. **Adorama Flash Point Beauty Dish Case.** A perfect and inexpensive case to carry beauty dishes up to 22".

8. **Kupo C-Stand with arm and knuckle.** Great stand. I love C-stands in general. I never fly with them though. They are too heavy and cumbersome for my tastes. I'll rent them once I get to my destination or I just use standard lightstands that travel well in the Lightware case.

9. **Some small generic laptop bag.** I had a lot of paperwork to deal with while I was on the road for this job, and I used this old laptop bag to hold that. It's not important for anything on a regular basis for me.

10. **Think Tank Photo Logistics Manager.** I love this bag! It's the coolest camera bag I've ever owned. I don't carry cameras in it, though. On a regular basis, it holds my big lights and grip gear. It holds my Alien Bee/Einstein gear along with two Vagabond Mini batteries, as well as cords, clamps, reflectors, barndoors, etc. It's easy to reconfigure as needed before heading out on a job. I love this bag. It travels really well as checked baggage. I've never had a light break in it, and I've flown on several international and domestic flights with it in the belly of the plane. It's worth every penny.

11. **Think Tank Airport Security.** I think this camera bag has 100,000 miles on it. I've replaced the wheels four times since I bought it five or six years ago. That's not a testament about it having bad wheels. That's just how much I have dragged this damn bag around. It holds my Phase One system and 35mm DSLR gear. It also holds my 15" MacBook Pro that I use for tethering on location.

12. **Think Tank Airport International.** This is the baby brother of the Airport Security. For this job, it's holding my Quadra gear and that is pretty much what lives in it right now.

13. **Full apple box.** Apple boxes are a must. Especially if you're short like I am. It can be a stool for a subject to sit on. It can be a step stool for yourself. You need a few apple boxes in your life. You'll find a dozen uses for them.

14. **The Rock-N-Roller folding cart.** This is a great cart that holds a ton of gear and folds up for easy storage. I replaced the tubeless air tires with solid rubber tires. I've loaded these carts to the point that I've popped the seal on the tubeless tires. Can't pop solid! Note: I drive a 2005 Scion xB and all of this gear fits in the back. Including the cart.

And here are a couple things not pictured.

Think Tank Photo Hubba Hubba Hiney. This is a small bag that can hold two of my Fuji cameras and that's about it. It's just a small shoulder bag that I carry all the time when I just need a body or two.

Think Tank Photo Airport Essential backpack. This is actually pictured on the opposite page. This is my new Fuji bag. It holds all of my Fuji gear—and then some: X100S, X-Pro1, lenses, two flashes, two Pocket Wizards, 13" laptop, iPad mini, hard drive, and assorted accessories. I use this bag as my main travel camera kit now.

Now let's discuss how this all changes depending on the job.

On a small editorial gig I take the Airport Security with my Phase system, the Airport International with my Quadras, and either the Lightware bag or the Kata bag for stands and modifiers. The Rock-N-Roller can collapse to half of its length so I'll pack these on the shortened cart for small jobs. It's easy to roll in and out of locations. Only one trip to and from the car!

When the scope of the job requires more gear I usually add the Logistics Manager to the cart. It'll hold larger lights and grip.

If I'm needing to get in and out on a job quickly and I don't need my Phase, or if I want to fly as light as possible, then I take the Airport Essentials backpack with my Fuji gear and the Kata bag with a stand and a few modifiers. I've checked the Kata bag on several flights and it has held up quite well. I'm loving that kit of gear right now. If I need more light than the two hotshoe flashes in the backpack then I'll grab the Airport International with the Quadras. I can still carry all of that in one trip without using the Rock-N-Roller. I can also carry on the plane the backpack and the Airport International, and just check the Kata bag.

I know this may seem like it has been sponsored by Think Tank Photo but it has not. I've owned just about every kind of camera bag out there from every manufacturer. Think Tank bags are by far my favorite and have been the most durable and dependable bags I've owned. I'm not paid to say that, either. :)

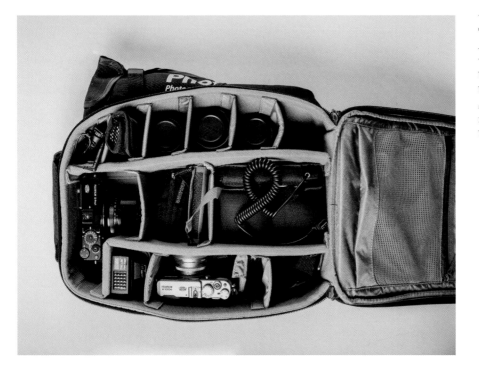

This is my Think Tank Airport Essential bag filled with my Fuji gear. My Phase brings me quality. This kit brings me joy. My Canon gear? It's just lost in the middle, getting sold off piece by piece these days.

Q: TWO QUESTIONS. I OWN A 50MM AND A 85MM AND I'M LOOKING FOR A WIDER PRIME. DO I GO 35MM OR 28MM? I SHOOT EVENTS AND PORTRAIT WORK. AND, WHAT ARE YOUR THOUGHTS ON USING LED LIGHT SOURCES FOR LIGHTING? I'M A FAN OF LEDS. I LIKE THE ABILITY TO CONTROL THE LIGHT THROUGH DIMMERS ON THE LED PANEL AND THE EASE WITH WHICH YOU CAN USE ALMOST ANYTHING AS A MODIFIER SINCE THEY GENERATE LITTLE HEAT.

A: The first part of your question is hard to answer because of personal opinion. I personally like a 35mm focal length. Some prefer the 28mm. Borrow one or rent both for a weekend and see which you prefer. You may also find that you prefer a 28mm on a cropped sensor but a 35mm on a full frame body. I can't say for sure for you. Try them both and you'll get an idea of what suits you.

As for LED, my thought is this: Light is light. No matter the source. That being said, the issue I have with LEDs is that they aren't all that bright. Yes, you can shoot great photos with them but a hotshoe flash can do what they do plus 10 times more. You're not going to chain enough LEDs together to overpower brighter ambient light sources. You'd have to pack a ton of them into a 50" softbox to get f8 at ISO 100.

The technology is coming along. I'm sure we'll soon see more advances in LED technology. As it stands now, though, I wouldn't put any money into it unless I was doing a ton of video. That's the only place LED beats flash.

You show me a shot that is done with LED and I can do it with flash. Then I can do this, this, this, this, this, and this, and that, and this thing, and on and on. I know that using continuous lights is attractive because what you see is what you get. You can see what the light is doing, meter for it with your camera, and take the shot. The problem is they aren't that bright. They can only do so much. A solid understanding of hot-shoe flash will take you much further down the road. You can also use any modifier you want because small flashes don't get hot when used in a modifier.

Q: I NOTICED THAT YOU USE YOUR NAME TO REPRESENT YOURSELF IN THE PHOTO WORLD AT LARGE. IS THERE ANY REASON YOU CHOSE TO GO THAT ROUTE RATHER THAN A COMPANY NAME? I HAD BEEN USING A STUDIO NAME FOR YEARS, BUT I HAVE TAKEN SOME TIME AWAY FROM PHOTOGRAPHY. NOW THAT I AM LOOKING TO GET BACK INTO IT FULL SWING, I AM HAVING THE TOUGHEST TIME DECIDING WHETHER TO USE THE SAME NAME OR IF I SHOULD JUST MAKE THINGS SIMPLER AND USE MY NAME.

A: Oh my gosh. You have no idea how I've gone back and forth on this about one million times. No idea. Every time I decided I was going to go with a "studio" name I would then decide I should just use my name. Then I'd be ready to pull the trigger on just using my name but then decide I should stick with the studio name instead. It has been such a frustrating process.

I've worked with designers and brand consultants, and I have talked to a ton of photographers up the food chain from me about this.

I used to go by the name "usedfilm." That was the first URL I bought. It was short and easy to spell. I had to leave photography for a while, and when I came back to it, I came back to that name. I liked that it was not about *me me me*. I could hide my ego behind a studio name. In my previous life, my ego got in the way at times. I didn't want that to happen again.

So, I'm officially usedfilm Studios, LLC as far as my company goes but yes:

I. Am. Zack. Arias.

That's my "brand." Ego and all.

I've gone back and forth on it and I finally realized that what I do is "me." I don't have associate photographers. I don't have multiple locations. It's me. When a photo editor is hiring me they aren't hiring usedfilm, they are hiring Zack Arias.

I made a pros and cons list to assess whether I should keep usedfilm or move to Zack Arias. It was a pretty even list between the two, but trusted friends, designers, and colleagues convinced me that using my name was the best route to go. I agree now. It just makes it easier when I'm networking and marketing.

That said, if your name is Aliaune Damala Bouga Time Puru Nacka Lu Lu Lu Badara Akon Thiam, you might want to go by something else. Like…Akon. Yes. That is Akon's full name. I wonder if he has that as a dot com. :)

Q: YOU OFTEN MENTION HOW YOU HAD A WEDDING/PORTRAITS WEB SITE AND A MUSIC WEB SITE WHEN STARTING OUT THE SECOND TIME AROUND. I'M VERY INTERESTED TO KNOW HOW THESE WERE SEPARATED: WERE THEY UNDER THE SAME DOMAIN/URL OR WERE THEY SEPARATE? I'M THINKING OF DOING SOMETHING SIMILAR AS I'M STARTING OUT AGAIN AND NEED TO COVER SIMILAR INDUSTRIES AT FIRST, BUT I'M CONCERNED ABOUT BRANDING AND ANY POSSIBLE NEGATIVE EFFECTS IT MAY HAVE IF THEY ARE ON SEPARATE WEB ADDRESSES. AND TWICE THE MARKETING, POTENTIALLY!

A: I had two different URLs. One URL for family portraits. One for music photography. They both looked different because they were targeting different kinds of people. The wedding work I was doing was for my friend Marc Climie, and so all of my wedding stuff was on his site.

You're right—having two sites doubles your marketing. You have to have two sets of business cards, two kinds of promo cards, and keep up with two sites with two blogs. It's kind of a mess, really. That's why I decided early on that whichever genre grew feet first would be what I pursued, and I would ditch the other. Thankfully the music photography took off first. I didn't, and still don't, want to run two sites and have two brands and two business cards. I sure as heck don't want to have to deal with two blogs.

I think some genres can be mixed onto one site. Weddings and Portraits make sense together. Weddings and Music don't. Musicians typically don't want to hire a wedding photographer for their press and promo work. I've only seen maybe two photographers who were able to mix things like weddings and commercial/music/editorial on one site and have it work well. I've seen hundreds try. Few can make it work. If I were to start my own wedding business today, I'd make a new site for it.

The worst genre combinations I see are when people are mixing "fashion" and family portraits. There are pictures of moms, dads, kids, seniors, and then half-naked or fully naked bad models draped over headstones with blood running down their chests. No, really. I see that shit all the time. All. The. Time. I've seen those types of pictures in *one* gallery! Cute four-year-old kid playing in the park—and then the next photo in gallery—bondage/fetish girl tied up with a dildo in her mouth. How many families are going to feel comfortable calling that photographer? I sure wouldn't call them. Separate sites, folks. Separate sites. You'd think it would be common sense but, alas, I see it all the time.

It's hard to run two sites, though. I'm not a big advocate for it but sometimes it's what you gotta do. What I am an advocate for is finding that one thing you absolutely love to do, throwing caution to the wind, and going after that *one* thing you want to do with everything you have. Laser-vision focus. Be great at one thing and the rest will follow.

VISUAL INTERMISSION

GET THE MOST OUT OF BORING JOBS

When you get started in photography, you will most likely take any and every job you can possibly get your hands on. It's not a time to be proud and selective with what you shoot, who you shoot it for, and how much money you are going to make. You need experience and a bowl of rice, so you get out there and do it. As you gain experience, at some point on your career path you can become a little more picky as to what you will and will not shoot.

Case in point. I was called by a friend at a PR company who was working with the equestrian/acrobatic performing arts show Cavalia. The daughter of cable media mogul Ted Turner was riding in a special performance of the show, and they were seeking a photographer to shoot grip-n-grin photos of Ted, his daughter, and the organizers of the event. Snooze fest photography dot com. I hate grip-n-grin photos. I was ready to turn it down, but…traveling horse circus shows are cool! There are jobs, and then there are *opportunities*, and you need to be able to find the opportunities in an otherwise boring photo request.

I asked about the job, got more details, and then asked if there was a possibility I could get an all-access pass for before, during, and after the show. You have to ask. Always ask. They want grip-n-grins; you want access to something different for your own portfolio. As luck would have it, the night Ted's daughter was performing was a rare press evening. They were allowing a few photographers all access. Bam! I let my friend know that if she could get me all access then I'd take care of her photo requests. All access *plus* a check? Score.

I shot a whole portfolio piece that night that was different from anything I had shot to that date. I'm still showing that work. Now, due to the agreement I had with Cavalia, I can't show specific images that are distinctly "Cavalia" in this *Q&A* book. The costumes and some specific set pieces are copyrighted, and they request I only show those images in personal portfolios. I can show these, though, to illustrate my point. Take the job you might not want, but always look for other photos that you can use.

Canon 5D Mk II / 24mm /
f2.8 @ 1/160th @ ISO 3200
/ Available light.

I shot this at a time when I had half Nikon and half Canon in my bag. I didn't have a longer fast lens for Canon, so I shot this with my Nikon 105mm f2 lens. Also note that sometimes a photo is not of the action but of something just off to the side of the action. The shadow of an acrobat caught my eye. :: Nikon D3 / 105mm / f2.2 @ 1/80th @ ISO 3200 / Available light.

Q: YOU RESPONDED TO A QUESTION ABOUT PERSONAL STYLE BY SAYING TO DEVELOP A STYLE AND MARKET IT TO CLIENTS WHO MATCH THAT STYLE. WHAT I WANT TO KNOW IS, WHAT DOES THAT KIND OF MARKETING LOOK LIKE? MARKETING AND SELF-PROMOTION ARE REAL WEAK POINTS FOR ME, AND I DON'T HAVE ANY SENSE OF WHERE TO START. HOW DO YOU GO ABOUT MAKING IT KNOWN THAT YOU'RE READY, ABLE, AND WILLING TO WORK?

A: Let's first look at marketing from a wide-angle perspective. Every marketing plan needs to have these key things:

WEB SITE :: Duh. A web site. Something professional with a custom URL. Not johnsmith.smugmug.com or whatever. It needs to be JohnSmithPhoto.com. That might point to some online template service but it needs to be your name/company name. Domains are cheap. If you want to work as a photographer, have your own domain name.

The site can be PhotoShelter. LiveBooks. Zenfolio. SmugMug. WordPress. A Photo Folio. Flosites. Etc. (Well, anything but SmugMug. Never been impressed with their sites. Maybe it's just their name; I hate their name. I hear they are good people, though. Anyway.) The design, the template, the back end, the front end; that's a huge landscape of options to navigate that you

would be best served by investigating all of that on your own. It's like "Canon or Nikon"? Either one. Just pick one. Go for it. Get what works for you in your budget. Personally I like PhotoShelter and A Photo Folio. LiveBooks does a good job, as well. Flosites did one of my sites back in the day. Those are all good options. Back to the topic at hand—marketing your work.

For the love of all that is good and holy—*Put your effing location on your web site and promo material!!! OMG.* I can't tell you how many photographers' sites I've been to and there's zero—and I mean *zero*—information as to where they are. There *might* be a phone number. Does everyone have every area code in the country memorized? You know how many folks move from one place to another but keep their old number? Where the @#$# are you?

John Smith—St. Louis. Done.

Don't be the pretentious prick who states, "Atlanta, Miami, New York, L.A." You can't possibly be in four locations at once. You live somewhere. Don't think for a second that anyone is impressed that you have four cities listed on your web site. If you're *that* damn good, then:

A) you aren't reading this book, and

B) you have people doing all of this marketing work for you, and

C) those hiring you already know you.

Unless—one caveat—you live in L.A. and have a rep in New York City. Then you put, "Based in L.A. Represented by Jane Smith in New York City." *Put your base!* You would think something so simple as listing where you are located shouldn't be something worth mentioning, but I see this all the time. Oh, and there's really no need to put "Available for assignments worldwide." Who isn't? In fact, if you aren't willing to take out-of-town assignments, you are a rare person and you might want to state that you only shoot locally. Nine out of 10 photographers are ready to jump on a plane to take pictures. Everyone knows that. No need to state it.

DIGITAL PRESENTATION (iPAD, LAPTOP, iPHONE) :: As a working photographer you'll be meeting with people. Families. Brides. Editors. Art Directors. Blah blah blah. You'll meet with them at your studio. Coffee shops. Their house. Your house. Their office. Blah blah blah. It's good to have a digital presentation of your work aside from your web site. You might get somewhere and not be able to connect to the Internet. It has happened to me more times than I can count. It's good to have an offline presentation ready to show at any moment. iPad. Laptop. Atari 2600. Whatever.

PRINTED BOOK / PORTFOLIO / SAMPLE ALBUM / SOMETHING PRINTED :: There's a quote that goes something like, "It's not a photo until it's a print." I heard that from David Burnett. If you are shooting weddings, you are probably trying to sell albums. You should be trying to sell albums. You want to sell prints of family photos. If you want to work for magazines, your work has to print.

I've said it before and I'll say it again. Any image can look good on an iPad. The truth comes out when you print it. There's a beauty to print that is lost in the digital world. The work we do in ones and zeros becomes tangible. Prints don't need batteries. They don't need a firmware update. They don't have to be moved from one hard drive to another. We are losing the life of a photo when we don't print it.

Have a print book. Inkjet. Blurb. Wedding album. Set of boxed prints. Something.

BUSINESS CARDS :: I think photos on photographers' business cards are sort of cheesy. It's not as bad as having your bio photo taken while you hold a camera, but almost. :)

Name. Email/Web address. Physical location (NYC, ATL, PDX). Phone number. Job title.

John Smith • Editorial Photographer
NYC • 212-555-1212
john@JohnSmithPhoto.com

Notice how your email is also listing your web address. Most folks are savvy enough to figure that out, so you don't need another line with your web address.

Do have an email at your domain name? You can run it through Google or whatever if you want, but I think it is unprofessional to have a domain name web address and then have your email address read "john.smith@ gmail.com." I've also recently seen business cards that had one business name for a photographer, then a web address that had nothing to do with the business name, and then an email address that didn't match the first two. It was something like:

Captured Light Photography
www.John-Smith-Photography.com
snapper77@yahoo.com

Also, don't print johnsmith.zenfolio.com or picasa.com/johnsmith on your card. While you might be using one of these services for your first portfolio, it doesn't really scream "professional." If you're professional enough to have a business card, you should be professional enough to buy an $8 domain and point it to your Zenfolio or whatever site. Someone can type in your custom URL and be redirected to another site. It costs less than $10 to do so.

Maybe add a logo. Maybe. If you can't design a good logo and you can't afford to have one made for you, then drop the logo. You don't have to have a logo to be in business. Besides, five years from now your brand will be developing and you'll want to ditch your logo.

Most business cards with photos on them are typically cheap gang-run printings. They look like crap, they're printed on bad stock, and they're cut with dull blades from big production printers. Having professional four-color printing done on good stock is going to cost you.

This is the stuff I take to meetings and portfolio reviews: my printed 11x14 book, an iPad with additional work on it, a leave behind, and a business card. I'm mostly inspired by street art these days, and my stuff looks dirty, beat up, and old...and I like that. It's taken me a lot of time working on this stuff, and I'm constantly changing it and tweaking it.

Also, if you go with a photo on your card, you have to really consider that photo. If you don't have a specific niche just yet and you're doing portraits, weddings, families, kids, dogs, and parrots, then what image do you put on the card? You meet a potential wedding client and your card has a dog on it? Or vice versa?

If you are dead set on having photos on your business cards then go with a company like moo.com. I like them because you can have 50 different photos and let someone choose what they like, or you can pull one out that is fitting for the person you are talking to. The paper stock is great. The printing is good. The price is right. Moo cards are awesome. I almost think of them like trading cards.

PROMO CARDS :: Promo cards are basically slick post cards. They typically feature an image on one side and contact info and address labels on the other side. They can be postcard-sized or half-page-sized. Some photographers will put two or three images on a card, others just feature one. Do a Google image search on "photographer promo card" and you'll see tons of different types and styles.

Typically you should come up with a multi-card campaign. You might design and print six different cards, make a mailing list, and then mail one every two months. Or you could mail a different one every month, or one every quarter. Or you might mail a set of cards in an envelope every two months, or a set every quarter.

There are a few key things to consider when doing promo cards.

Keep the cards and images on point with the clients you are sending them to. Don't send a product shot to people who hire portrait photographers. Don't send kid photos to people who typically hire photographers to shoot executive portraits. Don't send executive portrait cards to music magazines. You would think that would be common sense, but I have heard countless stories of editors and art directors getting cards that have

nothing to do with the type of work they hire for. It's like they are on a generic mailing list and some photographer is just shotgunning cards out into the world with no thought as to who they are actually going to. What does that make that photographer look like in their eyes? Like a dumb ass, that's what.

Whatever you do, be consistent. Sending out one card—and one card only—is useless. Send on a consistent basis. You develop a campaign that will last a year or so. Remember that the folks on the receiving end get tons and tons of these things all the time. Most end up in the trash. That promo has to stand out. It has to be memorable. It has to be noteworthy. Not another pretty card with a pretty font and a pretty girl—blah. Why are you different? Why should anyone take notice of you? How can you be signal in all the noise?

You make a mailing list. Creative directors. Art directors. Art buyers. PR people. Marketing managers. Photo editors. You can build a list on your own or use a service like Agency Access or Ad Base.

LEAVE BEHINDS :: You go to a meeting. You show your work. You leave the meeting. Typically you want to have something to "leave behind." This can be a set of your promo cards or it can be something unique. Think about it like this: You send promo cards. You get a meeting. You show your work. Do you want to leave behind a set of promo cards they already received in the mail that led to this meeting you just had? No. Typically, leave behinds are something different than your promo material. It could be a small Blurb book with 10 images. It could be a small box of prints. It could be promo cards that you only leave behind and never mail. Leave behinds are something tangible that you…Leave. Behind. Not just a clever name. :)

THANK YOU CARDS :: Should need no explanation. If you need an explanation then, well, I'm not going there. Send a thank you card after your meeting.

DATABASE / CLIENT LIST :: Having a web site is like sticking one little hook with a tiny bit of bait on it—into the middle of the ocean. If all you have is web presence, and you aren't actively promoting it, then you are hoping to feed your family from one tiny hook in one large ocean.

You need people to know you are alive and ready to shoot. You need to be actively promoting and marketing yourself and your work. There are seven billion people on this planet and you need the names, emails, phone numbers, and addresses of a few thousand of them. You might go out and mine this data on your own through the power of Google and Facebook and all that. You might sign up for a list through a service like Agency Access. You might hire someone to build a list for you. You might hit the streets and go to every bridal shop, boutique, venue, caterer, and planner in your town.

Note that previous clients need to be added to this list. Yes, you've worked with them before but you need to remind them that you are still around and available to hire. You need to market to them just as much as to the people you haven't marketed to.

Somewhere, out there, beneath the pale moonlight—somebody needs a photographer and you have to find them. You have to send them some promos. You have to email them or call them to get a meeting. You need to have a link to send them. You need to be able to show up, show your work, have your teeth brushed, and leave something with them to remember you by. You need to thank them for taking the time to meet with you. You need to be able to call, email, and show up later to follow up on that meeting.

And who are these people? They are your kind of people. They are the kind of people who like what you like. You like really bold colorful portraits. They like bold colorful portraits.

So you like bold colorful things? Your promos are bold and colorful. So is your site. So are your leave behinds. So are your thank you cards. You like red. You love red. Red turns you on. So there's some red on your site, and on your promo, and on your print book. Your iPad is red. Your business card has a line of red going through it. You effing love red and when someone sees *red* they think of you. *Red!* For life!

You love handmade things. Your book is handmade. Your promos are handmade. Your business cards are handmade. Your site incorporates things that are handmade. Your iPad case is handmade.

You love simplicity. You love minimalism. All of your furniture is from Denmark or something. You love black. Your clothes are black. Your car is black. Your heart is black. Your boyfriend is black. Your name is Black. Simple, beautiful, dramatic, soulful, black. Your site, your work, your cards, your furniture, your everything is *this*. You find people who get that. You find people who love that. You find people who are drawn to the same things you are drawn to. You convince people who aren't into what you are into that your stuff is what they should be into. They have to know who you are. How to contact you. How you work. Where you are. They need this info from your site. From a laptop or a phone. Your site works on a phone, right? If not, you're an idiot; fix that.

There's a big world in front of you. You don't need everyone to be your client. You can't possibly handle everyone being your client. You need X amount of them to hire you. They need to have X amount of money to pay you. You figure that out because you need X amount of money to live on. You will spend X amount of your time looking for them. Meeting with them. Talking to them. Shooting for them.

X + X (2X/X) = X

Okay. I'm bad at the maths. You get the idea.

 When you get started you'll probably do it on your own at first, and it's probably going to suck unless you are a talented graphic designer. As soon as you can afford to hire someone, do so, but you'll probably have to live with your own work for a few years.

As you are starting, your craft is more important than your brand. Work on your craft. You don't have a brand yet. You have no idea what your brand is at the start. Even if your "brand" is "you," you still have a lot of growing to do. You also don't have a brand to support or defend when you start because...you just started. You aren't a "brand" yet. You're barely a photographer. Work on the craft. The craft of photography is king. In time, your craft will begin to help you understand who you are. Knowing who you are, what you do, why you do it, and how you do it will slowly build a brand.

You can expect to pay $2,000–$5,000 for professional branding. That's a decent budget for it. Some are less. Some are more. Expect to pay another $3,000–$5,000 for a professional web site if you go that route. Again, some are less. Some are more.

For those of you emerging professional photographers coughing and choking at those prices and saying that they're outrageous—please go find another profession to work in. Please hang up your camera and walk away.

Photographers are *notorious* for bitching and moaning about getting undercut by everyone with a DSLR who thinks they can be a photographer. You've run your numbers and know what you need to live on to survive, and let's say you're charging $4,000 per wedding or whatever. Then you want to turn around and go to the $99 logo web site? Or try to get a student to do it for $100? Or better yet, you have Photoshop. You'll make your own logo and web site. Why hire a pro? Your clients most likely have a camera. Why should they hire you?

We all want a deal until someone wants a deal from us. We like to hunt through the bargain bin but we hate it when the bargain bin takes work from us.

Karma, as they say, is a bitch.

If you're going to be a professional photographer charging professional fees, then hire professionals and pay them professional fees. A good photographer is worth what they charge. So are a good designer and developer. Expect to pay for good service and great work. Be the client you would want to hire you.

If you are broke, then you have to make due with whatever you can. Just keep it really super simple and don't use cheesy-ass fonts. If you are not a designer, don't pick something that "looks cool," and don't do this: "Ooooo. Look what I can do to text with this filter in Photoshop!" It might look cool to you but it looks cheesy to the rest of us.

Clean and simple. Clean and simple. Simple fonts like Helvetica or Arial. Simple colors. Simple, simple, simple. Pick no more than two fonts: one is for your name or for headline information; the other is for basic text. That's it. Simple.

Ten years from now you're going to be embarrassed by your first site, first logo, first portfolio. It's okay. You have to start somewhere. Just keep it clean and simple and you'll be able to get to that 10-year mark.

Q: HOW WOULD YOU DEFINE A SUCCESSFUL PHOTOGRAPHER? TALENT, SKILL, INCOME, FAME?

A: That's a tough one. I will say that "fame" is never part of the equation of "success" for me.

I know some really talented photographers who don't have two dimes to rub together. I know some mediocre photographers who have very successful businesses.

Part of me says that success is feeding your kids and paying your bills with a camera, regardless of skill and talent. If you can do that then I think that's pretty successful. When talent, skill, and sustainable income can happen, then that is truly successful. If you look at a photographer and you love their work, the person they are, and their ability to pay all of their bills doing what they love—that's a successful person, I think. There are many people in that situation who most of us have never heard of. They are still as much of a success as Richard Avedon, Mary Ellen Mark, or Gordon Parks.

A: I use Aperture Priority (Av on Canon cameras) when I'm running and gunning on a job or just casually walking the streets and shooting in conditions that change from sun, to open shade, to sun, to deep shade, to sun, to cloudy, etc.

In run-and-gun situations, like chasing a subject moving through different lighting conditions, Av or Tv (Shutter Priority) are helpful because the light is constantly changing and you may not have the time to stop and constantly dial in new settings. Photo ninja photographers can do it. You had to in the days of all-manual cameras. We get to be a bit lazy these days.

Note that I'm nearly always in matrix or average metering mode when I'm shooting like this, and my thumb is riding the exposure compensation dial. I'm always looking through the viewfinder trying to anticipate how my camera is reading the scene and I'm constantly adjusting exposure comp anywhere from +2 to −2. I do find I live a lot around +2/3 by default.

Why am I constantly adjusting exposure compensation? Your camera is metering the scene and trying to average these readings to 18% grey. You have to look at what is in front of you and anticipate how the camera will interpret that, as opposed to just letting your camera expose for what it thinks is in front of you. If you have a white girl in a white dress against a white wall, your camera wants to make that all grey, thus underexposing the scene. You have a black guy in a black suit standing against a black wall and your camera wants to make that grey, thus overexposing the scene. Exposure compensation is telling the camera to add or subtract exposure value based on whatever it is thinking.

"Okay, camera. You want to shoot this at f2.8 @ 1/125th of a second. I'm setting the exposure compensation dial to +1 so give me one more stop of light than you think this needs." I'm in Av so I set the aperture to f2.8. The camera will then set the shutter speed to 1/60th to add a stop of light.

Basically, whenever things are on the move and the light is rapidly changing, I'm looking for the auto modes of Av, Tv, and TTL to help a brother out. Any other time, I'm on Manual for consistency. Av or Tv in unchanging light can still vary your exposures when it doesn't need to, resulting in inconsistent exposures, thus resulting in time lost sitting on your ass in front of your computer trying to fix all the inconsistencies. Why would exposures change if the light isn't changing? Remember that your meter is reading the scene. As you change composition or angles to your subject, your camera can be picking up different values and it will change exposures based on what it is seeing. The camera is stupid. It doesn't realize the light on the subject isn't changing.

Using Aperture Priority mode for portrait sessions in constant and consistent lighting scenarios bewilders me. I can't see why anyone would do that except for the fact that they don't know what they are doing technically, and consistency in post-production isn't a concern of theirs.

If the light isn't changing, exposure shouldn't be changing. If the light isn't changing, exposure shouldn't be changing. If the light isn't changing, exposure shouldn't be changing. If the light isn't changing, exposure shouldn't be changing.

Lock it down and shoot. You lock it down in Manual mode. You'll have far more consistent results and your post-production will be better.

These two shots were done in Aperture Priority mode. They are good examples of why you shouldn't always shoot in Aperture Priority. Notice the difference in exposure in these two images. The model, Gabriella, was standing in the same spot in the same light yet when I changed composition my camera meter read different tones throughout the composition and gave me two different exposures. I imagine her white shirt was throwing one of them off quite a bit. Now then, she was standing in the same spot in the same light. Exposure on her face should be identical but the camera is stupid and doesn't know what's going on. You have to be smarter and take your meter readings, set your camera to Manual, and shoot consistently. If you are shooting in the same light and your exposures are going all over the place, then get into Manual mode and lock that shit down.

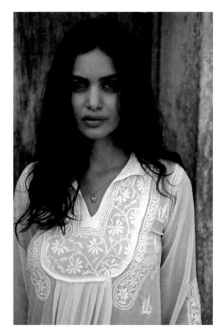 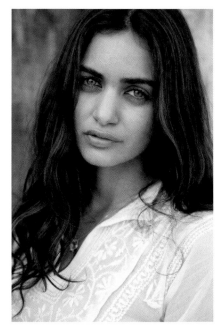

Q: 1) CROPPING: WITH EDITORIAL/COMMERCIAL WORK YOU LEAVE A LOOSE CROP AND LET THE END USER CROP TO FIT. BUT, YOU DO CROP SOME THINGS (PORTFOLIO, ETC). HOW DO YOU DECIDE THE ASPECT RATIO? WHAT ARE YOUR THOUGHTS ON NON-STANDARD CROPS (PROBABLY APPLIES MORE TO ART PRINTS)? 2) FOCUS/BLUR: I FEEL LIKE THERE'S A PUSH FOR "TACK SHARP" IMAGES BUT THAT BLUR CAN CONVEY MOTION. SOME OF THE PHOTOS ON YOUR WEB SITE ARE BLURRED/OUT OF FOCUS BUT I DON'T UNDERSTAND WHY. CAN YOU EXPLAIN THE THOUGHTS BEHIND SOME OF THEM?

A: Regarding your first question, I'm keen to stick to known aspect ratios when cropping my own work. For my printed portfolio book, I keep to the 11x14 size that it is or I'll print within its borders, but nothing non-standard.

As for your second question, sometimes an image has a sense of motion to it or conveys an emotion that is best suited to not be technically perfect. Some of those are just mistakes that worked, and some of them I intentionally blew focus on. Sometimes I do it because I'm just bored with always being "technical" with my work. I love the work of Paulo Roversi. His images are often "blown" technically, but they work. They are beautiful. Can't always explain it; it just feels right. When you step out of "technically correct" photography, it has to work or it doesn't work at all. It's also highly subjective. There are the "rules," and then there's "breaking the rules," but there isn't a rule for breaking the rules.

I am finding myself drawn more and more to imperfect photos. I shake my camera during longer shutter speeds. I rack focus during exposure. I underexpose. I'm trying to get out of the very technical mindset I usually have. If you are the type who doesn't get technical, then maybe you need to go in that direction to push yourself.

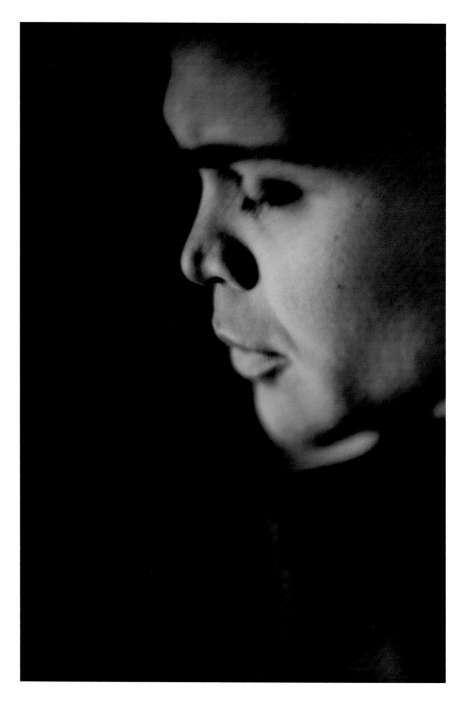

Q: I KNOW YOU DON'T DO WEDDINGS, BUT DO YOU HAVE ANY IDEA IF IT'S WORTH IT TO SIGN UP FOR A BOOTH AT A BRIDAL SHOW? IT'S $500 FOR A BOOTH PLUS $200 FOR A REQUIRED AD. IF WE COULD BOOK ONE WEDDING, THEN IT WOULD BE WORTH IT, BUT IF WE DON'T BOOK ONE THAT'S A BIG HIT, TIME- AND MONEY-WISE.

A: If this is a one-off marketing thing, then it will most likely be a waste of time. Anything you do that is one-off is typically a waste. You need to be consistent in your marketing and networking.

Let's say you have already been to two bridal shows this year, you have two ads running in local wedding rags, you are on the Kuhnot (Knot.com), and you've been meeting with local vendors for some time. Showing up at the bridal show makes sense. You're freaking everywhere. People see your name here, there, over there, and now here you are in person.

Or—you have no ads. You aren't on any of the web sites. You've met just a few vendors but haven't had much interaction with them. Then you blow in to this bridal show and no one has heard of you. You finish the day and no one hears from you again, nor do they see you on the weddings sites. You were just a little tiny blip on the radar for a day and then you are gone. Maybe you pick up a wedding, but remember that the cost of attending is not just the $700 outlay for being there.

You need prints. Albums. A flat-screen showing a slide show. You're given a space something akin to a horse stall, and you need to spruce it up a bit. You need promo cards and business cards. You need some tables, and you definitely need signage that is *far* better than what this bridal fair is going to provide.

A good booth is going to cost you thousands unless you're really resourceful and talented with a little. *Do not* go to Kinko's and get some cheap vinyl banner with "Special-Moments-4-U.biz" printed on it. No, no, no. Unless you have $350 packages. You've got to make your cattle stall look great, and that's going to cost some money.

Then you'll probably want the mailing list from the folks that are putting this show on. Sometimes that is included in your fee, but most of the time they'll offer to sell it to you after the event.

Now then, let's say you're the new kid on the block. You haven't done much advertising and no one knows who you are. You're fresh out of the gates. You go and do this show *not* to meet brides; you go to meet other vendors. You have someone man the booth while you make the rounds meeting caterers, florists, venue owners, planners, etc. Invite them to your booth to see your work. Get their card and chat with them for a few

minutes but *understand* they aren't there to talk to you. Don't take up too much of their time. You can become a pain in the ass very quickly if there is a soon-to-be bride standing around waiting to speak to the person you are speaking to.

Make your introduction. Invite them to your spot. Get their card. Leave yours. Get out of their way. If you feel you made a good connection let them know you'd like to take them to coffee in the next week or two. Then call them and set up a coffee chat. Maybe you can get a dozen coffee dates out of this thing. That's as good as gold. That is far better than booking one wedding from this show. That one wedding is one wedding with a few referrals available from it. Making nice with some good vendors can be a connection to dozens of weddings in the future.

Do not just pay the $20 or whatever to show up to one of these shows as an attendee and then go and schlep your stuff to the vendors there. Be ethical and pay to play. Photographers who show up on the day of the event and just pay the entrance fee are schmucks. Either commit to a space and be there legitimately or be a snake. Don't be a snake. Some places will kick your ass out if they find you doing this. And they should.

Anyway.

Whatever you do with marketing you have to have long-term vision for it. You can't take out one ad; you need to take out a year of ads. Don't just get a text placement 14 pages down on a web site. Pay to be up top. Don't just randomly show up at a bridal show hoping to get one bride. Don't randomly do anything in your marketing. Marketing and advertising take time, money, commitment, and vision. You have to be committed to it over the long haul. Each part has to have meaning and purpose. You have to be able to see past the initial cost to what it is really going to cost you (booth fee vs. booth fee plus prints plus flat-screen plus promos plus cards). You have to see potential beyond just booking jobs. You need to see the relationships that you can make—which can last a long time—and you have to cultivate those relationships.

You have to plant the seed. Water it. Nurture it. Let it grow. Give it time. The harvest comes a long time after the planting.

81-90

Giving the files away.

Giving the RAW files away.

Questions to ask when making a bid.

Which of your children do you love more? Portfolios.

Genre jumping.

What an art buyer wants to see in your book.

Great photographers you should know.

Videos of girls putting make-up on.

Great excuses for my crappy web galleries.

Using a light meter. Know your shit.

Q: WHAT ARE YOUR THOUGHTS ON SUPPLYING DIGITAL FILES TO PORTRAITURE CLIENTS WHEN ASKED? AS A RULE, I DON'T OFFER DIGITAL FILES TO PORTRAITURE CLIENTS; I ONLY OFFER DIGITAL FOR COMMERCIAL/WEB SITES, ETC. BUT I INCREASINGLY GET ASKED, "CAN I GET THOSE ON DISC/DVD, ETC.?" AND I FEEL UNCOMFORTABLE AND UNEASY ABOUT THE SUBJECT. ON ONE HAND, I WOULD RATHER HAND OVER AN ICONIC PIECE OF WALL ART THAT IS EDITED, CROPPED, PRINTED, AND FRAMED PROFESSIONALLY, AND ON THE OTHER HAND I FEAR LOSING CLIENTS IF I DON'T GO ALONG WITH THEIR REQUEST!

A: It's your work and your business and you can control what you want.

That's the easy answer.

The hard part is the demand and requests from your client base; don't meet their requests and they can easily go somewhere else.

I'd try to find a middle point. Include a handful of images on disk/thumb drive/FTP but do all you can to convince them of the value of your printing and presentation.

I know portrait photographers who are doing well giving files and some doing well by not giving files. It's all in their pricing and sales abilities, as well as the final end level of photography they deliver. To sell prints and hold on to the digital files means you have to be a great sales person. If you absolutely suck at sales, then you are probably going to end up giving files away.

If you are able to deliver a level of photographic excellence that can't be matched in your area, as well as top-notch customer service, *and* you are good at sales then you should be fine. I think charging more for fewer clients would be key here for you. Or shoot more for less and give files.

Again, though, giving a few files isn't so bad. What if you and your studio get hit with lightning one day, and you and your archive of jobs are up in smoke? It'd be nice if your clients had a copy to use for years to come since you and their photos just got blasted.

I know. We don't want to think about that stuff. Fact is—it happens.

If it were me, and it's not, but if it were, here is what I would do:

I'd first charge a large sitting fee for a portrait shoot. I'd be the most expensive photographer in town. F*ck it. Just go there. It's not unthinkable. There are $20,000 family portrait photographers out there. You just don't know about them because they don't run in the circles we all run in. I've met a few. They are alive and well. Anyway, I'd charge a hefty sitting fee for a shoot. Let's say $1,500 or so. With that, you would get one large wall print and a thumb drive of images for Facebook. I wouldn't offer a print smaller than 11x14. I'd offer small proof books, which would be a selection of images in a small book. Otherwise, I'd be all about the prints. I'd make the money I want to make on the sitting fee. Then I'd work on sales for more.

$100 sitting fees and $25 8x10s are where you start, but you would not want to stay there for your entire photographic life. You'd be better off getting a job at an office and working your way up to management. Seriously.

This is your craft. Your business. How do you want to handle it? Large wall prints? No delivery of digital files? Okay. I'm all for that. You just have to be awesome at what you do. You have to be *the* person in your town to work with. Everyone knows what you do and what you don't do. You do it with a smile. You aren't a smarmy-ass artist about it; you just stick to your guns and do the greatest job in town.

Q: HI ZACK. DO YOU EVER GIVE YOUR CLIENTS THE RAW FILES?

A: No.

Q: I WAS RECENTLY CALLED TO QUOTE EMPLOYEE AND LOCATION SHOTS FOR A MEDICAL OFFICE. IN THE INITIAL CALL, I ASKED EMPLOYEE COUNT? WEB USAGE? WEB *AND* PRINT USAGE? COUNT FOR PRINT USAGE? WHAT OTHER QUESTIONS WOULD YOU SUGGEST ASKING?

A: I think you covered the main stuff. You might want to ask about the style of photography they are looking for. Do they want a studio-looking portrait? Environmental portrait? Conservative? Do they want "different" but don't know exactly what that means? You might also ask if they want hair and make-up. A lot of the corporate work I do has a hair and make-up artist on set.

You can also ask if they have a budget. Some say you shouldn't ask that question and some say you should; I typically do ask about budget.

If they say, "We don't have a budget," then you make a bid and see where it goes from there. They may say, "$500," and you were thinking $5,000 as a ballpark figure. At this point, the conversation has to get serious.

"Let me put a bid together for you. It's going to be far more than $500, though. I'll let you know that up front and I might not be the photographer for you. I'll get the bid to you and let's talk from there. Maybe we can find some things to compromise on." You never know. Don't write them off. I've taken those calls only to be surprised later when they realized their budget was way off and they decided to spend the money on getting the job done correctly.

Sometimes folks just don't know what photography costs. I have no idea how much it costs to have a 60-second jingle written and recorded. If I needed one I'd think I could get one for $500 or so. It's just a 60-second jingle; how hard could that be? I bet you anything that someone reading this who has experience in the 60-second jingle industry can tell me the ins and outs of writing jingles and how $500 isn't going to get me very far. I don't know. So the person calling says, "$500." You educate them on what you do, what you offer, the value you bring, and then they decide if that's worth it to them.

I say this to say—I see too many photographers bitch and moan about "stupid" people who don't understand the value of what they do. Look, a lot of folks don't know what professional photography costs. They aren't stupid. I could bitch and moan that all these folks asking me questions about photography are stupid.

Why don't you know all this stuff? Oh yeah, because you're new. You're just getting started. You don't know because you don't know; it's not because you're stupid.

Back to budget talk:

If they say $4,000 and you're thinking $5,000 then you thank them for their call and you put a formal bid together. Maybe you stick to your guns and hope they go for $5,000. Maybe you tweak your numbers and get it to $4,200. At least you know you are in the right neighborhood.

Then there are times you're thinking $5,000 and they come back and say they have $7,000 for the job. "Yeah, I'll get a bid together for you. I can work in your budget."

Now then—*don't* get greedy here. Don't just inflate all your numbers to make a money grab. If you can honestly do it for $5,000 and it's a fair price, then bid $5,000 on it. You just made their day. You don't look like an opportunist, either. You actually look honest. Score for you! If that extra $2,000 can *actually* make the job better then tell them that you can do it for $5,000, but if they have a budget of $7,000, then you can add hair and make-up and a digital tech to help move the day along better, and get the files turned around faster. You state your base price under their budget but let them know that the extra budget can add some things to make the job better.

VISUAL INTERMISSION

LOCATION, LOCATION, LOCATION

Location photography. Sometimes you find these amazing places, with amazing details, texture, views, light, and the like. Then there's the other 90% of the time when you just have to find something wherever you land, and make the most out it.

Take a look at this photo from a workshop I taught. Where is this location? What city? What time of day was this image shot? I really wish I had taken an overall shot of this location.

This photo was shot in West Hollywood. We were in a back alley at ten o'clock at night. Directly to the left and to the right of our model, Sasha, are some pretty filthy dumpsters filled with some pretty nasty-smelling garbage. But it's so green and flowery and pretty! I know, right? I'm telling you—photography is a lie.

You don't need much—just a few feet of a background, a bit of light, something to modify that light, and some good direction for your subject. "I know I have you standing in between these nasty dumpsters, and I know it smells like death, but trust me. It'll be fine."

There's a location for anything just about anywhere. You just need a little bit. It has been said that composition is what you include in the photo as well as what you exclude from the photo. No one needs to know we were in a nasty back alley at night. As an editorial photographer, you learn very quickly to find useful backdrops in any location where you find yourself.

Also, need some nice pretty light for cheap that can be used anywhere? A 60" shoot-through umbrella can be had for $30 from B&H (get their house brand, called Impact). Throw that thing up over your shoulder, fire a light through it, and call it a day. It's simple, effective, affordable, clean, and easy like Sunday morning. Or Thursday night. In an alley. By the dumpster.

Canon 5D Mk II / 24–70mm
@ 24mm / f4 @ 1/160th @
ISO 400 / Nikon SB80-DX
flash in a 60" shoot-through
umbrella placed over my
right shoulder.

A: My dear friend, Marc Climie, has said of editing, "It's like lining up your children and deciding which ones you love the most." That quote isn't going to end up on the front of a greeting card anytime soon, but it does get to the heart of the matter. The process of editing your portfolio—whether it's for a physical book or web site—can suck, but it is a process you need to go through on a regular basis. At least twice a year.

The process of looking at your work and distilling it down to the best you have to offer is an arduous and time-consuming process. Your portfolio is the best of the best that you currently have. It is your résumé. It is your education. It is your work experience. It tells the world who you are, what you do, and how you do it. It proves either that you are the person for the job or that you are not the person for the job. Your portfolio is a story. It has a beginning, middle, and an end. It needs to start strong, have a good flow, communicate a message of who you are as a photographer, and finish with a happy ending. You want your portfolio to be substantial without getting boring or repetitive, or going in too many directions. You have thousands of images to start with and you need to boil that down to, let's say, fewer than 50. It can be a painful process. I'll walk you through my process, which has been the only way I've ever found to tackle this sort of project.

GET ORGANIZED :: Make a folder on your computer and label it "Master Portfolio" or something like that. Inside of that folder will be a series of subfolders. Something like "BIG Edit," "Edit for Print," "Print Finals," "Resize for iPad," "Resize for Web." For me, the "BIG Edit" folder is the dumping ground for any image that might have a chance of seeing the light of day again in a portfolio or web gallery. The "Master Portfolio" folder is going to eventually hold everything related to your best work. Everything from your print book to your web galleries will live in this master folder. Make sure you make regular backups of this folder. You may even want to consider an online service like PhotoShelter to keep these files online in case of a drive disaster. This folder will, after all, be holding your best work, so you want to hold on to it.

Editing your portfolio is a long and painful process at times, but it is something you have to do to be a professional photographer. By "portfolio," I mean everything from a print book to a web gallery.

THE BIG EDIT :: Brew 10 pots of coffee, grab all of your archive drives, kiss the wife/husband/lover/Aunt Molly and kids/cats/ferrets goodbye and start harvesting every photo that you like from all of your shoots. Grab the RAW untouched files where possible. Don't get the processed JPGs. Get the originals whenever you can. You may think your post-production skills three years ago were awesome but as you put your work together today you may not like those 14 crappy actions you dumped on your work back then. Trust me on this—harvest the RAW files every chance you can.

Go through your edits and any other RAW files you may have from the job that you did not deliver to the client. It's always amazing to go back into a shoot and find a gem of an image that didn't make the edit when you first shot and delivered that job. In your life, you not only grow as a photographer but you grow as a photo

editor. A shot you may have passed up three years ago suddenly jumps out at you now. That is why I never delete my unpicked files. I go through these old folders a few times a year. Try to be a bit disciplined and pull a handful of your favorite images into this BIG Edit folder after every job. Let this folder live on your main drive all the time, and constantly add to it as you are shooting.

You may spend a few days going through this process. Or a week. Or a month. The first time you do this will take awhile, though. Don't think, "Is this going to be in my portfolio?" Be very loose with your edit. You're just looking for photos you like. Maybe you shot five consecutive frames of someone laughing and you like all five. Copy all five of them to the BIG Edit folder. Notice I said to "copy" your photos into the BIG Edit folder. Don't move them out of their home in the job folder where they lived. Make a copy.

If you think an image might just be a good texture for a promo or something, throw it in this folder. Anything that has anything to do with your marketing and branding can get dumped in this folder. Go with your gut on these decisions. You can't have too many in there. Well, yes you can, but if you're hovering around 1,000–2,000, that's fine. Pretty soon you'll be going blind looking at a large sampling of your work. You don't want this folder to be 5,000 images. You don't want that.

As you can see in the screen capture, I use Photo Mechanic through this entire process. It is the fastest application I've found to date for viewing, rating, and sorting images. I wouldn't do this process in any other application.

TAKE A DAY OFF :: Now that you've collected a large amount of work, take a day off. Separate yourself from it all. Get away from it for a day or two. Cleanse the palate, so to speak.

HUNKER DOWN. HERE WE GO :: Now begins the process of lining up your children and figuring out which ones you love more than the others. This begins the painful process. It's not only painful to choose but, if you are a true creative, this is also the part where your self-doubt, anxiety, and loathing start to show up. You

A screen shot of Photo Mechanic. I love this program for sorting through large amounts of photographs.

come back to your BIG Edit and—it all sucks. All of it is now trash.

Here's what's happening:

The images that you want in your portfolio are not in this folder. They are still out in the world waiting for you to capture them. They are still stuck in your head somewhere. As you start to go through 1,000+ of your "best" images, they all begin to suck. You want to trash them all and just go shoot a new book. Well, sorry Charlie, you can't do that. You can't go shoot a new book. Those elusive images are just that—elusive. You have to harden yourself during this process and realize that you are building a body of work with what you have now. If you ever say, "I'll just do this when my work is ready," then you will never do it. That kept me from this process for a long time. Kick the demons out of your head and get to work.

Pull the images up one by one in full screen mode and start numbering or tagging or labeling them somehow. I typically use a numbering system. Do whatever you want; just start marking or flagging them with a keystroke command so that you can later sort your edits. I typically do the first edit with a 3-star label. That typically cuts more than half of the images out. Then I go through that edit and hit images with a 4-star label. Then I go through that with a 5-star label. You can do yellow, blue, green, etc. Just find something that works for you and do that. Keep in mind you want varying levels of ratings so that you can go through this process in waves, so to speak. You're going to cull that 1,000 or so images down to 300 pretty quickly. Then that needs to get down to 200. Then that needs to get down to 100 or so. Remember that your final portfolio is going to have a set of 20–40 images. You're starting with 1,000. These 1,000 are images that you responded positively to, but the vast majority of these have to die and won't see the light of day again for a long time, if ever. The first round is pretty easy. The fourth, fifth, or whatever round is ruthless.

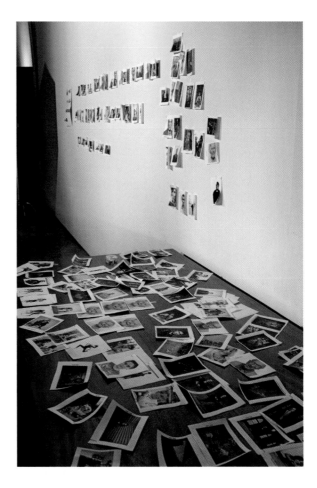

THE 100'ISH :: Culling your BIG Edit folder down to 100–150 images is a pretty good goal to set during your edit. Maybe you end up with 75 images after three or four waves of editing. Maybe it's 200. Whatever. Just get it to somewhere around 10% or so of where you started. It's time to get them off the computer and make small work prints of this smaller edit. I use an inexpensive color laser printer for this process. From Photo Mechanic, I print all of these images four to a page on letter-sized paper and then cut the pages into quarters.

These work prints aren't color correct. Some of these images may end up black and white. Some will get

cropped. Don't worry about all of that right now. You just need a fairly decent little print of the photo. If you want to work a few of these up in post-production then go for it. Sometimes I *know* an image is going to be black and white so I go ahead and work it up before I make my work prints. Just don't spend a week processing these images. You aren't going to use them all.

Once you have your small work prints done, start laying them out on tables. Make a dedicated area for this process that can be left out for at least a week. Clear off a few folding tables in your garage, basement, studio, or attic, and lay them all out. By the time you have culled your 1,000+ images down to 100 or so, you know each photo. You have a wide-angle view of your work. It's time to start focusing on the details now. Clear a wall and grab some tape.

TWO BY TWO :: Remember that your portfolio is a story. It has to have a beginning, middle, and an end. It needs to have a flow. A viewer needs to move smoothly through your images. There are times when your opening photo and your closing photo are obvious to you. If this happens, then tape the opener up high and to the left on the wall and the ending photo down low and to the right. Now you have to build the middle.

Start picking photos in pairs. That's the easiest way to get the middle process started. You're looking for images that work well when shown together, as if you were flipping through a book. Your web galleries may show images one at a time, but a print book typically will have spreads of photos together. Either way, there is a flow that you need to build. Start finding these pairs and tape them to the wall. Don't worry about the pacing of the whole book or gallery yet; just start getting pairs on the wall.

Once you start this process the pace picks up. At first it's slow, and then it finds a natural pace. It's sort of like playing the memory game where you try to find matching cards. This is a good time to show two different images from one shoot. Maybe you want to show what you can do in studio *and* on location with one client. Pairing two images like this can be done nicely. Some images may lend themselves to being a spread

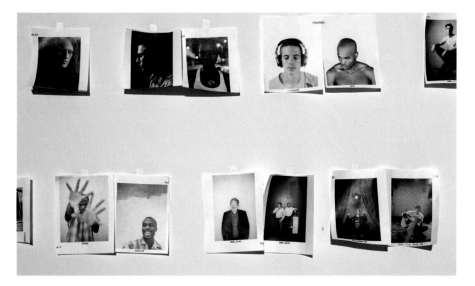

Start pairing your photos together. At first, do it by gut reaction, then start to fine-tune those pairings.

across two pages of a book. Put those on the wall by themselves.

Once you get a dozen or two pairs on the wall start to step back from it. Look at it as an entire body of work now. Start looking for your kick-ass beginning image and your kick-ass ending image. Look at the flow of the images on the wall. Read it the way you read words. We Westerners will start on the left and read to the right. Start rearranging the pairs on the wall. This spread leads nicely into this spread. Flipping the page from this image will lead into the next two images nicely. Images will get sorted by color, composition, subject material, etc. Start trying a few different pairings that may contrast with each other.

Let's look at an example.

The first pair (**A**) works because they have similar tones, compositions, and backgrounds. The second pair (**B**) also works based on composition, but the tones and backgrounds contrast with each other. Which do you choose? It's this crap that will finally drive you mad near the end of the process. Now, look at the third pairing (**C**). Those images running next to each other make no sense. The compositions don't work well together. The subjects don't work well together. The mood of each one is different, but the contrast isn't interesting enough to keep them together in a book or gallery. Nothing ties those images together.

You're going to find yourself putting an image on the wall and taking it down and putting it back up and taking it down again. Over and over. What's nice about having 100 or so images printed out is you can pull something off the wall and replace it with something else. You'll also find yourself running back to your BIG Edit folder and printing out a few more photos at a time because suddenly one image you passed over now fits with the body of work as a whole.

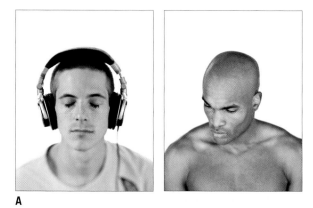

A

B

C

What sucks the most is when a shot you *really* love just. doesn't. fit. You *love* this image but when you view it as part of the whole piece it doesn't work. It's one of your favorite shots of all time. Or it's the best image you've shot to date. Or it shows a new direction you're going in with your work but it. just. doesn't. fit. Period. You have to kill it. It has to be put aside. If the rest of the work can't support it and it looks like a sore thumb, then it is a sore thumb. If you step back and say, "Wedding, wedding, wedding, wedding, kid, wedding, wedding, wedding," then the kid has to go. "Music, music, music, music, fashion, music, music, music, music, landscape, music, music." See what has to go? It can also be "dramatic, dramatic, dramatic, happy, dramatic, dramatic, dramatic." One of these is not like the others. A dramatic movie can have some comedy mixed in. A comedy can have some drama mixed in. Some movies are just one or the other. What is your book starting to look like right now?

Once you have a pretty solid set of images on the wall—and you're ready to punch holes in that wall—sit in the corner and cry, scream, smile, whatever. Turn the lights off and walk away.

TAKE A DAY OFF :: Step away from your work for a day or so. Not too long. Not a week. Not a month. Just a day. Clear your head. Mow the lawn. Play Legos with the kids. Chop firewood. Spit nails. Drop acid. Whatever you do to forget about work for a while.

GATHER YOUR TRUSTED COLLEAGUES :: You are not an island. You are not an island. You are not an island. You need to pull in some help at this point near the end of this process. You need honest and trusted people for this; people who will give you honest feedback. Don't bring them in at the beginning. You're walking in waist deep mud at the beginning. Bring them in when you start to have a solid rough draft.

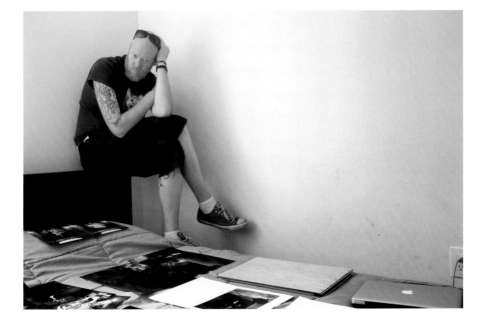

This is my dear friend and trusted colleague, Dave Jackson. Here he sits over his work while another dear friend, Cary Norton, and I look through Dave's work and give him feedback about it. You see that look on his face? Does it look fun? It's not. It's important to have trusted friends who know what they are talking about and to get together with them regularly. Beat each other down. Build each other up. Fight. Scream. Argue. Also, and more importantly, keep your mouth shut and listen to what they have to say.

Gather your folks around and have them look at your wall. Take a photo of the wall before you set them loose on it and then give them freedom to move things around. This photo gives you a reference to go back to where you started if you need to. Let them take photos down and put others up. Listen to what they have to say. Let them tell you why you shouldn't love that one child any longer and why you need to go get the other kid you just kicked out the door. They may be 100% correct and you need to listen to them. They might be complete idiots. But if five idiots *all* tell you to ditch that one image you love, you should probably ditch it. Five idiots together might just be right. It's at this part of the process that you need to start getting closer to some goal of X images in your book. 20 images? 30 images? My advice is to be well south of 50 images in your book. You should be able to tell your story in the 30-image range. My book usually has about that number of images, and I keep an iPad with me with expanded galleries if someone wants to see more.

CLOSE YOUR EYES AND GET IT DONE :: You've now spent a week, a month, a quarter of your life going through this process. *Stop* second-guessing. Stop replacing crap with more crap. Stop rearranging it till you fall over dead. Stop trying to figure out if you should put all your black and white work together, then put your color work together, or keep it mixed. Print the damn book, or publish the damn gallery, and get it out into the world. Period. "But I don't have X kind of photos that I want for my book." Well, guess what you're going to go out to shoot soon? "I wish I had this sort of image to pair with this one." Guess what kind of image you are going to shoot on your next job?

The edit of your book will start to show you the holes in your body of work that you now have to fill. You wouldn't really know that if you had not gone through this process. It's never going to be perfect. It's never going to be finished. It's never going to be ready. If you wait until you are ready you'll never accomplish a thing. Ever. Get the damn book printed and be ready to start replacing images in it as soon as you can. One by one. In pairs. Section by section. In a year, you want half of it replaced. If you are a student graduating with a portfolio, then you want to replace the entire thing as soon as you put your cap and gown in the closet.

I won't go into the physical book—the printing, sleeves vs. no sleeves, Blurb vs. DIY, etc. Those are all personal preferences. I can't tell you what your final book should look like just like I can't tell you what the photos inside of it should look like. It should look like *you*. It shouldn't look like someone else. Period. The size, materials, format, and paper choice are all personal preferences, and that process will drive you a new kind of nuts. Just get one and build it and then go show it to people so you can get hired.

For some examples, check out No Plastic Sleeves (noplasticsleeves.com).

I'm an editorial/commercial shooter. Do portrait photographers need a book? Maybe. You definitely have to have a web site. How do you put your images together for your web galleries? Go back to the beginning and read again. Print, web, iPad, wedding album—it's all the same process for me. When you have to collect a body of work and present it, you have to edit it into a cohesive collection. Book editor. Magazine editor. News editor. *Photo* editor. There's a reason that job title exists. Whether you are going to print your book or just have a web site, I can't recommend this kind of process enough. You will learn so much about your work and the work you should be shooting.

Q: I WANT TO MAKE THE JUMP FROM JUST WEDDINGS TO SHOOTING MORE EDITORIALS FOR MAGAZINES AND, HOPEFULLY ONE DAY, CAMPAIGNS FOR COMPANIES. I HAVE A FEW FRIENDS WHO DO THIS AND THEY TOLD ME IT'S JUST ABOUT DOING THE PROJECTS ON MY OWN AND THEN BEING IN THE RIGHT PLACE AT THE RIGHT TIME TO GET OPPORTUNITIES. I'VE BEEN FRUSTRATED FEELING LIKE NO ONE WILL GIVE ME A CHANCE. HOW DO I GET MY FOOT IN THE DOOR? DO I PITCH MYSELF TO REPRESENTATION? DO THEY FIND ME? DO I WAIT? I'M FEELING A BIT LOST.

A: Your friends are pretty much correct. If you want to move from one type of photography into another type of photography, then you are most likely going to have to shoot a whole new body of work. Weddings aren't going to translate to editorial and advertising. If you aren't getting hired already to shoot the work that you want to shoot, then you have to go shoot it yourself. Your time. Your dime.

Once you've shot this new work it's about networking and marketing. But not network marketing. :) Getting yourself and your work "out there." A rep (photography representative) isn't going to talk to you unless you're a phenom and have amazing talent, amazing drive, and they have the right kind of contacts who will accept you.

You see—a rep is looking for *working* photographers. It's kind of a catch-22 situation at times. They are most likely going to find you. There are times when you find them and they bring you on, but usually that's not the way it works. They need you to have a pretty stable list of clients going on your own. They have the types of clients your work can fit with. You have a unique enough style that they can market, and you can only create that style by getting out there and working for a while (read: years). You need to prove you can hustle and can get out there and get work. You need a rep not so much because you need them to get you work, but you need them to take over some of the business side of what you are doing. You need a rep because you're too busy. This isn't always the case, but it is pretty standard in the industry. Also note that getting a rep is like a marriage. You have to *love* your rep. You two have to connect personally and professionally. If you meet a rep and you wouldn't want to hang out with them,

then you two are probably the wrong fit; your marriage won't last.

A rep typically is going to take anywhere from 20%–30% of what you book. Even if it is a steady client of yours prior to getting this rep, and even if you get the call and book it yourself without their help. They still get a commission. They get a commission off everything you shoot. Of course there are exceptions; things can be worked out on a case-by-case basis. Expect them to take over your existing clients. Expect them to ask you for a lot of collateral like multiple portfolios, promo cards, mailers, leave behinds, etc. Some—and this is rare—will share the cost of these materials with you. Many expect for you to pay for all of these materials yourself.

I have never had a traditional photo rep. I've had business managers. I'm with Wonderful Machine; they are sort of like a hybrid. They can rep, or produce, or just pass contacts, or just bid. It's a pretty interesting thing they do. But as for a traditional rep—never had one. There are only a few reps out there I'd actually like to work with. This is based on the type of work they can land and where I would fall in their existing roster of photographers. I would want to be able to stand out from their pack just a bit.

To be honest, I've heard more bad stories of photographers working with reps than good stories of photographers working with reps. I've heard of photographers doing most of the legwork while the rep still gets a commission. I've heard of photographers feeling like their rep gets jobs for other people on their roster but not so much for them. They feel like they aren't being fought for. I've heard of photographers getting under a contract with a rep, being unhappy with them, and then feeling "stuck" until the contract is up. I have, of course, heard amazing stories, too. A great rep with a great contact list can make amazing things happen for a photographer. A rep can land a $50,000 job that the photographer would have done for $5,000.

So, don't bank on getting a rep just yet. You have a lot of hard work in front of you. First you have to build a book. Then build a site. Then get promo cards and other collateral together. Then you need to build a list of editors and agencies you want to work for. Then you start sending your work in. You promote yourself. You make cold calls. You set up meetings. You give all of this a solid year before you expect some returns. Don't be surprised if that one year turns into five years of hustling.

Building a new body of work? Building a new site? Creating something from nothing? That's about two years of work right there. *Two years!* How much does that suck? *A lot.* So what? Is it worth it? Do you want it that badly? If you do, then you'll do the hard work. If you don't, then you'll give up and go do something else, plain and simple.

•••

Ready to do the hard work? How do you get your foot in the door?

Your first step is to loosely (or narrowly, if you can) identify your style. What is the genre of work you want shoot? People? Travel? Food? Then what is your style within the genre you want to work? Natural? Composited? Black and white? Saturated color? Quiet? Loud? Subtle? Over the top?

Let's say you shoot natural environmental portraits; your style is fairly simple and straightforward. You're most comfortable in color but you can work in black and white as well. You gravitate toward everyday people (business owners, chefs, local politicians, grandmother of the year, etc.).

Now that you have an idea of what you shoot and how you typically shoot it, your job is to identify publications and agencies that mesh with your style. You may

find you are more of a fit with *Time* magazine and not *Wired*. More *Rolling Stone* and less *XXL*.

Make a list of all the publications, agencies, and brands you want to work with both locally and nationally for wherever you are in the world. Find out who the photo editors, art buyers, and art directors are at these places. Do your homework on them. You can find their names and titles in the masthead of the magazine, or you can use a service like Ad Base or Agency Access to do your research.

Now you need to introduce your work to these fine folks. They can't hire you if they don't know you are alive and taking photos for a living, right? If you don't know their name, they sure as heck don't know yours. While an editor might just find you in a Google search, don't hang the success of your career on that off chance they'll come to your web site. You need to be proactive in the introduction.

Plan your own personal advertising campaign. You need to start sending emails or mailers to these folks. Your campaign has to catch their attention. They get tons of photographers' promos and yours has to click. You need to be consistent with it, as well. They'll most likely not remember you on the first one, nor the second, nor the third. You have to be *consistent.*

Also note that if you want to work for five magazines you'll need to promote to 50.

There's no science to this, but consistency works. Following up works. If you can get a face-to-face meeting to show your work, that is huge! Mailers and emails are impersonal. A face-to-face meeting is invaluable and personal.

Plan on spending at least a year or two (or more) campaigning for yourself until you start to see some kind of return. If you haven't gotten a single call for a job in a year, then you need to rethink what you are doing.

Honestly look at your style and abilities as a photographer. If you mail 100 magazine photo editors and nothing happens after a year of mailers, then start over. Build a new book. Build a new campaign.

If you are thinking you want to make this switch in a year or so, then you have to start *now. Now! Now!* You better get a sketchbook, some coffee, and your camera, and start shooting new work *now. OMG now!* You have at least a year of promotions to do. Those promotions have to be made with your new work. You have to go make that new work. Oh shit. You're already behind. You're already late.

You build a new site now with editorial/commercial type of work and start promoting it now. The next year of weddings will be your day job as you start to build your name in another genre. Start *now. NOW!* Don't wait until that next year of weddings is over to start this process. If you do, you'll be so far behind you'll never catch up or you'll have to take weddings for another year.

Why are the successful photographers you see today successful? Because they worked their ass off for years before you ever heard of them. I was recently talking to John Keatley. He's a fantastic editorial and advertising photographer based in Seattle, Washington. As I was asking him about his career trajectory, he told me that it took a solid six years for him to finally start gaining traction with the type of work he has wanted to do. Six years! He's a great guy. Check out his work (www.keatleyphoto.com).

Is your pulse rising? Are you feeling overwhelmed? Anxiety taking hold? Confidence dropping to new lows? It's okay. Welcome to the world of photography! Buckle up and get ready for the ride of your life.

Q: WHAT DOES AN ART BUYER WANT TO SEE IN AN ADVERTISING PHOTOGRAPHER'S PORTFOLIO? I MAINLY SHOOT PEOPLE IN AND OUT OF THE STUDIO.

A:
It's hard to say but I'll tell you what I've learned in meetings with art buyers and art directors.

You want to show work that's within the style of the art buyer/art director who you're meeting with. If much of their agency's work is highly processed and incorporates a lot of slick production, then your book needs to swing in that direction. If they tend to have more of an editorial feel, then you would want your book to swing in that direction. It's not always cut and dry though.

A large agency can have several clients that have varied styles, so show what comes most naturally to you in hopes that your work could fit within the style of some of their clients. There's always an unknown factor, as well, in that the agency may have a new client in house that you know nothing about and maybe your book will fit well with this new client coming in. In fact, you may actually be having the meeting because of a new client

they have, and they have to find a few photographers who would be a good fit for this new client. Most of the time, you have no idea if this is the case or not.

Be true to yourself no matter what. If you're a natural light black and white photographer, don't feel you have to fake an overly lit colorful look to your book just to get work.

Personal work is always a good thing to show, too, and it can vary in style from your main book. My main book is very portrait heavy but my personal work is, at the moment, more street. By the end of the year, I'll have some portrait-driven personal projects that are in line with more of my work.

Remember: Less is more. If you don't have it, don't show it. Keep it on point. Keep it personal.

Q: YOU MENTION THAT YOU LIKE TO STUDY GREAT PHOTOGRAPHERS' WORK, AND THAT IF WE WANT TO UNDERSTAND GOOD WORK, WE SHOULD LOOK INTO DOING THE SAME. I AM CURIOUS, DO YOU HAVE A LIST OF YOUR FAVORITE PHOTOGRAPHERS?

A: In no specific order. Go look these folks up.

W. Eugene Smith	Gregory Heisler
Gordon Parks	David Burnett
Mary Ellen Mark	Susan Meiselas
Mark Seliger	Mario Testino
Edward Weston	Paolo Roversi
Dan Winters	David Turnley
Philippe Halsman	Sebastiao Salgado
Robert Capa	James Nachtwey
Yousuf Karsh	Dorothea Lange
Kareem Black	Margaret Bourke-White
Peter Yang	Gregory Colbert
Peggy Sirota	Sam Abell
Herb Ritts	

Mark Seliger is one of my personal photographic heroes. He has been an inspiration to me and my work for at least 15 years. I had the opportunity to hear him speak at Photo Plus a few years ago, and I cornered him on his way out the door for a portrait. He was kind enough to give me a minute of his time. :: Canon 5D Mk II / 24–70mm lens @ 70mm / f3.2 @ 1/160th @ ISO 100 / Lit with a Nikon SB80-DX in a 28" Westcott Apollo softbox.

That should keep you busy. These are folks, both new and old, that you should know about. There are so many more people I could list. Study these. They will lead you to others.

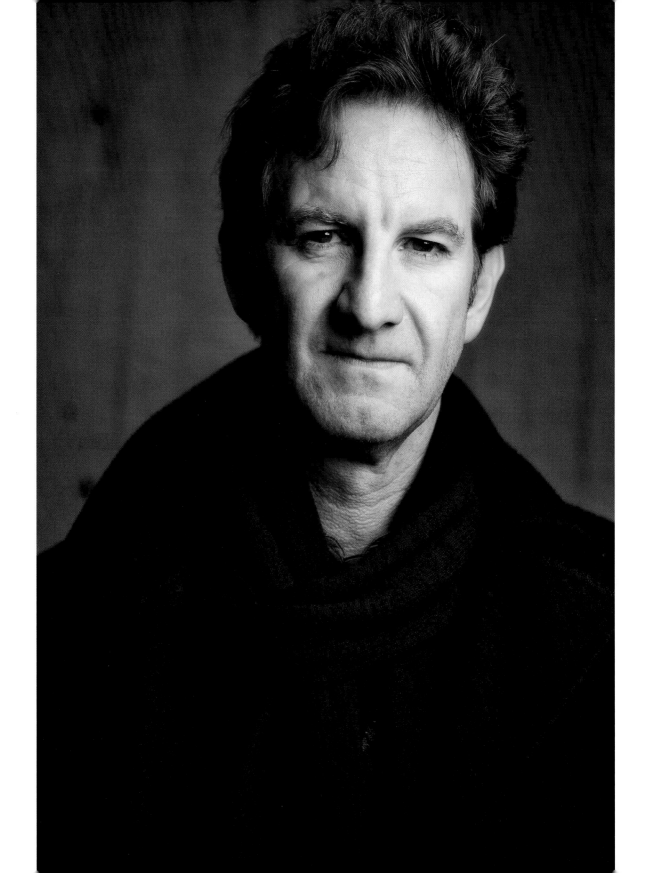

Q: IN A TIME OF BTS (BEHIND THE SCENES) VIDEO, DO YOU THINK IT IS NECESSARY FOR PROJECTS TO ALWAYS BE MARKETED AND PUT OUT WITH A BTS VIDEO FOR THE SAKE OF OTHER PHOTOGRAPHERS?

A: No. Also note they are not always for photographers. I did a BTS blog post (no video) about a shoot I did for *Harvard Business Review*. I photographed the CEO of the Coca-Cola Company, Muhtar Kent, for *HBR*. While the post was written in a language for photographers, I have gotten at least four more editorial gigs and one corporate gig for Coca-Cola from that one post because editors read it. The BTS post shows how I work, the research I do, and the hustle I have to get the shot in a small amount of time.

That was enough for others to trust me to work for them. I need to do more of those! :)

Also note that a lot of BTS videos are boring montages of hair and make-up and photographers pointing at the backs of cameras. If you're going to do a BTS video, make it interesting, informative, and remember that clients are watching, so let it speak to them as much as it can speak to photographers, if not more.

Q: WHY DON'T YOU SHOW MORE OF YOUR WORK?

A: Because I'm busy. Because I want to redo my entire portfolio. Because if I shoot a job today for a magazine I can't show the image until it hits the news stands, so I may have to wait 60 days or so to show it on my blog or site, but then I'm on to the next thing. I have a backlog of stuff I want to show. Because I lack discipline in staying on top of my own portfolio. Because I want it to be perfect. Because stuff I'm shooting today doesn't quite mix with what I already have so I need to shoot more of what I'm doing today so I can begin to mix it in. Because I want to. I really want to. But then I get sidetracked. Because the road to hell is paved with good intentions. Because sometimes I get lazy. Because sometimes I forget. Because life goes by too fast. Because I can keep coming up with excuses instead of sitting down and getting it done.

A: All right. Light meters. Do you need them or not in the digital age? Let's have a discussion about meters, calibrating your cameras and lenses, and really nailing exposure. A number of folks are going to hate this answer.

I've often said that we don't need no stinkin' meters in digital. We have our screens on the backs of our cameras, histograms, etc., but I always add a caveat. You don't *have* to have one; however, they are useful. I own a few and use them regularly. The thing is, a good light meter will be somewhere around $300. When you are just getting started, that $300 is sometimes better served elsewhere. Eventually, though, you'll find a light meter on your wish list and you'll most likely pick one up. An argument could be made that you should get one at the start. I could argue for that. I could argue against it.

Just never get caught up in the "You never need a meter" or the "You always need a meter" camp. Some think you're stupid for using one in the digital age. Some think you're stupid for not using one in the digital age. I ride the fence and say that anyone who plants themselves in either of those two camps is stupid.

Then everyone in each of those camps says I'm stupid. We're all stupid. Okay?

The reason meters are important is that, when you use them correctly, they give you consistency in your exposures. The more consistent you are as a photographer at the time of exposure, the better your life will be in post-production. If you are an inconsistent photographer at exposure, then your post-production life is going to be a living hell.

I use meters in the "incidence" mode 99% of the time. There are basically two types of metering modes: reflective and incidence. The light meter in your camera is a reflective meter. Spot meters are reflective meters. They are measuring the light *reflecting off* of a subject. Now then, your reflective light meter, spot meter, and in-camera meter don't know what you are photographing. You can read the light reflecting off of something white or off of something black. It doesn't see that what it is reading is white, or black, or grey, or red, or blue, etc. Since it doesn't know the value of what it is reading, there has to be a consistent measurement to bring that light meter reading to, and that measurement is 18% grey. I don't know why; it just is. Smarter people than me came up with that.

So you read light reflecting off something white and it's going to give you a reading to make that 18% grey. Read the light off of something black and it's going to give you a reading to make that 18% grey. White isn't grey. Black isn't grey. So you have to make a judgment call. "I'm getting f5.6 at 1/250th of a second off of the bride's white dress. The dress isn't grey. If I shoot this at f5.6 at 1/250th then the dress will be underexposed to grey. Therefore I need to open my exposure by X amount of stops to make the white dress white."

An incident meter (that little white dome on the light meter) is reading the light *falling on* the subject regardless of whether the subject is white, black, green, grey, blue, dog, etc. You walk over to the subject, put the meter where the light is falling, take a reading. It says f5.6 at 1/60th of a second or whatever. You set your camera to f5.6 at 1/60th and boom! Balls-on accurate. You don't have to think about it.

Well, you don't have to think about it *once you calibrate* it. ISO 100 is not a dead-on accurate thing across the board of camera manufacturers. ISO 100 on a Canon is different than ISO 100 on a Nikon and it's different than ISO 100 on a Fuji. Camera manufactures play a bit with these numbers. There's also a bit of room for your personal subjective tastes. Some like to expose just a little darker. Some like to expose just a little lighter. What's one to do?

Here is what you do. Get ready. Effing boring-ass technical talk. If you hate technical talk please bear with me. Since ISO settings across the board of manufacturers aren't all that consistent, you have to calibrate your meter. I found nearly a full stop difference between my Canon and Nikon cameras. You may also find that ISO 100 on a Canon 7D may be a bit different than

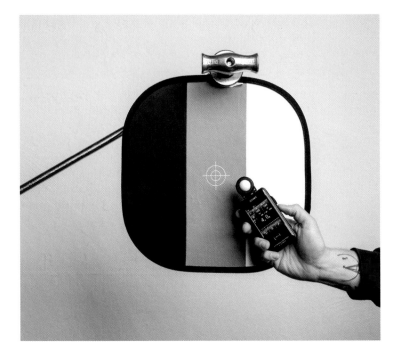

Many say light meters are not needed in the digital age. I've said that myself. I've come to find, though, that they are still important today. Pictured here is the Sekonic L-478DR. I love this meter.

ISO 100 on a Canon 5D whatever. There isn't much change within one manufacturer but you usually find a big swing from one company to another. To add another odd piece to this puzzle, you'll find that f4 on one lens can be off from f4 on another lens you own. As mentioned previously in this book, the ISO (International Standards Organization) allows manufacturers +/– 1/3 of a stop wiggle room on apertures in the manufacturing process, or so I hear.

I've found this to be true in real-world applications. I have a Canon 24–70mm f2.8 lens that is about 1/2–2/3 of a stop brighter than my Canon 70–200mm f2.8 at any given aperture. That means if I shoot something at f5.6 @ 1/250th of a second at ISO 100 on the 24–70mm and then shoot the same exact subject in the same exact light at the same exact settings with the 70–200mm lens, the resulting photo will be 1/2–2/3 of a stop *darker* than when shot with the 24–70mm. It happens throughout the aperture range on each lens.

I've found that my 70–200mm f2.8 is the most off from all of my other lenses. They all differ a little from each other but the 70–200mm is the most off from a standard base line. So what does this mean?

If you're really going to dial in consistency in your photography then you want to test your gear, and you want to calibrate your light meter to some sort of base line. I typically calibrate my meter to my most used camera and my most used lens. Here's how I calibrate.

I set up an evenly lit shot. I take a meter reading with my handheld light meter. Let's say it says f4 at 1/250th of a second at ISO 400. That's what the light meter says. I'm using the incident meter for this. I'm not worried what the camera is saying. I'll then shoot a bracket of images from one stop under that to one stop over that at 1/3-stop increments. I don't shoot these at the most open aperture. You can get aperture vignette at your maximum aperture, which makes the exposure

look darker. I'll typically do this calibration process at a middle aperture like 5.6 or 8 or something.

I take the card out of my camera, pull the images into Lightroom with no adjustments made, and look at the images on a calibrated monitor. I then choose the exposure that I would most like to be the starting point for my post-production. Let's just say that I choose the exposure that is 2/3 of a stop brighter than the light meter reading.

I then walk around in different light (full sun, open shade, deep shade, tungsten, whatever, strobes, etc.) and take photos at 2/3 of a stop more exposure than whatever the light meter says to shoot in that light. I go back to Lightroom and see how consistent that is. If I find I'm hitting the consistency that I want, then I go into the menu system on the meter and set it to +2/3. That way when I take a reading at ISO 200 at f2 and it spits out a shutter speed, I don't have to do any further math in my head. I set my camera to that shutter and I'm good to go.

Then I test my lenses. Then I test other cameras. I make notes and remember that this camera is one stop under from the meter. This camera is one stop over from the meter, or whatever. All the calibration is done with my *main* camera and my *main* lens, and that is the base line. Then notes are made where other cameras or lenses fall from that base line. I once had an old 20mm Nikon lens that had "+.5" scratched into the lens barrel. The photographer who once owned that lens tested it and made notes. It's been around since film, y'all.

Let's say I calibrate my meter to my Canon. Then I find that my Fuji cameras are 2/3 of a stop under from that. Where I would set my meter to, let's say, ISO 200 for the Canon, if I'm shooting ISO 200 on the Fuji then I set the ISO on the meter to ISO 125. This is 2/3 under ISO 200. I take a reading. Whatever that says, I set

my Fuji to that. I don't have to look at the reading and then subtract 2/3 from it. I want to look at my meter, dial that in, and go. I want to keep math out of my head as much as possible.

To the original question: Do you point the white dome at the camera or at the main light? Imagine having your camera on a tripod. Your subject is sitting on a stool directly in front of your camera. Your main light (sun or flash) is 45 degrees to the right of camera. You walk up to your subject and take a reading. Are you pointing the white dome to the camera or the light? This has caused PC vs. Mac types of debates for years. The best answer is to pick one and *always* do that. I think I started out pointing to the camera. Then I got into more dramatic lighting and that wasn't the best for me, so I began pointing the meter at the main light and that is what I always do now.

Another situation where the light meter is really helpful is when you are doing a multi-day job and you can't leave your lights set up between shooting days. I recently did a job for the Coca-Cola company that required shooting over two days. I had to set up, tear down, set up, and tear down over these two days. Another day might be added to the job for more of these portraits. It was a three-light setup, and all the portraits had to be consistently lit. Once I was dialed in on day one, I took meter readings and made notes so that I could get my lights *exactly* back to where they were again the next day. This is *not* something you want to do while chimping on your camera. You need to know that you are exactly right back to where you were before.

Oh—another note about this calibration thing. When you finally get your meter calibrated to where you want it, do this: When you have the images pulled up on your *calibrated* monitor with zero adjustments made to them, put that memory card back in your camera, pull up an image on your monitor and on the back of your camera. Take a look at how that image is produced on

the back of your camera. Does it look darker than the image on the monitor? Lighter? You can adjust your camera screen's brightness a bit to try to match them but make more of a mental note. On my Nikon D3 the screen was really off from what I'd see when I pulled the image into Lightroom. If the picture looked *perfect* on the D3 then it was going to be too dark once I pulled it into LR. If it looked just a bit too bright without highlights clipping, then it was going to be just right in LR. Make little notes of that so that when you chimp you can translate what you are seeing on your camera to how you expect it to look when you start editing.

I highly recommend getting a meter that reads ambient light as well as flash. Don't mess around with just getting a meter for ambient only. There are a handful of meters out there. People will most likely say, "Well, what about this one?" Here's my list and I'm sticking with it. Based on price range and personal experience:

- **Polaris** ($168). I had this meter when I was in school. It's a good meter on a budget. It's the least expensive meter that I recommend to people.

- **Sekonic L-308S** ($233). *Great* meter at a great price. Has a few more things under the hood than the Polaris. Sekonic makes the best meters, hands down.

- **Sekonic L-358** ($309). The nice thing about this meter is you can add a Pocket Wizard transmitter to it later for an additional $63.

- **Sekonic L-478DR** ($469). Touch-screen awesomeness. Great UI. Pocket Wizard control technology built in. Not only can you fire your PW lights from this, you can control the power of them if you are using their control technology stuffs. You can set custom profiles and

calibrations. Kick-ass meter. Just got one of these.

- **Sekonic L-758DR** ($634). If you're one of those jerks who just has to have the best of the best, then get this meter. It has it all except Pocket Wizard control. It has a transmitter but you can't control power settings from the meter like you can with the 478. Note that you can't control power via any sort of old Pocket Wizard. I'm not highly versed on all of that; perhaps check Sekonic's web site for the details.

I'm only touching on some of what a good meter can do. You can take several readings to find an average in a scene. You can figure out the ratio of ambient vs. flash in a mixed situation. You can add filter compensation into the mix. There's a lot you can do with a meter beyond finding what shutter speed you should use at ISO 800 at f2.8.

Is all of this overwhelming? Does it all sound like it's too much of a pain in the ass? Get over it. It's called professional photography. Be good at your craft. Be

great at your craft. Think a pastry chef trusts a new oven to be exactly 350 degrees when they set that on the dial? No. They test it. 350 degrees on the dial might mean 380 degrees in the oven. You need to know that. You need to know your cameras. Your lenses. Your lights. Your exposure. Your screens and monitors. You need to test this shit. It's boring and tedious and all of that, I know. It is. Get over it. Wait till you build color profiles for all your cameras, lights, and modifiers. Be a professional and do it. Don't be another mediocre photographer; there are millions of those. Don't be one. Be great at what you do. Know what you are doing. Do the hard work to learn all this stuff; it's worth it. It'll save your ass one day. Don't be another one of those dumb-ass photographers who doesn't know what they are doing. *Please*! God knows we have far too many of those people in the world right now.

For more info on light meters, hit up YouTube, search "How to use a light meter," and go through some of those. Most are pretty dry and boring, but you'll get a good primer on using a meter.

91–100

Delivering images you hate.

Basic checklist for permanent studio space.

Using a studio to your benefit.

'merica!

What keeps me alive on the streets.

He shoots with Sony. Hahahahaha!

Slow-paying clients.

When to charge for licensing usage.

Can't get no credit.

Learning to sell. Hold this book.

Q: HAVE YOU EVER HAD A SHOOT WHERE YOU DIDN'T FEEL SATISFIED WITH THE RESULTS, BUT YOU STILL HAD TO DELIVER THEM TO THE CLIENT? REGARDLESS OF THE CIRCUMSTANCES, MAYBE YOU ONLY GOT ONE SHOT YOU WERE HAPPY WITH, BUT THE CLIENT WAS EXPECTING A DOZEN? HOW DID YOU DEAL WITH THAT, AND WHAT DID YOU LEARN FROM IT? WHAT WAS THE TAKEAWAY?

A: We can't hit it out of the park every time we step up to the base. That's just the truth. We want to. We strive to. You'll get some asshole like me yelling at you for not hitting it out of the park on *every* job! I don't want your excuses! Make something awesome!

But, yeah, we aren't superheroes. We aren't able to create masterpieces on demand. Sometimes it's us. Sometimes it's our subject. Some subjects bring so much to the shoot with regard to personality and style that you can shoot some pretty great work with your eyes closed. Some subjects show up with one dirty t-shirt and a hatred for having their photo made. You only have so much time in your life to pull them out of their shell. You told them to bring tons of outfits. You've cracked every joke you know and then looked up some more.

I've had jobs I haven't been too pleased with. Remember, too, that you are most likely your own worst critic.

You may have let yourself down but the client is ecstatic with what you have done. I've delivered a lot of jobs like that. I think I could have done this better, I could have done that better. I'll wish that I pushed harder to get a certain location. My light was all wrong, etc. You cringe to deliver the job, and then *boom*! They love them! They aren't as hard of a critic as you are.

Guess what? You're actually a professional at this point. You can deliver a level of quality on your worst day that still makes the client happy. You might not be happy but they are. Status quo to you is "professional photography" to them.

Then there are those times you get a job done and you just aren't happy. The pictures suck. Something was wrong. Your head was in the wrong space that day. The locations sucked; the light sucked; everything just plain ol' sucked that day and you can't, in good conscience, deliver those photos. I have, on a handful of occasions, called the client and said, "I'm going

through these photos and I'm not happy with them. I know I can do better than this. Are you available for a few hours? I want to add some more images to this set for you. No charge."

Then I had better knock it out of the freaking park.

You can't do this for an event. You shouldn't ever do this for an editorial client. Can't do this for a big job that has crew because you have to hire all that crew again—on your own dime. When that sort of pressure is on, I tend to do whatever it takes to make damn sure I'll be pleased to deliver the images. You can't go back.

Some jobs you can. Some jobs you will. Some jobs you will release into the wild and move on to the next one. We all have to learn. We all have to grow. We all have to have an off day. It's when those off days are stringing together, one after another, that you really have to pull your ass out of a nosedive and straighten up and fly right. A bad day now and then—we all have them. Bad days leading to bad months? You need a kick in the ass and/or a break. Step back for a second, catch your breath, and go at it again.

A: High ceilings. Twelve feet or higher. Fourteen feet and up is even better. At least 30 feet in length and 20–30 feet wide. You can get most things done in that space. Note that I'm talking about shooting space only. Not 30 feet with an office. Big windows or a roll up door is nice to have for available light, but you'll want a way to block the light if needed. You need a good number of power outlets available. Preferably running on three or four different circuits so you can plug in steamers, lights, hair dryers, etc., without constantly blowing a breaker.

Parking! I was looking for a new space a few years ago and found a gorgeous studio. The problem with the space was parking. Meg and I drove by on a Friday and couldn't find one open spot for three blocks. Need a client and a crew at your studio on a Friday afternoon? Better have some parking for that. Foot traffic is rarely a need for a photographer. Maybe if you're a family portrait photographer, but then you have to have set hours and be there for all of those hours. Most folks aren't just going to walk in and book a shoot. I'm not saying it's bad, but it isn't a deal breaker.

Have a creative space. You're a photographer, damn it! I've seen studios with drop ceilings, fluorescent lights, and indoor/outdoor carpeting. Gads. Who in the hell wants to create work in a space like that? Burn the acoustic tiles; throw the carpet out the back door; punch a few holes in the wall; stick some beer cans under the couch; spill paint on the floor. *Create art!* You need a space you love walking into. Messy or clean, whatever your style is—get a place like that.

What is a studio? It's a floor and some walls. That's it. Any place can be turned into a studio. Why do I have a studio? The number one reason is so I can have a separate place for work and for home. I have a family of six and a dog. When I'm home I want to be home. When I'm at work I want to be at work. Having a separate studio allows me to do that. Now, the two mix. My kids regularly show up at the studio and hang out. I take a laptop home and do some work at the dining room table. Overall, though, work is at work and home is at home. That's why I love having a studio space.

I've had tiny spaces. I've had huge spaces. I've had dirty, nasty, old spaces. I've had clean and slick new spaces. My current studio is about to become my favorite. I call it "The Lab." I can clean it up or I can trash the place. I don't care. It's a box for me to create work in. I hang shit up on the walls. I spill stuff on the cement floors. I play my music loud. I smoke my pipe. The fridge has beer. There's always a pot of coffee on. I can make the place dark. I can make it light. I can do whatever I want in the space. I love it. Of all the places I've had, it doesn't have the best curb appeal, but it has plenty of parking and character and it's cheap— and a mile from my house. Done.

There was a group of folks in Italy that had a site up called smallstudio.com. The site is no longer there, but I can't tell you how amazing this site was. A photographer by the name of Eolo Perfido, along with stylists and hair and make-up artists and the like, shot fashion work in a one-and-a-half car garage. I was convicted by how little I was doing with my large space when I saw how much they did with their small space. They did more than I've done in a 3,500 square foot warehouse. It was amazing. The space I have now is larger than that, but not much. I'm still influenced by their work. If they did it in a garage, surely I can do something here.

Here's my current studio, which we call "The Lab." It's not too small. Not too large. It's just right. I wish it had a cyc wall but I'm living without it just fine right now. Wish there was some window light, but it sort of has a bunker feeling to it that I love. Rent is cheap. There's a coffee pot. Close to home. Right now it's perfect for me.

 Getting a studio isn't one of those "if you build it, they will come" sort of things. You need to be out and about getting people interested in you and your work, whether you have a studio or not. No one is sitting around wishing they could just find a studio photographer. Know what I mean?

It's you and your work that are going to get the bells ringing. If this was an offsite studio I'd say throw a party or host events, but if it's in your home that might not be the best solution, unless it's one of those studios built in a big barn in the backyard and you could have a bonfire/gallery opening sort of thing, something really unique. If it's a 15x20 room in your house then it's not going to be much of a big party.

Not saying that sucks. It's just not a good option of "using the studio to keep bells ringing."

A studio is a good place to work out of. Clients come to the studio first and then you head out on location or whatever it is you do. Having a consistent place to shoot is nice. You can let people know you have a studio but that isn't going to be the main reason anyone hires you.

Q: YONGNUO TRIGGERS CAN DELIVER WHAT THE BEST TRIGGERS CAN DELIVER EXCEPT FOR HI-SPEED SYNC. I THINK FOR THOSE WHO CAN'T AFFORD THE EXPENSIVE PROFESSIONAL EQUIPMENT, THESE TRIGGERS SEEM TO BE THE BEST ON THE MARKET. WHY IS NOTHING SPOKEN/COMMENTED ON ABOUT THESE IN ANY WORKSHOPS OR FORUMS? IS IT BECAUSE YONGNUO IS NOT *AMERICAN*?

A: *Damn right!* We only use *'merican* products! Like Nikon! And Canon! And Fuji! And Phase! And Sony! And Elinchrom! And….

Oh wait.

I can't speak for the whole of the internet, but I only recommend gear that I have personally used and that I know, for a fact, actually works. Take Pocket Wizards, for example. Pocket Wizards just work. Has nothing to do with where they are made because look at the vast majority of our photo products! They aren't made in America!

There are things in photography that are cheap and there are things that are inexpensive. Cheap things break and are unreliable, and you end up spending that money over and over again. Inexpensive things don't cost much but they are quality products that can be counted on. I recently picked up some Yongnuo 560 II flashes. They are great flashes that only cost $73! I'd peg those as being inexpensive. Can't speak to their triggers. I know several people who are happy with their Phottix triggers. I have used a few of their products and they've always been reliable.

FREEDOM!!! HELL YEAH!!! AMERICA!!! And Japan. And China. And Sweden. And all the rest. :)

A: Let me first define "drug boy" so there isn't any confusion. "Drug boy" is a common street term for young men who hang out on street corners in my city of Atlanta. They aren't necessarily selling drugs but each street term comes from some sort of known fact. Basically what we're talking about here is hanging out on street corners that aren't going to be named as the safest places to raise a family by Martha Stewart. Know what I mean?

How do I keep from getting my ass kicked? I summon up what I call my inner Forrest Gump. Sometimes it's my inner Dennis Hopper, too. I come across as being either way too stupid and naïve to understand that I'm somewhere I don't belong, or too crazy to be messed with.

I'll be walking around and turn a corner that I suddenly realize is a corner I might not need to be on. If I turn and run for cover at that moment I feel as though I'd be a target. So I walk boldly down the street. Let's say there are four or five dudes hanging out wondering what in the hell I'm doing on that street. I'll walk right up to them. I'll put my hand out and introduce myself. I'm either stupid or crazy. Either way, I'm an anomaly that most don't know what to do with. Then I just start talking and asking questions. I'll make a comment on someone's tattoo or something and ask to take a photo of it.

I get asked a lot if I'm with the police. "F#ck no, I'm not a cop. I know I look like I eat a lot of donuts but I ain't no cop." Now—that's not a dig on cops. That's just me staying alive for a few more minutes.

"No, really. That's a badass tattoo. I'm a street photographer. This is what I do. I wander the streets and take photos of shit that's cool. I won't push you, though. It's good. People think I'm a crazy mutherf#cker. I guess I am. Y'all have a good day."

A detail shot of a neck tattoo that I found interesting while walking the streets one day. :: Phase One IQ140 / 80mm / f2.8 @ 1/80th @ ISO 100 / Available light.

I show a lot of respect, as well. There are times when I puff my chest out and take a strong stance, but that's only when I'm dealing with someone who's just drunk or stoned. The "drug boys" are pros. They aren't messin' around, and respect goes a long way. I make a lot of eye contact. I stand my ground. I'll make the first connection. But I'll bow my head and say "Yes sir" and "No sir" a lot.

I get yelled at sometimes. I get called all sorts of names. I've had people get right in my face. The ones who make the most noise aren't the ones I'm most fearful of. They're just the crazy ones that a Phase One camera to the temple could take down pretty quickly. It's the quiet ones I look out for. How I handle myself around them goes a long way.

I'm not saying it's for everyone. I'm not saying I won't get my dumb ass jacked tomorrow. Some people skydive for a thrill. I walk the streets with a Phase One. :)

At the end of the day, people are just people no matter the profession. Respect goes a long way. When people realize I'm not a threat I'm treated kindly.

Q: I HAVE BEEN A PRO PHOTOGRAPHER FOR ABOUT 18 YEARS. I HAVE BEEN SHOOTING FILM FOR 15 OF THOSE YEARS. MY FIRST DSLR PURCHASE WAS THE SONY A900. FOR THE MONEY IT JUST SEEMED THE RIGHT MOVE. SO ANYWAY, THIS YOUNG PHOTOGRAPHER JUST STARTING HER BUSINESS (BABY PORTRAITS ON PROPS) LOOKED AT THE CAMERA IN MY HAND AND CHUCKLED THAT IT WAS A SONY. BY THE WAY, SHE WAS HOLDING A CANON. WHY ARE SONY SHOOTERS MADE TO FEEL LIKE THIRD-CLASS CITIZENS? WHY IS HER GEAR BETTER THAN MINE?

A: You've been a pro for 18 years and you don't know the answer to this question? Who is at the top of the pro game in the 35mm format world? Canon and Nikon.

Sony, Pentax, Olympus, and the like have always been the distant cousins to the hot shots of Canon and Nikon. Right? Oh yeah, and those Minolta kids way back when.

You shouldn't be asking this question because it doesn't matter. You shouldn't ask this because you have 18 years of experience. I always make fun and bust the chops of Sony/Pentax/Oly shooters. It's just fun, but anyone who takes photography seriously knows it doesn't really matter. If this young photographer wants to laugh at you and think that she has the upper hand because of the brand on her camera, then you should know that her priorities are wrong. "It ain't about the camera, honey," would have been my reply.

Canon and Nikon remain at the top of the game because the majority of pros shooting that format are going to be in one of those two camps. Go to any rental house in the world and they are going to have a larger selection of Nikon and Canon. Any pro shop is going to mainly have Nikon and Canon. There are more sites dedicated to them. Better pro service for them. More selection in parts, pieces, repair shops, etc.

But again. You've been a pro for 18 years. Who cares? If you like Sony then rock the Sony. Let 'em laugh. Prove your experience with the images you make—not the gear you use. Point them to the work of Brian Smith (www.briansmith.com). He's an amazing photographer and he shoots with Sony.

Sony. That's funny. Why would you shoot with a Sony? **chuckles**

VISUAL INTERMISSION

FEELING SORRY FOR YOURSELF

So, I'm in the passenger seat of this Lamborghini as I'm flying down Sheikh Zayed Road in Dubai. I'm holding my camera over the dashboard that is upholstered with beautiful Italian leather. I'm shooting blind and trying to not let the camera touch the leather. I *cannot* leave a scratch on this car. The roar of the engine is intoxicating and I'm trying to shoot *and* enjoy this surreal moment. The air is warm and filled with a fragrance I've only smelled in the Middle East.

Okay. Who has two thumbs and sounds like a pompous asshole right now? Yeah. Me. How many of you are currently saying, "Zack, you son of a bitch. I hate you"?

Let's review the three years before I made this photo.

Three years earlier I was sitting at home wasting time on the Internet, as I am prone to do. I was making the rounds through blogs I have bookmarked, and I hit David Hobby's blog, strobist.com. He was blogging from an event in Dubai called Gulf Photo Plus. Dubai was at the top of the list of places I wanted to visit before I die. At that time I didn't so much as have a passport, let alone the ways or means to travel to Dubai. But there was David in Dubai. Of course he was.

I started feeling really sorry for myself as I read his blog post about that crazy city. He was there with a bunch of other photographers, and they spent their evenings at the rooftop bar of the hotel where they were all staying. There I was in Atlanta, struggling through a bunch of personal stuff. Business was okay but it wasn't stellar. I was teaching here and there, and

that was cool, but I wasn't finding any real traction. There's Hobby. In Dubai. Livin' the dream. Son of a....

I was always close to making it, but everything always seemed to just stay out of my grasp. I closed my browser and threw myself a good ol' pity party.

About three months later I got an email. From a guy named Mohamed Somji. He said he got my name from David Hobby. He was in need of another lighting teacher at this event he runs in Dubai called Gulf Photo Plus. He wanted to know if I'd be interested in flying out there and teaching.

You know what I say about comparing yourself to others? It's not good. Pity parties don't move you forward. When you see others find success, you have to rejoice with them because that means there is hope for you as well. You never know who is talking about you today about an opportunity for you down the road. Just keep going; keep working; struggle through it. I do not possess anything special aside from working hard and sharing my stories as I navigate these waters. Hard work and sharing. That's it; that's my formula. It only takes years of rinsing and repeating for it to finally gain some traction.

Work hard. Share. Rinse. Repeat.

Canon 5D Mk II / 24mm /
f8 @ 1/160th @ ISO 800 /
Available light.

Q: WHAT DO YOU DO ABOUT A BIG COMMERCIAL CLIENT THAT IS EXTREMELY SLOW TO PAY? I'M A FULL TIME PHOTOGRAPHER AND I'VE GOT KIDS TO FEED, SO I'M TORN BETWEEN BUGGING THEM ABOUT IT OR PLAYING IT COOL SO I DON'T SOUND LIKE I'M BROKE AND DESPERATE. I WANT TO GET MORE WORK OUT OF THEM IN THE FUTURE, SO I'M KEEPING QUIET AND WAITING FOR THE MAILMAN RIGHT NOW. HOW WOULD YOU HANDLE IT? I GENERALLY ASK FOR 30-DAY PAYMENT TERMS, BUT PEOPLE OFTEN GO OVER AND I HAVE TO CALL THEM TO GET PAID. ADVICE? THANKS.

A: This is one of the worst aspects of our jobs. Working with individuals is so great because you get a check and do the job on the same day in most cases. With large commercial work, I typically get a deposit of anywhere from 25%–50% of the estimate, depending on my cash flow needs at the time and whatever hard costs I may incur doing the job. Sometimes I need more money up front. Sometimes I know I need more of that money 30 to 60 days from the point of shooting. Either way, I at least get my hard costs covered up front so I'm not holding those costs for 30 to 60 to 90 days out from doing the job.

I invoice and start the waiting game. Sometimes it's a full 30 days. Then it hits 45 and I'm sweating. I'll let it hit 30 days and then email the week after that 30-day mark. At 45 days I'm on the phone. At 60 days I'm emailing and calling anyone and everyone who made a decision on that job from the client side.

The problem with commercial work is the person you dealt with and who hired you typically isn't the person signing the check. They get the invoice from you and then send it into the abyss of some accounting branch of the company, oftentimes in another city. You don't have direct access to whoever is approving the invoice and cutting the check.

It sucks. You wait and wait and wait. It's a good thing to have a mix of commercial work you invoice for and local work you collect a check for the day of the shoot. Cash flow is a bitch in this industry. If they go over 90 days, don't work with them again. They aren't worth it and they don't respect you. Work you aren't paid for in these conditions is not the kind of work you want more of.

Q: WHEN SHOULD YOU CHARGE FOR LICENSING OR "USAGE"?

A: Usage. Let's put it in simple terms so I can understand what I'm talking about:

You get hired to shoot a job for a client. They want to use the images. You can spell out how they can use the images. Where they can use the images. How long they can use the images. You are licensing rights for them to do this. You negotiate all of this and how much it will cost at the beginning of the bidding process.

It's a lot like renting a car. The car rental company says how long you can use the car. How far you can drive. Who else is allowed to use the car. You can rent a car for one hour to drive 15 miles. You can also rent a car in New York City and drop it off in L.A. Renting the car for an hour is a lot less than a cross-country road trip and dropping it off in another city. You cannot rent the car and then rent it out to someone else. You can't sell the car. You don't own it. You can't ship it to Europe and drive around the south of France with it either. You can't pay for it for a week and use it for a year. If you want a car you can use at any time, anywhere, and let anyone else use it, then you do what? You *buy* the car.

You use this same sort of thinking with images. At least in editorial, commercial, corporate, advertising, etc. You never deal with this with family portraits or weddings or the like*. Unless you're shooting family photos of a celebrity or big CEO or something. You might shoot a family portrait of a CNN anchor and then CNN or whoever starts using that image. That gets dicey.

When you are negotiating rates, you are also negotiating usage for the job you are going to shoot. This has to be in writing and signed by everyone involved. Even modeling agencies will quote rates on usage so if you are hiring a model they need to be in on the usage. Usage can look like:

"One year unlimited usage for North America in print only." You can limit it to web; or web and print; or trade publications only. Or whatever. You can limit the time. The place. This is part of the initial talks you have with people. Some places have standard usage they need and dictate it to you: "We need unlimited North American coverage for print, media, web, etc. for two years." Or something like that. I'm speaking in simple terms. Some usage language runs on for paragraphs at a time. You'll get into situations where you quote $5,000 for one-year usage. They want two years usage for $4,000. You go back and forth and agree on $5,000 for three years usage. Or you do it for $3,500 for six months usage. I don't know. Just trying to show a range of stuff that can happen.

If you ever work under a "work for hire" contract, then you are giving the ownership of the images to the client and they have unlimited lifetime usage. You no longer have control of the work. I would rather change that to lifetime unlimited licensing and keep ownership. I don't run into that a lot but it comes up from time to time.

Realize that usage is just as negotiable as price, and it is sometimes more valuable. If you can keep the images, you have the potential to sell them later. I've been hired by a magazine to shoot a photo of X person. That person works for X company. X company then licenses usage of those photos from me. A $300 magazine shoot can turn into a $3,000 licensing sale later. If you are under a work-for-hire contract with that magazine, then that $3,000 sale is out the window. The magazine can actually license the images to the subject and make more money off of your work. Fun, huh?

When I started working with bands I never really put any of this in writing. The verbal agreement was: You pay me money; I give you pictures. I own the pictures and can do whatever I want with them later except commercial work since I didn't get model releases. I didn't want to chase an unknown band down three years later because I saw one of my pictures stapled up to a phone poll promoting their show at Tom's Wing Shack. Know what I mean?

Well, then I shot this guy named Zac Brown. Zac was just a local musician working the local Atlanta scene.

I first met Zac Brown when he was just a local musician working the local venues in Atlanta. He's sort of a big deal now. :: Nikon D100 / 85mm / f10 @ 1/160th @ ISO 200 / Vivitar 285 flash in a 50" Westcott Apollo softbox.

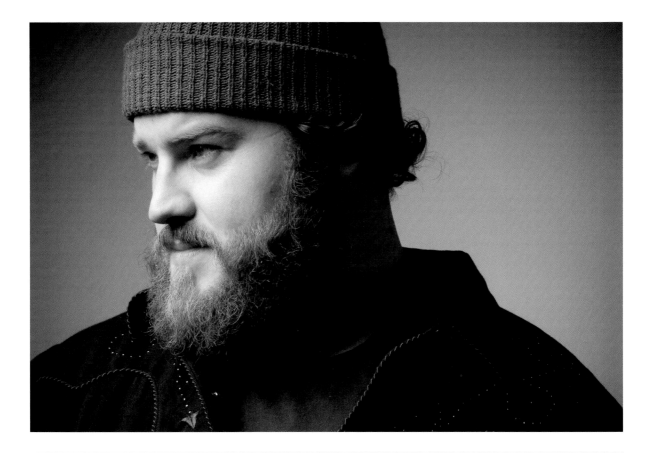

I shot photos for him for $250 and gave him a disc of images. He's sort of a big deal now. As his career took off, those images went all over the place. They got put on t-shirts. He picked up sponsors. They used the images. He did a cookbook recently—and guess what?—my photos from that shoot are in that cookbook. I had no written agreement. There wasn't a contract signed that spelled out usage.

I could have caused a stink when I saw them on a Jagermeister poster. Legally they didn't have rights to the photos. I could have raised hell about the cookbook. I could have started sending letters attached to invoices. I could have lawyered up. Or—I could learn my lesson and move forward with life. Zac owns a record label now. He works with a lot of artists. Guess who does some shoots for them? Guess who charges more than $250 for those shoots? Guess who has an *effing* contract on those shoots that spells out usage? Guess who has two thumbs? Me. I've joked with him since, saying I should have charged more and had a contract. He smiled, slapped my back, and said, "Damn right!"

You learn. You move on. It's good to have this stuff in writing, even on the small jobs. Let's say we look at the person who asked about shooting for the salon (page 152). Photographer shoots photos, gives the photos to salon owner, and then the photographer goes home. One day a sales rep for the products this salon uses comes in and sees the photos. The sales rep loves them and wants to use them for an advertisement. The salon owner, not being versed on usage, hands the sales rep the disk and the photos end up in a national advertisement.

What's next? Well, the photographer can call the salon and tell them that what they did was wrong. The salon owner didn't know; they thought they could use the images any way they wanted. Plus, they like this sales rep and this company and they need to keep a good relationship with them so it helped them out. Now the photographer contacts the product company and lets them know they didn't have rights to the images. The

sales person was told they did. *Nothing* is in writing and people start to get upset. The photographer feels taken advantage of, the sales rep is pissed at the salon owner, the salon owner is pissed at the photographer, and the photographer is pissed at everyone. This isn't going to end well even if the photographer manages to negotiate a check out of this situation. The salon will never call this photographer again. Any ties that could have been made with the product company—you know, the one who liked the work—well, those ties are cut. The photographer gets one check and is now bad-mouthed every day for a month at the salon. *Suck!* The salon owner looks at the photos on the wall, thinks of the photographer, and isn't happy.

Take a deep breath if you get in this situation. You just got cornholed. Put on your diplomacy hat, head to the salon, and talk to the owner. Let them know the company didn't have usage to those photos, but it's okay, the salon owner didn't know. *You* were wrong for not dealing with that when you did the job. *No* worries. You're actually really happy the product company liked the photos. Can you get the name and contact info for that sales rep so you can hire a hit man? No—not to hire a hit man.

You call the sales rep and nicely state that usage wasn't granted but you aren't going to make a stink. Just in the future they need to contact you about usage. You're super duper happy they liked the images and you'd love to talk to them about doing some more work. "I did that job on a shoestring budget. I'd love to talk to you about what we could do with more time and more resources." Or something like that. Politely inform all parties involved, show no malice, and look for future opportunities to come out of it. Remember—it's *your* fault you didn't cover this at the start. Blame could be spread but just don't go there. Learn your lesson. Educate. Move forward one step.

*Even for weddings and family stuff, many photographers will give a release with digital files that states the images can be used for *personal* usage only.

Q: I WAS HIRED BY THE DIRECTOR AND A TEAM MEMBER OF THE BIGGEST ART FAIR IN THE COUNTRY TO DO HER PROFILE SHOOTS. I TOLD THEM SPECIFICALLY TO GIVE CREDIT WHEREVER THE PICTURE APPEARS. MY PICTURE WAS USED IN AT LEAST EIGHT MAGAZINES AND SEVEN TO TEN NEWSPAPERS. NO CREDIT WAS GIVEN ANYWHERE. I TOLD THEM ABOUT THIS. THEY STILL SEND MY PICTURE TO MAGAZINES/NEWSPAPERS WITH NO CREDIT. ONE OF THEIR TEAM MEMBERS SAID, "YOU SHOT FOR US, NOT FOR THE MAGAZINE." WHAT SHOULD ONE DO IN A SITUATION LIKE THIS?

A: I'm sitting here at my computer letting out a deep sigh. I feel your pain.

What do you do? Be a nag about it? Do you have it in writing, which you can kindly point them to, with *their* signature on it? You can put that stuff in the contract, you know. Not that they'll remember it. But it can be in writing that anywhere this is placed a credit must be given. You have a contract, right? :)

Now then—that being said—a few things happen here.

A) The client forgets to tell the publication to do this. You have to remember that you think about this stuff *way* more than your client does. They have a million things going on. They get interviewed and asked for a photo. They fire off the photo in an email while doing a million other things and forget to mention the credit thing.

B) The client does remember to include the part about the credit but the publication forgets and/or doesn't care and runs the photo and moves on to the next thing. Or the writer who gets the email then forwards it to their editor, and the editor misses the part in the email about credit.

Both of these things happen to me on a regular basis. The only time I'm nearly guaranteed to get a credit is when I have shot the image specifically for the publication. Outside of that situation it's a crapshoot as to whether I'll get credit or not.

And here's the truth about photo credits. I have never been able to trace a job I've gotten back to someone reading the photo credit in a magazine. Honest. True story. I ask every new client how they heard about me. It's from web searches or word of mouth or direct referral or a promo card I sent, or something. I've never had

anyone tell me they saw my photo credit, looked me up, and are now hiring me for a job. So—at the end of the day—whether my name is on there or not, it isn't really making a difference to my business.

I once put a clause in my contracts with bands that if they get an editorial request for a photo I shot, then they must send all of those requests to me to fulfill. I figured that'd be a good way to deal with that issue *plus* give me the opportunity to interact with a publication for possible future work. The problem with this, however, was the band or artist would forget about that clause and just send photos; or they'd send a request that would need to be taken care of right then and there and I'd be out of town, or on a job, or something. I couldn't get to their photos immediately when they were being requested. So I'd have the band/artist go ahead and send them in. This "bright" idea of mine actually turned out to be more of a pain than a good thing, so I removed that clause in my contract.

On the client side I can see where they just need it to be an easy transaction. You shoot photos for them. They pay you. You give them the usage they need. They pay for that usage. Then you release the images out to them and move on to the next job. You can't police everything, and they need to just do what they have to do without constantly looking out for you. Months or years could have passed, and they're still trying to follow up with publications about your credit line? That's a pain for them.

I know. It sucks. You'd like credit where credit is due. I get that. We all want that. But it doesn't always happen and it ain't the end of the world. Put yourself in their shoes, follow that image through all the email chains, and it's pretty easy to see how we photographers get lost in the shuffle after the job is done.

Q: HOW DO YOU GET POTENTIAL CLIENTS TO BE *ACTUAL PAYING* CLIENTS? WE HAVE A LOT OF PEOPLE INTERESTED IN PHOTOS AND SAY THEY WANT TO DO A SHOOT, BUT WE CAN'T GET COMMITMENTS. THREE WEEKS AGO WE HAD 12 PEOPLE SAY THEY WANTED PICTURES DONE—WE HAVEN'T DONE ANY FOR THOSE PEOPLE.

A: This is where you have to put on your shiny white shoes and your colorful plaid suit and wide brown tie and become a salesman! Step right up, ladies and gentlemen! Look at the deal we have for you today! *Big* smiles!

Twelve people interested and not one booking tells me that you're not selling yourself or something. You have your name out there enough to get them in the door, and then they walk in said door, and you look up from your book or something and mumble, "Hi," and go back to reading. That isn't what you are doing (I hope), but something is falling apart here.

Are they not booking on price? Are they not booking because of your availability? Are they not booking because you're sort of quiet and shy and lacking in confidence and you can't turn on the bright eyes and smiles to keep them interested?

When I was in high school I thought about going into sales as a profession. A friend of mine worked at the piano store at the mall across from the drug store I was working in. His name was John. John couldn't play three notes that sounded good on a piano. He couldn't show you the "A" key. That mofo could sell pianos, though. He could sell ice to the Eskimos, so to speak.

Okay. Funny story. I have to tell you this story about John. I was on my break hanging out in the piano store and I saw this whole thing happen. True effing story. A couple was in his store looking at a piano. The guy really wanted the piano; he had his heart set on it. It was a lot of money, and the wife was complaining it was too much. They got to the point of sitting at John's desk, and he was writing up the bill of sale. The wife would not stop talking about how they should not buy this piano. John finished the paperwork; all the man needed to do was sign it.

So, the wife would not stop talking. The husband began to rethink his decision and was hesitating on buying the piano. John opened a desk drawer and pulled a phone book out. He turned to the wife and said, "Ma'am, can you hold this for me, please?" and then handed her the phone book.

Stunned, she took the phone book, and stopped talking; I suppose she was silently wondering WTF just happened. John turned to the man and handed him a pen and said, "I just need you to sign here and we'll have your new piano delivered in two days!"

The man signed. John took the phone book back from the wife, shook both of their hands, and then walked them to the door.

It was one of the greatest things I've ever seen! :)

•••

What can we learn from John? Other than handing a phone book to your wife when she's telling you to not buy that next camera?

John had to make that sale. He got a small draw every week that he couldn't live on. He could only live if he sold pianos. He needed to sell a quota of pianos each week or he'd be broke. If you showed interest in a piano then John was going to part you from your money and you'd get a piano; he had to.

•••

There are two main things you need in order to be a good salesman/saleswoman. One is hunger and the second is confidence in what you are selling. When you are a freelance photographer, you are a hungry individual. You have to make this work. You have no choice but to make this work. You have to get out there and get paying clients in the door. You have to. Your life, and the life of your family, depends on it. You can't take "no" for an answer.

The other thing is confidence in what you are selling. I see photographers fail on this part the most. This is where I have failed the most in my "sales" life. You have to be confident in what you do and what you deliver. I know I can deliver for my clients. I know I can make them happy. I know that I can hate my own work and beat myself up and pick out every mistake I make, but at the end of the day—I come through for my clients. If I don't, then I work at it some more until I do. I fight my inner demons on every job and deliver the work I need to deliver that day. I know I can do it.

You also have to be confident in the rates you are asking for the job. You can't apologize for your work or for your rates. You have to show your work to people and with unflinching confidence look them in the eye and say, "This job will cost $5,000." Or $500, or whatever. $50,000. Whatever your number is.

Unflinching confidence. In your work. In your rates. You can't take no for an answer. You're hungry and you have to make this sale. You dance around a very thin line separating laid-back coolness and over-the-top desperation. Twelve people interested in you and then not booking? Someone needs a phone book handed to them. You need to look them in the eye and hand them a pen. Even on your darkest days, when you think your work is shit, when you are being eaten by the cancer of comparing yourself to others, when it's all heading south on you—you have to be able to brighten your eyes. Widen your smile. Put out your hand. Close the deal.

I can't give you a pre-written sales pitch. I don't know what you do. I don't know your clients. I don't know a lot about what you do to be able to tell you to say this line and then that line. I don't know your personality. There isn't a template. I'm sorry I can't give that to you. Lawwwwd above knows there are places out there offering template services for marketing and sales. Some may work for you. Some will be utter failures.

Instead of looking for a template, I want you to think about how hungry you are and how confident you are. I'd bet you are more hungry than confident. You need both in equal measure. Your clients don't deal with your inner demons. You need to silence those demons.

101–106

Gear porn.

Cards & Battery system.

Do as I say. Not as I do.

Personal Personal Projects.

One day you're great. The next, you're a hack.

Putting the camera down forever.

Q: ASSUME YOU HAD TO START YOUR GEAR LIST OVER FROM SCRATCH AND ONLY HAD A BUDGET OF ABOUT $5,000. WHAT WOULD YOUR RIG LOOK LIKE? ALSO, IF YOU WERE TOLD YOU HAD TO GIVE UP ALL YOUR GEAR EXCEPT ONE CAMERA, ONE LIGHT, AND ONE MODIFIER, WHAT WOULD THEY BE AND WHY?

A: If I had $5,000 to spend on gear to start over with:

- Used 5D Mk II as main camera. Used 5D Mk I for backup. ($2,000-ish for both)
- Used 35mm f2 and used 85mm f1.8. ($450-ish for both)
- 2 Yongnuo 560 II flashes ($150)
- 2 Pocket Wizard X triggers ($200)
- Paul C Buff Vagabond Mini battery ($250)
- Used Alien Bee 1600 ($250)
- 2 8' light stands ($150)
- 2 60" shoot-through umbrellas ($60)
- 4 8-GB CF cards ($100)

That's less than $4,000. That would give me around $1,000+ for various little things like sync cords, a bag, Lightroom, Photoshop Elements, and a used Apple iMac. If, in this scenario, I already had a computer for editing, then I'd use the extra bit of money for a good Wordpress template and cheap hosting. If the cameras cost more than $2,000, then I'd get cheaper stands and cyber syncs or Phottix triggers for the flashes.

I'd also possibly look at just getting a Fuji X100S and learn to live with the 35mm lens for most jobs at the start. The leaf shutter on the X100S allows you to sync at 1/4,000th of a second. If you can sync with flash at that fast of a shutter speed then you don't need the Alien Bee gear at first. The faster the sync you have, the less flash power you need. That takes $500 or so off the budget. I'd need to pick up something like a Wein IR trigger to get to those sync speeds, since most radio triggers can't sync beyond 1/250th–1/500th of a second. I'd still get wireless triggers in this situation. It's good to have both.

Going the X100S-only route also shaves about $800 off of the camera budget and shaves $450 from money spent on lenses. So one $1,200 camera could shave $1,700-something off of this $5,000 budget. Something to think about.

Let's take a look at some different rigs.

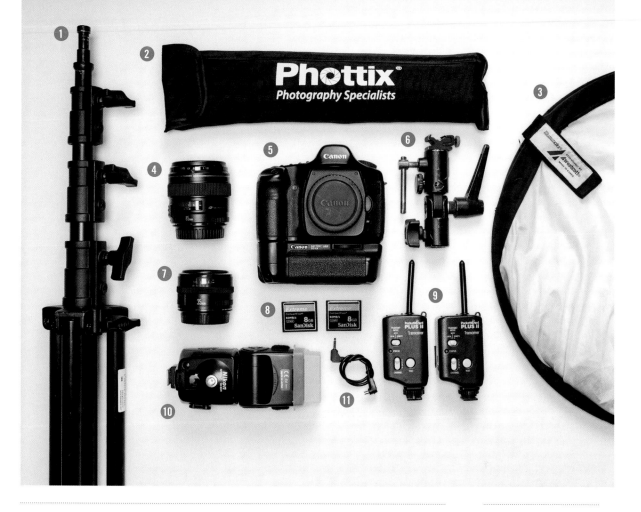

Above: Despite being old and outdated, I believe very much that if you can't get it done with this rig then you can't get it done. There is so much that can be done *today* with this rig. The 5D Mk I was an amazing camera when it came out. It's still an amazing camera. Don't think that old is mold.

1. Kupo 12.6' Baby Kit Stand
2. Phottix 36" Double Fold Umbrella
3. Westcott 42" Collapsible Reflector/ Diffuser
4. Canon 85mm f1.8 (bought used)
5. Canon 5D Mk I with BG-E4 Battery Grip
6. Manfrotto 026 Swivel Adapter with Stroboframe cold shoe
7. Canon 35mm f2 (bought used)

8. Some CF cards. I'm not loyal to one brand or another.
9. Used Pocket Wizard Plus II triggers
10. Nikon SB-80DX flash. When you go off camera with flashes you can mix and match different manufacturers.
11. PC to Miniphone sync cords. Attaches the Pocket Wizard to the flash.

Opposite: While this image was shot with a 5D Mk II, it could have easily been shot with the Mk I body. :: 35mm / f2 @ 1/640th @ ISO 125 / Available light with a little fill to the eye from a 42" reflector. B.o.B. shot for *Nylon* magazine.

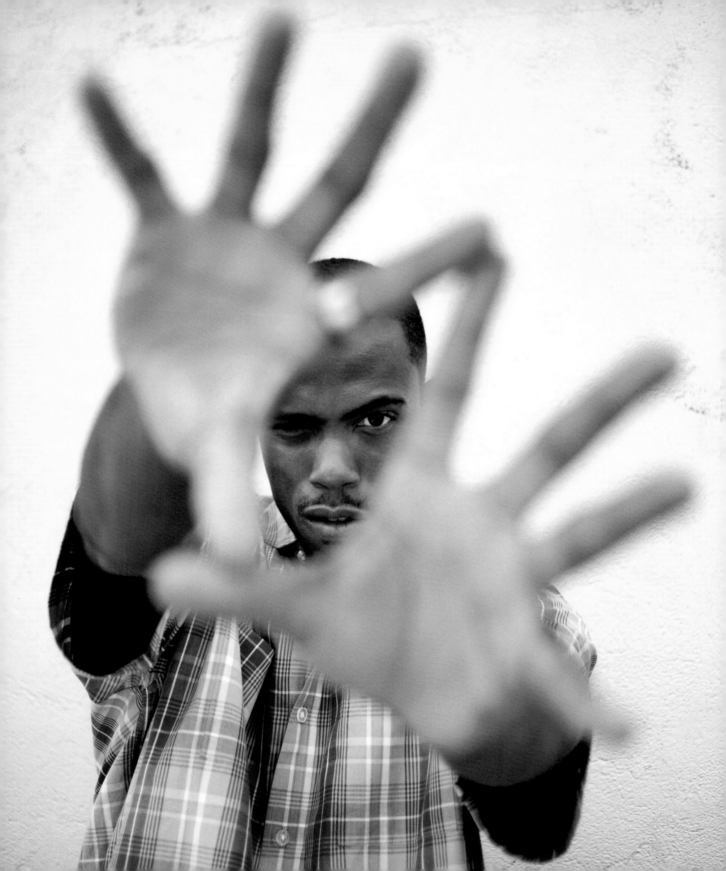

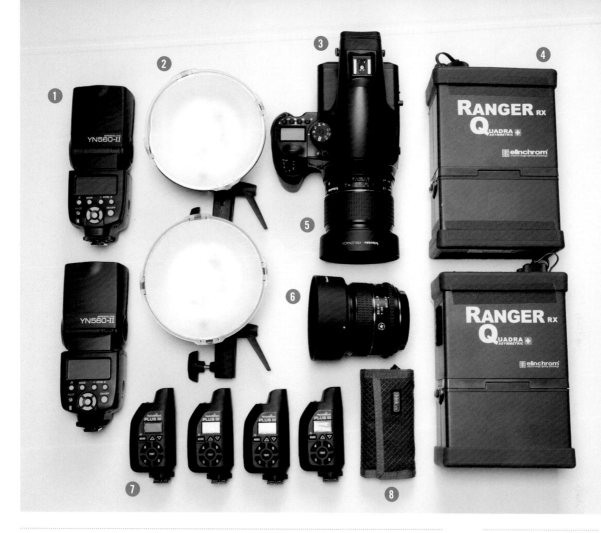

Above: The one thing missing from this kit is a good portrait focal length lens. That's the last thing I need to finish my Phase kit. I'm trying to decide between the 120mm f4 macro and the 150mm f2.8. I rarely, if ever, need high-speed sync with a longer lens, so I'm not looking for a leaf shutter telephoto. Currently the 80mm is my portrait lens. 80mm is the standard, or normal, focal length for medium format.

1. Yongnuo 560 II flashes. I know it seems silly to have cheap gear mixed with nice gear, but these little Yongnuo flashes do the job. No reason for me to spend the money on high-end Nikon or Canon hotshoe flashes.
2. Elinchrom Quadra A heads. A is for "action." These have very fast flash durations.
3. Phase One DF body with IQ140 digital back

4. Elinchrom Ranger Quadra 400 watt second packs
5. Schneider Kreuznach 55mm f2.8 leaf shutter lens
6. Schneider Kreuznach 80mm f2.8 leaf shutter lens
7. Pocket Wizard Plus III radio triggers
8. Think Tank Pixel Pocket Rocket to hold CF cards

Opposite: Photographers Philip and Allison Given on the day of their wedding. :: Phase One IQ140 / 55mm f2.8 lens / f5.6 @ 1/250th @ ISO 50 / Lit with an Elinchrom Quadra and a 60" reflective Impact brand umbrella...in the rain. I ain't scared of no rain. :-)

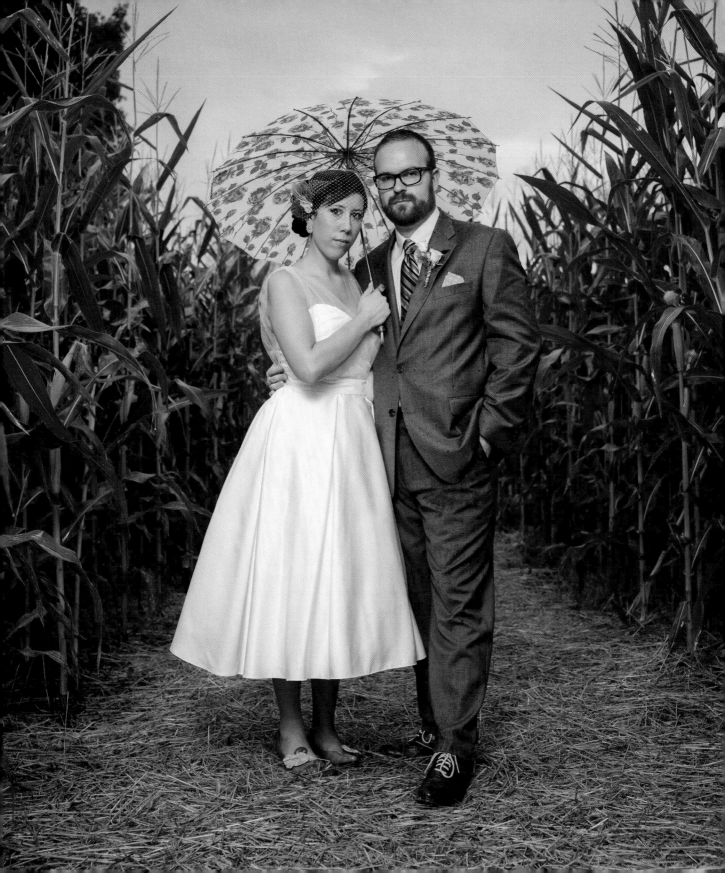

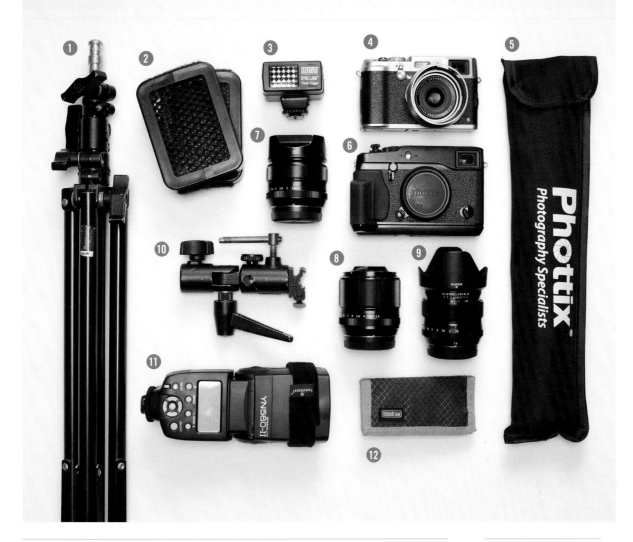

Above: As much as I love the quality that my Phase/Elinchrom kit gives me, nothing comes close to making my heart as happy as this kit right here. This is my favorite kit of gear. It's small, quiet, capable, and an absolute joy to work with. This is my new go-everywhere-do-anything kit. Note the lack of my Canon gear in this section of the book. That's not because I forgot. It's because I'm selling most of it. I'm kind of done with traditional DSLRs right now.

1. Avenger A625B 7.8' stand
2. Honl Photo 1/4 and 1/8 speed grids
3. Wein Sync Link IR flash trigger
4. Fuji X100S
5. Phottix 36" Double Fold umbrella
6. Fuji X-Pro1 with grip and soft release button
7. Fuji 35mm f1.4
8. Fuji 60mm f2.4
9. Fuji 14mm f2.8
10. Manfrotto 026 Swivel Adapter with Stroboframe cold shoe
11. Yongnuo 560 II flash with LumiQuest Velcro strap to attach Honl grids
12. Think Tank Pixel Pocket Rocket to hold SD cards

Opposite: A Kushti wrestler in Dubai. :: Fuji X-Pro1 / 35mm / f1.4 @ 1/600th @ ISO 200 / Aperture Priority mode with +1.3 stops of exposure compensation dialed in / Available light.

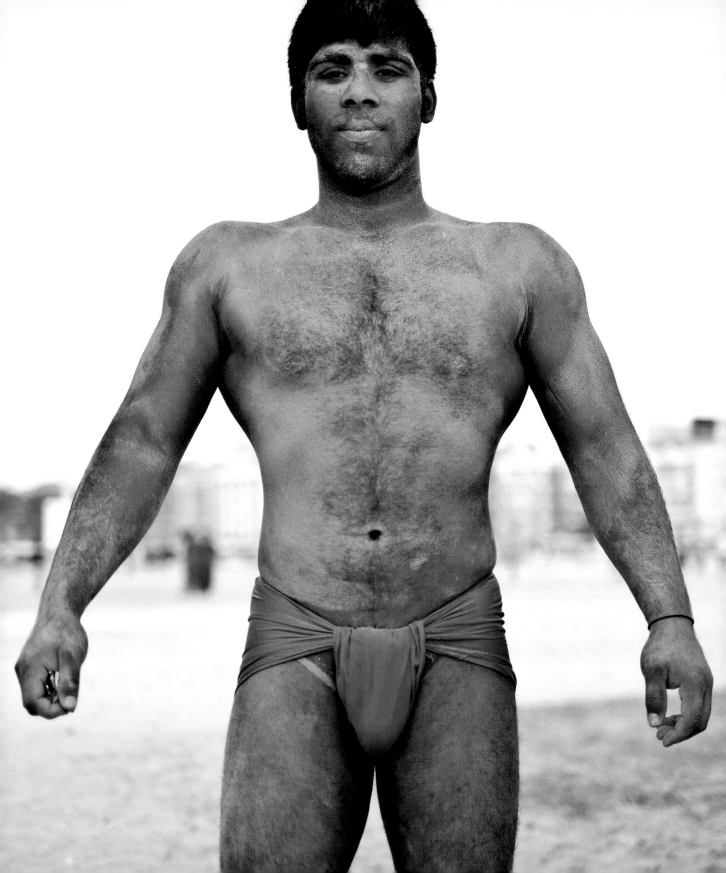

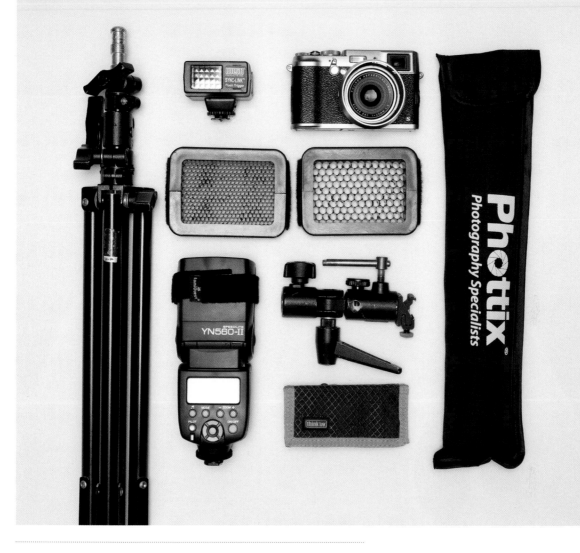

If my studio was on fire and I could only save one small kit of gear, it would be this kit. An X100S, a flash, the Wein trigger, some grids, and a small stand and umbrella. If any rig best represented me and what I do and what I want, then it would be this rig. I could let everything else go if I had to. I'd mourn the loss of my Phase. I'd cry Justin Timberlake a river if I lost my Elinchroms. But I'd move on with life with this rig and get the job done. I don't care if people think I'm crazy. I've never had a kit of gear like this that has made me more happy. It's my desert island rig. No doubt about it.

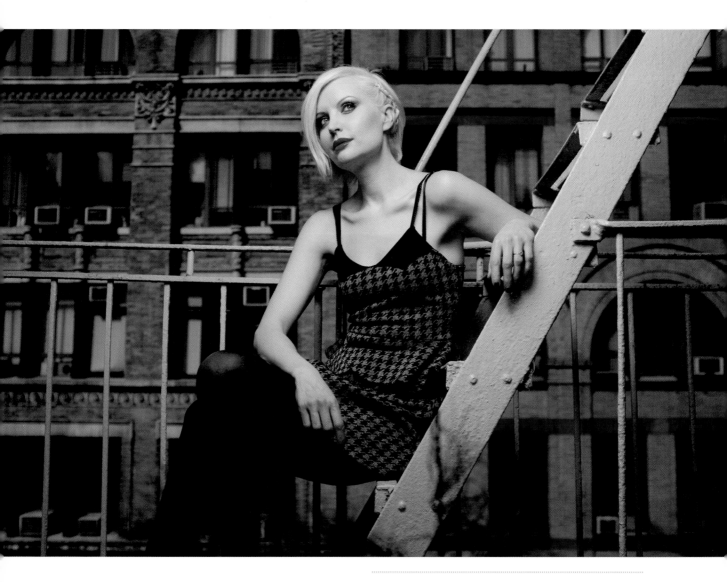

Shot at 3 p.m. on a sunny day in NYC. Musician Jennie Vee, shot for press and promotional use. :: Fuji X100S / f2.8 @ 1/640th @ ISO 200 / Lit with a Yongnuo 560 II flash with the Phottix 36" double-fold shoot-through umbrella. Triggered with the Wein IR trigger. Also note that the internal three-stop neutral density filter was engaged.

If I had to choose just one camera, one light, and one modifier?

BEST-CASE SCENARIO ::

- Phase One with 80mm f2.8 LS lens: Untouch-able image quality. High sync speed (1/1600th).

- Elinchrom Quadra: 400 watt seconds of light that fits in a camera bag. Plenty of juice for most things I need, and plenty of power to get a lot done with the high sync speed of the Phase.

- 60" convertible umbrella: The Swiss Army knife of modifiers. Can do a number of things. It can light single subjects and groups, and it can be half-closed for more of a small softbox type of look.

WORST-CASE SCENARIO ::

- Used Fuji X100 or new X100S: Leaf shutter = high-speed sync. Amazing lens. Great camera.

- Yongnuo 560 II flash: Small, powerful, and affordable.

- Phottix 36" double-fold umbrella: Small. Afford-able. Nice quality of light.

For me, and for many photographers out there, you don't need a ton of gear to get the job done. Working with limitations will make you a better photographer because you have to learn to do more with less. I often suggest having two solid prime lenses. Something a little bit wide and something a little bit telephoto. A 35mm and an 85mm lens can get a lot done. A simple flash and a simple reflector can get a lot done. In my opinion, these rigs I just showed are great solutions, from small budgets to large budgets. Don't think you have to get this "exact" gear. These are just things I use and trust. You may find you prefer Nikon gear over Canon. Or Hasselblad over Phase. Or Sony over Fuji. Don't freak out about the exact model numbers. Also note that I didn't go into backup gear. Suffice it to say, if you are shooting professionally you need some backup gear.

A: Good question. I had that problem for a while when I was getting started. I have a system down now that I stick to at *all* times.

For memory cards, I keep them in a Think Tank Photo Pixel Pocket Rocket. Before going on the job I check all my cards and format them in camera. When I walk on a job, I want all cards clear and clean. I will not format these cards again until they have been downloaded and backed up to at least two different hard drives. Empty cards go into the cardholder with the brand label facing up. When I have shot them, I put them back in with the brand label facing down.

For things like AA batteries I use plastic battery holders I get from B&H for about $6. Fresh and fully charged, they are placed in the battery holder in alternating polarities. Just like they get loaded into a flash or something. Once shot, they go back in the holder but I have all the batteries facing in the same direction.

Camera batteries are placed in accessory pockets in the flaps of my Think Tank bags. Metal contacts down if they are charged. Metal contacts up if they are used. Keep a consistent system with these things and your shooting life will be much better for it. You can quickly glance at your cards and/or batteries and know exactly what has been used and what has not been used. Note: After a job is complete, my cards do not leave my person until they are downloaded and backed up.

You should have a system for dealing with your equipment so that a quick glance of your gear tells you everything you need to know. How many cards have you shot? How many do you have left? How many sets of batteries do you have ready to go? Also, make a system for how you pack your bags. A place for everything, and everything in its place. A two-second glance at your open camera bag should let you know what is packed and what is missing. I try not to bury too many things under other things.

Q: HOW IS IT THAT MANY PROFESSIONAL PHOTOGRAPHERS RARELY FOLLOW THEIR OWN ADVICE? I SEE SO MANY PROS GIVING ADVICE TO PEOPLE ASPIRING TO MAKE PHOTOGRAPHY A CAREER BY SAYING, "IT'S NOT ABOUT THE EQUIPMENT. YOU DON'T NEED EXPENSIVE EQUIPMENT." YET YOU'RE OUT THERE WITH EXPENSIVE LIGHTING, $20,000+ MEDIUM FORMAT RIGS, AND FULL-FRAME DSLRS. ERIC KIM SAYS, "BUY BOOKS, NOT GEAR," YET HE WALKS AROUND WITH $10,000+ WORTH OF LEICA GEAR. IF HE FOLLOWED HIS OWN ADVICE, HE'D BE SHOOTING WITH A POINT-AND-SHOOT. WHAT GIVES?

A: Because we got to medium format gear and Leicas with crap gear. We started somewhere. Most of us got caught up in chasing the gear instead of the light, the moment, the photo. I had more gear at one point in my life than I knew what to do with. I'm afraid I'm back at that point in my career, and I've been honestly assessing what is too much and have started selling a few things.

Give me a Canon Rebel and a kit lens and send me on a job and I can get the job done. Is it the camera I most want to use? No. Is there a place and time to upgrade? Yes. You build up to that. The reason I preach that it isn't about the gear is because I finally learned…that it isn't about gear. Great photography isn't about the gear; it just isn't.

David duChemin has a great quote: "Gear is great. Vision is better."

So I have a Phase One hanging around my neck and I'm telling you it's not about the gear. I got that Phase One by having to work my ass to the bone with minimal gear that was held together with gaff tape and the Holy Spirit. The Phase One didn't get me here. The crap gear got me here. I'm also not shooting the same stuff I was with the D100 and Vivitar 285 that I used to shoot. The level of work I'm doing is rising and the quality of what I want to produce is rising. Gear helps. It does. It doesn't make you a photographer, though. It's the grey matter between your ears that makes you a photographer. That's why Kim says to buy books and not gear.

If you can do a lot with a little then you will grow. You'll prosper. You'll finally get to own a decent kit, but I swear you'll look back and realize that it wasn't gear that got you to where you are.

Vernon Trent said, "Amateurs worry about equipment. Professionals worry about money. Masters worry about light. I just take pictures."

Just take pictures—with whatever gear you have today. Master that. Better gear will come as you work your way through the craft.

Q: ANY ADVICE FOR CREATING PERSONAL PROJECTS? AFTER YEARS OF WANDERING AROUND WITH MY CAMERA TAKING PHOTOS OF EVERYTHING, I WANT TO FOCUS ON SMALL PROJECTS. HOPEFULLY IT WILL SLOW ME DOWN, ALLOW ME TO FOCUS, AND LEAD TO BETTER WORK. WITH A DAY JOB AND FAMILY LIFE (INCLUDING A TWO-YEAR-OLD), I DON'T GET MUCH TIME TO WORK ON PHOTOGRAPHY. IT'S A TOUGH JOB TO DO AS A PROFESSION, SO I THINK I'M HAPPY TO STAY AS AN AMATEUR IN THE TRADITIONAL SENSE, BUT WOULD LOVE TO SOMEHOW SELF-FUND MY HOBBY. IS IT WORTH SENDING LINKS TO ONLINE BLOGS OR MAGAZINES TO GET SOME FEEDBACK AND SEE IF I AM HEADING IN THE RIGHT DIRECTION? OR IS IT BEST TO "DO MY OWN THING," AND IF IT'S GOOD PEOPLE WILL FIND ME?

A: Thanks for the question. I'm going to expand on your question with a larger discussion of personal projects.

When it comes to finding and creating personal projects, it's hard to give advice on this due to the nature of the name itself—personal. I think finding personal projects is based on a series of questions you ask yourself:

The lead image from my personal project retelling *Don Quixote* as a modern hip-hop tale. :: Canon 5D Mk II / 80–200mm lens @ 190mm / f4.5 @ 1/125th @ ISO 160 / The main light is a 50" Westcott softbox lit with an Alien Bee 1600. There's a light on each side of him. Each is an Alien Bee 800 firing into 60" shoot-through umbrellas. The side lights are adding a rim to the subject and lighting the white background behind him.

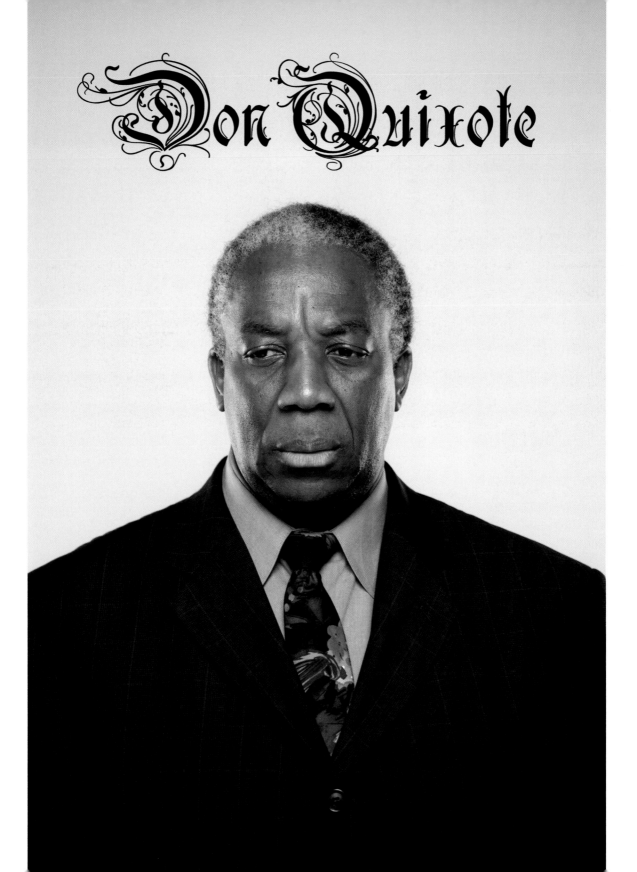

A photo from my Faces & Spaces project. This is "The General." Lit with an Einstein in a 22" white interior beauty dish. That's the 5–in–1 white reflector behind him being lit by another Einstein. Have you noticed I shoot this setup a lot? It's my instastudio! :: Canon 5D Mk II / 85mm / f2.8 @ 1/125th @ ISO 100.

- What interests me that I haven't explored visually? (People, details, darkness, light, shadows, faces, hands, bars, food, politics, shapes, emotions.)
- What are my strengths that I have to work with? (Portraiture, lighting, landscapes.)
- What is something I've never done before that I would enjoy pursing? (Portraiture, landscapes, macro, fashion, street.)

- Do I want to visually narrate a novel? A story? A feeling? A song? A social issue?
- Do I want to "say" something? Do I want to make a statement about culture, politics, religion? Is it about me, or my culture, or another culture I have observed?
- Is there a project I can work on that will eventually be able to help an organization, a group, my community, or me?
- How long do I want to work on this? How much time per day/week/month can I dedicate to this?
- Will I need resources to complete it? If so, what's my budget? (Locations, talent, gear, wardrobe, plane tickets.)
- What is the outlet for the work? How will I share it? (Personal site, blog, Blurb book, submit to publishers of blogs or magazines.)
- Am I going to work on a project that gels with what I already shoot, or will it be something that will stand apart from everything I've created so far?
- Are there other projects out in the world similar to mine? Better? Worse?

All of these questions run through my mind when developing a personal project. Some projects just invent themselves, like my #de_VICE project. Some come from feedback regarding my portfolio. I was told a few times last year that I should diversify the age of my subjects in my book, so I started my Faces & Spaces project.

My Don Quixote project started from a statement I once made to Meg. I was in some squabble with some folks in the photography industry and I said, "Sometimes I feel like I'm the Don Quixote of the photography industry; I'm chasing windmills." Meg asked if I had ever actually read Cervantes' *Don Quixote*. I admitted that I never had. "Well, before you go around comparing yourself to a senile old man with a shaving basin on

your head and delusions of grandeur, you might want to read the actual book," she joked. I picked up the book a few days later and it sparked an idea for me to create a modern-day story of that novel.

My #de_VICE project is something I can work on any time I have a camera with me. My Faces & Spaces project requires using social media and my network of friends and family to find willing subjects. Don Quixote was more like a commercial project where we cast talent, scouted locations, and spent some money to complete it. I actually bought Don's car on Craigslist after I couldn't find a place to rent a car that I needed for the story.

These three projects mix well with who I am as a photographer and the work I do as a working photographer. I can show this work in my book, I can make promo pieces from them, and I'm excited to share them.

First the face. Now the space. For each subject of this project, I photograph the headshot then an environmental portrait. I usually shoot these with the Phase and Fuji setup but on this particular day, for some reason I can't remember, I only had my Canon on me. Probably forgot to charge the batteries or something professional like that. :: Canon 5D Mk II / 35mm / f2.5 @ 1/160th @ ISO 800 / Available light.

My #de_VICE series and my street photography are a departure from my portrait work, but they all mix well together.

In 2010 I worked on some personal fashion stories. I'm not a fashion photographer. I don't shoot fashion. I don't plan on pursuing fashion work; it was just something I wanted to do. However, it didn't gel with the whole of my work, and those who knew fashion were not impressed and tore it to shreds. Besides some new lighting techniques I worked on while shooting it, it was sort of a failure. I now use those technical things I learned on other genres of work I create. So that, at least, is the silver lining in that dark cloud. Aside from this book you're holding in your hands, it's never been shown publicly, nor will it be shown again. Most likely. Never say never, right? :)

A personal project is the best way for you to hone your skills technically and visually. It gives you focus. It gives you purpose. It allows you to cut through the noise and find the signal. You can go out one day and fail miserably, step back, think it through, and go try again. Especially with subjects and projects that give you that sort of time. When you book talent and locations and fail, then it's a little more difficult to give it a go once more.

The next project that I'll start at some point is a series of portraits that I've been mulling over for the last three or four years. I wasn't sure how I was going to approach it until the Trayvon Martin killing in Florida. That devastating story sort of congealed the idea for me, and I'm now sketching the project out in my mind. (I'm not the type that physically storyboards. I wish I were. I just don't think or work that way.) The news story sparked my loose project idea and turned it into something more concrete.

I want you to think of your day job as the corporate funding for your photography projects. You are a photographer whether or not you have that word on your business card. You don't have to be a paid photographer to be legit. In some ways, you are far more free to create what you want when you don't have the pressure of it being part of your day-to-day work.

It's great if you can have an outlet for your work, but you should shoot as though you will be the only one to see it. Look at the street work of Vivian Maier. She was a nanny who took photos. Her work wasn't discovered until it was bought at a yard sale. How's that for an outlet?

If you can get feedback on your work from *trusted* sources while you are working on a project, that is a great, great, great thing. It really is. Not having that shouldn't stop you from doing it, though. Work through a project for a while and then find sources of feedback that can resonate with what you are trying to do. By this I mean: Don't send landscape details to a portrait blog. Don't show vivid color stuff to a blog that deals mostly in black and white. It's just like marketing your work to magazines or

Opposite: From my Don Quixote project. See that car in the garage? Dan Depew and I went to Southwest Atlanta at 11 p.m. to buy that car from a guy outside of a gas station. It barely ran but it looked good! It ran enough to get through this project. The car is "Rosie," by the way. Short for "Rocinante," Don's horse.

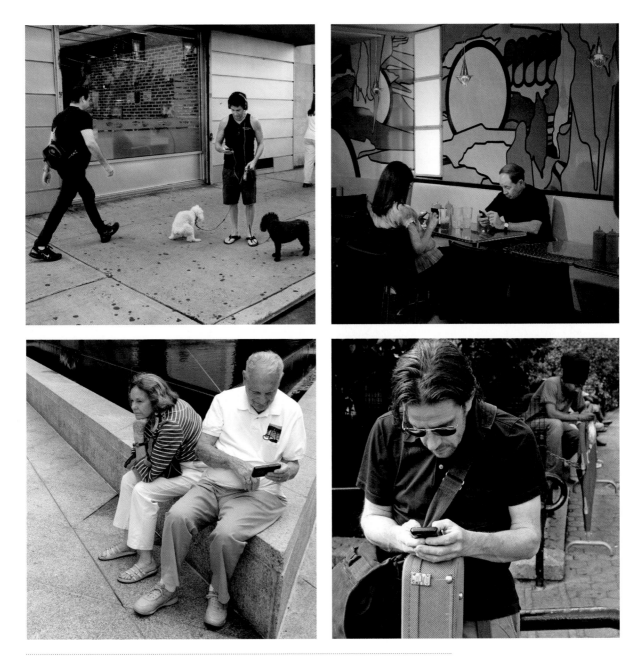

A selection of images from my #de_VICE project. This project started when I was walking the streets of NYC with my newly acquired Fuji X100. I took a photo of a person engrossed in their phone. Then I turned around and took a photo of another person on their phone. Then I walked 10 feet and took another one. I've been focusing on this project for two years now. I can shoot for it anywhere in the world at any time. I'm now trying to build layers of devices into my images. I no longer shoot single devices unless it's really, really good, like the dog walker. All images shot with an X100.

agencies; find outlets that showcase work that will mesh with what you are doing.

As a working photographer I'm in the same boat you are. I don't have the time to work on the projects I have in mind. My day job takes me away from other things I want to do with photography. Meg and I have four boys. Speaking of Meg—if you want to talk about frustration, you should talk to her. She's a brilliant musician but had to put her career on hold to raise these boys of ours. My career took off; Meg's came to a standstill. It's tough. Pursuing your art and taking care of your responsibilities are monumental tasks. Whichever you pour yourself into, the other will suffer. Finding the balance, or the rhythm, is the job ahead of you.

An image from my "fashion" personal testing that hasn't seen the light of day until being printed in this book. I like this image. I had fun shooting these images. It's cool light and a pretty girl, but it's not fashion photography. It's more like a lighting exercise than anything else. :: Nikon D3 / 35mm / f10 @ 1/250th @ ISO 200 / The main light is an Alien Bee 1600 in a 22" white interior beauty dish. There are two Alien Bee 800 strobes behind her with 20° grids facing back into the camera. In postproduction I removed one light stand that was holding a background light.

Q: WHAT DO YOU DO WHEN ONE DAY YOU LOOK AT YOUR STUFF AND THINK, "GREAT!" AND THEN THE NEXT, YOU THINK YOU'RE A COMPLETE HACK AND YOU SHOULD PACK AWAY YOUR GEAR AND SAVE YOURSELF THE TROUBLE? I GUESS IN LAYMAN'S TERMS—HOW DO YOU GET PAST ANY NEGATIVITY YOU MAY HAVE TOWARD YOUR OWN WORK AND GET BACK TO MAKING GREAT IMAGES? THIS IS, OF COURSE, ASSUMING YOU HAVE THOSE DAYS.

A: Hey! Welcome to every day of my life! Seriously! I'm not even joking.

I've had to just accept the fact that I'm my own worst critic. The best photographs I've ever taken are still in my head. I'll do a shoot, love it for 48–72 hours, then start to rip it apart. Sound familiar?

You'll never be perfect. You'll never have your dream portfolio. You'll never get it 100% right. You'll never be ready for the big leagues—*in your own mind.*

I've shot jobs, delivered the images, and waited in fear for the response to the work because I was already ripping it apart in my mind. I felt that I failed. The client then tells me I've knocked it out of the park; they could not be happier with the work, and they have two more jobs for me. Really? Okay. But see, I only knocked it barely over the fence. I was aiming for the parking lot across the street from the stadium. Why can't I just be happy that I hit a home run for the client?

Creating work brings the inner demons; it just does. That is if you are any good at all. Those who think their shit is awesome and totally love what they do and flaunt that stuff all the time are going to hit a big wall of complacency. They won't grow. They won't change. They won't develop. They'll stay right where they are, and one day they'll wonder why their work is so dated.

One thing I had to learn *not* to do was compare myself to others. That will kill you. Stop doing that. Don't ever do it; it will never help you. *Admire* the work of others. Take *delight* when they find success because if they found it, you can too.

If you are one style of photographer comparing yourself to the clients/lifestyle/work of another photographer with a different style from you, you'll just dig your own

grave. If they have a similar style and have found success, you need to be really happy about that; it means there is hope for your work.

You suck. You know it. We know it. Get over it. We all suck. Some suck less than others, but you will never ever ever find success and fulfillment if you sit at home and have a pity party every day.

I'll tell you what I tell myself: Get the f*ck over it and go shoot. Get over yourself. Quit bitching and moaning and complaining like an eight-year-old. Grow a pair and go do what you love to do.

Look—at some point you have to stand by your work and have confidence in it. That's a good place to be. But you know yourself well enough to judge how happy you actually are with the images you create. I think an

honest and good photographer will always be critical of their work. They will always have a level of unhappiness and uncertainty with their images that drives them to do better.

Hopefully you won't ever stop being critical; just make sure you don't become paralyzed by it and give up. Then your inner demons win, and you are leaving the photography industry to the douchebags who constantly Twitter and blog about some suuuuHHHHweeeeet *killer* rockin' awesome photos they just shot of the bestest clients they've ever worked with!!! Yeah!

Kill me now.

Q: AT WHAT POINT DO YOU DECIDE TO PUT DOWN THE CAMERA AND WALK AWAY FROM IT—POTENTIALLY FOREVER? I'VE BEEN SHOOTING FOR ABOUT FIVE YEARS, AND I FEEL LIKE I'VE HIT A WALL, BOTH IN CREATIVITY AND IN BEING A SKILLED PHOTOGRAPHER. I'VE BEEN WATCHING YOUR VIDEOS RECENTLY AND FELT VERY INSPIRED, BUT WHEN I PICK UP MY CAMERA TO DO SOMETHING WITH THAT INSPIRATION I FIND MYSELF AT A LOSS FOR IDEAS. I CAN'T SEEM TO FIND LOCATIONS OR BANDS WILLING TO BE SHOT SINCE THEY ALL HAVE THEIR OWN PHOTOGRAPHERS. MORE AND MORE, I FIND MYSELF DISCOURAGED AND I'M STARTING TO WONDER IF MAYBE I'M JUST NOT CUT OUT FOR THIS PROFESSION NO MATTER HOW MUCH I LOVE IT.

A: Okay, it's time to kick your ass a bit and give you some advice that will push you over, pick you back up, and, ultimately…just leave you in the exact place you started when you asked this question. I have an uncanny ability to do this. :)

Here we go.

I checked out your Tumblr. There's nothing there. Then I went to your Twitter profile. There's no link to your site. No information about who you are, where you are, what you do, etc. Popped over to your Instagram account and it was the same. Garden-variety IG photos like we all have, with a few live music shots thrown in. Again—no link. No bio, no location, no full name.

So I went through your Twitter feed. What do you Twitter about? Sports. Video games. Bad Model Mayhem models. A desire to break into sports photography.

Hating on your day job. Feeling uncreative, cynical, frustrated, and down on yourself.

Lemme get Dr. Phil on ya for a minute.

I'd say you have very little confidence in yourself. I'd say it's you against the world most days. I'd say that in 5th grade you had a chance to punch Jack Tullis in the mouth and you didn't take that chance. In 9th grade you had the chance to kiss Beth Treadaway and you didn't take that chance.

I'd say you have a few extra pounds on your bones; you have a shit day job; you see people climbing mountains and, well, you haven't found your boots yet.

In short—you sound *exactly* like me. Damn it. I had that chance to punch Jack's lights out and I never took it. 5th grade. J.G. Dyer Elementary. On the playground. Had the chance. I'm 40 and I still wish I'd have kicked him in the balls or something. Should have grabbed Beth by the hand, pulled her close, and planted a big ol' awkward 9th grade kiss on that girl.

WTF does this have to do with photography? *Everything!!!*

Look. I was the shy fat kid for just about all of my life. Now I'm just the fat kid! I wanted to do something great with my life but had zero direction until a camera was put in my hands. At the start, though, it was almost like being lost in the desert and finding a compass…that had no needle.

"Okay. Here's a thing that can help me find the way, but there's still something missing so, at the end of the day, it's no help at all."

Yeah. That was my life. By the time I reached my mid-twenties I was pissed off, cynical, and ready to take a bullet. I was a quarter of a century old and didn't have a damn thing to show for my life. I had yet to be successful at anything. I had yet to do something I was proud of. I had more regrets than anything. Should have punched Jack; should have kissed Beth; should

have paid attention in college; should have found a better job—on and on.

I sold everything I owned in 1995, bought a VW bus, and left it all behind for six months. That was one of the greatest things I've done for myself. At the end of that trip I realized I *had* to do something with my life or I'd just end up a bitter and cynical asshole. So I went back to school for photography; I learned the craft; I assisted; I built a portfolio; I got out into the world and started becoming a photographer.

Then guess what?

I failed miserably at all of it. Photography. Life. Creativity. All of it. A 100% total loser.

I moved into my brother's basement at the age of 29. That was fun. Single dad. No job. No money. No photography. Bitter. Cynical. Hating life. Hating myself. On and on. Couldn't take off. Couldn't run away. I was a dad now. I had obligations. Got a day job I hated. Worked the grind. Did all that shit. In short, the one thing I wanted to do the most—photography—I had to leave.

Then I got a chance again. I was *not* going to f*ck it up this time.

I *had* to get out there. I had to get over all of my damn insecurities and make this happen. I wanted it more than anything. I got focused. I set some goals. I set my priorities. I learned how to talk to people. I learned how to get over the fact that I wasn't awesome, but that also was not going to stop me. A lot of people who sucked were finding success. If they could do it, I could do it.

I changed my attitude. I made it a point to help people. I made it a point to be thankful for whatever little bit I had. I made it a point to be okay with who I was and what I did, even in the dark days. It was okay. Everyone sucks. Everyone is struggling with something.

Everyone gets knocked down. The great ones get back up. The great ones keep going. The great ones don't take themselves too seriously. The great ones lend a hand when they can. The great ones don't sit in self-pity. The great ones don't bitch and moan about everyone else. The great ones put their hand to the plow and do their work.

Yeah. I want to be a great one. I want that more than anything. If I can't shoot for the cover of *Rolling Stone* magazine then damn it, I'm going to *help* someone shoot for the cover of *Rolling Stone* magazine. If today I'm shooting photographs of toilets instead of gorgeous

My wife, Meghan, is a musician. She's been playing the piano and writing songs for a long time. People have told me, and rightly so, that she is more talented as a musician than I am as a photographer. This is a photo of her playing a show two days before the final deadline for this book. Think she doesn't struggle with giving up on music? Music for her is as much a muse as it is a demon. Every struggle every photographer asks me about is manifested in my house on any given day. If it isn't me, it's her. Or both of us. She's made the most sacrifices of either of us, though. She raises our boys and keeps this house in order. At the cost of her music and at the cost of her heart. You can find her music on iTunes. Look her up. She's amazing.

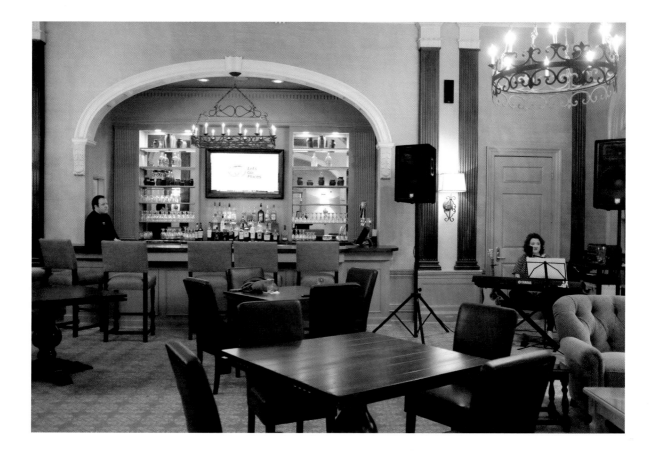

Italian models (Ferraris, Lamborghinis, etc.), then damn it, I'm thankful I get to take photos at all. My work might not be great but I'm going to share. I'm going to put it out into the world. I'm going to make it so people can find me. I'm going to get out there and not take no for an answer. I'm going to work harder and harder and harder. I have the rest of my life to make a go of it and that is what I'm going to do.

Whatever your life has been up to now…leave it behind. Seriously. Wash your hands of it. It's done. It's gone. It's past. That still leaves you exactly where you are—which isn't much to stand on. And guess what? That's fine. You have a shit job. Fine. You can't get bands to give you a second thought. No problem. Whatever. It's all good. It's where you are but it isn't where you'll end up. You're living your story. Every great story starts at the bottom.

You tweeted this: "I want to start a studio/product portfolio, band promo portfolio, wildlife portfolio, and update my live music portfolio."

In addition to all of that, you also want to shoot sports. Each of those things will take years to work on. You might want to narrow your focus a little bit. Figure out what you *most* want to do and go after *that*. Your day job is now your own personal corporate sponsor to get you going in that direction. Drop every expense in your life that you can live without. You need a camera, a lens or two, and a flash. That's it. Don't get all caught up in buying gear and gear and more gear. It doesn't matter. Rock what you have.

Get a web site up and running. Whatever you have now as far as a portfolio, put that up there. Link to it from your Tumblr, your Twitter, etc. Put your full name on all of this stuff. Put your location. Get your phone number on the web. When people start to look you up, give them plenty to look at and make it easy for them to find you. I'm not saying, "Build it and they will come." You still have to get out there and market yourself, but having an online presence is very important to your marketing. You're online right now. You have zero presence, though. See the difference?

Drop the negative vibe from your feeds. I'm not saying you should be untruthful, but just drop the negative vibe from your head more than anything. Stop being down on yourself. You have a long way to go, and it's going to be hard, and you can be honest about that, but let people find you with your head up, your eyes on the prize, and your hand on the plow. Not sitting on the side of the road with your tail between your legs and an Xbox controller in your hand.

Oh yeah—burn your Xbox. Or PlayStation. Or whatever it is. You have a hella ton of work to do, and that shit is eating your time and keeping you from your goal.

Google the article from *The Guardian* by concert pianist James Rhodes, entitled "Find what you love and let it kill you." Print that shit out and put it on your bathroom mirror. Read it every day until you are living it.

Pet some puppies. Smell a rose or two. Be thankful that whatever hardship you are facing today ain't shit compared to most of the world's population. Instead of buying a lens, buy a plane ticket to India. Go couch surf in Mumbai. Tell me you have it rough after that. I dare you.

Get off your ass. Stop staring at your feet. Stop watching my videos. Go and "do." Smile. Laugh. Facebook that girl from 9th grade and tell her you should have kissed her. Unless you're married. Then don't do that shit. No, no, no. Right, Meg? Right, honey? Right?

Go!!! It's going to take you the rest of your life to reach your goal. You better freaking get started.

Seriously…burn your Xbox. Or, pawn it. Use the money to get a passport and a malaria shot. When you are breathing your last breath, will you be proud of traveling the globe and pursuing your dreams (even through failure) or will you be proud of sitting on your ass playing a video game every night?

GEAR CHECK

This, IMHO, is a solid roadmap to follow as you progress through the craft of photography. Get a camera and a lens or two. That's all you need to get started. Do not get G.A.S.* or it will kill you. Live in the Round 01 stage for a year. As you continue forward, add a backup body and maybe some lighting gear.

When you are two or so years into this endeavor and you know your small kit of gear inside and out, then start to add some more glass and lighting options. Finally, if you find yourself going pro, you'll be at a point where you should upgrade a few things, but not too much. Go ahead and check off what you already have on this list. Fill in the gaps over time.

While you are working your way through these rounds, your Christmas and birthday wish lists are full of things like rechargeable batteries, memory card holders, battery cases, lens hoods, etc. All that little stuff adds up to a lot of money, but your friends and family would love to get that stuff for you as a gift. $6 battery cases are awesome stocking stuffers for me.

Note that there are things missing here, such as tripods, ultra-wide lenses, long telephotos, filters, etc. The type of photography you pursue will dictate changes from this basic roadmap. Maybe you're really into landscape photography so you'll want a good tripod. Maybe you're shooting kids' sports so you'll need a longer lens. This list is simply a guide. It's also here to show you that you don't have to have bags and bags of gear to be a photographer. Looking back 15 years, I really, really, really wish I would have followed this roadmap. I got into all the gear and all the debt, and it never made me a better photographer.

*Gear Acquisition Syndrome

Opposite: This is a random selection of images that have been made with gear up to Round 02 on this list. Camera. Lens. Light. Nothing fancy. Bands, ballerinas, bums, and bouquets. A simple kit will take you a long way.

ROUND 01 :: (JUST GETTING STARTED)

- [] Camera body (Nikon, Canon, Sony, crop, full frame, whatever)
- [] A lens that's a bit wide (i.e. 28mm f2.8 to 35mm f2)
- [] A lens that's a bit long (i.e. 85mm f1.8)
 (Note: Something like a 35–70mm or 24–105mm zoom covers the range you need.)
- [] Reflector
- [] Handful of cards and batteries
- [] Decent bag
- [] Decent computer with basic editing software

ROUND 02 :: (WEEKEND WARRIOR)

- [] Backup camera body *or* a small mirrorless (4/3's, Fuji, etc.) system, if those appeal to you
- [] 50mm 1.8—the "nifty-fifty"
- [] Light stand with swivel adapter
- [] Flash
- [] Trigger for flash (i.e. infrared, Phottix, Pocket Wizard, etc.)
- [] Umbrella
- [] Grids
- [] Monitor calibrator

ROUND 03 :: (GETTING SERIOUS)

- [] Your original kit lens has been donated or thrown in the recycling bin
- [] One more lens based on how you shoot—wide or telephoto. Pick one.
- [] Backup flash and trigger set
- [] Strobe with battery (i.e. Alien Bee 1600 with Vagabond mini battery)
- [] Softbox—something small or large. Pick one.
- [] Bags to hold lighting gear, stands, and modifiers
- [] Upgraded computer

ROUND 04 :: (GOING PRO)

- [] Update camera bodies. Have two matching bodies if you can do so.
- [] Whatever lens you passed on for Round 03, get the other one
- [] Fresh batteries and cards if needed
- [] Update triggers if needed
- [] Add another strobe
- [] Whatever softbox you passed on for Round 03, get the other one
- [] Upgrade software
- [] Upgrade camera bags if needed
- [] RAID storage solution

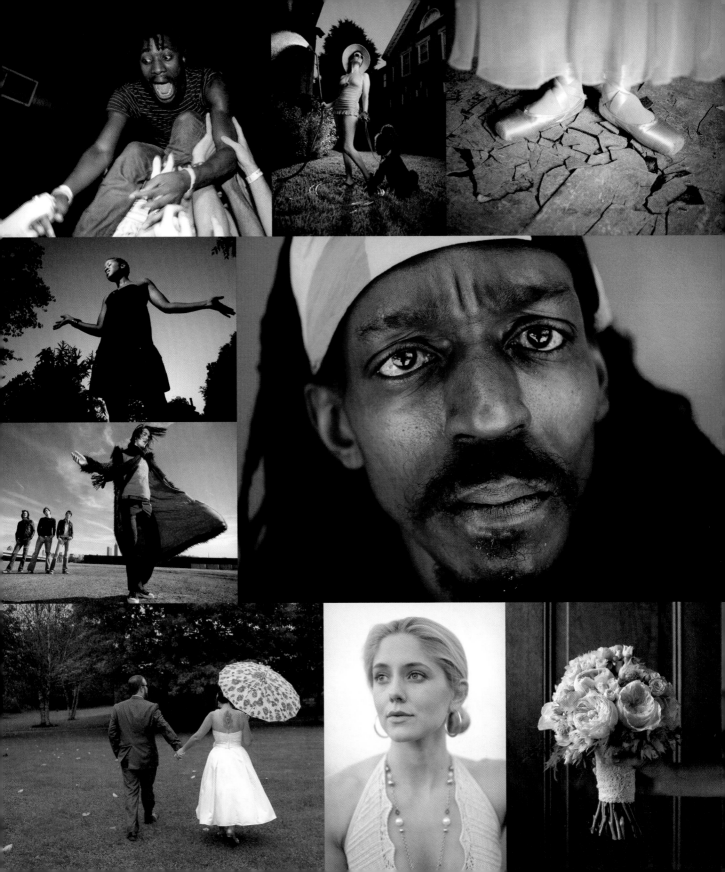

MONTHLY COST OF DOING BUSINESS

Mortgage/Rent	$1,000
Utilities	$350
Renter's/Home Insurance	$30
Other Home Expenses	$200
Health Insurance	$150
Student Loans/Credit Cards	$325
Car Payment	$270
Car Insurance	$120
Gas	$150
Maintenance	$50
Cell Phone	$100
Internet	$50
Cable	$75
Web Host	$10
Groceries	$300
Dining Out	$200
Coffee Shops	$75
Entertainment	$150
Clothing	$75
Camera Gear	$150
Computers	$100
Software	$75
Repairs/Maintenance	$50
Business Insurance	$60
Accountant/Bookkeeper	$100
Portfolios	$25
Marketing Materials	$25
Postage	$50
Mailing List/Database Service	$45
Misc. Stuff	$350

Monthly Expense Total	$4,710
Number of Shoots You Can Do Per Month	8
Expenses Divided by Shoots	$588.75

This is a basic, bare-bones, minimal look at monthly expenses. If you really look into your financial life, you'll find many additional expenses.

There are some major line items missing in this list. Things like taxes, savings, retirement, emergencies, transmissions, kids, gifts, etc. This is a look at 12 months in a year, as well. There will be months when you don't have jack for work. This list is more like a survival list than it is a true business guide. I'll leave the real numbers up to the real business and financial people.

Now then—look at the total of your expenses. Divide that by the number of shoots you honestly think you can do each month. Every month. From here until the end of time. The fewer jobs you can shoot, the more you have to make on each one.

When someone calls and asks what your rate is, you are now armed with real information. Your rate—minimum— just to stay breathing and out of the rain for one more month is basically $600 a day. You can't retire on that. You can't take a vacation. You can't pay taxes yet. May God be with you and help you if your car explodes, because you're done if that happens. Welcome to the gauntlet!

MONTHLY COST OF DOING BUSINESS

Mortgage/Rent _____

Utilities _____

Renter's/Home Insurance _____

Other Home Expenses _____

Health Insurance _____

Student Loans/Credit Cards _____

Car Payment _____

Car Insurance _____

Gas _____

Maintenance _____

Cell Phone _____

Internet _____

Cable _____

Web Host _____

Groceries _____

Dining Out _____

Coffee Shops _____

Entertainment _____

Clothing _____

Camera Gear _____

Computers _____

Software _____

Repairs/Maintenance _____

Business Insurance _____

Accountant/Bookkeeper _____

Portfolios _____

Marketing Materials _____

Postage _____

Mailing List/Database Service _____

Misc. Stuff _____

Monthly Expense Total _____

Number of Shoots You Can Do Per Month _____

Expenses Divided by Shoots _____

MY PERFECT WEDDING / PORTRAIT CLIENT

Age _____

Occupation _____

Education level _____

Zip code _____

Zip code they'd rather be in _____

Income _____

THEIR FAVORITE ::

Coffee house _____

Restaurant _____

Bar _____

Clothing store _____

Box retailer _____

Team _____

Movies _____

Bands/artists _____

TV shows _____

Books _____

Magazines _____

Web sites _____

The coffee they order would be a _____

The cocktail they order would be a _____

They would vacation here _____

They drive a _____

They vote for this party _____

Their personal faith is _____

They are passionate about these issues _____

These emotions drive their decisions _____

Their family is _____

Their friends are _____

They buy from these brands/companies _____

They avoid these brands/companies _____

They hate _____

They'll do anything for _____

Close your eyes. Picture your perfect client. Where are they hanging out on their day off or after work? What kind of job do they have? What kind of job do they want to have? What part of town do they live in? Is there another part of town they'd rather live in? Do they want a house or a loft? Are they driven by career and lifestyle or by family? Are they religious people? Are they flaming liberals? Are they really into fitness? Do they hate sports? What kind of bumper stickers are on their car? Do they like vintage bicycles? Do they miss their childhood? Close your eyes. Look at them. Who are they? When they walk past your marketing material that is push-pinned to the wall, what makes them stop and look at it? What makes them take it? Close your eyes. Watch. Nine times out of 10 your perfect client either looks a lot like you or they look like the person you would like to be. #psychobabble #thedoctorisin :-)

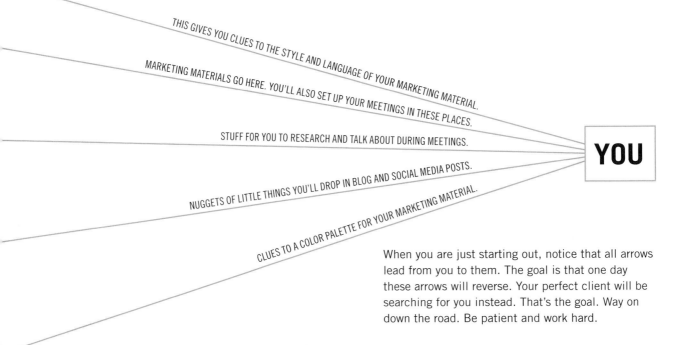

THIS GIVES YOU CLUES TO THE STYLE AND LANGUAGE OF YOUR MARKETING MATERIAL.

MARKETING MATERIALS GO HERE. YOU'LL ALSO SET UP YOUR MEETINGS IN THESE PLACES.

STUFF FOR YOU TO RESEARCH AND TALK ABOUT DURING MEETINGS.

YOU

NUGGETS OF LITTLE THINGS YOU'LL DROP IN BLOG AND SOCIAL MEDIA POSTS.

CLUES TO A COLOR PALETTE FOR YOUR MARKETING MATERIAL.

When you are just starting out, notice that all arrows lead from you to them. The goal is that one day these arrows will reverse. Your perfect client will be searching for you instead. That's the goal. Way on down the road. Be patient and work hard.

Kindergarten art or brand research? Look at the color palettes of the brands and publications your clients support. Grab some markers and just squiggle those colors on the page. Now, which ones do *you* respond to? Form some thoughts on this, and then just ponder these things for a month or two. Don't act on these feelings right now. Let them steep. These are clues to the colors you will use in your own marketing material.

I WANT TO SHOOT FOR _____ MAGAZINE

ADDRESS :: _____

SR. PHOTO EDITOR :: _____

Phone _____

Email _____

Twitter _____

Facebook _____

LinkedIn _____

Instagram _____

Blog _____

Additional editors _____

Photographers they regularly hire _____

TYPE OF PHOTOGRAPHY THEY TYPICALLY USE ::

☐ Color only ☐ B&W only ☐ Mix ☐ Bold colors ☐ Muted colors ☐ Vertical ☐ Horizontal
☐ Portraits ☐ Architecture ☐ Details ☐ Lit ☐ Available light ☐ Candid portraits
☐ Posed portraits ☐ Subjects make eye contact a lot ☐ Subjects seem to always look off camera
☐ Mix ☐ Props are used ☐ Studio work ☐ Location ☐ Simple compositions
☐ Complex & layered compositions ☐ One image per feature ☐ Multiple images per feature
☐ Loose crops/Lots of negative space ☐ Tight crops

Other noteworthy style observations _____

I'm a good fit for them because _____

NEXT STEPS ::

☐ Call for portfolio submission guidelines ☐ Email short and sweet introduction with link to my site
☐ Mail promo material ☐ Call to ask for a meeting ☐ Follow up on all of this

I WANT TO WORK FOR _____ COMPANY/BRAND

MARKETING DIRECTOR :: _____
Phone / Email / Address _____
LinkedIn / Twitter / Etc. _____

CORPORATE COMMUNICATIONS :: _____
Phone / Email / Address _____
LinkedIn / Twitter / Etc. _____

PUBLIC RELATIONS :: _____
Phone / Email / Address _____
LinkedIn / Twitter / Etc. _____

INTERNAL CREATIVE DIRECTOR :: _____
Phone / Email / Address _____
LinkedIn / Twitter / Etc. _____

OTHER :: _____
Phone / Email / Address _____
LinkedIn / Twitter / Etc. _____

ADVERTISING AGENCY/AGENCIES OF RECORD FOR THIS BRAND

FOR PRINT :: _____
Phone / Email / Address _____
LinkedIn / Twitter / Etc. _____

FOR WEB :: _____
Phone / Email / Address _____
LinkedIn / Twitter / Etc. _____

FOR VIDEO / FILM :: _____
Phone / Email / Address _____
LinkedIn / Twitter / Etc. _____

CREATIVE DIRECTOR :: _____
SR. ART DIRECTOR :: _____
ART DIRECTOR :: _____
ART BUYER :: _____

CREATIVE DIRECTOR :: _____
SR. ART DIRECTOR :: _____
ART DIRECTOR :: _____
ART BUYER :: _____

CREATIVE DIRECTOR :: _____
SR. ART DIRECTOR :: _____
ART DIRECTOR :: _____
ART BUYER :: _____

PUBLICATIONS THEY ADVERTISE IN :: _____

☐ Direct mailers
☐ Print catalogs
☐ Billboards
☐ Banner ads (on sites like _____)
☐ Annual reports / corporate communications / press releases
☐ Advertorial content (advertising that looks like editorial content)

Photography style _____ (see editorial worksheet [opposite] for examples)

Photographers they are hiring _____

These photographers are ☐ represented ☐ independent

Charities / foundations this brand is involved with _____

ME

INDEX

1:1 enlargements, 104
18% grey, 6, 7, 232–233
20-pound sandbags, 182

A

Abell, Sam, 228
advertising photography, 22
advertising your business, 168, 207, 226
 See also marketing your business
AF (auto focus) points, 96
albums, printed, 195
Alexander, Noah, 103
Alien Bee strobes, 8, 77, 163
American Photographic Artists (APA), 35, 82
American Society of Media Photographers (ASMP), 35, 82
annual report photography, 26
anxiety issues, 170
aperture
 image sharpness related to, 100
 variations between lenses, 81, 234
Aperture Priority mode, 202–203
Aperture program, 61
APhotoEditor.com website, 35, 147
apple boxes, 184
archived images, 113
Arias, Meghan, 143, 144, 284
art buyers/directors, 227
artist statements, 161
aspect ratios, 204
assistant jobs, 125–127, 128
 music photography, 164, 165
 pay rates for, 155
Atlantan magazine, 108

attitude change, 282–285
Austin, Dallas, 40
auto focus (AF) points, 96
Avedon, Richard, 201
average metering, 6, 7

B

back button AF technique, 96
backdrop support kit, 182
bad days vs. good days, 20
band photography
 charging for, 143–146
 client involvement in, 169
 See also music photography
battery organizers, 269
Baumgartner, Felix, 141
beauty dish case, 184
bidding on jobs, 212–213
Big Boi photo shoot, 32–33
Black, Kareem, 46, 228
blowing up images. *See* enlarging images
blurred photos, 99, 101, 204
BMI photo shoot, 174–175
B.o.B. photo shoot, 260–261
body language, 58
books, portfolio, 223
boring jobs, 190–193
Bourke-White, Margaret, 228
branding, 199
bridal shows, 206–207
Brown, Zac, 252–253
BTS posts/videos, 230
Burnett, David, 195, 228
business. *See* photography business
business cards, 195–197
buying equipment, 31, 77

C

calibrating light meters, 234–235
cameras
 client requests for, 16–17
 full frame vs. crop sensor, 51–52
 handholding and focusing, 96, 97
 ISO differences between, 233–234
 Nikon vs. Canon, 13
 Sony, 247
Canon cameras/lenses, 13, 247, 260
Capa, Robert, 228
Capture One program, 61
Cavalia photo shoot, 190
cheap equipment, 77, 243
Cheetah Stand softboxes, 159
cityscapes, 120
Clary, Ed, 22
clients
 bidding on jobs for, 212–213
 building a list of, 198
 calculating pricing for, 152–155
 dealing with slow-paying, 250
 delivering disappointing photos to, 238–239
 equipment requests made by, 16–17
 perfect client worksheet, 290–291
 personal style related to, 48–49
 pricing info for prospective, 177–179
 providing digital files to, 209–210, 211

selling to potential, 256–257

Climie, Marc, 14, 103, 144, 188, 216

Clinch, Danny, 164

Clue game photos, 135

Coffee, Meghan. *See* Arias, Meghan

Colbert, Gregory, 228

commercial photography, 22, 293

comparing yourself to others, 129, 249, 280

competitions/contests, 42–44

composition, 214

confidence, 141, 257

connections, 167–168

content over technique, 71

continuous lights, 186

contracts
 licensing/usage, 251–253
 photo credit, 254–255

corporate photography, 22, 26, 293

Cost of Doing Business Calculator, 157

Cowart, Jeremy, 13, 20, 46

craft vs. equipment, 270–271

credits, photo, 254–255

critique of photos
 obtaining from others, 35, 222–223
 self-criticism and, 280–281

crop sensors, 51–52

cropping photos, 204

CVs/résumés, 84

cynicism, 2–4

D

database of clients, 198

delivering photos to clients, 238–239

dental work trade story, 32

Depew, Dan, 37, 277

Design Bureau magazine, 25

#de_VICE project, 275, 277, 278

digital files, 209–210, 211

digital presentations, 195

DigitalRev YouTube channel, 55

directing models, 58–60

documentary photography, 25

Don Quixote project, 272–273, 274–275, 277

drinking with friends, 131

Dubai story, 249

duChemin, David, 271

E

Eagle Creek luggage, 183

editing portfolios, 216–223

editorial photography, 25, 26

Einstein strobes, 163

Elinchrom Quadra flash, 262, 268

enlarging images, 104–108, 155

Epson R-D1 camera, 95

equipment
 advice on buying, 31, 77
 bags for carrying, 182–185
 cheap vs. inexpensive, 77, 243
 checklist for acquiring, 286
 client requests for, 16–17
 craft vs., 270–271
 enjoying your own, 94–95
 kit recommendations, 259–268
 light meters as, 232–236
 Nikon vs. Canon, 13
 rental houses for, 30
 sports photography, 30
 systems for organizing, 269
 when to sell, 34

exposure
 camera settings and, 202–203
 learning about, 6–7
 light meters and, 232–236

exposure compensation, 202

F

Faces & Spaces project, 274, 275

farce/phony, feeling like, 5

fashion photography, 25, 133–136, 277, 279

files, digital, 209–210, 211

filters, UV, 67

flash
 grid added to, 160
 hotshoe, 8, 160, 186
 LEDs compared to, 186
 lighting setups for, 78–80
 low-light photography and, 103
 strobe features, 163
 See also lighting

Flickr critiques, 35

focusing cameras, 96–97

followers/fans, 121–122

food chain, 137–138

free work, 167

Fuji X100S camera, 259

full frame cameras, 51–52

G

Gardner, Drew, 105
gear. *See* equipment
genres, photography, 21–26
 combining on web sites,
 188–189
 moving into new, 224–226
Given, Philip and Allison, 262–263
goal of personal projects, 139
good days vs. bad days, 20
grids, softbox, 159–160
Grimes, Joel, 180
Gulf Photo Plus event, 249

H

Halsman, Philippe, 228
handholding cameras, 96, 97
Harvard Business Review, 37, 230
Heisler, Gregory, 228
Hobby, David, 121, 249
home studio space, 242
hotshoe flash, 8, 160, 186
Howe, Jamie, 41
Hurtt, Chris, 150

I

IBM Systems Magazine, 22
Impact 5-in-1 Reflector, 37
imperfect photos, 204–205
incident meters, 233
inexpensive equipment, 77, 243
Innis, Sherri, 146
IS lenses, 96
ISO settings
 camera-based variations in, 233
 noise in images due to, 100, 130

J

Jackson, David E., 48, 129, 222
Jarvis, Chase, 121
Jones, Travis, 14

K

Karsh, Yousuf, 228
Kayser, Chris, 108
Keatley, John, 226
Kent, Muhtar, 36–39, 230
Killer Mike, 24–25
Kim, Eric, 270
Kupo C-Stand, 184
Kushti wrestler, 264–265

L

Land, Gary, 137, 138
Lange, Dorothea, 228
laptop bag, 184
leave behinds, 197
LED lights, 186
Lee, Andrew Thomas, 131
legal issues, 110, 253
lens hood, 67
lenses
 experimenting with, 186
 f/stop variations between, 81
 Nikon vs. Canon, 13
 prime, 80, 268
 UV filters and, 67
 VR and IS, 96
Lerner, Paula, 176
licensing agreements, 251–253
light
 controlling spill of, 159, 160
 quality of, 12, 100
light meters, 232–236
 calibrating, 234–235

controversy about, 232
 list of recommended, 235–236
 metering modes, 232–233
lighting
 exposure settings and, 202–203
 grids used in, 159–160
 LED technology for, 186
 low light situations, 98–103
 number of lights used for, 78–80
 off-camera flash for, 103
 softbox, 8, 10, 12, 159–160
Lightroom
 Aperture compared to, 61
 noise reduction using, 130
lightstand/modifier bag, 182
Lightware Rolling Stand bag, 182
live music photography, 164–166
Living Things photo shoot, 86–93
location photography, 214–215
logos, 196, 199
loved ones, portraits of, 62–65
low light photography, 98–103

M

magazine photography
 average pay for, 164
 information worksheet for, 292
Maier, Vivian, 139, 277
making the leap, 140–142,
 171–172
Mark, Mary Ellen, 201, 228
marketing your business, 194–198
 bridal shows and, 206–207
 business cards for, 195–197
 genre jumping and, 225–226
 promo cards for, 197
 starting out and, 168, 225–226
 web site used for, 177, 194–195
Martin, Trayvon, 277

McNally, Joe, 13, 20, 56, 121
medium format systems, 104–105, 108
Meiselas, Susan, 228
memory card organizers, 269
Men's Book magazine, 72
Messi, Lionel, 137–138
meters. *See* light meters
models
 directing and posing, 58–60
 fashion photography with, 133–136
monthly expenses worksheet, 288–289
Moo.com business cards, 197
motion blur, 99, 101, 204
moving subjects, 100
multiple exposure mode, 86
music photography, 25
 author's start in, 14–15
 charging a band for, 143–146
 cities for working in, 165–166
 client involvement in, 169
 connecting with artists in, 167
 live music shoots in, 164–166
 Living Things photo shoot, 86–93
 T.I. photo shoot, 174–175
 White Stripes concert, 118–119

N

Nachtwey, James, 228
naming your business, 187
National Press Photographers Association (NPPA), 157
newspaper jobs, 165
Nikon cameras/lenses, 13, 247
No Plastic Sleeves web site, 223
noise
 high ISO settings and, 100
 reducing in images, 130

Norton, Cary, 222
nude photos, 72, 116–117
NYC Photo Works, 35
Nylon magazine, 40, 86, 260

O

off-camera flash, 103
one-light setup, 78
organizations, photography, 82

P

paid work, 147–149
Palm Springs Photo Expo, 35
Parks, Gordon, 201, 228
paying your dues, 66
PDN magazine, 78
perceived sharpness, 100, 103
perfect client worksheet, 290–291
Perfido, Eolo, 241
personal projects, 139, 272–279
personal style, 48–49, 180
Phase One cameras, 105, 108, 262, 268
photo credits, 254–255
Photo Mechanic program, 218
Photo Plus Expo, 35
Photoflex Pro-Duty Backdrop Support Kit, 182
photographers
 genres for, 21–26
 list of great, 228
photography business
 bidding on jobs in, 212–213
 deciding to start, 140–142, 171–172
 making connections for, 167–168
 marketing, 168, 177, 194–198
 monthly expenses worksheet, 288–289

naming considerations, 187
personal work vs., 120
posting pricing for, 177–179
relationship stress in, 173
taking underpriced jobs in, 176
working with reps in, 224–225
photography competitions, 42–44
photography jobs, 66, 176
photography organizations, 82
photography representatives, 224–225
photography schools, 123–124
photojournalism, 23
photos
 cropping/blurring, 204–205
 delivering disappointing, 238–239
 editing your portfolio of, 216–223
 finding in every situation, 28
 honest critiques of, 35, 222–223
PhotoShelter service, 216
Phottix triggers, 243
pixel peeping, 104
Pocket Wizards, 243
Polaris light meter, 235
portfolios
 building, 18, 167
 editing/organizing, 216–223
 reviews of, 35, 222–223
portraits
 fashion photos and, 136
 finding subjects for, 18–19
 getting work shooting, 147–149
 importance of loved ones in, 62–65
 perfect client worksheet for, 290–291
 pricing examples for, 210

providing files of, 209–210
self-assignment on, 150–151
street photos as, 18–19,
110–111
posing models, 58
post-processing, 48–49
pre-shoot anxiety, 170
pre-visualization, 58–59
pricing
bidding and, 212–213
compromising on, 176
example of calculating, 152–155
guidelines for setting, 156–157
music photography, 143–146
portrait photography, 210
posting on your web site,
177–179
prime lenses, 80, 268
printed book/portfolio/album, 195
Professional Photographers of
America (PPA), 82
promo cards, 197

Q

quality of light, 12, 100
Quarles, Wes, 45–46, 47

R

Ramsay, Gordon, 158
rate setting. *See* pricing
rating photos, 219
RAW files, 211, 217
referrals, asking for, 168
reflective meters, 232–233
reflectors, 37–41
relationship stress, 173
release forms, 110
renting equipment, 30
reps, photography, 224–225

résumés/CVs, 84
Rhodes, James, 285
Richardson, Terry, 149
Ritts, Herb, 228
Robbins, Tony, 172
Rock-N-Roller folding cart, 184
room size considerations, 29,
240–241
Roversi, Paulo, 204, 228

S

Salgado, Sebastiao, 228
sandbags, 182
schools, photography, 123–124
second shooter jobs, 127–128, 144
Sekonic light meters, 235–236
self-assignments, 150–151
self-criticism, 280–281
self-promotion, 194–198
Seliger, Mark, 228–229
Sellers, Bryan, 41
selling
unused equipment, 34
your services, 256–257
sensors
cropped, 51–52
medium format, 105
sharpness
focusing issues related to, 96–97
low light photography and,
98–103
shoot-through umbrellas, 214
showing your work, 231
shutter speed
handheld cameras and, 96
sharpness related to, 99, 100,
101
Silvin, Rene, 72–75
Sirota, Peggy, 228

slow-paying clients, 250
Smith, Brian, 247
Smith, W. Eugene, 228
softboxes, 8–11
grids used on, 159–160
quality of light from, 12
umbrellas vs., 8, 10
Somji, Mohamed, 249
Sony cameras, 247
space considerations, 29, 240–241
sports photography
equipment for, 30
photos of players, 137–138
spot metering, 6, 7, 232
starting out, 131
stock photos, 113
street photography
candid, 68–70, 110
personal safety in, 244–246
portrait, 18–19, 110–111
Strobist.com blog, 249
studio space, 240–241, 242
style
finding your own, 48–49, 180
substance over, 71
substance over style, 71
success, definitions of, 201

T

talking to strangers, 54–57
teaching and learning, 85
technical mindset, 204–205
tenacity, 149
Testino, Mario, 228
thank you cards, 197
Think Tank gear bags, 184, 185
three-light setup, 80
T.I. photo shoot, 174–175
time considerations, 47, 53, 131

trade shows, 83
Trent, Vernon, 271
Turner, Ted, 190
Turnley, David, 228
two-light setup, 80

U

umbrellas, 8, 10, 214, 268
underpriced jobs, 176
usage agreements, 251–253
UV filters, 67

V

Vee, Jennie, 267
vision, 60
VR lenses, 96

W

wage setting. *See* pricing
war photography, 135–136
web sites
 creating, 194–195, 199–200
 mixing genres on, 188–189
 photo galleries on, 223
 posting pricing on, 177–179
Wedding and Portrait Photographers
 International (WPPI), 82
wedding photography
 marketing at bridal shows,
 206–207
 pay rate for second shooters of,
 144
 perfect client worksheet for,
 290–291
 supporting a passion through,
 120
Weeman, Michael, 145–146
Weems, Hassel, 32

Westcott
 Apollo softboxes, 8–11
 white cotton backdrop, 183
Weston, Edward, 228
White, Jack, 118–119
white cotton backdrop, 183
white seamless, 29
White Stripes concert, 118–119
wide-open aperture, 100
Winters, Dan, 46, 122, 228
Wonderful Machine, 146, 225
work prints, 219–220
work-for-hire contracts, 251
worksheets
 advertising/commercial
 photography, 293
 gear acquisition timeline, 286
 magazine photography, 292
 monthly cost of doing business,
 288–289
 perfect wedding/portrait client,
 290–291

Y

Yang, Peter, 228
Yongnuo flashes, 243, 262, 268
YouTube resources
 DigitalRev channel, 55
 light meter info, 236

PHOTOGRAPHY Q&A

REAL QUESTIONS. REAL ANSWERS.

Zack Arias

New Riders
1301 Sansome Street
San Francisco, CA 94111
415/675-5100
Find us on the Web at www.newriders.com
To report errors, please send a note to errata@peachpit.com
New Riders is an imprint of Peachpit, a division of Pearson Education

Editor: Ted Waitt
Production Editor: Lisa Brazieal
Cover and Interior Design: Charlene Charles-Will
Layout and Composition: Kim Scott, Bumpy Design
Copyeditor: Meghan Arias
Indexer: James Minkin

ISBN-13 978-0-321-92950-1
ISBN-10 0-321-92950-0

9 8 7 6 5 4 3 2 1

Printed and bound in the United States of America

PHOTO GRAPHY Q&A

Real Questions. Real Answers.

ZACK ARIAS

New Riders

VOICES THAT MATTER™